The Complete Book of
DECORATIVE PAINT TECHNIQUES

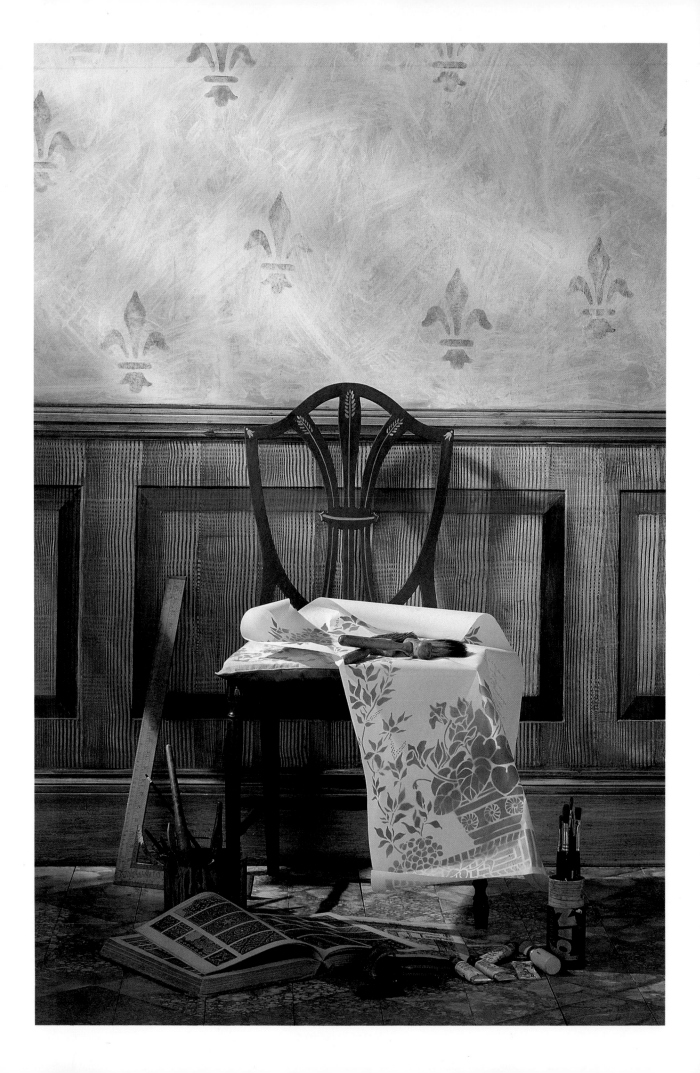

The Complete Book of
DECORATIVE PAINT TECHNIQUES

A Step-by-step Source Book of Paint Finishes and Interior Decoration Techniques

Annie Sloan & Kate Gwynn

Century

LONDON · MELBOURNE · AUCKLAND · JOHANNESBURG

A Mobius International book
Edited and designed by
Mobius International Limited
197 Queens Gate
London SW7 5EU

© 1988 Collins & Brown
Text copyright © 1988 Collins & Brown / Annie Sloan
and Kate Gwynn

First published in 1988 by Century Hutchinson Ltd.
Random Century House, 20 Vauxhall Bridge Road, London SW1V 2SA

Century Hutchinson Australia Pty Ltd.
PO Box 496, 16–22 Church Street, Hawthorn, Victoria 3122, Australia

Century Hutchinson New Zealand Ltd.
PO Box 40-086, Glenfield, Auckland 10, New Zealand

Century Hutchinson South Africa Pty Ltd.
PO Box 337 Bergvlei 2012, South Africa

ISBN 0 7126 1905 4

Reprinted 1991

Filmset by Tradespools Ltd, Frome, UK
Origination by Columbia Offset (UK), London.
Printed and bound in Hong Kong
Produced by Mandarin Offset Ltd

Contents

Paint is an extremely versatile medium, and decorative painting is an interesting area because it is where the skilled tradesman decorator and the fine artist meet. With a little patience, thought, and confidence great effects can be made. However, it is as well to take note of the quotation below from a book written in the early part of the century. This is not intended to put a student off, but to show how broad the subject is. The apprenticeship of a decorator would involve not only paint and colour mixing, but stencilling, gilding, sign writing, the principles of drawing and perspective, and general design and colour harmony.

An understanding of colour is vitally important to all decorative painting, so we have included a section on mixing colour and the palette. We hope this will inspire and help sort out the huge variety of colours available.

Do not be ashamed of your calling.
It takes five years to make a lawyer,
six a parson and seven a decorator.

The Modern Painter and Decorator

Gilding, stencilling, murals, and painting furniture have traditionally been done by artists and specialist craftsmen. There was always a strong folk tradition in the art of stencilling, both in northern Europe and in America, although in Britain in the 19th century craftsmen decorators, such as J.D. Crace, gave stencilling a sophistication and elegance it has never lost.

Besides stencilling, we looked at making blocks and other printing methods. For this reason, we brought in many elements from all over the world. As we both have a training in modern art, we hope a feeling of 20th-century fine art, African and other ethnic art, and the influence of major designers, such as the Bloomsbury group, come through.

The freehand painting section requires on the whole more artistic ability, but we have included a step-by-step of *trompe l'oeil* playing cards on a table, which can be done by anyone with a careful hand.

Gilding has always been an area on its own. Although akin to decorative painting, it has never been fully integrated. Gold transfer leaf is not so expensive that cost prohibits experimentation, and you can have fun with varnishes, gold and silver powders and Dutch metal.

People have been painting their furniture and the walls of their houses for almost as long as homes have existed. It seems that the ancient Egyptians mastered almost every refined decorative paint technique we know. They perfected the arts of gesso and gilding, and also used woodgraining and marbling. We are still using very much the same techniques and effects today.

Surfaces were painted for a number of practical reasons, such as protection and to disguise a cheaper wood, as well as for decoration. Initially, coloured distemper was used on walls and a less definite finish was created by scumbling the paint with dry brush strokes. Later, oil glazes were developed, and these gave a greater lustre and depth to the surfaces.

The joy of paint is its versatility, beauty, and practicality, although fashions and trends have often treated practicality merely as a coincidental bonus. Paint offers endless possibilities and, since so many people are increasingly interested in decorative paint finishes, we wanted to produce a book that is as

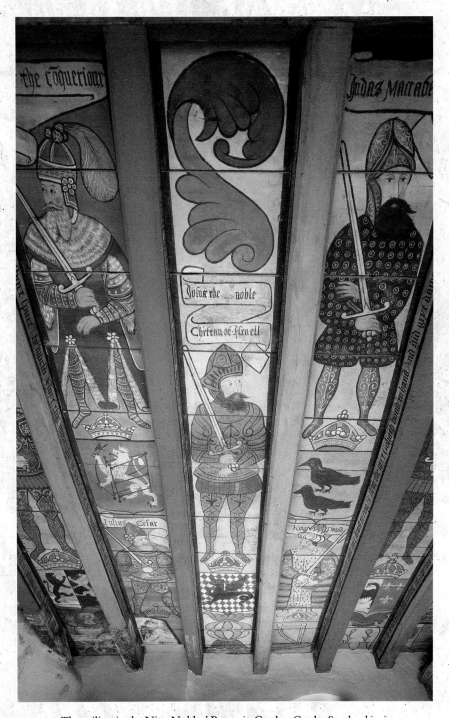

The ceiling in the Nine Nobles' Room in Crathes Castle, Scotland is, in fact, painted on the underside of the floorboards overhead. Painted ceilings were more usual in the 16th century, particularly in Scotland. The beams were painted simply.

instructive and comprehensive as possible.

The techniques of most decorative paint work can be taught and learned as a craft in a fairly straightforward and practical manner. The techniques in this book range from the very simple to those requiring considerable skill and knowledge. The advantage of many of the simpler techniques described is that people who have never considered themselves to be artistic and those who have never been taught can both enjoy themselves with paint and be successful.

Working on the basis that this book is to be put to use, we have tried to make its approach accessible and simple. Wherever possible, each paint finish is described and illustrated on two facing pages, so that every step can be seen at a glance and followed without the need to keep turning pages backwards and forwards. Each finish has its own 'recipe' of specific, practical advice: notes on the most suitable surfaces, the proportions for mixing oil glaze, and a list of the materials and equipment required.

We have tried to keep instructions about preparation to a minimum because there are already plenty of good diy manuals available. After the step-by-step sections we have suggested what may be done to the rest of the room. After the walls have been painted, the woodwork, cornice, floors, and furniture may need some paint effects to complete the look. However, thinking and planning before the first touch of paint is applied is extremely important.

People have different approaches to paint; some handle it vigorously, others much more delicately. Consequently, one person's ragging, for example, will probably look very different from another's. This is certainly true as the finishes and techniques become more involved and allow more scope for individuality and creativity. Also some people are classical and traditional in their approach, while others are more broadly interpretative, building on the knowledge, experience, and skills they have already acquired, and adding to them their own particular style and technique.

This book is intended for a wide range of people, from those who wish to learn and develop new decorating skills to those already familiar with mixing colour and manipulating paint. We have used a system of stars to indicate the level of difficulty of the basic techniques. We hope that the beginner will be able to start on a fairly simple project and gradually build up experience, confidence, and ideas. Please do not be put off if you feel that your first attempt is not wholly successful. Practice gives confidence and leads towards perfection. The second attempt should be stunning. We hope, too, that more experienced painters will find new ideas and further inspiration.

Finally, we should like to thank all the craftsmen, craftswomen, and specialists who have generously given their time and advice: in particular, Felicity Binyon, Dorothy Boyer, Elaine Green, Belinda Hextall, Elizabeth Macfarlane, and Harry Levinson. We are also grateful to Daler-Rowney for the generous provision of paints.

Kate Gwynn

Annie Sloan

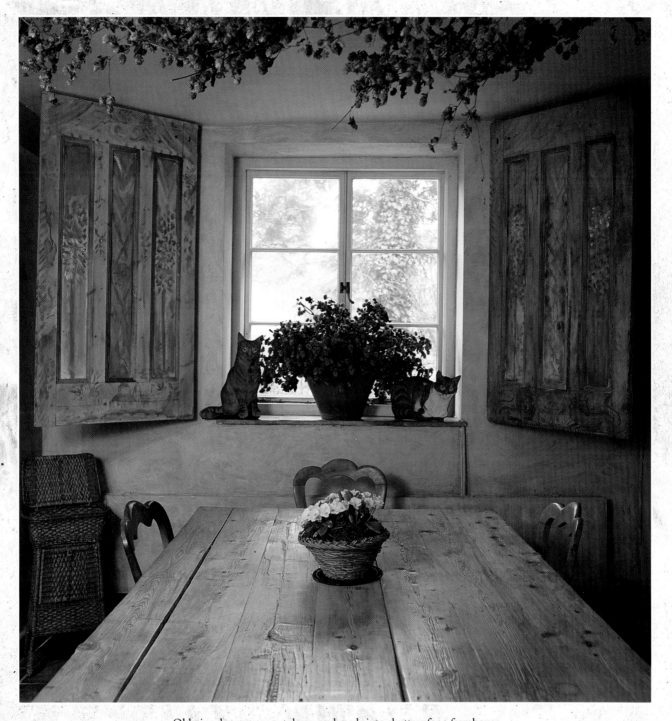

Old pine doors were cut down and made into shutters for a farmhouse
kitchen. They were not primed and parts of the wood were saturated
with turpentine. They were painted in thinned oil colour and wiped so
that the colour was barely visible in parts to create an aged and faded
look. English embroidery and tapestry were used as the source for ideas.
The walls were colourwashed in Siennas and Umbers.

CHAPTER I

Colour

AND OTHER SOURCES OF

Inspiration

The effect of decorative paint techniques lies, to a considerable extent, in the subtlety and nuances of coloured, transparent glazes laid over a base colour. The limitless variations of depth and intensity, the one colour informing, absorbing, reflecting, and echoing the other, can be mystifying and bewildering for those who have previously only ever used ready-mixed paint straight from a can. The next few pages should resolve the doubts of those who have never mixed their own paint, and, we hope, inform and inspire those who have.

It is easier to decide on the colour of your room by starting with the curtain and upholstery fabrics. The paint can be made to match the fabric exactly in colour or mood, but it is harder to find fabric to match the wall. Leave the paint samples on the wall for several hours so that you can judge the effects of natural and artificial light.

Colour and the palette

When you are planning the colour scheme of a room you will have to think in terms of two colours: the eggshell basecoat and the transparent oil glaze applied over the top. They should be related in some way, either different tones of the same colour or different colours that are close to each other in tone. Generally, pale effects require a white or off-white base with a pale colour tint over it, while a strongly coloured oil glaze will need a similarly strong basecoat.

The basecoat is an eggshell paint to which artists' oils may be added to alter the colour. The top coat is a mixture of glaze, white spirit, and artists' oil colour in varying proportions depending on the finish you have chosen. It is important to mix up a good satisfactory colour with the artists' oil colours. It is well worth spending time and effort experimenting, especially if you have never mixed colour before. Do not forget that the colours you mix will be considerably thinned down and altered by the addition of glaze and white spirit.

If you are going to buy a selection of colours for experimenting, it is sensible to confine yourself to a limited range, such as those recommended below, so that you may become better acquainted with the characteristics of particular colours and how they mix with others. It is also worth buying some small sheets of hardboard for trying out different colours and effects. You can buy them ready-coated or prime them yourself and then give them a coat of white eggshell paint.

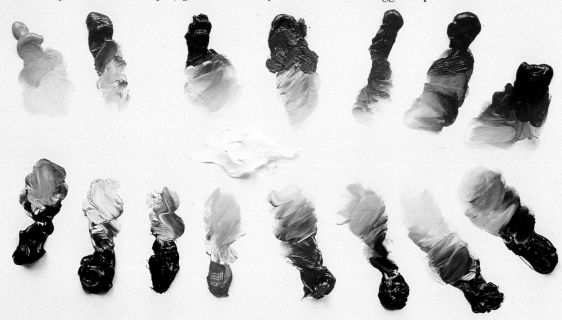

The decorator's palette: most colours can be mixed from this basic palette.

The decorator's palette

The decorator's palette and thoughts on colour will differ from the artist's. Artists' colours vary widely in their miscibility and stability. Some are infinitely more satisfactory and satisfying to use than others.

All brands of oil colours have a grading system indicating their permanency; some colours are fugitive and fade under the effects of sunlight, or change colour when they are mixed with others. Generally, manufacturers divide their colours into four categories. The first, four-star category colours are extremely stable, durable, and permanent—they do not react adversely with other colours. The second, three-star grading colours are thought of as durable. They have a degree of permanence comparable with the four-star, but there may be some loss of permanence if they are used with a thin glaze or are reduced with a lot of white. Colours in the two-star and one-star categories are not recommended. However, the colours in the first two categories (three- and four-star) are adequate for mixing a complete range.

The palette

This is a good basic palette from which most colours can be mixed. They are all permanent colours and mix well together to produce a wide range.

Raw Umber ★★★★, Burnt Umber ★★★★, Raw Sienna ★★★★, Burnt Sienna ★★★★, Cadmium Yellow ★★★, Yellow Ochre ★★★★, Alizarin Crimson ★★★, Terre Verte ★★★★ (can be made from Monestrial Green and Raw Umber), Oxide of Chromium ★★★★, Monestrial Green or Aubusson ★★★★, French Ultramarine ★★★, Prussian Blue ★★★, Ivory Black ★★★★ (a softer browner black), Titanium White ★★★★ (for better covering power), Indian Red ★★★★, Light Red ★★★★, Venetian Red ★★★★.

Cobalt Blue ★★★★, Naples Yellow ★★★ (can be made using Yellow Ochre, Light Red, and white), and Coeruleum Blue ★★★★ are also colours you may wish to use occasionally. Neither purple nor a tomato red (colours seldom used on walls) is included, but they can be bought. Choose from the more expensive ranges of oil colours if they are to be permanent.

Reds can sometimes present a few problems and, for reds other than those mentioned above, you would need to look in an expensive range of oil colours for one that did not fade. The reds in some cheaper ranges, such as Cadmium Red and Scarlet Lake, fade, particularly when added to white.

There is no lemon yellow and no orange included in the palette. Neither is really used in decorating, and, if it is required, the latter can be mixed. Various greens are also omitted, but most shades can be mixed from the colours included in the palette, and several strong shades of green are included.

The four-star category usually includes all the earth colours: the durable Ochres, Siennas, Umbers, synthetic oxides, blacks, Cobalt, and oxides of chromium. The three-star group includes the whites, cadmium colours, Ultramarines, Monestrial Blues, greens, and colours based on Alizarin Crimson or Hansa Yellow. There is often an overlap in the grading system—some manufacturers include a colour in one category, while others do not. This is because they undergo very stringent and exacting tests. Colours are exposed to sunlight, sometimes for up to 500 hours. Their permanence depends both on their use and on the strength and character of the daylight to which they are exposed. Read the manufacturer's instructions carefully for full details about permanency and any other characteristics. Catalogues often provide more information than the instructions on tubes, and paint stockists may also be helpful.

Some colours are available in every range of paint while others are specific to just one. Many manufacturers make two ranges—a high quality artist's range and a student's range. It is not usually necessary to buy the more expensive paints, but some colours are not available in the student ranges. Earth colours (Siennas, Umbers etc.) are always fine and unchanging.

Some colours are not 'real'; they are now man-made substitutes for natural colours. There has been no lapis lazuli since the 17th century and no malachite green since the 18th century because of the high cost and rarity of the natural minerals. Nowadays, French Ultramarine replaces lapis lazuli, and Monestrial Green is a close substitute for Malachite. These new, organic colours tend to be very powerful and intense.

For freehand decorative painting you may like to use the more expensive range of colour. Alizarin Crimson in the student range uses chemical substitutes; but from the expensive artist's range you may use Rose Madder Genuine or Rose Dore which use real madder root.

Mixing

The beauty of using oil paint to colour glaze, rather than tinting it using manufactured eggshell or stainers, is the wide variety of colours and the subtle shades you can achieve. This quality ought to be fully exploited. Colour taken straight from the tube is far less sophisticated and interesting than colour mixed on a palette and tends to be a little too 'clean' for most decorative schemes. It is better

not to think in terms of pure colour; decorating colours tend to be knocked down or dirtied. Colour straight from the tube is easily recognizable to those who use colours often, even though it might be something new and exciting to you. A colour which has been mixed will be infinitely more satisfying than one dreamed up by a manufacturer's colourman, even though it might be a pure colour with just a hint of another added to it. Try mixing two or three colours together. It is better to avoid mixing too many colours; it only confuses you when you try to copy it later or mix up larger quantities, and can result in an unappealing sludge.

You can mix a wall colour to complement or to bring together the various elements in a room. This is more easily done by mixing together a few tubes of colour in a paint tray when you are on the spot than by being confronted with endless rows of cans or a confusing array of colour swatches in a shop. Strong colours tend to be used to highlight or accent.

A few colours have a chemical reaction when mixed with each other, particularly when mixed with white. Colours such as Scarlet Lake fade when used with white. The palette given above is as permanent as colour can be. If you are in doubt about a particular colour, contact the manufacturer. For example, Payne's Grey, a beautiful oil colour, can go green when mixed with glaze.

Some colours are opaque (that is to say dense and very good colourers), and some are translucent (i.e. you will need to add a lot of colour to your glaze). To counteract the colour of the glaze (see below) you have to add sufficient colour. Some oil colours, such as Ultramarine and Alizarin Crimson, are very strong, but you will need more paint to mix up some other colours. For very pale colours, you will have to add white eggshell. You could use Titanium White for small quantities, but artists' oil colour is no good for large quantities of pale colour as you would require far too many tubes. Adding white to a colour changes it dramatically. It makes translucent colours opaque and opaque colours more opaque. It also brings out the shade of a colour. This is something learnt only with practice.

When mixing paint always use the same brand for a particular colour. Although different types of oil paint are interchangeable and mix well together, individual colours have differences in shade and emphasis from one manufacturer to another.

Yellowing properties of glaze

Glaze contains linseed oil which is yellow in colour, and this obviously has an effect on colours when you mix it with artists' oils. Some glazes are yellower than others. It presents problems when you mix colours like turquoise, which turns green (see pp44–5).

Glaze needs light to retain colour and prevent it yellowing. If it is deprived of light, because shutters are kept folded back, for example, it will become increasingly yellow. Exposure to light will restore it to its original colour after a period of time.

The importance of colour

When you are starting off with an undecorated room, inspiration and ideas for the colour have to come from somewhere. Let yourself be inspired by the colours around you, and take colours from natural objects. Mediterranean colours seen in a magazine may look wonderful, but transferred to a house in a colder climate, they will look bright and artificial.

Try not to become confused by colour clichés. For example, commercial usage has thoroughly debased peach and apricot, which now appear in a wide range from pale orange to a washed-out and sickly pink. Take your colours directly from the source of your inspiration. For instance, if you are aiming for a terracotta, try bringing some pots or tiles into your room to help you mix your colour. If you are matching fabric, remember that generally the base colour of the walls should be the same as the background of the fabric.

Colours are often best mixed through the memory of natural objects, so that they appear as if seen through an early morning mist. Modern commercial colours are often too sharp and clear to mingle well in a decorated room.

In decorating the same colours frequently recur, as they are useful, pleasant colours to live with. Paint which provides colour in our everyday surroundings is as necessary to a feeling of well being and contentment as it is to the protection and preservation of materials. It affects the feelings we have about our surroundings, and colour in our homes has always been important.

Colour inspires a room but it should not be thought of in isolation. Colours contrast and work with each other to different effects. Do not be overwhelmed by the big plan, rather, work on each detail until you are satisfied. Start with what you have in a room and think about any architectural features and furniture you cannot change or dispose of. Bring out the good points and disguise the weaknesses. Think about the atmosphere of a room whether it is casual, classic, country, formal, or informal—the look will come as much from the colour itself as from the finish. Test your ideas before you start slapping on the paint and live with them for a few days.

Look at the furniture, the curtains, and the quality of light in the room. Think about when the room is used—some colours look very different in artificial light and might not be suitable for a room which is most often used in the evenings. Generally, rooms which are used a great deal tend to be on the lighter side of the tonal spectrum unless they are big enough and light enough to take a darker and richer colour. Small, frequently used rooms, like kitchens, should be light; alternatively, they can be cosy places where people feel they can hibernate.

Think about the view through the windows, particularly if you are contemplating painting green and there is a vista of trees and fields. Perhaps the contrast of a dull, pale terracotta might be better. Take the direction in which the room faces into consideration, too. If the room faces north and has little light, warm or bright colours, like yellows and pinks, are the answer. A south-facing room with lots of light is easier, as most colours will work.

Style in colour

There are popular and well-used colours which have repeatedly been used throughout the history of decorating with paint. They are the colours which trigger people's imaginations, so that they want to have them in their rooms. There have also been periods when rather bizarre colours have been used that we now find difficult to comprehend. The Victorians, for example, used many colours together in what to us seem bold and unusual combinations. They were nearly all tertiary colours with a few secondaries (see below). A typical scheme on a Victorian wall would be an olive frieze, the filling would be in salmon, and the dado in blue slate, or perhaps a frieze in sap green tint, the filling in rose grey, and the dado in pomegranate red. The 1960s, too, produced colours like canteloupe, lime green, chocolate, and purple.

Nowadays colours tend to be more atmospheric, moody, and dirty. We use lots of secondary colours and think of them as being sophisticated and subtle. Pompeian and Ancient Greek colours, reintroduced by Robert Adam in the 18th century, are now regenerating interest.

Apart from personal preferences, an emotional response to colour is shared by people of the same culture. Account must be taken of the spiritual and emotional effects of colour, although theorists are apt to go too far. Still, the broad implications are that reds and yellows are stimulating, while greens are soothing. Blues and purples are said to be depressing or cold. This might be true of purple, but blue can be an ambiguous colour. Traditionally people have shied away from it, but some blues have been popular, particularly 'Swedish blue' and 'duck egg blue'. The adage, blue and green should never be seen except with white in between, has now also been challenged. Colour symbolism, which at all events from an historical point of view has an importance for decorators, has been built up on this tradition of emotional influence.

Tone and colour

Red, yellow, and blue are known as primary colours. They are rarely used in their pure form, although not so long ago there was a vogue for such bright colours, combined with white, especially in children's rooms.

Any two of these colours mixed together will produce what are known as the secondaries, that is to say orange (red and yellow), green (blue and yellow), and purple (red and blue). The tertiaries are colours made by mixing two secondaries.

Colours also have opposites or complementaries. The complementary of orange is blue, that of green is red, and that of yellow is purple. The colours yellow and purple are rarely, if ever, used together in decorating, but certain tones of the other opposites complement each other very well. In their pure form, red and green together produce a vibrancy that the eye finds very disturbing, particularly if they are used in close proximity. But a rich red and a dark green, or pink and dark green can look very well together. Similarly, an orange red and a blue can work well, whereas pure orange and pure blue have the same visually disturbing effect as red and green.

Tone is different from colour, and beginners sometimes find it difficult to deal with. Recognition of tonal values comes with familiarity and practice; for some it presents no problems, while others take longer to master it. The word 'colour' refers to the hue—whether it is red, green, blue etc.—while 'tone' refers to how light or dark the colour is. Black and white are at opposite ends of the tonal spectrum on the grey scale. Therefore a red and a blue may be the same tone (i.e. have the same degree of dark or light in them) although they are different colours.

Getting two or more colours to work in a room is as much to do with their tonal relationship as it is to do with their hues. A good way to see the tonal values of colour is to half close your eyes and squint, so that colours of a similar tone will merge. It is generally best to mix all your colours—for walls and woodwork—using the same tone, with darker or lighter toned parts in small areas, unless you want to create a strong, positive look.

Understanding the use of tones in colour and how to mix them goes a long way towards understanding colour. The popular range of whites (magnolia, ivory, apple white, etc.) have made us more aware of how subtle tones of a similar colour can be. If you wish to use a pale colour on the walls, a perfect balance may be achieved by putting the same amount of white in a contrasting colour for use on the woodwork. This will create two colours of the same tone. The contrast may be more decided by using proportionately more or less white eggshell; the

nearer the tone of a colour approaches white or its own pure form, the more marked the contrast will be. The greatest contrast in the whole range of colouring lies between black and white.

It is also worth thinking about the proportion of one colour to another. Some colours have greater luminosity than others because they reflect more light. A room with light walls will seem larger because the light is reflected and bounces from one wall to another. Colours like whites, creams, yellows, and pale reds work in this way and are, therefore, good colours for small rooms. Dark reds, greens, and blues absorb more light and make a room seem smaller; this is why they are generally recommended for larger rooms with high ceilings and plenty of natural light.

Making use of opposites

All colours even browns and the so-called neutrals, can be divided into the two groups of warm and cold colours. Warm colours include pinks, oranges, and reds; cold colours include blues. Only a grey mixed with pure black and pure white would be totally dead. Colours can be called clean, pure, rich, dark, intense, and dry in an attempt to describe what only the eye can perceive. Talking and thinking about colour is a difficult process—everyone sees colours differently in the mind's eye.

Every colour and group has an opposite on the spectrum that is also the opposite to the eye. Not only can opposites be used together, they can be mixed together to produce an interesting range of subtle colours. For example, if you are using a terracotta that is a little too hot, add a little green which will darken it and yet not dirty it. Black is a dangerous colour to mix for darkening a colour as it only makes it dirty and dull—it kills the luminosity. By using a colour's opposite you retain colour and interest. Similarly, if you have a colour that is too sweet or ordinary, such as a pale blue, add a little terracotta or orange for sophistication.

Blacks, greys, and whites

Black harmonizes with almost any colour of the spectrum, but obvious cohorts would be silver, gold, and white. Even so, it is a difficult colour to use, especially on large expanses. It totally absorbs light and, even in a small cloakroom-sized room, it has a depressing effect. It is best used for pattern or detail. It should rarely be used to darken other colours, as it has a tendency to kill them.

Texture in black is very important; it looks far better matt. A high-gloss, shiny surface tends to look plastic.

Blacks from a range of artists' oil colours have different characteristics, although they may look very similar in their undiluted form. Lamp Black is a cold black, while Ivory Black is a browny black. Blacks can be mixed to produce more subtle and interesting variations by mixing, for example, French Ultramarine, Alizarin Crimson, and Raw or Burnt Sienna. They can be very dark tints of virtually any colour.

Greys
Greys tend to be rather ambiguous, mysterious colours, like smoke, pearl, opal, silver grey, slate, and pewter.

There are warm greys using pinks with greens, cool greys using Prussian Blue and Umber, and rather distinguished green-greys. It is a good colour at night and absorbs the light. The renowned English decorator Nancy Lancaster would walk into a room and suggest it was painted 'the colour of elephant's breath'. This evokes a specific feeling rather than a specific colour, and somehow we all know what she was talking about.

The obvious way to mix a grey is by adding white to black, but this produces a lifeless colour with no character. It is better to use a variety of colours to give more interesting dimensional greys. Mixing complementaries with white produces more interesting colours.

Although it can be a very cold colour, there are warm greys which work well on walls if used sympathetically. It can be used as a wall colour or as a neutral. It is a difficult colour to pin down as it varies so greatly in temperature and character; rather like a chameleon, it takes on the colour of its surroundings. Add red to colour it for warmth. Take care not to use Payne's Grey, unless it is used thickly. This rather beautiful blue-grey colour can

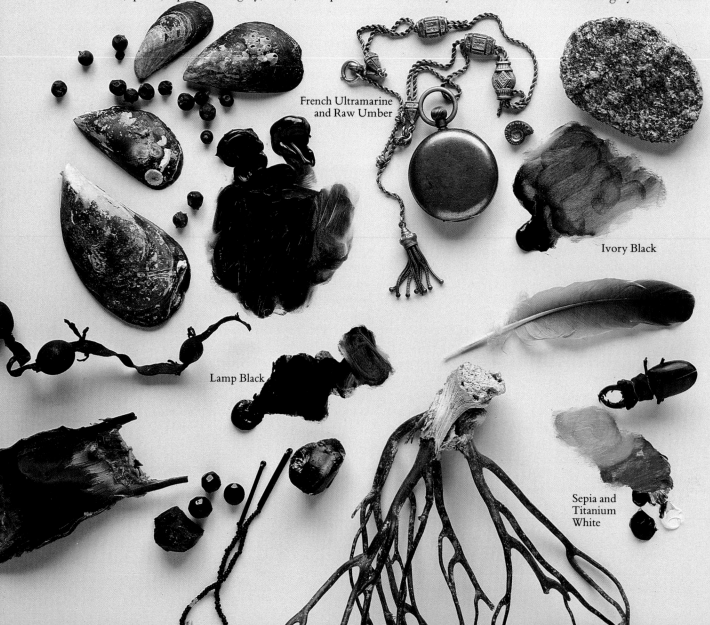

French Ultramarine
and Raw Umber

Ivory Black

Lamp Black

Sepia and
Titanium
White

change to green when mixed with glaze.

Colours that go well with grey are pinks, whites, and sand or beige colours.

Interesting base and glaze combinations are: Wedgwood grey—white and Prussian Blue base with Terre Verte glaze; dove grey—white, Ivory Black, and Prussian Blue base with Terre Verte glaze; and pearl grey—white, Prussian Blue, and Vermilion base with Terre Verte glaze.

Whites

Whites harmonize with most colours and colour mixtures. Whites can look very stark and bland, but, equally, they can provide a wonderful foil for other colours and be sophisticated.

White is a colour often associated with the soft beginnings in a nursery, but it can also make a very positive contribution to a colour scheme. Elsie de Wolfe, Syrie Maugham, and Oliver Messel are designers of famous rooms based on an all-white concept.

The theorist's views couple white with white vestments signifying hope, joy, ritual, cleanliness, and purity,

although a decorator would prefer to think of them as they do in India, where they say there are four tones of white. These are the greeny white of sea foam, the blue white of clouds, the yellow white of the moon, and the gentle pink white of the conch shell. We might also think of the whites of linen, damask, lace, ivory, and ecru.

In the artists' oil range there are three whites. The most useful and frequently used is Titanium White. Said to be the whitest of whites, it is the most opaque. Zinc White is transparent and, although this would theoretically work well for using with a glaze over a basecoat, in practice it takes too much paint before it makes any impact on the glaze. It is also quite a brittle paint and therefore would not be good for use on furniture unless well protected. Flake White is more durable than other whites and has superior drying properties, but is not as opaque as Titanium White and so would use up too much paint. It also contains lead and is, therefore, poisonous.

In general, eggshell paint is used for white or light tints, whether basecoat or glaze. This is simply because a lot of white is needed to carry a small amount of colour.

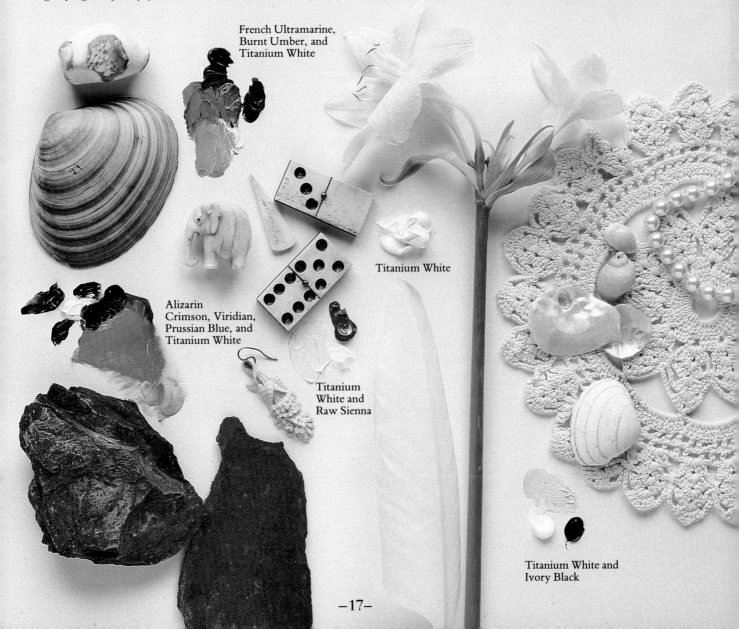

French Ultramarine, Burnt Umber, and Titanium White

Titanium White

Alizarin Crimson, Viridian, Prussian Blue, and Titanium White

Titanium White and Raw Sienna

Titanium White and Ivory Black

Off-whites

Off-whites are very pale tints of white with a hint of another colour added. At their worst they are bland, at their best mellow and sophisticated. They are extremely useful decorator's colours because they tend to blend and harmonize the entire spectrum.

Off-whites are used as neutrals and, classically, are used to complement the rest of the room. Examples of these colours include biscuit, mushroom, fawn, honey, mouse, buff, beige, and stone. The decorator John Fowler used a range of three 'whites' together for woodwork, in particular doors. He mixed Raw Umber and white in varying proportions, painting the panels of a door in the deepest tone, and the stiles and rails in the lightest. This gives a greyish mouse colour.

Off-whites can be mixed by using any of the earth colours or any of the colours from the suggested palette for tinting with large quantities of white eggshell or Titanium White. They tend to be warm colours with a yellow tint (Raw Sienna) or with a pink tint (Burnt Umber). Adding Raw Umber gives a cool white that is like a greyish mushroom colour. Experiment to find the exact colour you want. A frequently used, popular colour, known as mouse, was a Burnt Umber glaze over a white and Prussian Blue basecoat.

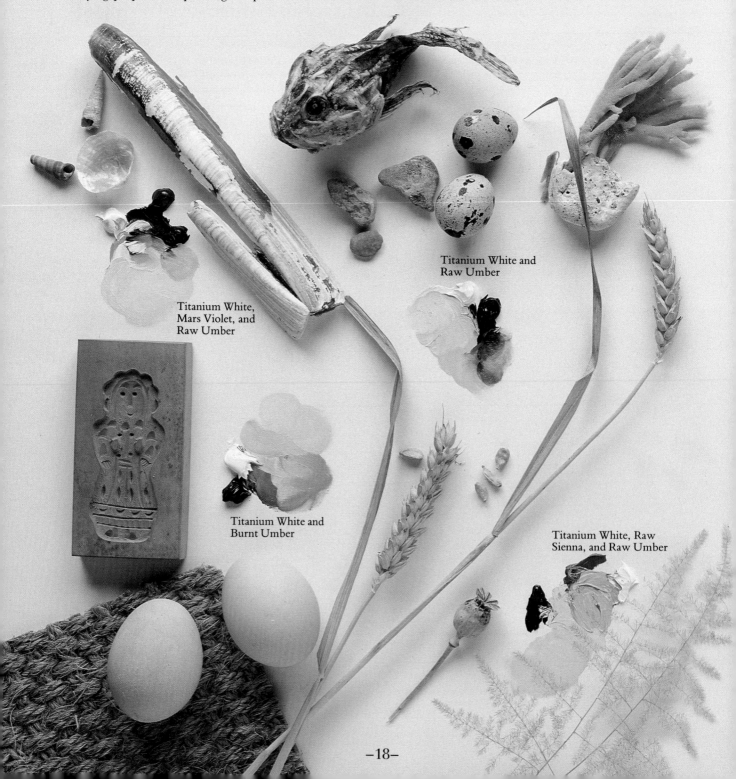

Titanium White and
Raw Umber

Titanium White,
Mars Violet, and
Raw Umber

Titanium White and
Burnt Umber

Titanium White, Raw
Sienna, and Raw Umber

Yellows

Yellow radiates warmth and a sunny exuberance. Its opposite is purple, and just as this conjures up visions of solemnity (a favourite colour for Roman togas) and death, so yellow evokes light, warmth, and radiance. Add purple to deepen and darken yellows. A painting of a yellow rose may have purple added for the shadows.

Yellows range from earthy ochres and builder's sand, to 'white' sand, through to bright Chinese Yellow. Most yellows in a decorator's palette are very slightly muddy colours, tending towards mustard and egg yolk rather than the greenish tinge of lemon. Corn, brass, maize, topaz, amber, and Cheddar yellow are warm, golden colours. The golden ochres and Chinese Yellow that John Fowler and Sybil Colefax used are well-known decorator's colours that add brightness and yet sophistication to rooms. Try mixing Burnt Sienna or Burnt Umber with white and other true yellows. Return to nature for your reference when mixing yellows.

Yellows are difficult colours to use because they change with artificial light. Pale yellows disappear at night; a bright lemon yellow (with green in it) may just look very acid and psychedelic. It is particularly important with this colour to do a test patch to see the effect at night.

You may need to use a lot of oil colour to get the intensity you need. This is one of the few colours where the use of stainers is justified. The luminosity of pure, intense yellows can be overwhelming. Yellow reflects light and makes a room seem larger and full of light. Consequently, a small room painted yellow can be very intense. A dark, north-facing room painted yellow could be transformed into a bright, happy, and cosy place. Paint a ceiling yellow, and the room immediately seems bright and sunny.

Colours that complement yellow are deep blue, deep red, grey, and pale ochre.

Interesting colours and glazes quoted by some Victorian decorators are: amber—white and Yellow Ochre base with Cadmium Deep glaze; brass—Yellow Ochre, white and Orange Chrome base with Vandyck Brown glaze; canary—white and Naples Yellow base with thin Viridian Green glaze; and melon—white and Lemon base with Raw Umber glaze.

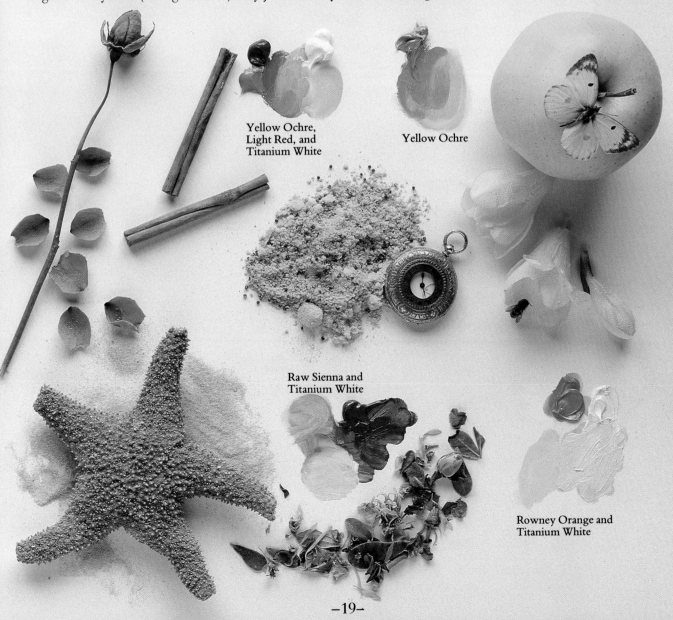

Yellow Ochre,
Light Red, and
Titanium White

Yellow Ochre

Raw Sienna and
Titanium White

Rowney Orange and
Titanium White

Pinks

A rich variety of pinks can be mixed from the palette—and they are by no means the sweet and sickly colours that many people associate with pink. Many can be made by mixing terracottas with white. The obvious and unappealing baby pinks usually arise out of mistakenly mixing a pure, clean red with white. Some pinks, like the pink of prawns and the pink of smoked salmon, can be quite intense. Crushed strawberry and crushed raspberry pinks can be strong too. However, the decorating colours that work particularly well are the dirty, washed-out pinks of Indian and Italian walls. There are some tough and positive pinks too, verging towards brown pinks, the pink of fresh plaster, and red-skinned potatoes. The delicate bloom of ripe peaches and budding roses gives us a freshness far removed from the range of brown pinks.

Pinks mix well with rather sombre tones of green and blue and, surprisingly, sometimes a range of ochres, especially the drier, colder ones. Grey is another colour which harmonizes well.

Pinks with blue in them can be made with Indian Red and white, Madder Brown and white, and Alizarin Crimson and white. Pinks with yellow in them can be mixed with Light Red, Yellow Ochre and white, Venetian Red and white, and Indian Red, Burnt Umber and white.

Interesting glaze coats are: rose—white and Vermilion base, or white and Lemon Chrome base, with Alizarin Crimson glaze; pomegranate—white, Venetian Red, and Lemon Chrome base with Burnt Sienna glaze; coral—white, Vermilion and Lemon Chrome base with Alizarin Crimson glaze; and peach—white, Vermilion and Lemon Chrome base with Cadmium Red Deep glaze.

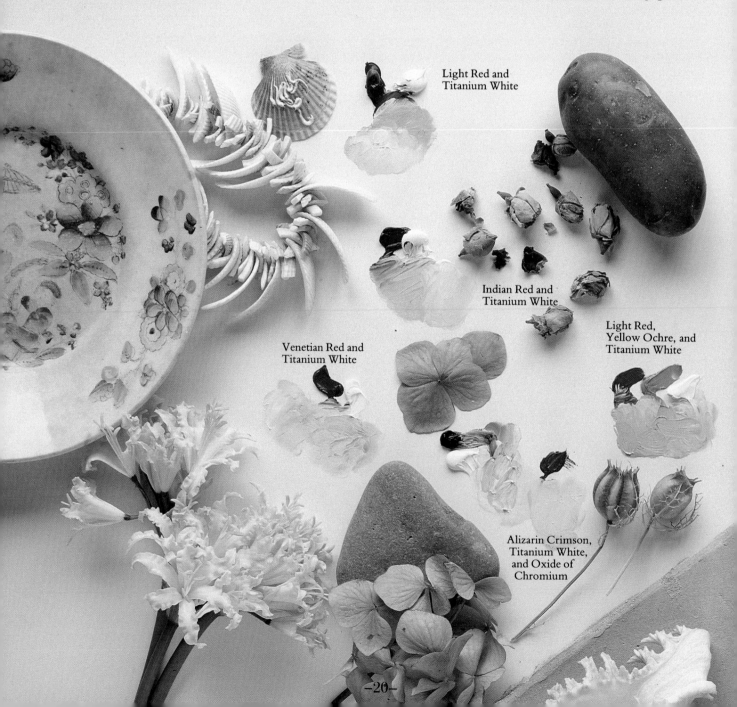

Light Red and Titanium White

Indian Red and Titanium White

Light Red, Yellow Ochre, and Titanium White

Venetian Red and Titanium White

Alizarin Crimson, Titanium White, and Oxide of Chromium

Terracottas

Terracotta colours range from orangey to pinky browns. Based on earth pigments, they have been used almost since time began. Cavemen used them to decorate their walls, and red ochre was used by Ulstermen to paint the lower half of the walls of their cottages. Terracottas generally remind us of earth colours—red soil, brickwork, fired tiles, and clay pots—but mahogany, cherry, and chestnut colours also come under this umbrella. Russet is a slightly drier colour, tinged with a hint of green.

Terracotta is a good colour for interior decorating, particularly in colder climates, as it is warm. It can be cosy when used lightly, perhaps with a little white, or rich and opulent when used over a coloured basecoat, such as a sharp orange or a shocking pink. It should be colourwashed, stippled, or mutton clothed.

These warm colours can be too hot and sticky. Try adding an opposite colour (green or blue) to bring it down and make it cooler. Similarly, Raw Umber and Burnt Umber can be used to tone it down.

Terracottas go well with blues, greys, yellows, and olives, but these should all be on the cooler side of the spectrum to counteract the hotness. Terracottas are either orangey colours, in which case blues complement them well, or they verge towards pinks, in which case greens harmonize well. Russet looks rich and opulent with gold.

Terracottas can be mixed with Indian Red, Light Red, and Burnt Siennas.

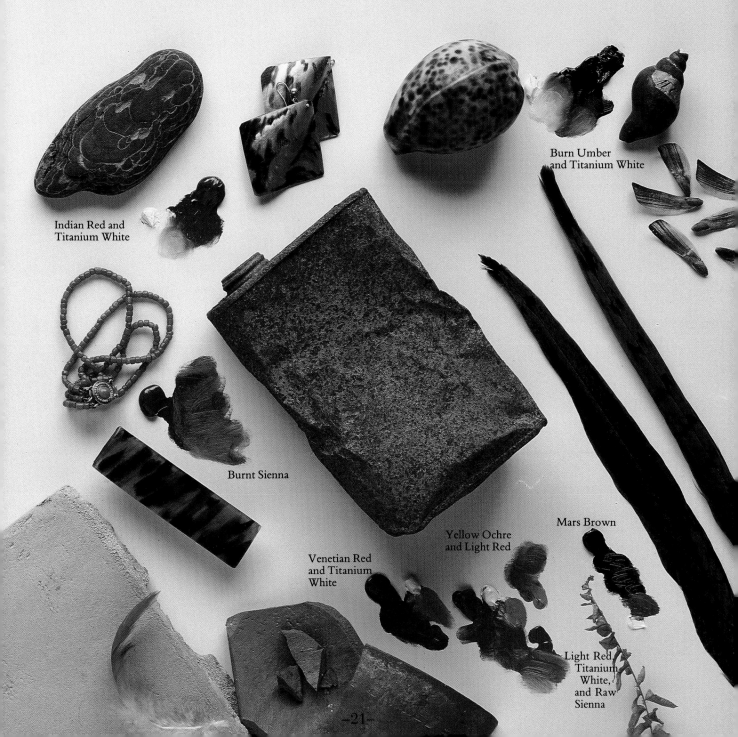

Burn Umber
and Titanium White

Indian Red and
Titanium White

Burnt Sienna

Mars Brown

Yellow Ochre
and Light Red

Venetian Red
and Titanium
White

Light Red,
Titanium
White,
and Raw
Sienna

Blues

Of all the colours, blue presents the greatest range of contrasts; it is the easiest to combine with other colours, but the most difficult to use as a decorating colour. It can be smart and masculine, like navy, petrol, and military blue, or gentle and natural, like lavender, hydrangea, cornflower, lilac, and heliotrope. Some blues are associated with places, like Provençal blue, Portuguese blue, and French blue; while others, like azure and sea blue, are reminiscent of a summer's day and the sea. Man-made and natural objects, like Wedgwood china and ducks' eggs, also give us specific colours.

Many people shy away from decorating with blue as it is said to be a cold colour and difficult to use, particularly in a north-facing room. Nevertheless, it can be bright, light, and happy, and it harmonizes well with a wide range of colours, particularly with the warm ochres. In some countries, like Sweden, it has long been a popular colour, and we now associate a specific colour with Swedish blue. Blue and white used together need to be qualified in a cold climate, otherwise the effect can look stark and clinical. It is a colour which benefits from strong colours to lift and complement it.

There is a wide variety of blues and they are easy to make. Try adding white and black to Cobalt Blue, or white to either Ultramarine or Prussian Blue. Blues mixed with Ultramarine will be warm—Ultramarine has a lot of

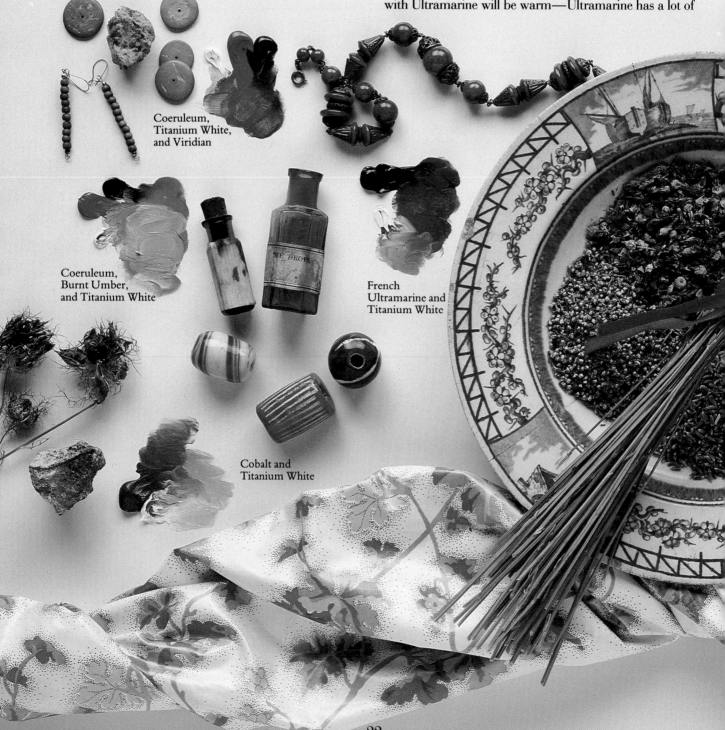

Coeruleum,
Titanium White,
and Viridian

Coeruleum,
Burnt Umber,
and Titanium White

French
Ultramarine and
Titanium White

Cobalt and
Titanium White

red in it—while Cobalt and Prussian Blue are cooler colours. Light blues nearly always need white eggshell added to them, particularly when they are very pale. If you are not adding white, the blue you want to use must be at least three times stronger in tone than the natural glaze colour, otherwise the linseed oil in the glaze will cause it to go yellowish and become turquoise.

Coeruleum Blue with white is light and bright, reminiscent of a summer sky, but a room in this colour can lack cosiness. Prussian Blue mixed with a little Raw Umber makes a very smart colour; you might use it for lining a military-style chest of drawers.

Colours that harmonize with blue are greys, pinks, reds, some greens and off-whites, orange/reds and golden ochres, maize, straw, drab and stone colour, salmon, crimson, chestnut, and mahogany.

Old decorator's manuals can still provide us with quite clear and fascinating instructions on how to achieve specific colours. Among these are: azure blue—Ultramarine and white base with a white and Cobalt glaze; sea blue—Ultramarine and Raw Umber base with a white and Cobalt glaze; turquoise—white and Cobalt base with a Monestrial Green glaze; and Wedgwood—white and Prussian Blue base with a terracotta glaze.

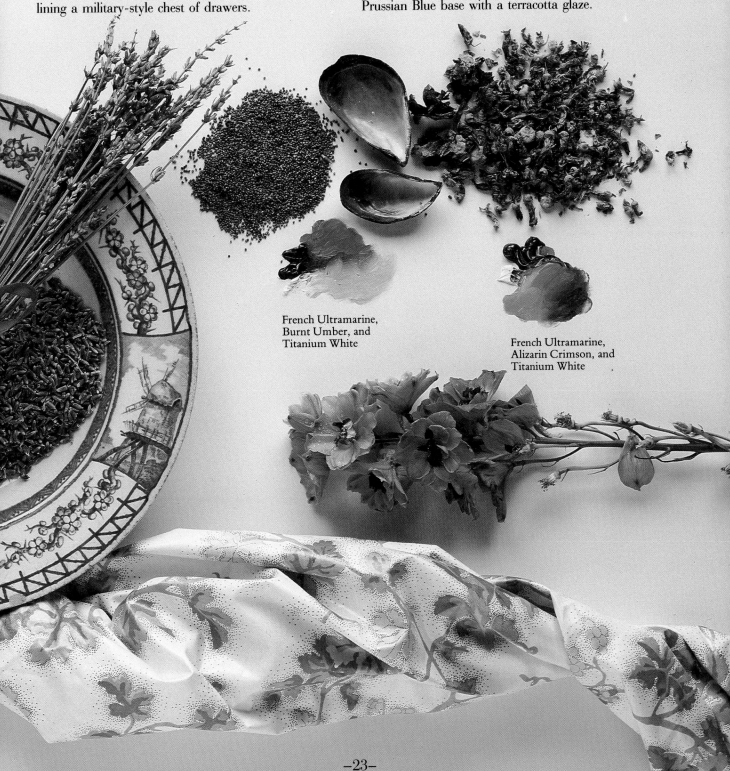

French Ultramarine,
Burnt Umber, and
Titanium White

French Ultramarine,
Alizarin Crimson, and
Titanium White

Reds

Here, we are looking at mixed reds used without the addition of white, which turns it into pink. Red is a warm, dark colour with a feeling of opulence and splendour. This is more typical of the reds of magenta, burgundy, claret, mahogany, red velvets, and ox blood than the orange-reds of tomatoes and geraniums. It can either be used as a strong, main base or as a foil to another colour. It is a rich, vibrant colour that requires courage to apply, but it can be rewarding. It is so strong that it could not be used as a wall colour in a day-to-day living room, but could be used to good effect in a dining room, for example, which is used less frequently and usually in the evening.

The paint itself can be difficult to handle. There are many reds which are too transparent and fugitive to use. A hard-and-fast rule is to use only high-quality paint.

The basecoat can either be a bright pink or a bright orange with pink over it. This increases the depth and resonance of the colour.

Deep reds harmonize with dirty green, gold, blue, and the off-whites, such as grey, maize, and drab.

Some suggestions from old recipes that might prove interesting include: plum—white, Indian Red, and Ultramarine base with Alizarin Crimson glaze, or white and Indian red base with Ultramarine glaze; Claret—white and Ultramarine base with Alizarin Crimson glaze, or white, Venetian Red, and Vermilion base with Madder Brown glaze; and carnation—white and Vermilion base with Alizarin Crimson glaze.

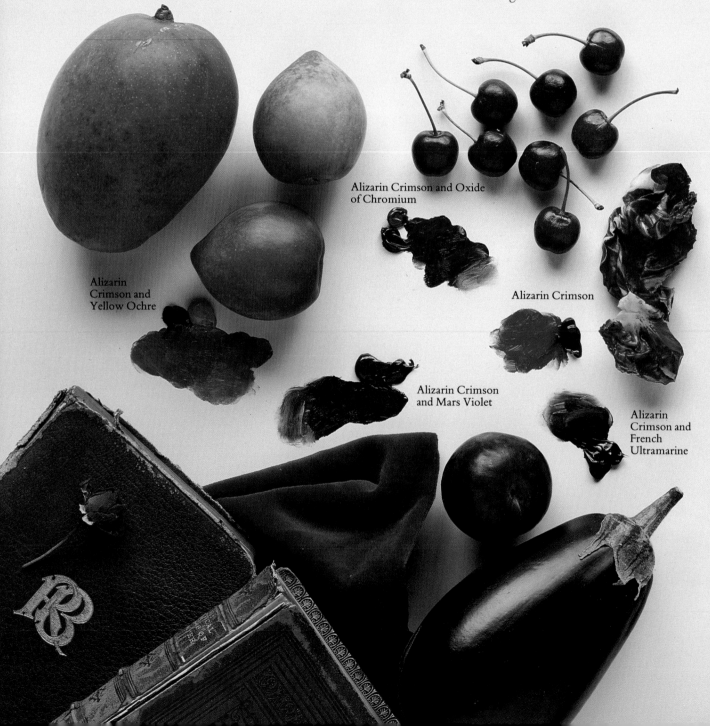

Alizarin Crimson and Oxide of Chromium

Alizarin Crimson and Yellow Ochre

Alizarin Crimson

Alizarin Crimson and Mars Violet

Alizarin Crimson and French Ultramarine

Greens

Green is one of the most restful colours to the eyes and invariably linked with nature—sage, olive, apple, chive, ivy, seaweed, willow, and sea green. Even malachite, emerald, jade, and chartreuse have an attenuated association with mother earth. It is often thought of as 'the English colour' and was particularly popular in the 18th century when it was much used by Robert Adam.

Its advantage is that, as a mid-green, it falls between both blue and red, being neither markedly cold nor hot. This may have been the reason why it was used a great deal for lining furniture. A cold, grey-green is a very Swedish colour, and a dark, bottle green is a traditional colour for exterior paintwork in Holland. It is not often seen as a wall colour, probably only because it has been unfashionable recently.

Greens can tend towards yellow, in which case they can become sickly (lime), or they can go towards blue and become quite cold (turquoise). Some greens, such as Terre Verte and Sap Green, are translucent, so that you

need a lot of colour to mix them, but this can be an advantage for glaze work. Oxide of Chromium is an opaque colour. Greens can be mixed in quite a number of surprising ways but it can be difficult to find a range of greens. It is easy to end up with a similar colour every time. It is worth experimenting with these suggestions: Raw Umber, Prussian Blue, and white; Cobalt and Lemon Yellow; Cadmium Yellow Mid and Coeruleum Blue; Raw Sienna and all blues; blacks and yellows (or with whites); and Naples Yellow or Yellow Ochre and blues or black.

Colours that complement green are deep reds, russets, greys, blues, Raw Umber, and pink.

Some interesting colours and glazes are: eau de nil—white, Lemon Yellow and Prussian Blue base with Monestrial Green glaze; duck egg green—white and lemon base with Prussian Blue glaze; Etruscan green—white and Prussian Blue base with Terre Verte glaze; and myrtle—white and Raw Sienna base with Cobalt glaze.

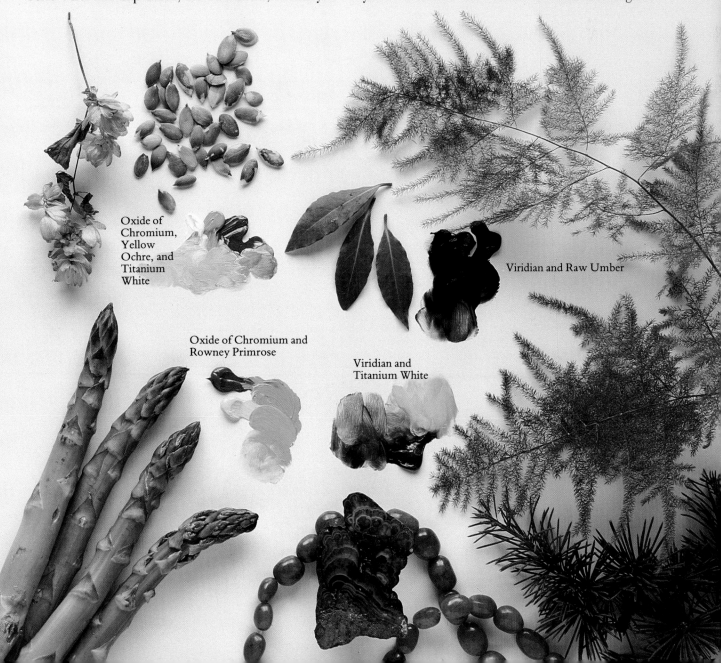

Oxide of Chromium, Yellow Ochre, and Titanium White

Oxide of Chromium and Rowney Primrose

Viridian and Titanium White

Viridian and Raw Umber

Motif and pattern

A motif is a single design that has been stylized to be used as a repeated pattern or as a central design. Motifs taken from various eras and cultures are now used internationally. The Celts provided us with elaborations of spirals and interlaced ribbons and crosses. From India, we use paisley designs and arabesques, and from the Orient we get the style of many familiar motifs but translated into an eastern look. From 17th-century England we take inspiration from blackwork embroidery, and other motifs can be found in carpets, lace, architecture, and tapestries.

Many contemporary motifs derive from Greek and Roman decoration. Plants are among the most popular: laurels, olives, vines, papyrus, ivy, palm, oak, corn, and flowers. The acanthus leaf is one of the commonest motifs. Although the acanthus does not grow in northern Europe, the motif appears everywhere in many different designs and forms.

Many traditional motifs, such as the *fleur de lys*, have developed from heraldry. From the Napoleonic era, we have the symbols of the bee, eagle, swan, and lyre.

Many motifs have 'real' origins. For example, festoons of fruit, a popular decorative motif in Roman times, the Renaissance, and later, have their origin in the practice of hanging real fruit as a decoration on the friezes of temples. They alternated with the skulls of real animals, and often ribbons filled the empty spaces between.

Animal forms have been used less extensively. They tended to be symbolic, and the most popular animals were the lion, ox, ram, eagle, and dolphin. Shells and serpents were also common.

The Greeks used to hang the weapons, which their fleeing enemies had left on the battlefield, on the trunks of trees. These tokens of victory soon found a place in decoration, and trophies formed of hunting weapons, and sometimes musical instruments and craftsmen's tools, were developed. Personal trophies can be made up using the various implements of the keen gardener or the artist.

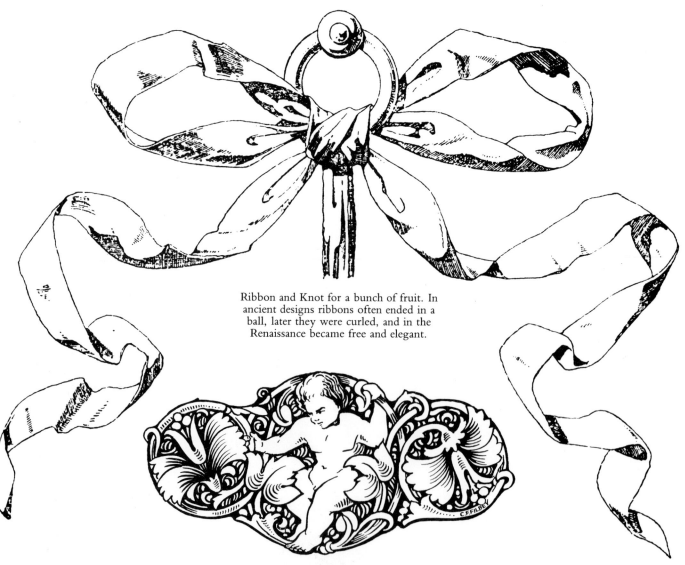

Ribbon and Knot for a bunch of fruit. In ancient designs ribbons often ended in a ball, later they were curled, and in the Renaissance became free and elegant.

This cherub motif is an example of balance and subordination.

Using motifs

Using a grid, motifs can be used to make repeat patterns for handpainted or printed wallpaper and curtain fabric, or stencilled floors. Becoming familiar with patterns and motifs is useful for many aspects of decorative painting, from stencilling and printing to freehand painting.

Repeated pattern

Pattern is made by repeating a motif or line; the repeat is based on a grid, which may be a series of squares, circles, or triangles. By using dots, lines, and curves, simple but effective decoration can be made. Geometric shapes are also useful for building up a pattern. Using just stripes, checks, gingham, tartan, Indian plaids, Madras cotton, and houndstooth checks can be made. Using other systems, such as symmetrical or mirrored pattern, or a grid based on a series of dropped or stepped motifs, many elaborate patterns can be made. Motifs can also be used randomly on the wall without a grid.

Marking out the grid

More complex geometric borders can be designed using graph paper, a ruler, and a pair of compasses, but pattern does not necessarily have to be neat and exact. If you are going to print or stencil a pattern on to a wall, it will help to establish grid lines or reference points with a plumbline and a steel ruler or a straight edge. If the same measurements are repeated, mark the distance off on a piece of paper and use that as your ruler; it is much quicker. Think about a central point, a focus of interest, and surrounding details.

Panels may have a central motif surrounded by borders and corner ornaments, or, alternatively, a blank centre with an encircling border.

Try to avoid patchiness; each element of the pattern must be related in some way, and the space between should be carefully judged. Too much space between small and scattered sprigs of flowers means that each element will tend to hang in mid-air.

Indian motif

Egyptian motif Egyptian motif Persian motif

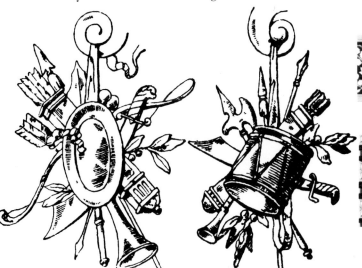

French Renaissance trophy motif Louis XIII style trophy motif

Four conjoined triquetrae Chinese circular ornament

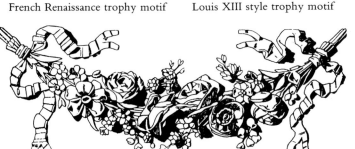

The Leaf Festoon in Louis XVI style

Greek ornament Greek ornament

Variations on the heraldic motif of the fleur-de-lys, once the royal arms of France.

Mexican ornament South Sea Islands motif

CHAPTER II

Materials
AND
Equipment

An old sheet, a paintbrush, a bottle of white spirit, a few tubes of oil paint, a can of glaze, and you are ready to rag! The range of equipment you will require depends on the finish you have chosen. It extends from modestly priced and readily available items to more expensive, specialist brushes. This chapter serves as an introduction to and explanation of the wide variety of equipment, paints, and glazes you may encounter: what they are called, what they are used for, and how to look after them.

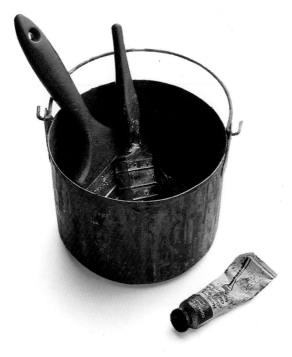

Many of the specialist brushes were first developed in the 18th century. These craftsmen's tools are a delight to handle and a pleasure to work with. They are worth taking care of.

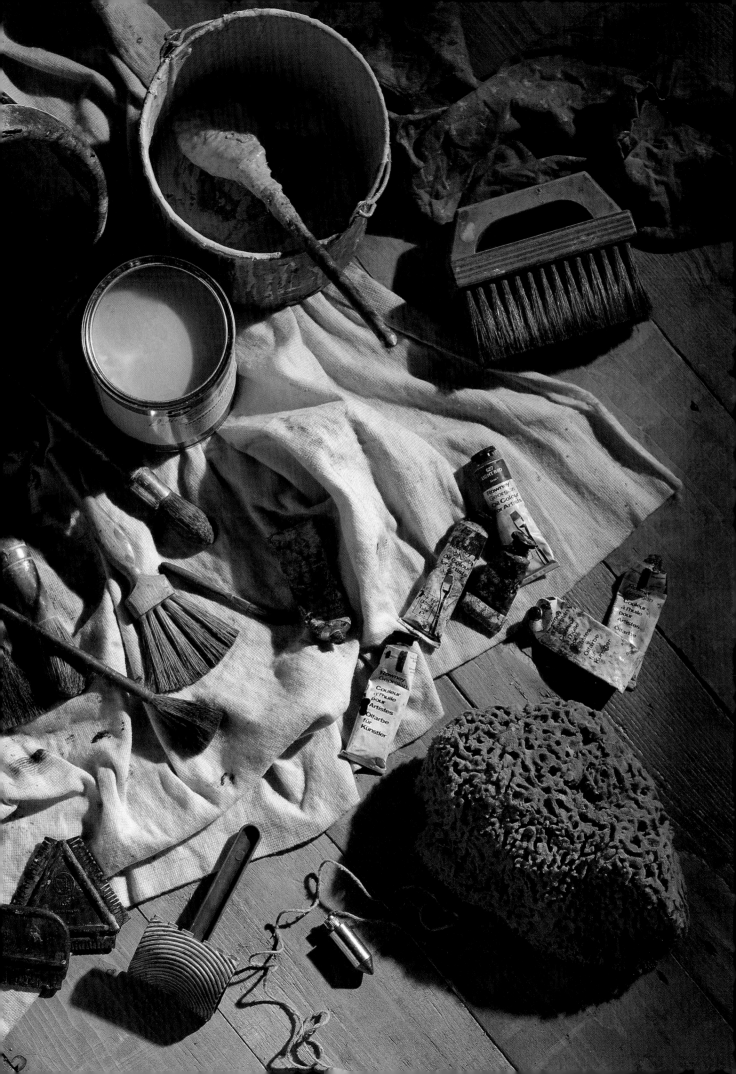

Brushes

It is essential to use the correct brush for the job to ensure that it holds the right quantity of paint, provides the appropriate degree of coverage, the necessary level of accuracy and fineness, and, where required, reaches into corners and awkward spaces. These considerations apply to any kind of painting, but are especially important for decorative finishes; using unsuitable brushes can result in a disappointing and time-wasting failure. Furthermore, some decorative painting, especially some of the bravura finishes, can only be achieved with special brushes. There are no substitutes for some brushes, such as softening and stippling brushes, but for some finishes, there are alternatives that can sometimes be used for a successful compromise. For example, although a dragging brush is required for a classical look, an effect like dragging can be achieved with a household brush. A household brush can also be used to stipple out excess paint in corners.

A wide variety of brushes exists. Many are available from good paint shops, but some can be obtained only from specialist stockists (see pp222–3). Artists' brushes are obtainable from suppliers of art materials.

Specialist brushes have specific names that are used by suppliers and artists alike. Many of them are made in a range of sizes. It is important to specify the name and size when purchasing, especially if you are ordering from a catalogue. Prices vary considerably and may depend on the materials used. Buying cheaper nylon brushes rather

10 × 8cm (4 × 3in) stippling brush used for furniture and for awkward corners in rooms.

Stippling brush
A stiff bristle brush for lifting off fine freckles of paint. Also used for rag rolling and colour wiping. Available in a variety of sizes. The larger brush—18 × 12cm (7 × 5in)—is used for stippling walls.

10 × 2cm (4 × 1in) stippling brush for finishing off many basic finishes, furniture, and awkward small areas.

Wallpaper brush
A substitute for a flogging brush producing an idiosyncratic dragging effect or a wild and carefree colourwash.

than sable, for example, can prove to be a false economy. However, the general rule that you should buy the best quality that you can afford does not always apply; when dragging, for example, cheaper household brushes often achieve an effect more like classical dragging than more expensive ones.

Whether you are painting with household or specialist brushes, it is sensible to use the size appropriate to the job—large brushes for applying basecoat to the walls, small brushes for cornices, mouldings, and smaller items of furniture, and so on.

Short-haired for mahogany

Long-haired

Sable-haired

Bristle-haired

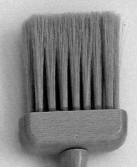

Mottlers and overgrainers
Brushes used for the second stage of woodgraining to give added depth. Made from bristle or softer squirrel or sable, they are available in various widths and shapes e.g. fan and wavy.

Softening brushes
The badger hair (right), originally used in watercolour work but now also used for oil work, is designed to blend the edges of paint for many bravura finishes. Various sizes and shapes are available. The hog-hair brush (left) is made for blending and softening oil work, but requires more skill to use than the badger softener.

Pencil overgrainers
Used for birdseye maple and mahogany.

Soft-haired brushes
Used for veining, lining, and freehand painting for water and oil work.

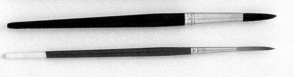

Swordliners
Designed for lining on furniture, also used in marbling as substitutes for feathers, as they act erratically to produce broken, vein-like lines. Sizes range from 0–3. They need careful storage.

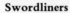

Radiator brush
A long-handled household brush for painting behind radiators.

Fitches
Hog-hair brushes made mainly for oil work. Shapes are round, filbert, long, short, and herkomer. Used for marbling, other bravura finishes, and freehand painting.

Household brushes
A 10cm (4in) brush (right) is good for applying glaze and eggshell to walls. A 2cm (1in) brush (above right) is useful for small, fine areas. A better quality brush lasts longer.

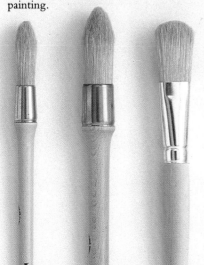

Flogging brush
Designed for oak graining, these coarse, horsehair brushes are also used for dragging and flogging. Available in a variety of sizes.

Sponges, rags, and combs

The essence of decorative paint finishes is to manipulate the paint in some way. Sometimes brushes are used, sometimes other equipment.

Sponges are used both for applying and removing paints and glazes. They are flexible and easy to handle. Natural sponges are used for sponging on and off (pp52–5), and for one type of marbling. Man-made sponges are really not suitable

Rags are used in ragging, rag rolling, and colourwashing. Cotton sheeting is best for a classic look, but other lint-free materials can be used.

Combs originated from woodgraining techniques, but are now used for other decorative painting (see pp72–3). Various different plastic combs are manufactured. Rubber combs are also made, but care must be taken with these as the black colour comes off after contact with oil colour and white spirit. Homemade combs can easily be made from stiff cardboard.

Woodgrainers—whether wood or plastic—are used, obviously, for woodgraining, and for moiré

Mutton cloth, also known as stockinet, is a cotton cloth with a variable weave. Do not buy the nylon type. It is used for mutton clothing (pp56–7), and for lifting off surplus paint and eradicating brushmarks in many of the more advanced finishes and in combing.

Synthetic sponge
This has a harder edge and is denser than natural sponge. It can be cut and shaped for blocking.

Mutton cloth
Used for simple mutton clothing and for lifting off surplus paint in many bravura finishes. Always ensure you buy cotton mutton cloth, also known as stockinet.

Rags
These are used for ragging, rag rolling, and colourwashing to remove glaze in a particular way to reveal the basecoat beneath. They should be made mainly of cotton.

Natural sponge
Only natural sponges are suitable for sponging on or off. Also used for some marbling. Available from specialist brush suppliers and, more expensively, from chemists.

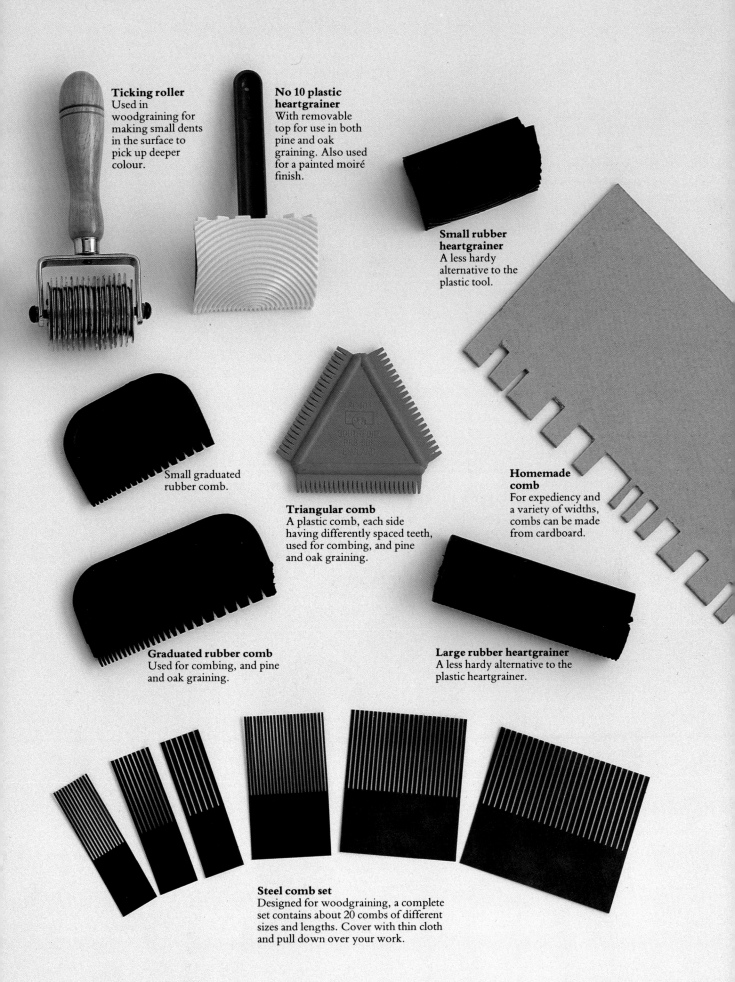

Ticking roller
Used in woodgraining for making small dents in the surface to pick up deeper colour.

No 10 plastic heartgrainer
With removable top for use in both pine and oak graining. Also used for a painted moiré finish.

Small rubber heartgrainer
A less hardy alternative to the plastic tool.

Small graduated rubber comb.

Triangular comb
A plastic comb, each side having differently spaced teeth, used for combing, and pine and oak graining.

Homemade comb
For expediency and a variety of widths, combs can be made from cardboard.

Graduated rubber comb
Used for combing, and pine and oak graining.

Large rubber heartgrainer
A less hardy alternative to the plastic heartgrainer.

Steel comb set
Designed for woodgraining, a complete set contains about 20 combs of different sizes and lengths. Cover with thin cloth and pull down over your work.

Paints and glazes

Most of the finishes described in later chapters use oil-based paints for a variety of reasons. Water-based paint (emulsion) is opaque and tends to produce a rather flat, dull finish. An oil glaze, however, is transparent and the finish will have a more attractive translucency. It can be built up in layer over layer to create a feeling of depth. On a practical level, oil paint mixed with glaze takes time to dry, thus allowing you to manipulate it and to correct mistakes; emulsion dries so quickly that there is little time to work on it.

To achieve the best results, you will need to mix your own colour. Commercially mixed paints are unsuitable for decorative finishes. Moreover, when you mix the paint yourself, you can obtain exactly the colour you require. Colours are mixed in a transparent glaze. (pp44–5).

Glaze

Oil glaze (not to be confused with varnish) is a transparent mixture of linseed oil, driers, whiting, and other oils. There are three different sorts: Ratcliffes, Keeps, and Craig & Rose (McCloskeys in the U.S.). It is known by a variety of names, such as transparent oil glaze, scumble glaze and Luxine Glaze. The old name for glaze was Megilp. It is also possible to make your own glaze. The linseed oil has a yellowing effect, particularly in the case of Keeps glaze, which is not, therefore, suitable for pale-coloured work.

Glaze has a flashpoint of 40°C (104°F). Spread glaze-soaked rags out to dry before throwing them away.

There is also an emulsion glaze that is water based. It works in the same way as oil glaze, but it dries quicker and is not so flexible.

Colours

The best colours to use are artists' oil colours because they offer the most extensive range, although some people prefer stainers which are simpler to use but more restricted in choice. With artists' colours you can mix subtle changes and match colours very accurately. Although they intermix, it is best not to change brands when trying to match colours, as they do vary slightly. Look out for the permanent grading system of stars and use only three- or four-star colours (see pp12–3).

Prices vary and some colours are simply not available in the cheaper range. As a general rule, the more expensive the paint, the oilier and easier to mix it will be. It also contains more and purer pigment.

Eggshell and other paints

Other types of paint may also be required. Eggshell is an oil-based paint used as a basecoat over which the oil glaze is applied. It is essential for all finishes, except watercolour work. (The name refers to its mid-sheen finish.) It is also used for mixing with glaze instead of white artists' oils.

Various floor paints are available. They provide a tough base for decorative painting, including stencilling. They are suitable for stone, wood, lino, and concrete, but not for vinyl, thermoplastic, or rubber floors, and are available in a variety of colours.

Special paints are made for stencilling or freehand painting on fabric.

Fabric paint
A range of paints and pens are available for freehand painting and stencilling.

Silk fabric paint
Specially made for painting and stencilling on silk fabrics.

White spirit
Used as a paint thinner, it also accelerates the drying time. It is advisable and more economic to buy it in large quantities e.g. 5 litres (1 gallon). **Turps. sub.** is a cheaper and inferior alternative, good for cleaning brushes. **Oil of turpentine** is an oil-based, natural solvent. It has a slower drying time and is chiefly used in *trompe l'oeil* work and marbling. It is more expensive than white spirit.

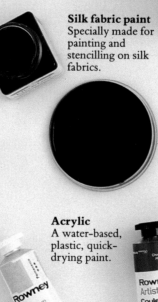

Acrylic
A water-based, plastic, quick-drying paint.

Oil paint
Artists' oil colours are used to colour oil glaze. They have a greater range and subtlety than stainers. Also used for freehand painting.

Egg tempera
A permanent water-based paint that provides a durable and washable surface. Used for freehand painting and murals, it gives soft, delicate colour.

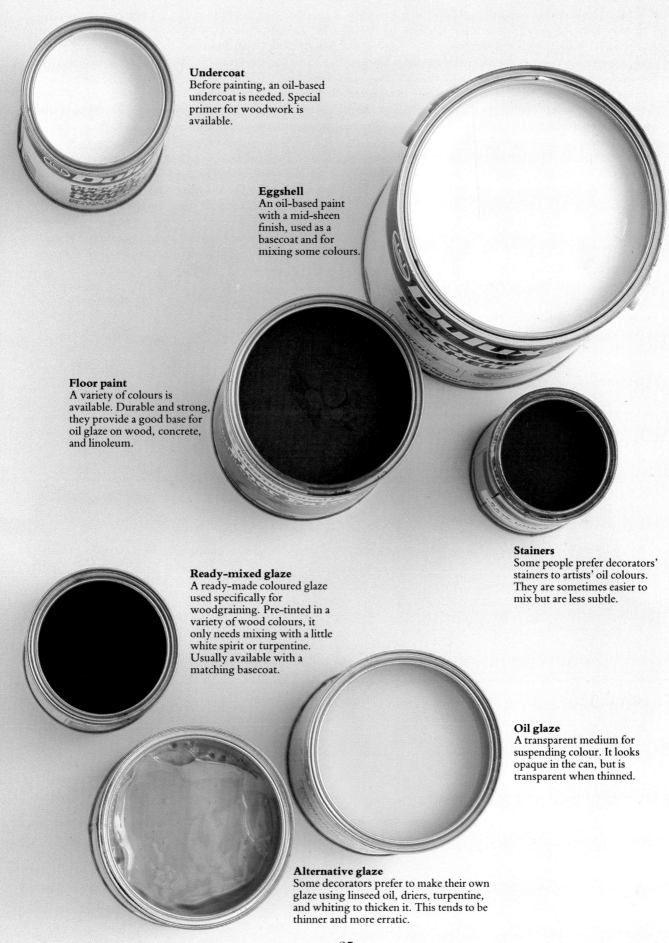

Undercoat
Before painting, an oil-based undercoat is needed. Special primer for woodwork is available.

Eggshell
An oil-based paint with a mid-sheen finish, used as a basecoat and for mixing some colours.

Floor paint
A variety of colours is available. Durable and strong, they provide a good base for oil glaze on wood, concrete, and linoleum.

Stainers
Some people prefer decorators' stainers to artists' oil colours. They are sometimes easier to mix but are less subtle.

Ready-mixed glaze
A ready-made coloured glaze used specifically for woodgraining. Pre-tinted in a variety of wood colours, it only needs mixing with a little white spirit or turpentine. Usually available with a matching basecoat.

Oil glaze
A transparent medium for suspending colour. It looks opaque in the can, but is transparent when thinned.

Alternative glaze
Some decorators prefer to make their own glaze using linseed oil, driers, turpentine, and whiting to thicken it. This tends to be thinner and more erratic.

Other equipment

To paint efficiently and well and to achieve the result you have envisaged, a number of other pieces of equipment are invaluable investments.

It is essential to protect furniture and carpets while you are working. Cover stacked furniture and other items that cannot be removed from the room with dustsheets. Decorators' dustsheets or old bed sheets are better than plastic sheeting because the fabric absorbs spillages, rather than creating slippery puddles of paint.

You will need a supply of clean rags for all sorts of clearing up operations. Masking tape is a self-adhesive, paper tape which is fairly easy to remove after use. Different widths are available. Its main purpose is to protect surfaces and fixtures, especially those where it may be difficult, or even impossible, to wipe off paint smears.

A variety of fairly simple and inexpensive equipment is necessary for measuring and drawing up shapes, such as panels, or preparing areas for marbling: T-square, ruler, straight edge, plumbline, pencils, and chalky string. (Chalk-o-matic is a commercial device with the powdered chalk and string provided together.)

Sandpaper is required for the essential preparation of the surface. A sanding block is better and more efficient for rubbing down furniture.

A roller paint tray can be used like an artist's palette. Jam jars are ideal for mixing artists' oil colours before adding them to the glaze mixture. Screw-top lids enable you to store the paint for longer periods and, because the jars are transparent, you can see the colours clearly. A bucket is necessary for mixing up large quantities of oil glaze. A second bucket is useful for carrying white spirit and for washing out sponges and brushes. A plastic or metal paint kettle enables you to pour off a more manageable quantity of paint for working with.

Finally, a mahl stick, used by artists and signwriters to rest and steady their hands, is especially useful when you are working on murals and large areas where the paint is still wet and might smudge.

Masking tape
Self-adhesive paper tape that is easily removable. It is used for painting stripes, making straight edges, and protecting surfaces and fixtures.

Chalk and string
This is used for marking out grids on floors and walls for repeat patterns, panels, tiles, stencilling, marbling, murals, *trompe l'oeil*, and many other paint techniques. Chalk-o-matic is a commercial version.

Mahl stick
This is used to rest the hand and to prevent smudging wet paint.

Plumbline
Used to establish vertical lines. It is useful when painting stripes and panels.

Straight edge
A metal straight edge is useful because it does not warp.

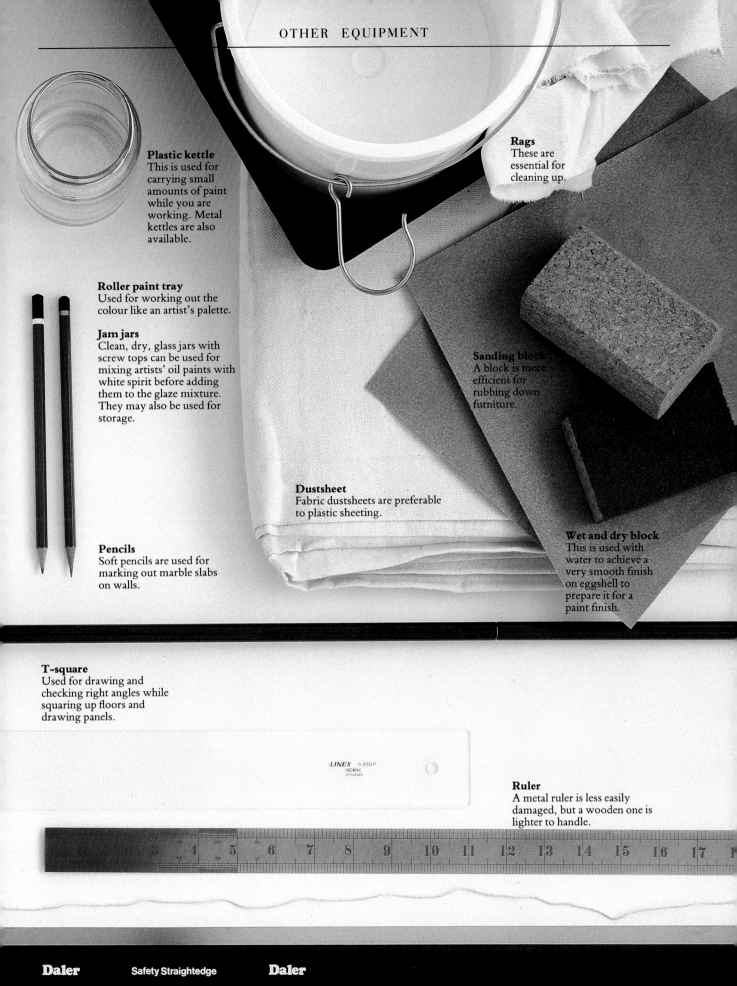

Plastic kettle
This is used for carrying small amounts of paint while you are working. Metal kettles are also available.

Rags
These are essential for cleaning up.

Roller paint tray
Used for working out the colour like an artist's palette.

Jam jars
Clean, dry, glass jars with screw tops can be used for mixing artists' oil paints with white spirit before adding them to the glaze mixture. They may also be used for storage.

Sanding block
A block is more efficient for rubbing down furniture.

Dustsheet
Fabric dustsheets are preferable to plastic sheeting.

Wet and dry block
This is used with water to achieve a very smooth finish on eggshell to prepare it for a paint finish.

Pencils
Soft pencils are used for marking out marble slabs on walls.

T-square
Used for drawing and checking right angles while squaring up floors and drawing panels.

LINEX A-370 P
ACRYL
DENMARK

Ruler
A metal ruler is less easily damaged, but a wooden one is lighter to handle.

3 4 100 5 6 7 8 9 10 11 12 13 14 15 16 17

Daler Safety Straightedge **Daler**

Stencilling equipment

The simplest way to stencil is to use a pre-cut stencil kit. Dover Books pre-designed stencils are almost as simple to use. The design is printed on manila paper on one side only, and this must be treated to seal it. Rub the paper with a mixture of equal parts of boiled linseed oil and turpentine. Hang the page up to dry, and then repeat the process. You will then need to cut out the stencil.

You can make your own stencils using paper or acetate. Stencil paper is made from oiled manila. Easy to cut, it works well for intricate and delicate designs without splitting when you are cutting awkward corners. It is quite sturdy and can be handled and reused frequently. Lining up and registering for stencilling with two or more colours are slightly more difficult than with acetate stencils. You can draw directly on the paper with pencil or felt-tip pens or, if you prefer, you can draw the design first and then transfer it on to the manila.

Acetate is a transparent or semi-transparent film available under a range of trade names (Mylar, Melanex etc.). Large sheets have a tendency to curl up and awkward corners are inclined to split during cutting. It is easier to use than stencil paper when you are registering two or more colours. You can trace directly on to acetate with a technical pen.

Whether you choose Dover Books, stencil paper, or acetate you will require a scalpel or craft knife for cutting. The most versatile types have replaceable blades of different designs and shapes. Disposable knives with flexible but sturdy blades are also available.

You can cut out your stencil on a hard surface like hardboard or glass, or a cutting mat.

Stencil brushes are designed to hold the right amount of paint so that it does not seep underneath the edges of the design. They are available in a variety of sizes with long or short handles. Stiff-bristle brushes keep their shape better than softer brushes.

Special stencil paints are produced but other paints are satisfactory as long as they are quick drying. You can use car paint retouching sprays on unorthodox surfaces, such as refrigerator doors, as well as on walls and woodwork. You can also use wax crayon for stencilling. Make a paste with oil-based crayon and apply with a stencil brush.

1 Cutting mat
A self-healing mat is a worthwhile investment if you plan to make many stencils yourself.

2 Acetate
This transparent or semi-transparent film makes registering two or more colours easier, and the semi-transparent type enables you to see clearly the shape you are cutting out.

3 Stencil paint
Quick-drying paint that is either water- or oil-based, is available for stencilling.

4 Frisk film
This is a sticky, transparent, plastic sheet with a paper backing. You can draw a design directly on it, cut it out, and then peel away the backing sheet. Good for masking out and stencilling.

5 Metallic powder
Various qualities and colours are available. Stencilling with metallic powders is traditionally done on a black ground.

6 Spray paint
Household and car retouching sprays are quick-drying paints that work well on unorthodox surfaces as well as walls. Always wear a protective mask as the vapour is toxic.

Craft knife
A variety of cutting knives with replaceable blades are available.

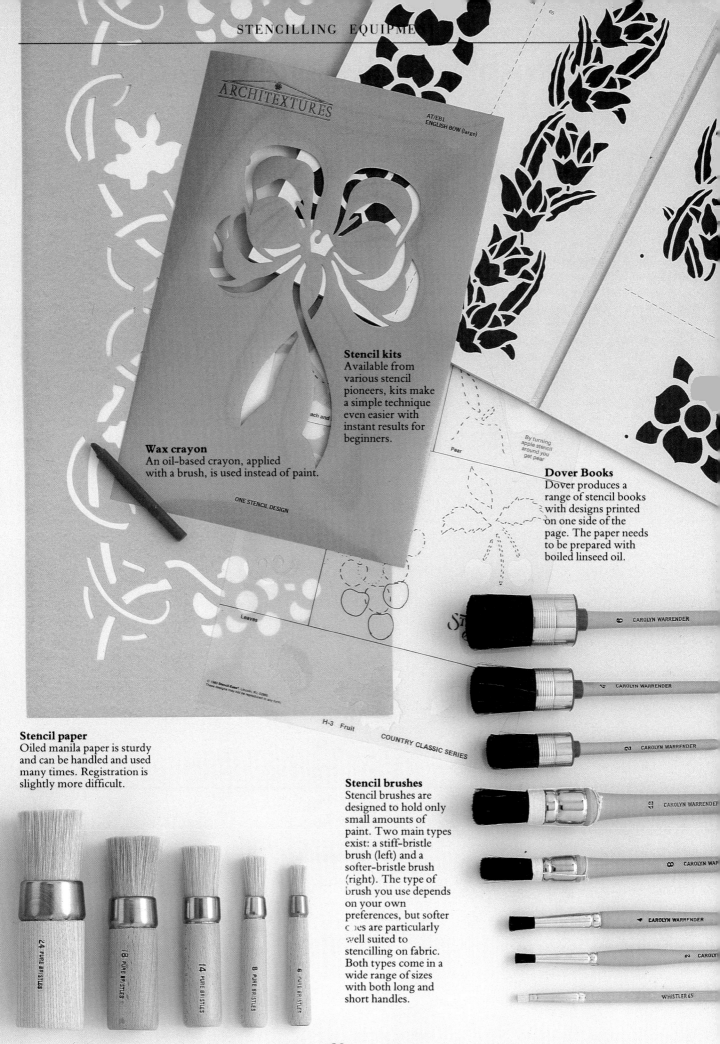

Stencil kits
Available from various stencil pioneers, kits make a simple technique even easier with instant results for beginners.

Wax crayon
An oil-based crayon, applied with a brush, is used instead of paint.

Dover Books
Dover produces a range of stencil books with designs printed on one side of the page. The paper needs to be prepared with boiled linseed oil.

Stencil paper
Oiled manila paper is sturdy and can be handled and used many times. Registration is slightly more difficult.

Stencil brushes
Stencil brushes are designed to hold only small amounts of paint. Two main types exist: a stiff-bristle brush (left) and a softer-bristle brush (right). The type of brush you use depends on your own preferences, but softer ones are particularly well suited to stencilling on fabric. Both types come in a wide range of sizes with both long and short handles.

Varnishes and gilding materials

Varnish primarily protects and prolongs the life of decorative finishes, and is especially important on surfaces which need to be hard wearing, such as some items of furniture and woodwork such as doors and bannisters. It also helps to give walls an even finish by covering the difference between eggshell and oil glaze. Some varnishes, such as Crackleglaze, are used as part of the finishing technique.

Varnish also gives you a choice of the type of finish. Many are available in gloss, eggshell (mid-sheen), and matt. There are many different types of varnish, but almost all have a tendency to yellow the paint colours slightly. Trade varnishes, which are both tough and less inclined to cause discoloration are not generally available to the public. They are often highly toxic and dangerous to use, except in carefully controlled conditions and experienced hands.

Varnishing brushes are designed to hold a lot of varnish. They should not be used for painting; otherwise you may find colour seeping into your work when varnishing later. They should be carefully stored in a clean, dust-free place.

Other specialist materials used for advanced finishes include metallic powders, gold leaf, and various gilding materials. Metallic powders are available in as many as 15 different colours, including copper, bronze, silver, and antique gold. They are manufactured for frame makers and are normally used with rabbit-skin glue. Suspended in gum arabic or a PVA medium, they can be used for decorative finishes and stencilling.

Gesso is used to provide an extremely smooth surface before gilding or marbling. It can be bought ready for use in a can, or in powder form, which is then mixed with rabbit-skin size. It must be prepared with care, as using gesso of the wrong consistency will result in an uneven surface and may cause flaking. Apply several coats, sanding down between each, for a smooth surface which is cold to the touch (see p78). Before gilding the gesso may be coloured by painting it with a clay called bole.

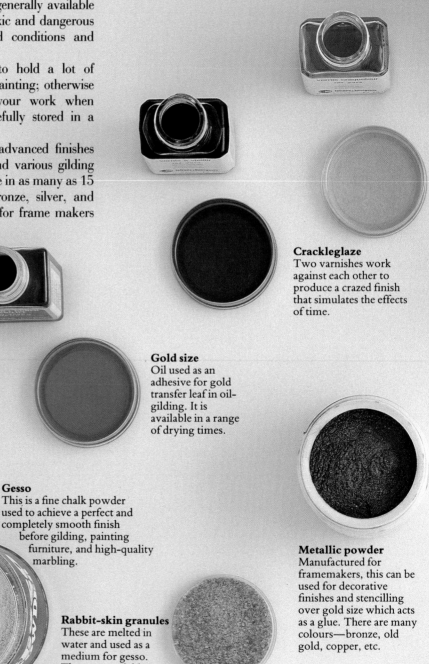

Crackleglaze
Two varnishes work against each other to produce a crazed finish that simulates the effects of time.

Gold size
Oil used as an adhesive for gold transfer leaf in oil-gilding. It is available in a range of drying times.

Acrylic gesso
A quick and easy way of creating a smooth finish, it is less satisfactory than traditional gesso.

Gesso
This is a fine chalk powder used to achieve a perfect and completely smooth finish before gilding, painting furniture, and high-quality marbling.

Rabbit-skin granules
These are melted in water and used as a medium for gesso. They are available in a variety of forms.

Metallic powder
Manufactured for framemakers, this can be used for decorative finishes and stencilling over gold size which acts as a glue. There are many colours—bronze, old gold, copper, etc.

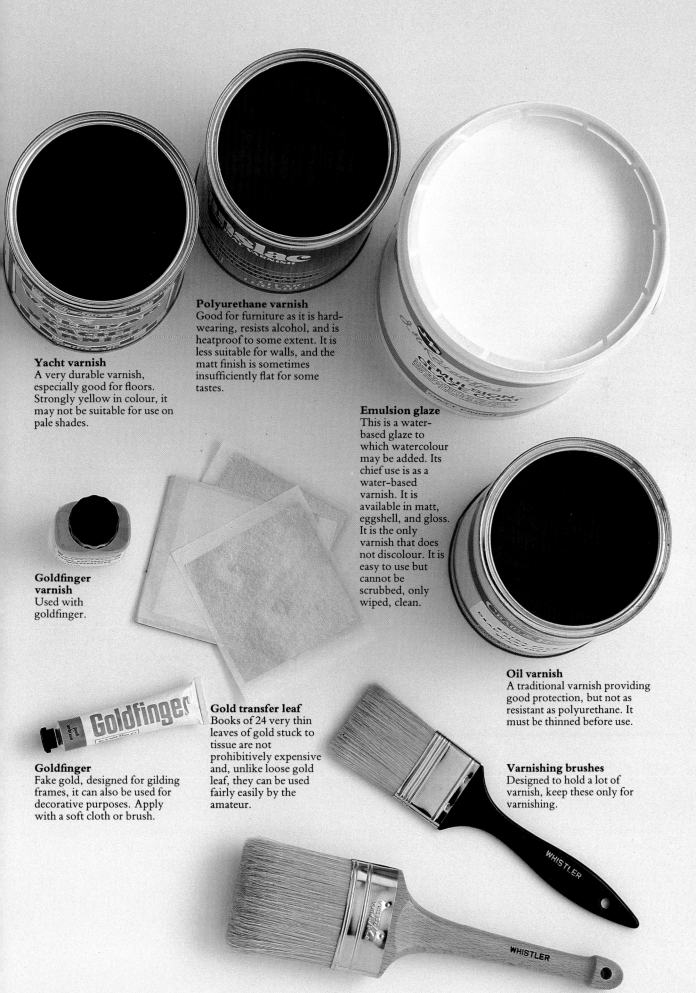

Yacht varnish
A very durable varnish, especially good for floors. Strongly yellow in colour, it may not be suitable for use on pale shades.

Polyurethane varnish
Good for furniture as it is hard-wearing, resists alcohol, and is heatproof to some extent. It is less suitable for walls, and the matt finish is sometimes insufficiently flat for some tastes.

Emulsion glaze
This is a water-based glaze to which watercolour may be added. Its chief use is as a water-based varnish. It is available in matt, eggshell, and gloss. It is the only varnish that does not discolour. It is easy to use but cannot be scrubbed, only wiped, clean.

Goldfinger varnish
Used with goldfinger.

Oil varnish
A traditional varnish providing good protection, but not as resistant as polyurethane. It must be thinned before use.

Goldfinger
Fake gold, designed for gilding frames, it can also be used for decorative purposes. Apply with a soft cloth or brush.

Gold transfer leaf
Books of 24 very thin leaves of gold stuck to tissue are not prohibitively expensive and, unlike loose gold leaf, they can be used fairly easily by the amateur.

Varnishing brushes
Designed to hold a lot of varnish, keep these only for varnishing.

Preparing to paint

After the excitement of deciding what to paint and how to paint it, comes the rather laborious task of preparing the surface. This can be arduous, depending on how much needs to be done, but skimping on time and effort during preparation can detract from the final effect and waste all the work that you will have put into it. Some country houses will take an uneven wall surface better than others, but generally walls and woodwork should be as flat and smooth as possible. Paint is not merely decorative; it also serves to protect surfaces from wear and tear. Nevertheless, it can crack, craze, flake, or fail if the preparatory work was neglected.

Some surfaces will require very little preparation. Others will need a lot more, the extent depending on their age and condition. Manufacturers of diy products usually provide good instructions on how and where to use them, and individual manufacturers can sometimes be helpful with specific problems. In addition, there are many excellent books with detailed instructions on basic preparation of walls, woodwork, and so on before painting. You may also be able to find assistance at various research establishments or specialist paint firms if your particular problem will not go away.

Whatever surface you are planning to paint and whatever finish you intend to apply, the fundamental rules of preparation are the same. To ensure that the paint bonds and dries in an even colour and texture, the surface must be clean, dry, and free from any loose, extraneous, and unwanted materials, such as crumbling or damp plaster, rust, and old flaking paint.

When the bare surface has been prepared, it may then require priming and undercoating. All the finishes require an eggshell basecoat, with the exception of watercolour work (see pp120–21) and sponging on using emulsion paint. Eggshell refers to the finish of the paint; it is oil based with a mid-sheen finish. It is available in a very large variety of colours. You may need to apply one or two coats of eggshell before the finish is applied (see pp44–5). Remember to allow each preparatory coat time to dry thoroughly before applying the next one. If in doubt, wait rather than spoil your previous efforts. Drying times can vary considerably and depend on atmosphere and temperature. To achieve a really smooth finish on furniture, fireplaces, and doors rub down lightly with fine grade sandpaper in between each coat. Think about your choice of finish before you apply the last coat of eggshell—some effects are solely dependent on the correct colour of the basecoat. Be wary of the lead content in your paint if the surface is likely to be bitten or sucked by a baby or toddler.

Old walls

Cracks and holes in walls should be filled with a commercial filler. Overfill the crack or hole slightly; it can be sanded smooth when dry. Then paint the filled areas with two coats of undercoat before applying the eggshell basecoat, otherwise the eventual finish will dry in patches of different colour and texture. Allow the filler to dry out completely before painting, as any dampness will show through your glaze coat as a dark patch.

Do not strip old paint unless it is absolutely necessary. However, surfaces that have previously been painted with finishes such as distemper and whiting do need stripping down. Scrubbing with a stiff brush and a solution of detergent is usually sufficient. For stubborn specks of distemper, soak in hot water and use a paper scraper.

Emulsioned walls

If the wall has already been painted with emulsion, you will need to paint an eggshell basecoat before you can apply the oil glaze. Take care not to leave any patches of emulsion showing through the eggshell. If any emulsion is left exposed, the oil glaze applied over the top will dry with dark patches. It may help to paint an undercoat in a slightly tinted colour over the emulsion before you apply the eggshell basecoat. The difference in colour between the undercoat and emulsion will help you ensure that you have covered all the wall.

New walls

New plaster needs a drying-out period of at least six months to allow any moisture in the walls to escape. After this period cracks may appear due to shrinkage, and they will need filling. Untreated plaster will need a coat of sealer to stop any salts or fungi appearing on the surface. This should be followed by two coats of eggshell paint. For the best results, apply the last coat with a brush rather than a roller. A roller finish gives an 'orange-peel' texture which can be distracting on certain finishes. It is only a minor point and if you find it easier, quicker, and do not mind the finish, then there is no reason not to use it.

Lining paper

Lining paper provides a good surface for many paint finishes and can conceal the poor condition of a wall. Nevertheless, cracks and holes still have to be filled and the wall made as smooth and clean as possible before the paper is hung. Seal the paper with a coat of oil undercoat diluted with 10 per cent white spirit.

The disadvantage of lining paper is that the joins can be seen and may be distracting to the eye.

Wallpaper

Wallpaper may have to be removed, depending on the quality of the wall and on the state and type of the wallpaper. It is always preferable to remove it rather than

hang new lining paper over it. However, if the underlying plaster is in poor condition, you may judge it wiser to leave it where it is rather than uncover further problems. A raised wallpaper should almost always be removed, as the only possible finish you can apply to it is sponging on.

Painted woodwork

Painted wooden surfaces in good condition may simply need dusting, washing down with a household detergent or sugar soap, and rinsing with clean water. When they are thoroughly dry, they should be lightly sanded with wet and dry sandpaper. Sanding down ensures that subsequent coats bond well.

If the surface has been knocked or chipped, fill with a commercial plaster filler and rub down when dry. Then apply the undercoat. Prime exposed wood. The first coat of eggshell can then be applied.

Stripping is only necessary when paint is flaked or loose. It is a messy, lengthy business and should be avoided if at all possible. If the flaking paint has been applied fairly recently, it is worth examining why it has not adhered properly. It may also be worth stripping if there are several layers of paint which are not likely to stay firm.

There are several ways of stripping oil-based paint. The easiest and quickest, but most expensive, is to employ the services of a professional paint-stripper. He will work at your home on immovable items like bannisters and architraves, and at his own workshop on smaller, transportable pieces.

The next easiest, if somewhat messy, method is to use chemical strippers. These are painted on and then left for a specified period, during which they dissolve the paint. Read the manufacturer's instructions and warnings carefully. The chemicals dissolve plastic, so wear rubber not plastic gloves to protect your hands. After the given time, scrape the paint shavings into a metal container and wash the surface with water or white spirit. Allow to dry (at least overnight) and then rub down as necessary.

If paint is cracked you may be able to remove it with scrapers. These are available in a variety of shapes and sizes. Wear safety goggles to protect your eyes from flying chips of paint. Scrapers can also be used in conjunction with a blow lamp or hot air blower. This is a quick method but needs practice.

All stripped wood should be treated as new woodwork.

New woodwork

Softwood (pine, deal, or cedar) will need sanding. If the wood is to be painted, any nail holes, dents, or cracks should be filled and sanded flush with the surface. If you plan to varnish or stain the wood, choose a filler which matches the wood and one which will take the stain. Seal any knots with shellac knotting before priming. Hardwoods (oak, mahogany, beech) do not usually require filling as they are closely grained with no knots.

All stripped wood and most new wood needs either priming or sealing. Then apply one coat of undercoat,

followed by two coats of eggshell in the appropriate colour. Rub down lightly in between coats of paint with a fine grade of wet and dry sandpaper to achieve a smoother more perfect finish.

Floors

How well you prepare the floor depends very much on the look you wish to achieve. Obviously, the surface requires some preparation in order to take the paint well, but, for instance, you may feel that a concrete floor with chips and gouges that you are intending to marble might look more authentic and 'old' left as it is.

It is best to use proprietary floor paints, especially if you are not planning to varnish, as they are very strong, do not scratch easily, and are not stained by water (it may leave whitish marks on some dark colours of eggshell, but these disappear when the floor dries). There are several brands in a wide selection of colours on the market. If the colour you require is not available, you can use eggshell paint. If you are planning to marble or stencil the floor, then it will be varnished and this will protect it.

Wooden floors

Old floorboards may need quite a lot of attention before you can start to apply any paint. They often need sanding first. Hiring a commercial sander makes this process slightly less laborious, noisy, and dusty. Make sure that all the loose floorboards have been nailed down firmly and that all protruding nails have been hammered flat.

Wax polish can be removed by rubbing hard with white spirit and steel wool in the direction of the grain. Clean with a rag and repeat several times.

If you are going to stencil directly on to the natural wood, the floorboards should be stripped, well scrubbed, sanded, and cleaned.

Older floorboards sometimes have gaps in between. These may need filling, especially if they are to be completely painted. Filling them with a mixture of shredded newspaper and wallpaper paste is the easiest method. Make a pliable papier mâché mess and press it into the cracks, levelling it off with your fingers.

Unless you intend to leave some of the floor as bare wood, the whole area should be painted with primer and an undercoat, followed by two coats of eggshell paint in the appropriate colour. Allow each coat to dry thoroughly.

A floor in poor condition can be vastly improved if you lay down hardboard panels. These can be laid in large panels or cut up into squares. They can be nailed down using special hardboard nails or stuck down with adhesive, or both. Do not use impact adhesive. Hardboard provides a firm, flat surface which can be stained, stencilled, or painted.

Metalwork

Remove any rust and rub down the surface. Apply one coat of metal primer and two coats of eggshell. Car spray paints adhere well to metal and are especially suitable for some objects and effects.

Completing the preparation

The initial stages of preparing the surface, organizing your equipment, and deciding about colour are important. Having made sure that any cracks in walls and woodwork have been filled and rubbed down and that the surfaces have been as well prepared as possible, you must, if necessary, apply a coat of oil-based undercoat.

Deciding on colour

Before the eggshell basecoat is applied, you must consider the effect you want to achieve. Some traditional finishes require very specific colours in order to be successful. As the eggshell basecoat is going to show through the oil glaze, choosing its colour is really quite crucial. If you are planning to use a dark-coloured glaze, a white eggshell base will probably be unsuitable: strong effects generally need strong basecoats, just as subtle and gentle effects need light basecoats. If the difference in tone or colour between the basecoat and the glaze is marked, then the effect is bound to be striking and you will need to consider your choice of colours carefully. In other words, if the base is a pale colour and the glaze is dark, the overall effect is likely to be too crude.

A white basecoat would be satisfactory for pale-coloured glazes, but pure white can look stark; softer shades may be more sympathetic. You can mix your own colour by adding artists' oils to a can of white eggshell. Start with a drop at a time, mix it well, and compare it with the original white to see how much you have coloured it. You could choose a close tone of the same colour instead. Alternatively, for a different kind of effect, choose a completely different colour background from the colour of the oil glaze, but keep the tones close.

Generally, the background is a lighter colour than that of the glaze, but this is not necessarily an unbreakable rule. It is a good idea to mix colours and experiment with them on a paint tray. You can test the colour of paint directly on the wall; later you can paint over it or wipe it off. Alternatively, you can test colours on coated hardboard. Used as a backing sheet in kitchen and bathroom cupboards, pre-coated hardboard is available from hardware shops. The surface is slightly shiny, but it is ideal for experimenting. You can, of course, paint small sheets of hardboard in an appropriate colour yourself. It is a good idea to leave the colour samples overnight, as they can look very different in artificial light from the way they look in daylight. Make a mental note of the colours you have used for your experiments so that when you are satisfied with a shade, you can use the same proportions for mixing a larger quantity. Scaling up the quantities in the same proportions has to be done by trial and error—there is no absolute method for measuring artists' oils, but there are a few tricks that will help. As you gain more experience with mixing paint, you will find it easier to estimate quantities and proportions.

When you have decided on the colours you are going to use, apply one, or if necessary, two coats of eggshell basecoat to the prepared surface.

Mixing up the glaze

A good rule for calculating how much glaze to prepare is to make up about half the amount you have used for one coat of eggshell. If you are in doubt, it is always better to make more rather than less glaze than you think you will require. Making up new batches and matching the colour can be difficult.

A standard glaze mixture consists of equal quantities of glaze and white spirit. So, if you are making up approximately 2 litres (3·5 pints) of glaze mixture, then add 1 litre (1.75 pints) of white spirit to 1 litre (1.75 pints) of glaze in a large bucket and stir well. The consistency should be similar to that of single cream. The density of glaze is not consistent and the evaporation rate of white spirit is affected by atmospheric conditions, so you will have to use your judgement about the precise proportions. Some finishes require a 'wetter' glaze mixture, that is equal quantities of glaze and white spirit. (Specific details are given on the appropriate pages for the individual techniques described in Chapters III and IV.)

Mixing the colour

After you have mixed the glaze you will need to add the colour. Mix the artists' oil colours with a little white spirit in a clean glass jar, such as a jam jar. Scale up the proportions you used for experimenting on your paint tray until you are satisfied with the colour. When the ingredients are thoroughly mixed slowly pour the colour into the bucket of glaze mixture, stirring well and stopping to check that it is right.

Some colours have to be mixed with white eggshell to overcome the yellowing effect of the linseed oil in the glaze. For example, if very pale blue is mixed with artists' colours alone, the yellowness of the glaze will turn it turquoise. Similarly, pale pinks will turn orange. The opacity of eggshell, however, prevents the yellowness of the glaze showing through.

Pale colours are also usually mixed with white eggshell, rather than with artists' oil colour. This is a simple matter of economics because eggshell goes much further than artists' oils. (Pale colours mixed with white artists' oil colour would use a considerable number of quite expensive tubes of paint.) Eggshell also provides extra protection, but it is best not to use it for mixing colours unless it is necessary. One of the beauties of using glaze is that it is transparent, allowing the base colour to be seen. Adding eggshell means that the translucency is lost, either partly or completely.

White eggshell is dense, so you will need to add more white spirit to the glaze mixture. You may also need to add more white spirit if you have used a lot of artists' oil colour. As before, aim for the consistency of single cream.

The same rules apply to the use of stainers. The range of colours available is more limited and less subtle.

Painting a room

Before you start to paint, clear as much out of the room as possible. Light fixtures, curtains, and blinds should be

removed. If possible, roll up and remove the carpet; otherwise put a strip of masking tape along the edge to protect it from fresh paint on the skirting board. Any remaining furniture should be stacked tidily and safely in the centre of the room and then covered with a dustsheet. Your aim is to prepare the room so that you can paint it in one continuous session without having to pause.

Apart from the inconvenience of constantly having to move objects out of your way, clutter increases the risk of spills and other damage. It also interrupts your work pattern and, most important, delays will cause the glaze to become tacky and difficult to work with.

Assemble your equipment. You will need a step ladder (large or small depending on the height of your ceilings), one bucket for mixing large quantities of paint and another for washing out brushes or sponges in white spirit, a paint tray, a jam jar for mixing oil colour, brushes, a paint kettle, rags and paper for cleaning, white spirit, glaze, and tubes of oil paint. After you have mixed your paint in the large bucket pour some of it into the paint kettle. This will be less cumbersome to move about the room and reduces the chance of large spillages.

Take the telephone off the hook or switch on the answering machine, and do not answer the door—a wall should be painted in one uninterrupted session.

Painting a wall

The best wall to start with is the one in which the door is sited. The theory is that by the time you start painting the wall with the greatest visual impact—the one directly opposite the door—you will have perfected the technique. Start at the top left-hand corner of the wall if you are right-handed, and the top right-hand corner if you are left handed. Complete one section at a time, brushing the glaze on and then wiping it off in whatever manner you have chosen. Sections should be no wider than a comfortable arm span.

Do not apply the oil glaze too thickly; spread it thinner than you would ordinary paint. Most beginners tend to apply it much too thickly. It should be stressed that this is a *transparent* glaze through which the basecoat is visible. Brushmarks will be eliminated at the next stage. Be careful not to put excess paint in the corners and in the edges of the ceiling; at the same time, be sure to go right up to the edges.

You have only about five minutes to return to the top of the wall to start wiping off the glaze before a dark line develops as it begins to dry. If this should happen, keep a wet edge, that is do not wipe off the paint right up to the edge. If you have to finish painting before you have completed the room, stop at a corner, preferably one that

is fairly inconspicuous. Tackle corners as a single unit rather than finishing at the edge of a wall.

It is difficult not to get excess paint on the ceilings, cornice, and corners. If you do, leave it to dry for about 15 minutes, and then stipple out the dark areas with a household brush or a 10×3cm $(4 \times 1$ in) stippling brush. If you try to stipple out excess paint while it is still fairly wet, you will also stipple out the marks you have just made and remove too much glaze.

Working in pairs

You can tackle a small room like a bathroom on your own, but it is much easier to work in pairs in larger rooms. One person can concentrate on putting the paint on, the other can wipe it off. You will almost certainly both need to go up and down a ladder, which, to begin with, may involve some jostling for position. You will, however, quickly get into the rhythm of working together. The second person probably has about five minutes to get to the top of the wall before the paint begins to dry.

Finishing off

Wait before you start wiping stray paint marks and splashes off the woodwork and ceiling. The glaze takes several hours to dry, so you can afford to wait until you have finished the entire room before you start clearing up. Use a rag dampened with white spirit to wipe off any excess paint. Take care not to brush it against the surface of the wall as scuff marks can ruin the finish. If the ceiling has been painted with emulsion, wipe off any marks immediately with a dry cloth (it is easier if the whole room has been eggshelled). Be careful when removing the dustsheet; if the surface of the glaze is still wet, dust particles will adhere to it.

If you do scuff the wall, it is very difficult to make good. The drier the glaze, the harder it will be. Try replacing the glaze colour and then redoing your finish. Unfortunately, this may make a dark 'edge' to the affected area. Some basic finishes may be rectified by stippling out the mark with a small stippling or household brush. There is no really good way of overcoming or solving this problem completely.

If you have to take two days to paint the room, cover the glaze with cling film or allow a skin to form, which you can discard next day. It may need additional white spirit because of evaporation.

Leave your work for a day or two to dry thoroughly before you varnish it. The drying time of oil glaze depends on the amount of artists' oil in the glaze and on the atmosphere; on a cold, damp day the paint will take longer to dry than on a warm dry one.

Suitability of surfaces

	Good plaster finish	Roller plaster finish	Lining paper	Concrete floor	Fine cork tiling	Curved walls (cottage)	Rough plaster finish
Preparation (see pp42–3)	New walls need six months to dry out. Prime.	New walls need six months to dry out. Prime.	Surface dependent on state of wall. Seal.	Smooth concrete only. Prime.	Seal.	Consider the character.	Fill cracks and rub down.
Sponging on/sponging off (pp52–3, 54–5)	Perfect	Good	Good	Possible	Good	Good	Good
Mutton clothing (pp56–7)	Perfect	Good	Good	Not bold enough	Good on walls	Possible	Not possible
Ragging (pp58–9)	Perfect	Good	Good	Good	Good	Soft colours show up bumps	Good
Stippling (pp60–1)	Perfect	Not good for purists	Good	Not bold enough	Good on walls	Too delicate	Not possible
Rag rolling (pp62–3)	Perfect	Good	Good	Not bold enough	Good on walls	Not possible	Good
Colourwashing (pp64–5)	Perfect	Good	Good	Possible	Good on walls	Good	Good
Dragging (pp66–8)	Perfect	Good	Good	Use plaid	Good	Inadvisable	Not possible
Flogging (p69)	Perfect	Good	Good	Inappropriate	Good on walls	Inappropriate	Not possible
Basket weave (pp70–1)	Perfect	Good	Good	Inappropriate	Good	Possible but should be loose	Good but should be loose
Combing (pp72–3)	Perfect	Good	Good	Possible	Good	Borders possible	Good
Spattering (pp74–5)	Perfect	Good	Good	Good	Good	Good	Good
Floating marble (pp80–1)	Not possible	Not possible	Not possible	Possible	Good on floors	Not possible	Not possible
Marbling (pp82–95)	Perfect	Good	Good	Good	Good	Inappropriate	Possible
Malachite (pp96–9)	Perfect	Good	Good	Good as inlay	Good	Not possible	Not possible
Porphyry (pp100–1)	Perfect	Good	Good	Good as inlay	Good	Inappropriate	Not possible
Lapis lazuli (pp102–3)	Perfect	Good	Good	Good as inlay	Good	Inappropriate	Not possible
Agate (p104)	Perfect	Good	Good	Good as inlay	Good	Not possible	Not possible
Granite (p105)	Perfect	Good	Good	Good	Good	Inappropriate	Not possible
Tortoiseshell (pp106–7)	Perfect	Good	Good	Inappropriate	Good on walls	Inappropriate	Not possible
Moiré (pp108–9)	Perfect	Good	Good	Inappropriate	Inadvisable	Not possible	Not possible
Woodgraining (pp110–21)	Perfect	Good	Good	Inadvisable	Good	Inappropriate	Not possible
Stencilling (pp180–91)	Perfect	Good	Good	Possible	Good	Good	Good

Raised/woodchip paper	Glass	Laminate/shiny surface	Stonework/brickwork	Vinyl floor tiles	Floorboards new/old	Painted woodwork and furniture	Metal	Hessian
Very few finishes work.	Paint under glass by reversing the process. Good for tables.	Difficult to make paint adhere permanently.	Use a brick or stone sealer.	Prime with lino paint.	New: prime. Old: fill, rub down, and prime.	Fill, rub down, and prime.	Rub down and prime.	Prime (emulsion paint).
Possible	Good	Possible	Good	Good	Good	Good	Good	Inadvisable
Possible	Good	Possible	Not possible	Not bold enough	Inappropriate/not possible	Needs a perfect surface	Good	Inadvisable
Not possible	Good	Possible	Not possible	Good	Inadvisable	Good	Good	Inadvisable
Not possible	Good	Possible	Not possible	Not bold enough	Inappropriate/not possible	Needs a perfect surface	Good	Not possible
Not possible	Good	Possible	Not possible	Not bold enough	Inappropriate/not possible	Needs a perfect surface	Good	Not possible
Not possible	Good	Possible	Possible	Not bold enough	Inadvisable/not possible	Inappropriate	Good	Inadvisable
Not possible	Good	Possible	Not possible	Inappropriate	Inadvisable/not possible	Not on chipped or dented wood	Good	Not possible
Not possible	Good	Possible	Not possible	Make use of squares	Inadvisable/not possible	Good	Good	Not possible
Not possible	Good	Possible	Not possible	Good	Possible	Good	Good	Not possible
Not possible	Good	Possible	Not possible	Good	Good/inadvisable	Good	Good	Not possible
Try a wild spatter	Good	Possible	Good	Good	Good	Good	Good	Inadvisable
Not possible	Good	Possible	Not possible	Perfect	Good/inadvisable	Good	Good	Not possible
Not possible	Good	Possible	Not possible	Good	Good/inadvisable	Good	Good	Not possible
Not possible	Good	Possible	Not possible	Perfect as inlay	Good as inlay/inadvisable	Good	Good	Not possible
Not possible	Good	Possible	Not possible	Perfect as inlay	Perfect as inlay/inadvisable	Good	Good	Not possible
Not possible	Good	Possible	Not possible	Perfect as inlay	Perfect as inlay/inadvisable	Good	Good	Not possible
Not possible	Good	Possible	Not possible	Perfect as inlay	Good as inlay/inadvisable	Good	Good	Not possible
Not possible	Good	Possible	Not possible	Perfect	Good as inlay/inadvisable	Good	Good	Not possible
Not possible	Good	Possible	Not possible	Inappropriate	Inappropriate	Good	Good	Not possible
Not possible	Not possible	Possible	Not possible	Inappropriate	Inappropriate	Good	Good	Not possible
Not possible	Not possible	Possible	Not possible	Possible	Good/not possible	Good	Good	Not possible
Inadvisable	Good	Good with car spray paints	Not possible	Possible	Good	Good	Good	Good

The end of the day

When you have finished painting, you should clear up the room and remove any stray smears and splashes of paint. Remove and store dustsheets and discard masking tape, once the paint is dry.

Buckets, paint trays, kettles, and other equipment should be cleaned and put away. All brushes should be thoroughly cleaned. In particular, expensive, specialist brushes must be treated with great care.

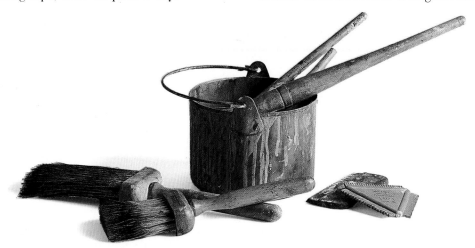

Taking care of your brushes

The following information applies only to brushes that have been used for oil-based paints.

Household brushes Clean thoroughly with white spirit and then wash in washing-up liquid and water. Make sure that all paint is removed from the ferrule. Rinse thoroughly.

Good quality household brushes are easier to clean, and a well-cared for brush lasts longer. The older the brush, the more flexible it becomes. New brushes are always stiff and will initially shed some loose hairs. These should always be lifted off your work with the hairs of the brush and not picked up with your fingers.

If the brushes are in constant use, they may be temporarily stored in white spirit.

Softening brushes These must be extremely well cared for. Both during and after use they must be washed out with white spirit. Gently run your fingers through them to get rid of all the paint. Wash in washing-up liquid and water, and rinse well. Remove excess water by briskly rolling the handle through your hands. Treat them with petroleum jelly or olive oil if they get very dry, and wash it out later with white spirit.

Stippling brushes The paint must not be allowed to dry on stippling brushes while you are working, and they must be cleaned thoroughly at the end of the day. Do not leave them lying around for prolonged periods; keep lunch breaks short. Do not stand them in white spirit because it will penetrate to the top of the brush and then saturate your work. The brush must be dry when you start work. If you need a break during painting, clean the brush in white spirit with your fingers, then wash in washing-up liquid, rinse, and dry properly.

If your brush becomes saturated with paint while you are working, get rid of the paint by stippling on to newspaper or by wiping it off with a dry cloth.

Flogging brushes These are hardier than stippling brushes and can withstand quite a lot of paint. Wash in white spirit and washing-up liquid. Rinse and then flick downwards to dry. A build-up of paint will change the character of the marks that the brush makes. While you are working, flick or wipe the brush to remove excess paint collected by dragging down.

To store, wrap them in paper to preserve their shape, and keep them lying down.

Fitches These are hardier than the specialist brushes. Wash in white spirit until clean.

Swordliners These are very delicate. Clean them in white spirit to remove all traces of paint. Wash in washing-up liquid and water, and then rinse thoroughly. This tends to dry them out, so gently smooth on a small amount of petroleum jelly with your fingers. Before you use them again, wash them in white spirit. Store them lying down.

Varnishing brushes Varnishing brushes are fairly hardy. Wash out all traces of varnish in white spirit only.

Artists' brushes Wash them out in white spirit and rinse well in water. Gently smooth on a little petroleum jelly before storage to help retain their shape.

Troubleshooting If the worst comes to the worst, and paint dries on a brush, put it in a proprietary brush cleaner. In really bad cases, try a paint remover like Nitromors. Try a diluted solution at first, and wash the brush out well in washing-up liquid afterwards. Such strong solvents will not treat your brush kindly, but using them may be preferable to losing it altogther.

Taking care of other equipment

Combs Wipe off paint with a rag dampened with white spirit. Never soak them in white spirit.

Sponges Immerse sponges in a bucket of white spirit and squeeze out all traces of paint. Then wash in washing-up liquid and water until completely clean. Rinse well, and let them dry naturally.

Mutton cloths and rags must be dried out before being thrown away, as they are highly inflammable. Spread them out to let the air get at them.

Storing glaze and paint

Wipe excess paint and glaze from the rim of the can and press the lid on firmly. Then bang it down with a hammer to ensure it fits tightly. Store the can upside down. When you need to use the paint or glaze again, turn the can the right way up. This method means that no skin is formed at the top of the paint surface, but it requires the courage of your convictions.

Glaze and paint stored for long periods tends to go sticky and lumpy. Remove the skin completely, and strain the paint through a mutton cloth or an old pair of nylon tights into a paint kettle.

Drying times

The time a job takes from beginning to end depends on whether you are covering the surface with one or two coats of eggshell and whether you are going to finish with a coat of varnish. The actual process of painting will take less time than the decision making, the forethought, the preparation, the finishing off, and the cleaning-up operations afterwards.

Generally, two coats of eggshell are better than one. Allow the eggshell to dry for 12 hours or overnight. Depending on the size of the room or object, a normal plan of action is as follows: day one a.m.—apply undercoat; day one p.m.—apply first coat of eggshell; day two a.m.—apply second coat of eggshell; day three—apply glaze coat.

It is impossible to give precise times for the drying of the oil glaze. It depends very much on the atmospheric conditions; whether the surface is being painted on a hot, sunny afternoon when the white spirit dries particularly quickly, or a cold, damp autumnal morning.

It also depends on the amounts of eggshell and artists' oil colour in the mixture. Light colours that require a lot of white eggshell in the mixture will dry more quickly than a mixture with a lot of oil colour. This is because household paint contains chemical driers to speed up the process, while artists' oil colour dries naturally. Some deep blue oil glazes, for example, need a lot of colour to counteract the

yellowness of the glaze and will take considerably longer to dry than a light blue with white eggshell in the mixture. Also some people are lighter-handed with their brushes and the application of paint than others. Some finishes, mutton clothing and stippling, for example, require more paint or more oil colour than others.

Generally, the more oil colour in the mixture, the longer it will take to dry. Manufactured glaze does contain chemical driers. Finishes such as malachite, porphyry, lapis lazuli, and tortoiseshell, where a lot of oil colour is used, will need up to one week to dry thoroughly before varnishing. Breccia marble, on the other hand, needs very little time, as the surface is so dry and thin.

There is a minimal difference in the natural drying times of various pigments, but these will not really affect your calculations. If in doubt, it is best to wait!

Surfaces that need rubbing down between coats must be thoroughly dry, as sandpaper will disturb the first skin of paint and ruin the surface.

You will need to allow much longer for the entire process of painting floors. They need up to seven coats of protective varnish, as well as the initial preparatory stages, the eggshell basecoats and the decorative oil glazes. Painting objects or furniture does not disrupt the pattern of life so much, and they can be quietly left to dry undisturbed between coats of paint.

Standard glaze mixture

The standard glaze mixture is 50 per cent white spirit and 50 per cent glaze. Artists' oil colour, with or without white eggshell, is then added to colour it. Some techniques require more glaze or white spirit, and these proportions are given on the appropriate pages.

For the basic finishes, the glaze mixture is applied much more thinly than most people imagine. It should not present a flat surface like ordinary paint, but being transparent, should allow the basecoat of eggshell to show through. The brushmarks of the oil glaze will still be visible.

Oil glaze dries to a state where it becomes unworkable fairly quickly, particularly in warm temperatures. Once

started, you have to proceed quite fast to prevent an 'edge' forming where the glaze has become quite dry. This time is generally about five minutes. However, it remains soluble in white spirit for quite a long time, so that splashes on other eggshelled or glossed surfaces can be wiped off after the walls have been finished.

If the oil-glaze mixture is left overnight, the paint kettle should be covered with cling film to prevent dust dropping on to the surface and to minimize evaporation of the white spirit. You may need to add more white spirit to glaze that has been standing around for a while. Old glaze will form a skin, so it must be strained through a mutton cloth or an old pair of nylon tights.

CHAPTER III

Basic Finishes

Basic finishes are all relatively simple; those early in the chapter are the easiest, becoming more difficult towards the end. They all work on the same general principle. A transparent oil glaze is applied over an eggshell basecoat, and then broken up with brushes, rags, combs, or sponges to reveal the base colour. Some techniques are very controlled, while others have a more carefree appearance. They are all very versatile and can be used on walls, woodwork, and furniture. Basic finishes may be used on their own, or in combination with each other, or with techniques described in later chapters.

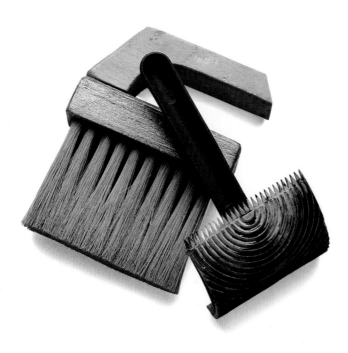

Do not be intimidated by a blank wall; build up your effect in stages. Above the dado, the wall is colourwashed, using an Indian Red glaze over ivory eggshell. The dado is combed horizontally and then vertically, using a graduated comb, in a mixture of Alizarin Crimson, French Ultramarine, and Oxide of Chromium over an ivory basecoat.

Sponging on

This is one of the easiest and quickest finishes to achieve. It simply involves dipping a sponge in oil glaze and dabbing it on the wall. Sponging on differs from other techniques in that the sponge is used to apply the oil glaze, whereas most finishes use a sponge, brush, comb etc. to remove glaze previously applied with an ordinary household brush. It is the only finish that can be successfully applied using thinned emulsion paint over an emulsion wall. This creates an opaque and chalky look that is flatter than that achieved with oil glaze.

Sponging on can be used to camouflage unsightly objects, such as radiators, so that they merge into the background. It is the only finish that can be used on woodchip or other raised wallpapers. It is suitable for walls, furniture, and small, plain objects. It would probably only work on a floor as part of an overall design, perhaps as an imitation sponge marble.

Large areas of a wall can be covered relatively quickly, so it is a satisfying technique for first-timers. It provides the opportunity to practise some of the fundamental skills required for many paint techniques: mixing up the required quantity of oil glaze, mixing and using different colours and tones to create a feeling of depth and richness, and applying an even surface of paint on to a wall.

Before you can start to apply the oil glaze the surface must be coated with eggshell paint. This can be any colour you choose, but it should be related to the colour and tone of the oil glaze that you are going to sponge on. If you are intending to use oil glaze rather than emulsion and the wall has previously been painted with emulsion, make sure the eggshell covers it completely. Any exposed patches of emulsion will darken the oil glaze.

Both colour and tone require careful thought, as sponging on can look quite crude if it is handled unsympathetically. The finish looks best on a coloured background with a range of tones or colours applied on top. Tones and colours at opposite ends of the spectrum produce startling effects that can be difficult to control and to live with. Off-whites are easier to work with as a base than pure whites. (You can colour pure white by adding artists' oil paint or universal stainers, or you can buy various shades of off-white ready mixed in cans.) It is a common mistake for beginners to vary the colour too strongly with too marked a difference between the tones.

There are various different ways of applying paint to the wall and giving sponging on a different feel. You can apply two colours at the same time, one in between the other. Alternatively, you can sponge on one colour, leave it to dry, and then sponge on another. The last colour you apply will be dominant. Applying several layers of glaze gives a deep translucent quality that cannot be achieved with emulsions or stained eggshell. If you are going to apply two layers of sponged on glaze, the finish looks best with the whiter colour on top. Keep the tones close together—sponging should be a soft, not startling look. You could use a pattern deliberately to your advantage.

The difficulty is covering an area evenly without establishing a pattern that looks too obvious or geometric. Step back from your work and look at it from a distance. One of the advantages of using oil glaze is that mistakes can be wiped off with a rag soaked in a little white spirit. As the oil glaze is applied very thinly, this does not create the same mess as wiping off gloss paint.

Before you start, squeeze out the sponge in clean water to soften it. When you have mixed up your oil glaze, pour a little into a paint tray. Dip the sponge lightly into the tray; this prevents it becoming saturated with glaze. If the sponge becomes saturated, you will lose definition. When you have finished working, wash it out in white spirit, and then in water and washing-up liquid. Rinse in clean water and squeeze well. Always squeeze out the sponge in water before use to make it soft and pliable.

SUITABILITY

Everything, including walls, ceilings, floors, and furniture.
Unsatisfactory on small or carved items.

DIFFICULTY

★

MATERIALS

Glaze

White spirit
slightly more white spirit than standard mixture

Oil colour

Water to soak sponge

EQUIPMENT

1 natural sponge

Paint tray

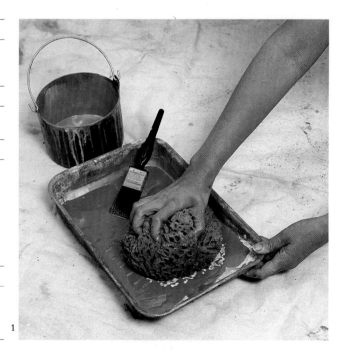

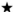

1 Having dipped the sponge lightly in the paint tray, dab it gently on the wall, making sure that you create an even, overall pattern. You can vary the pressure.

2 The effect can be varied by leaving larger spaces between the sponge marks and applying a second colour while the first colour is still wet. Keep base and glazes close in tone.

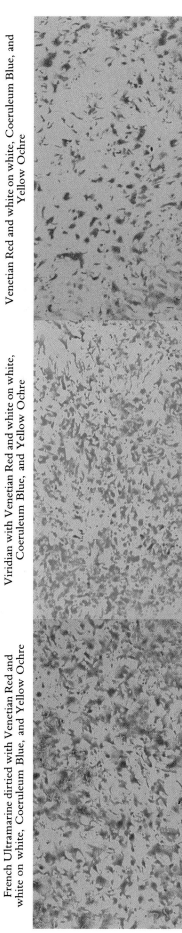

Venetian Red and white on white, Coeruleum Blue, and Yellow Ochre

Viridian with Venetian Red and white on white, Coeruleum Blue, and Yellow Ochre

French Ultramarine dirtied with Venetian Red and white on white, Coeruleum Blue, and Yellow Ochre

3 The final colour will be dominant. You can achieve innumerable variations by experimenting with sponging additional colours over dry glaze coats. A stronger look can be created by using a darker coloured base.

1 When you have decided on your colour, make up a sufficient amount in a paint kettle. Pour a small quantity into a paint tray.

2 A glaze was made from Indian Red deepened with a little Oxide of Chromium. Used over an off-white basecoat, it created a bright and dramatic effect on a hallway wall.

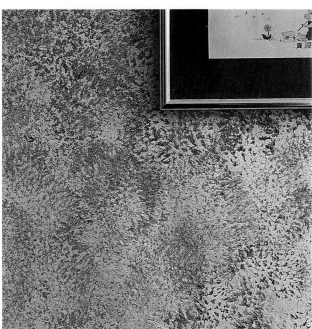

Sponging off

This is another easy technique, although slightly more difficult than sponging on. After the eggshell basecoat has dried, oil glaze is applied with a brush and then lifted off with a sponge to allow the colour of the base to show through.

It is a casual, informal finish and, depending on how the sponge is handled, it can be spotty, blobby, flowery, or cloudy. Try moving the sponge lightly and swirling it around. Like sponging on, it can be done in several colours. A good combination of the two techniques is to sponge off, and, when the surface is dry, sponge on in the same colour. This gives great depth, especially when done in dark colours and varnished afterwards with gloss. It can also look very light and pretty.

You need to establish a working pattern for applying the paint with a brush and then taking it off with the sponge. Work in strips no wider than a comfortable arm's reach so that you do not have to overstretch. The paint should not cover such a wide area that it becomes dry and unworkable before you can lift it off with the sponge. As a general rule, you should start to sponge off within five minutes of applying the glaze, but if the weather or the room is warm, the paint will dry much more rapidly. If the paint becomes too dry, it will be unworkable. Do not delay between finishing sponging off one strip of wall and applying the glaze to the next. This would result in a dark line between the two adjoining areas. If you find that the sponged oil glaze is drying too quickly, do not sponge right up to the edge, but leave it as brushed-on glaze.

Whatever you are painting, it is very important to cover the surface evenly with the oil glaze. This is particularly difficult in corners, where there is a tendency to deposit too much paint. If this happens, it is best left until the whole room has been sponged and any excess paint can then be stippled away with a stippling brush or a good-quality, firm household brush. Any spills, runs, or unwanted paint on walls or woodwork can be wiped off with a rag dampened with white spirit at the end of the day. This applies to all finishes.

SUITABILITY

Everything, including walls, ceilings, floors, and furniture.

DIFFICULTY

MATERIALS

Glaze

White spirit
slightly more white spirit than standard mixture

Oil colour

Water to soak sponge

EQUIPMENT

1 natural sponge

1 household brush (the largest possible for the job)

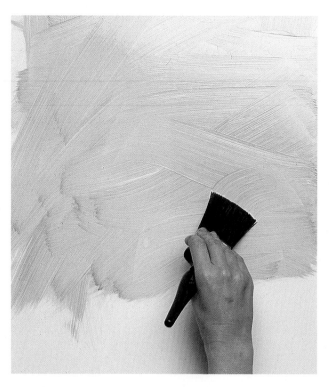

1 Apply a thin coat of glaze with a household brush to cover the surface evenly. Work on small areas at a time so that the glaze remains wet and workable.

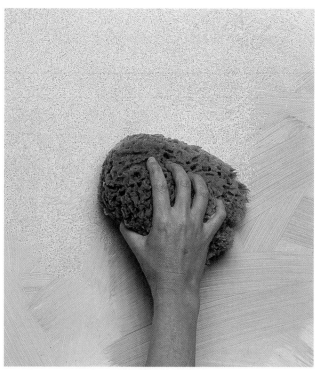

2 Squeeze out the sponge in water and dab it evenly on the surface to lift the glaze. When it is saturated wash the sponge in white spirit and then washing-up liquid. Rinse.

3 You can vary the look by sponging off over a surface that has previously been sponged on in a different colour. These techniques allow scope for experimentation with colour, tonal variation, pressure on the sponge, different basecoats, and drying times, to achieve a wide range of different effects.

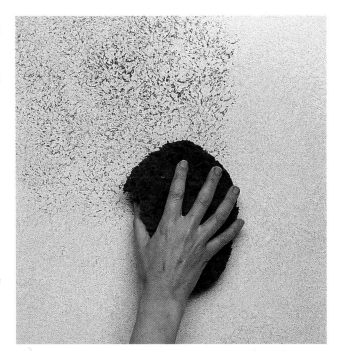

1 The panels of this door have been sponged off. The architrave, stiles, and rails were stippled. As sponging off is a fairly loose finish, the mouldings were colour wiped to contain and emphasize the looser finish of the panels.

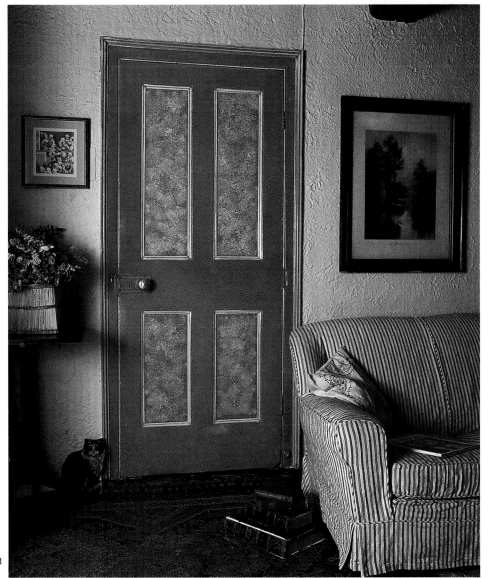

1

Raw Sienna on white, Raw Sienna, and Burnt Sienna

Coeruleum Blue and Oxide of Chromium on white, Raw Sienna, and Burnt Sienna

Mars Orange with Oxide of Chromium sponged over on white, Raw Sienna, and Burnt Sienna

Mutton clothing

Mutton clothing gives a fine and delicate finish, unlike the more robust and busy effect of, say, ragging. It is one of the simpler techniques. Oil glaze is applied over an eggshell basecoat and then the surplus is lifted off with a mutton cloth, leaving an impression of the weave behind it. It has a rather gentle, erratic look where the mutton cloth has absorbed more paint in some areas than in others, with soft, cloud-like shapes blending together on the surface. Mutton cloth is also known as stockinet. Usually used for polishing and cleaning, it can be bought from hardware shops and garages.

Where a single colour is laid over the basecoat, the finish can be applied and completed fairly quickly, but richer effects can be achieved by painting several layers over one another.

Mutton clothing can be a good alternative to stippling, a rather more difficult technique that requires a very smooth surface. Generally speaking, if your wall is not sufficiently smooth for stippling, mutton clothing makes a very good alternative.

As it is a delicate finish, it lends itself more naturally to paler colours, although there is no reason why you should not try stronger tones. It works as well on furniture as it does on walls, and looks especially good used in conjunction with dragging on surrounding woodwork.

The mutton cloth is folded to make a firm pad, and frayed edges are tucked into the middle. To minimize the number of loose threads, do not cut the piece of mutton cloth with scissors. Pull a continuous thread until it snags (like tights or stockings) and then you can tear it apart. The size of the mutton cloth pad will affect the kind of mark you make; a large pad will leave a more generous mark, a small pad will give a tighter, more controlled feel.

After a while the pad will become saturated with paint and cease to make any impression. In fact, it will start to put paint back on rather than take it off. Unfold the mutton cloth and refold it, leaving a fresh, clean part on the base of the pad. When the whole of the cloth is wet, tear a fresh piece and start again. Be warned—a large wall can use up quite a lot of mutton cloth. It is advisable to prepare a pile of mutton cloths in advance.

SUITABILITY

Walls, ceilings, and furniture, particularly larger pieces. Not suitable for ornately carved objects.

DIFFICULTY

★★

MATERIALS

Glaze

White spirit
slightly less white spirit than standard mixture

Oil colour
N.b. more oil colour than usual is required as the mutton cloth absorbs the paint.

EQUIPMENT

Household brush

1 roll mutton cloth

10 × 2 cm (4 × 1 in) stippling brush for corners and cornice.

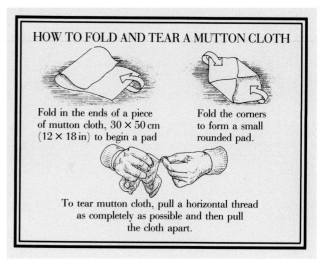

HOW TO FOLD AND TEAR A MUTTON CLOTH

Fold in the ends of a piece of mutton cloth, 30 × 50 cm (12 × 18 in) to begin a pad

Fold the corners to form a small rounded pad.

To tear mutton cloth, pull a horizontal thread as completely as possible and then pull the cloth apart.

1 Fold the mutton cloth to form a pad, with the edges to the inside. As the pad becomes saturated, fold to make a fresh one. When the entire cloth becomes saturated, take a new piece. (It is sensible to have a pile of cloths already torn up.)

2 The finish in this hall is a variation of simple mutton clothing. The pad has been twisted to create swirls of pattern (detail left). The colour provides a strong contrast to the marbled dado.

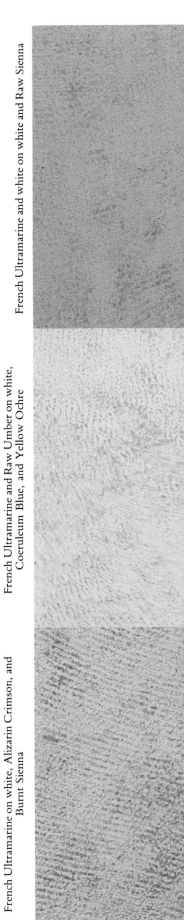

1 Paint the oil glaze evenly and thinly over the basecoat. If it is too thickly applied, the mutton cloth will not have enough impact and become saturated too quickly.

2 Fold the mutton cloth into a pad and lift the paint off. Use a swift, firm dabbing action. It is impossible to achieve a completely even, all-over look.

French Ultramarine and white on white and Raw Sienna

French Ultramarine and Raw Umber on white, Coeruleum Blue, and Yellow Ochre

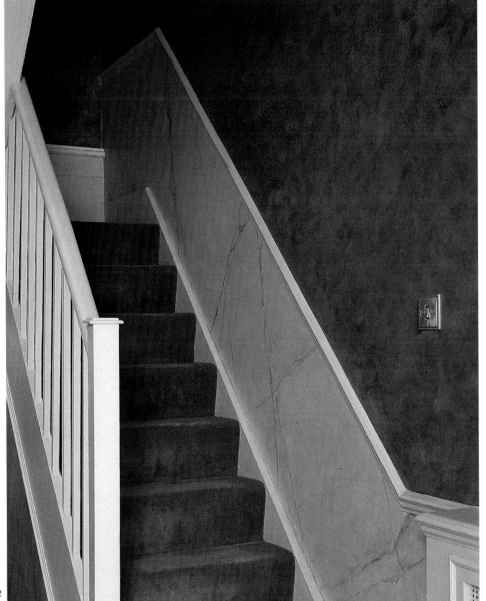

French Ultramarine on white, Alizarin Crimson, and Burnt Sienna

2

Ragging

Ragging is one of the best known decorative finishes for several reasons. It is very adaptable, quick, and easy to execute, and needs no specialist tools. It can range from a soft, delicate, and subtle feel to a wild, carefree, more defined look, depending on the range of colour and the type of rag used to lift off the glaze. It is suitable for walls and furniture, and looks especially good as a background to stencilling.

Oil glaze is painted over an eggshell basecoat with an ordinary household brush and then lifted off with rags to reveal the colour beneath. It can be done with two colours at the same time or with two colours in separate coats to give extra depth. The standard style of ragging is to paint a glaze colour a few tones darker than a pale background. It is usual to rag until there are no brushmarks visible, but they can be left to make a feature. Ragging is not the same as rag rolling. In rag rolling, the glaze is stippled before it is ragged.

It is usually done with a soft cotton rag. Different rags can make a huge variation in the appearance and effect of this technique. Before you start, make sure that you have a sufficient store of the same type of rag to enable you to complete a whole room. Old sheeting is ideal, and you might also try leftovers from jumble sales and unwanted charity clothes. Try J Cloths, heavy cloths, and rags with a small proportion of man-made fibres. In general, cotton rags are best because they absorb the glaze. Glazed cotton does not work, and you will end up putting on more glaze than you are taking off. Other possible materials include plastic bags, paper bags, heavy linen, and chamois leather. When you are using non-absorbent material, such as plastic bags, you must have plenty of newspaper to wipe off the excess glaze that will build up. Glaze-soaked rags cannot be reused and should be carefully dried until they can be disposed of safely.

Ragging is most easily executed by two people working together, although it is quite possible to do it on your own. The first person applies the oil glaze to the wall, starting at the ceiling and working downwards in a workable strip about 1 m (3 ft) wide. The second person rags over the strip, following the first person around the room. Any extraneous marks can be cleaned off at the end of the day. Sometimes the person applying the ground coat of oil glaze splashes work already ragged. This can be obscured by lightly dabbing over unwanted marks just to lift off the paint. Any thin patches, caused by applying too little glaze, can be improved with a single brush stroke over the offending area, and then ragged again to blend in, providing this is done while the glaze is still fairly wet.

SUITABILITY

Everything, including walls, ceilings, floors, and furniture.

DIFFICULTY

★★

MATERIALS

Glaze

White spirit
standard mixture

Oil colour

EQUIPMENT

Cotton rag* (standard look)
or
other lint-free, non-nylon rag
or
J cloth
or
crinkled plastic bag
or
small, inflated plastic bag

Household brush (size appropriate to work)

10 × 2 cm (4 × 1 in) stippling brush or household brush for corners and cornices

*For an average room, about 3.75 × 4.5 m (12 × 15 ft), you will require the equivalent of a torn-up double sheet.

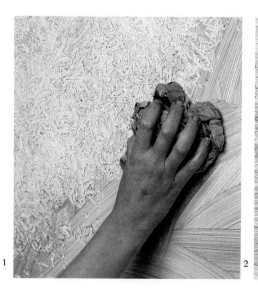

1 Ragging with a paper bag produces a less delicate finish because it is not as absorbent as cotton.

2 Another effect can be created using a plastic bag. As plastic is non-absorbent, it will quickly start to put glaze back on the wall, so you will need a ready supply of plastic bags.

3 A room can be ragged quite quickly. It is a very adaptable technique, suitable for many different types of houses and interiors. It can also be used in conjunction with many other finishes and techniques, including stencilling.

1 Cover the surface with a thin layer of oil glaze. Try not to build up too much paint in the corners and edges, but make sure that the whole surface is adequately covered.

2 Lift the glaze off gently with a loosely crumpled cotton rag. If the glaze has become too dry, you will need to apply more pressure. This should be avoided if possible.

3 As the rag becomes covered with glaze, re-fold it. Eventually, the rag will become soaked and will have to be discarded. Rags should be spread out to dry first.

4 When the whole of the room has been ragged, any excess glaze that has built up along edges or in corners can be evened out using a small stippling brush.

Raw Umber and white on white and Burnt Umber

Mars Violet with white and Viridian on white and Burnt Umber

Viridian with Mars Violet on white and Burnt Umber

Stippling

Stippling is a very delicate and sophisticated finish suitable for furniture, walls, and panelling. It is a traditional, 18th-century finish which looks at its best combined with dragging on Georgian panelling, or used on a dado with dragging above.

It is quite a difficult technique to do properly. It relies on the even application of paint and the steady, firm motion of the stippling brush to lift it off. A wide range of stippling brushes is available; choose one appropriate in size to the area you wish to cover. An 18 × 12 cm (7 × 5 in) brush is most useful for walls, while an 8 × 10 cm (3 × 4 in) brush is very practical for furniture. A 10 × 2 cm (4 × 1 in) brush is useful for corners and small areas. Much larger brushes, suitable for bigger areas, are also available.

You should aim to achieve a very even look, although there will be a gradual change in colour. Stippling needs excellent walls, as it shows up every single change in the surface. As with many of these basic finishes, it is quicker and easier (but not essential) to work in pairs—one to brush the glaze on and one to take it off. It takes a short while for the stippling brush to build up a little paint on the bristles to give it a good 'feel'. You will develop a pattern of working which becomes easier as you go along. Start in a place that is not going to be the focal point as you come into the room. When the stippling brush is saturated with glaze, wipe it with a rag. Do not wash it in white spirit until you have completed the job; a wet brush will leave white spirit runs all over your work. For edges, mouldings, and other small, inaccessible areas, a 10 × 2 cm (4 × 1 in) brush is necessary.

Stippling is an extremely delicate finish, so very pale colours cannot be seen. Strongly coloured glaze requires a coloured background. The eggshell basecoat should also be strong and bright to add vitality to the top coat. A typical combination might be a bright pink basecoat stippled with burgundy.

It is not a good idea to use a lot of white eggshell in your glaze because it dries very quickly and makes stippling more difficult. A small amount may be used to counteract any yellowishness with medium and lighter blues and pale colours. A lot of oil colour is necessary, as the brush seems to absorb the paint.

A small stippling brush is invaluable for taking out the excess paint that can easily build up in corners and along architraves with this and other techniques. Wait until the glaze is almost dry before you attempt to do this, otherwise you will disturb all the work you have just done. A stippling brush is also used in marbling (see pp82–9) and on moulded cornices (see pp142–3), and stippling can also be used to blend one colour into another. Panels can be aged and given a patina by stippling a darker colour at the edges and corners.

SUITABILITY
Walls and furniture (large and small)

DIFFICULTY
★★★

MATERIALS
Glaze
White spirit *slightly more glaze than standard mixture*
Oil colour *N.b. more oil colour is needed as it is a very dense look*

EQUIPMENT
Stippling brush (size appropriate to work)
Household brush (size appropriate to work)

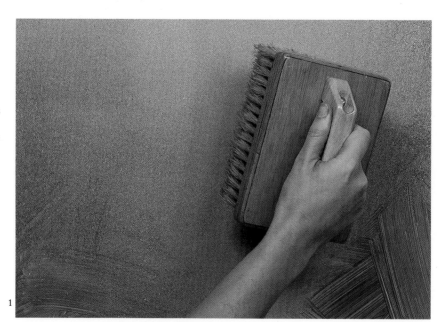

1 Cover the surface in a thin layer of oil glaze. Dab a stippling brush firmly and evenly to lift the glaze. Once the glaze is drying, it is difficult to remove scuffs and splashes, so take care not to disturb previously finished areas. As the paint builds up on the brush, wipe it off gently with a clean rag.

2 Stippling has a very even look which, from a distance, can look almost flat. It nevertheless has a mysterious quality and depth; flat paint appears quite dead by comparison. Here, the mouldings on the panelling have been varnished to give them emphasis. Stippling over a coloured basecoat gives a vibrant quality.

2

3

3 Stippling provides a good background in a room that has a lot of architectural detail and many pictures on the wall.

4 Mouldings and carved objects can be painted in oil glaze and then stippled. Sometimes the raised areas are then wiped to give contrast.

4

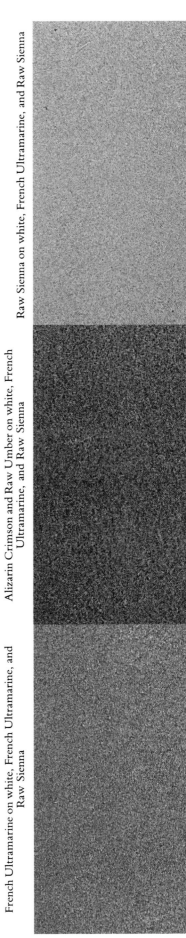

Raw Sienna on white, French Ultramarine, and Raw Sienna

Alizarin Crimson and Raw Umber on white, French Ultramarine, and Raw Sienna

French Ultramarine on white, French Ultramarine, and Raw Sienna

Rag rolling

This finish is a sophisticated version of ragging. It involves three different stages: the oil glaze is brushed on with a household brush, stippled, and then rag rolled. All three stages have to be completed before the oil glaze becomes tacky, so large areas are best undertaken by at least two, possibly three, people. One person alone can tackle panels or small areas, but large areas can be an arduous and laborious task.

Once the glaze has been stippled, you can rag heavily or lightly, according to the effect you want to create and how much of the stipple you wish to leave revealed. Contrary to popular opinion, the rag should NOT be folded into a sausage shape, but crumpled and then rolled up the wall. You could also try the opposite effect— stippling over ragging. This creates a rather busy look.

As rag rolling is a combination of stippling and ragging, much of the advice for both these techniques applies (see pp58–9 and pp60–1). Aim for an all-over evenness; this depends on the even application of paint and a steady hand with the stippling brush. Excess paint should be stippled out of the corners after the oil glaze has had time to dry. This will take at least 15 minutes, but may be longer, depending on atmospheric conditions and the amount of artists' oil colour. If you are tackling a whole room, you can delay this process until the room is completed. If you have waited too long and the glaze is practically dry and unworkable simply be a little more vigorous with the stippling brush.

SUITABILITY

Large areas, such as walls, panels, and larger pieces of furniture.

DIFFICULTY

★★★

2 or even 3 people may be necessary

MATERIALS

Glaze

White spirit
slightly thicker than standard mixture

Oil colour

EQUIPMENT

Stippling brush (size appropriate to work)

Cotton rags*

*For an average room, about 3.75 × 4.5 m (12 × 15 ft), you will require the equivalent of a torn-up double sheet.

1 The surface should be given a coat of glaze
and stippled as described on pages 60 and
61. Use a brush appropriate to the size of the
surface.

2 While the glaze is still wet, roll a crumpled
rag up the wall, taking care not to slip or to
make a pattern that cannot be repeated. Do not
fold the rag into a sausage shape.

2

1 In this kitchen, rag rolling
on the panels and drawers has
been used in combination with
stippling and dragging. The
mouldings have been carefully
colour wiped to provide some
relief and to match the colour
of the crockery.

2 How lightly or heavily you
rag the wall after stippling is a
matter of personal taste. Here,
the wall has been ragged fairly
lightly to leave quite a lot of
the stipple revealed.

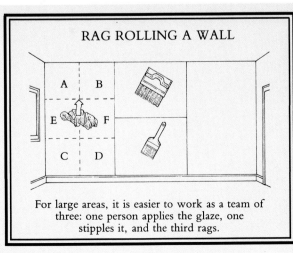

RAG ROLLING A WALL

For large areas, it is easier to work as a team of
three: one person applies the glaze, one
stipples it, and the third rags.

Raw Sienna on white, French Ultramarine, and Raw Sienna

Prussian Blue on white and Cadmium Yellow

Prussian Blue, white, and Burnt Umber on white,
Alizarin Crimson, and Burnt Sienna

Colourwashing

Colourwashing is a fairly carefree, flexible technique which can be varied in appearance according to the way in which the oil glaze is wiped off. You can use a cloth, a wallpaper brush, a bunch of long feathers or a wide household brush, and each of these will give a different feel and texture to the overall look. The cloth gives a very soft look as no brushmarks are apparent.

The oil glaze looks best brushed or wiped so that only a thin skin remains. It needs to be quite well worked until the glaze feels dry. Pale colours work best on a white or off-white base. This can give the feeling of casually applied whitewashing, so a matt varnish may be applied. Colourwashing can be given a stronger and more sophisticated look by using a darker base and another darker tone or colour over it. More layers of oil glaze can be brushed on when the first coat is thoroughly dry. After using darker colours, perhaps deep reds, a gloss varnish may be used to give a mock lacquer look.

Generally speaking, colourwashing looks best using pale colours in a cottage, and rich, darker colours in a town house. In a more formal house, it may look better contained within a panel to give it more form and structure. Because of its looseness it is really not suitable for decorating furniture.

This is a good finish for walls in poor condition. Walls may be 'undulating' and the plasterwork may even have pits and lumps. As long as the base colour and glaze are similar in tone, then any imperfection merges in and becomes part of the finish.

A deft and practised hand may find this finish possible using thinned emulsion paint over an emulsion basecoat.

SUITABILITY

Walls, ceilings, floors and large areas of furniture, such as table tops. Particularly suitable as the background for stencilling etc.

DIFFICULTY

★★★

MATERIALS

Glaze

White spirit
slightly more glaze than standard mixture

Oil colour

EQUIPMENT

Rag

Large brush, such as a wallpaper brush

Large bunch of feathers

Household brush (size appropriate to work)

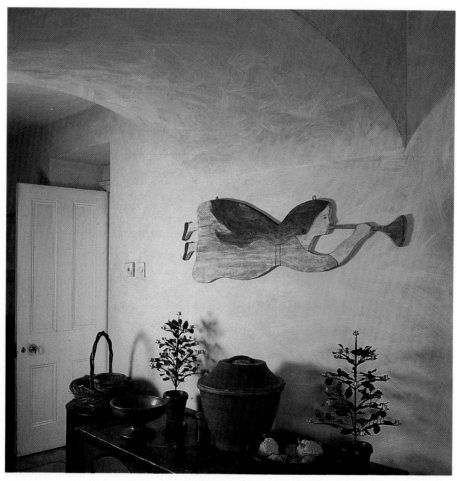

1

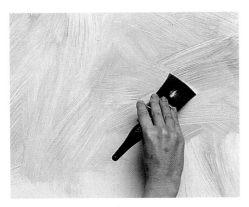

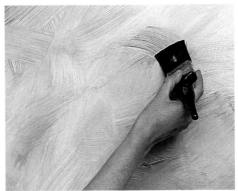

1 Apply a thin coat of glaze to the wall, brushing it out even more thinly than usual.

2 With a large, dry brush, wipe off the glaze in broad and sweeping strokes.

3 A dry cotton rag may be used as an alternative for wiping off the glaze. This produces a gentler effect. You can take off more or less of the glaze, according to the desired effect, and when it is dry another colour can be added.

1 Three different coloured glazes were brushed on the wall in a random fashion, and then wiped off. The colours used here were Raw Sienna, Burnt Sienna, and Burnt Umber. Take care to avoid making crosses and definite patterns.

2 As it is a loose and informal finish, colourwashing is a good solution in a country house where the plaster walls are uneven. It can provide a good background for additional decoration such as stencilling, or printing, as shown here.

Raw Sienna on white

French Ultramarine, white, and Burnt Umber on white

Indian Red on white, Viridian, and Burnt Umber

Dragging

Dragging developed from woodgraining techniques in the mid-18th century. Oil glaze is applied with a household brush in a vertical movement; a flogging or dragging brush is then dragged down in strips to give a variegated, stripy look. It is an extremely useful, classical technique for use on doors, panelling, dados, and skirting boards, and would have been used in this way in a typical 18th-century room.

You can use various brushes and cloths for dragging, depending on the surface and on the effect you want to achieve. For a classic interpretation, use a flogging or dragging brush, but a cheaper, poorer-quality household brush can also be employed. This will not give the classic look, but will produce a satisfactory alternative. The advantage of a flogging brush is that it does not leave brushmarks when it is used on a long wall. Cloths soaked in white spirit, glaze, and oil colour can be used for dragging on furniture, but not on walls where they will leave a mark as they are removed. This technique gives furniture a soft, watercolour look.

A contemporary adaptation is to drag vertically in one colour, and, when the oil glaze has dried, to drag horizontally with a second colour or tone. This gives a chequered or plaid effect. You can create a wild silk effect by dragging down and then flicking the brush slightly to one side. It is quite a hard technique, requiring concentration and a steady hand. The lines should be parallel and not allowed to slip to the left or right of the flow.

Do not drag on a white basecoat unless you are using very pale-coloured oil glaze. The tones of the basecoat and glaze should be close, so that the general effect is quite subtle even if strong colours are used. Too much tonal or colour variation will result in a very stripy, variegated look. If you want a strong look, it is better to use darker colours that are tonally close. For a classical look, you might drag a pale sage green over darker green, or a drab colour over a sand basecoat. A more contemporary look might be a red base dragged with emerald green, or a chrome yellow base dragged with mauve.

During dragging, the brush will become saturated from time to time; flick the paint off and wipe it on a rag. A build-up of paint on the brush will alter the character of the stripes it makes. Sometimes this is done deliberately to create a rougher, less precise look.

There is a particular method and order for dragging doors (see pp138–9). Dragging over anything else, such as panels, should always follow the grain of the wood.

SUITABILITY

Walls, all woodwork, including skirting boards and doors, furniture, particularly larger items.

DIFFICULTY

★★★

MATERIALS

Glaze

White spirit
slightly more white spirit than standard mixture

Oil colour

EQUIPMENT

Flogging brush (size appropriate to work)

Household brush (size appropriate to work)

1 Apply a thin coat of glaze with a household brush. Brush on with an up-and-down movement rather than haphazardly (as in some other finishes).

2 Draw a dragging brush down the wall using reasonable pressure, keeping the brush strokes parallel. The mark is made by the lower part of the bristles.

You may also drag with a rag, by dipping it into the oil glaze and drawing it down the surface. This technique is most suitable for dragging small areas.

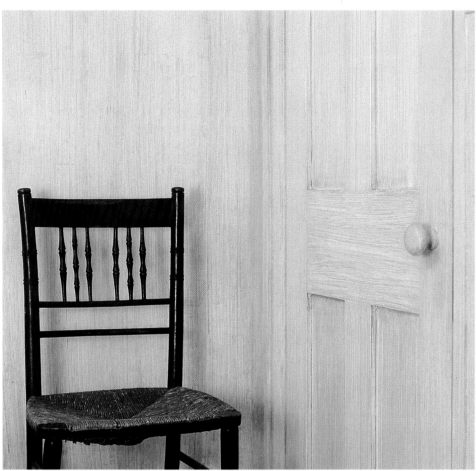

French Ultramarine and white on white and Raw Sienna

Alizarin Crimson and white on white and Raw Sienna

Viridian on white and Raw Sienna

1 To avoid a stripy look, continue brushing up and down.

2 When working from the cornice, use your other hand to apply pressure to the end of the bristles until you can feel that the brush is making its own mark.

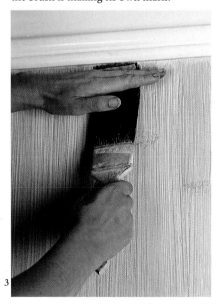

3 After lifting the brush, to avoid conspicuous joins, glide it along the dragged lines in a flowing movement, gradually increasing the pressure.

1 Dragging works well in combination with many other finishes. Small and intricate details may be colour wiped.

2 For a checked look, dirtied yellow was dragged horizontally, then pale blue vertically. The area on the right was dragged in crimson.

3 Dirtied yellow was dragged vertically, crimson was dragged horizontally, and then pale blue was dragged vertically.

4 Green was dragged in one direction and red in the opposite.

Flogging

This technique is derived from oak graining, but it can be used decoratively. You will need a long-haired flogging brush. Quite a dry mixture of oil glaze is laid over the eggshell base. It is then dragged and 'flogged', that is, hit with a small series of upward brush movements to break up the flow of the dragged paint.

It is important that the oil glaze is the right consistency. If it is too wet when it is hit with the flogging brush, the appearance may be very crude and 'hairy'.

Theoretically, a flogged finish can be painted anywhere, but it is quite time-consuming, difficult, and hard work to flog walls. It is a more suitable technique for furniture and panels, and a good alternative to dragging on architraves.

The surface should be good and flat; any slight bump will take more of the paint and therefore become apparent. Sometimes this can look quite attractive depending on the age and style of your house, but it will not have the classic appearance of flogging.

SUITABILITY

Doors, particularly architraves, walls, dado rails, larger items of furniture, frames.

DIFFICULTY

★★★

MATERIALS

Glaze

White spirit
slightly more white spirit than standard mixture

Oil colour

EQUIPMENT

Flogging brush (size appropriate to work)

Household brush (size appropriate to work)

1 Drag the surface, working the glaze until it is 'dry' (not wet and sticky). Use close tones of the same colour.

2 Starting from the base, hit the surface with a series of upward brush movements.

Here flogging has been used in the panels, while the stiles and rails have been dragged, using Viridian over white. This has an unusual, contemporary look.

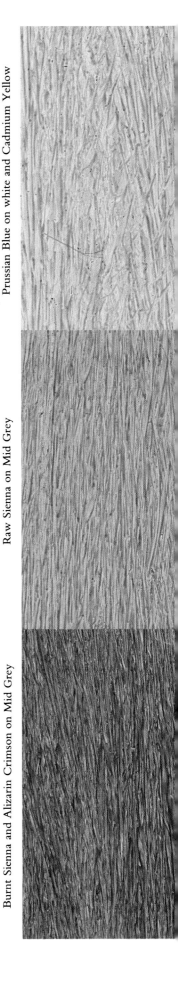

Prussian Blue on white and Cadmium Yellow

Raw Sienna on Mid Grey

Burnt Sienna and Alizarin Crimson on Mid Grey

Basket weave

This is a decorative pattern made by using a dry household brush to wipe off the oil glaze in a way that gives the appearance of a woven, interlocking design that resembles basketry. The structure of the pattern takes a few minutes to understand but, once comprehended, it is easily applied.

It is a modern finish, probably derived from colour-washing. It is a loose, country-style finish that works well on cottage walls; it would probably look out of place in the more formal confines of a town house. It has the feel of rush matting, and so looks better in natural colours, dirty pinks, and sludge colours.

There are two sorts of basket weave: a wide, less controlled variety for use on walls, and a tighter, more controlled basket weave for decorating small objects and furniture. Table tops, in particular, work well.

This technique is more easily executed by two people, with one applying the oil glaze, while the other concentrates on wiping it off in the criss-cross pattern that gives it its name.

When applying basket weave to an inset panel area, you will find that it is difficult to wield the brush into the corners and edges, which will then tend to look rather messy. It is best to finish the panel off, and then paint in or wipe off around the edges, so that the basket weave is both contained and defined.

SUITABILITY

Walls, including panels, and furniture, particularly table tops.

DIFFICULTY

★★★★

MATERIALS

Glaze

White spirit
standard mixture

Oil colour

EQUIPMENT

Household brush for applying glaze

Dry household brush for taking off

1 Apply the glaze and, with a dry brush, make a diagonal mark from the top, left-hand corner. Brush a diagonal across from the right, leaving no gaps. Continue.

2 Taking as your starting place, the point of the first triangle, bring the brush down parallel to your first diagonal.

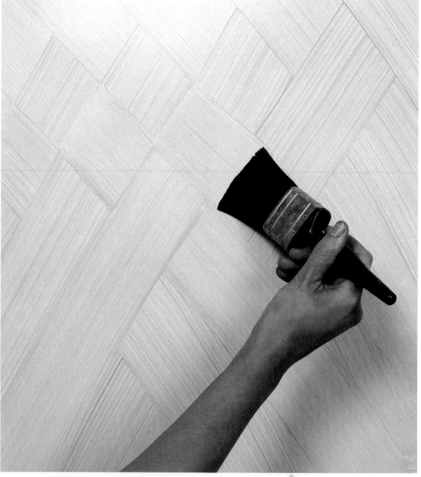

3 Continue making alternate left and right diagonals. Wipe the brush regularly with a rag to keep it dry.

Yellow Ochre and Raw Sienna on white

Ivory Black and white on white

Alizarin Crimson and Indian Red on white

1 This kitchen wall has a loose basket weave, painted in Light Red and white. (The steps shown on page 70 demonstrate tight basket weave.) This is a particularly good finish for a bad surface, as the variation in texture disguises poor plasterwork.

2 Loose basket weave is painted in a series of casual criss-cross patterns, using a dry brush to remove the glaze. Gaps and overpainting add to the effect. At the corners of the room, line the brush up with the wall and then pull down diagonally.

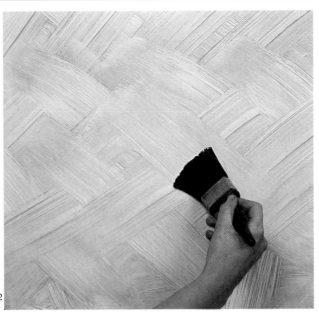

Combing

In this technique, a comb is used to lift off areas of glaze. The history of combing is twofold. Combs were originated for woodgraining where they are used to simulate the grain, but they have also been used extensively in European folk decoration in Scandinavia and Germany, and in America among the early German settlers in Pennsylvania.

As a decorative technique, combing is usually thought of as fun and folksy, but with underpainting and careful colouring it can be elevated to something rather more sophisticated. It offers a vast range of possibilities, and its effects depend more on the ingenuity and sensitivity of the decorator rather than the skill with which it is wielded. It may be used quite simply to make a border along the frieze or around a door, or to create a whole look across a wall. You can comb a colour in one direction over the basecoat, and then comb another colour over the top in a different direction. The last coat will be dominant, so, if you do this, think about whether you want a vertical or a horizontal feel on your wall, and which colour you want to stand out. Even used very simply, combing can be very creative with lots of different patterns and effects.

On bumpy walls the comb will miss bits, and how much this matters depends on the style of your house and your own preference. A very smooth wall also causes problems, as the comb tends to slip about; this means you have to be quite slow and careful.

Commercially available combs are really intended for woodgraining and tend to be quite small. This does not have to restrict you; a large, homemade comb can easily be made out of thick cardboard. Cork tiles make good combs, too, as they are soft and will not scratch the wall.

Varnish it to stop it absorbing too much paint and becoming soggy. With a homemade comb you can cover a wider area more quickly than with a commercially manufactured one, and can create your own design. It can also be used for furniture and panels.

Glazes can also be brushed on in a variety of colours or with added spots of colour before combing. Small objects intended to bear close inspection should be mutton clothed first to eliminate brush strokes. Do not apply the paint too thickly, as this causes unsightly ridges along the edges of the combing.

SUITABILITY
Walls, floors, panels, furniture, and frames.
DIFFICULTY
★★
MATERIALS
Glaze
White spirit *standard mixture*
Oil colour
EQUIPMENT
Household brush for applying glaze
Mutton cloth (for removing brushmarks on furniture)
Comb(s)

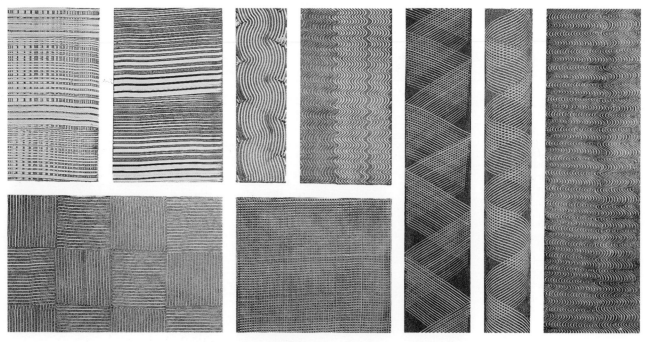

A myriad of patterns is possible, using both triangular and graduated combs. Here, before combing Indian Red over white, the glaze was mutton clothed.

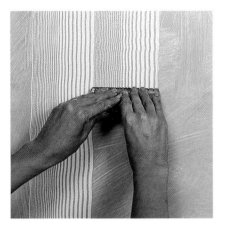

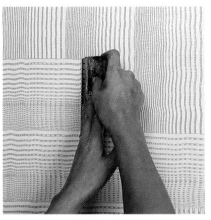

1 Mutton clothing is not necessary for an overall wall pattern. Using both hands, pull a graduated comb down carefully with an even pressure.

2 To make a chequered pattern, while the glaze is still wet, work horizontally from bottom to top or vice versa after combing vertically.

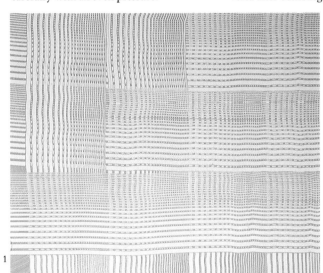

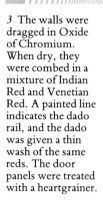

1 This is a standard chequered pattern. You can introduce an element of variety, by turning the graduated comb round for alternate rows.

2 A border or edging can be made by combing an undulating line. This gives a three-dimensional effect.

3 The walls were dragged in Oxide of Chromium. When dry, they were combed in a mixture of Indian Red and Venetian Red. A painted line indicates the dado rail, and the dado was given a thin wash of the same reds. The door panels were treated with a heartgrainer.

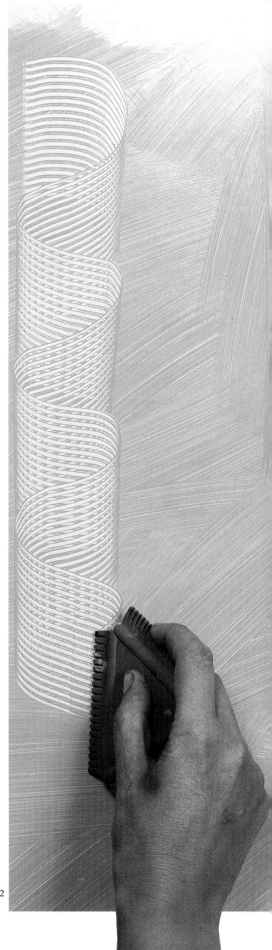

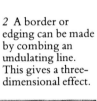

Spattering

In spattering, a paint brush is loaded with paint and the handle of the brush is hit with a stick, often another brush, to throw the paint in a random, but not uncontrolled, manner on to the surface. It is much more difficult than is generally realized. Many people think they can just splash the paint on; in fact, it requires both control and thought to do it properly.

It is quite difficult to spatter, small, round objects and those with acute angles because the paint flies past the surface and forms an elongated splotch rather than a circle. Whether you mind this or not depends on how much of a purist you are. This effect may or may not be what you want.

The farther from the surface you hit your brush, the bigger your spots will be. So for spots of the same size, hit in the same place each time. When spattering small objects, using your finger to tap the brush offers a greater degree of control. Spatter in a contained way will begin to look like porphyry; anything larger will start to acquire a more contemporary look like a Jackson Pollock painting with streaks and spots. Small, contained spatter is quite time consuming, so it is not usual to spatter finely over a large area. On a wall, it might look good contained by stripes or some kind of edge. It is one of the techniques which works better as part of a larger and more complex design rather than as a single effect.

Bristle brushes are best for spattering. The brush retains far more paint than is apparent, so it is always good to test it to take off the excess. Although you can use toothbrushes, they are not really recommended as the spatter is too fine to have any impact. A toothbrush will also eventually disintegrate with the white spirit. How you handle the paint and the materials depends on what you are decorating. For a small object, the quality of the paint must be exactly right. Too much thick paint will result in very thick lumps which look awful and messy; it can

actually produce three-dimensional spots where the paint is raised above the surface looking more like blobs than spatter. Equally, it should not be too thin; too much white spirit makes the paint too runny and wet, so that the dots of spatter leak into each other. Experiment with the consistency of the paint before you get into the swing of it. This goes for all techniques.

If you are going to do a wild spatter on the floor, colours and tones are extremely important. Limit the number of colours used, and think carefully before you start—just any old colour will not work. Tones of different colours should be similar with, perhaps, one different tone as a highlight. Alternatively, use one light tone, one dark tone, and one mid-tone of the same colour. You might, for example, use two different sorts of blue, one dark and one bright, with medium blue-grey, and perhaps a bright red to highlight it.

SUITABILITY
Walls, floors, small and large furniture.
DIFFICULTY
★★★
MATERIALS
Oil colour/eggshell
White spirit
EQUIPMENT
Hog hair fitch of appropriate size (round or Herkomer)
Paint tray
Stick or handle of another brush

1 To spatter a floor, flick a half-full fitch with your hand. The paint must be thin to avoid lumps. The further the brush is from the surface, the larger the spatter.

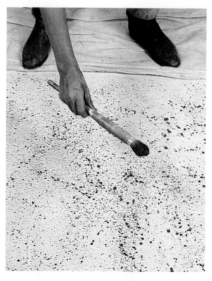

2 Spatter a second colour or tone in the same way. Although the effect is abandoned, the brush can be aimed precisely if the paint is the right consistency.

3 A painted background, either flat or colourwashed, can give an additional intensity to the spattered colours. Limit the range of colours.

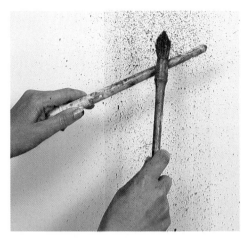

1 For small spatter, the paint should be sufficiently dilute so that when a full brush is wiped on the edge of a paint tray, it runs. Hit the brush against a stick.

2 For very fine spatter, flick the bristles back with your finger.

3 Spatter the surface fairly densely with three colours. Remove any masking tape and wipe the surrounding areas to reveal a strip of fine spatter. There is no glaze in the spatter because it makes the paint sticky, so it takes a long time to dry. Colours are, therefore, applied one after the other in the same painting session.

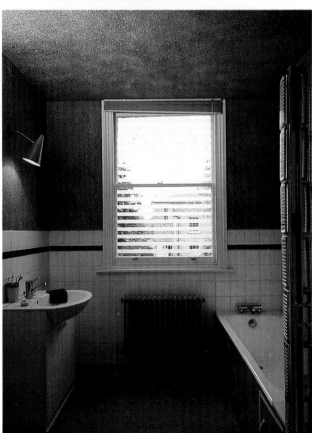

Raw Sienna, Ivory Black, and white on Raw Sienna colourwashing

Raw Sienna, Coeruleum Blue, Ivory Black, and white on white and Ivory Black colourwashing

1 Modern colours have been used to decorate this 1930s style bathroom. A Fuso machine was used. (2) This detail shows the range of colours used over a grey background. (3) A Fuso is a spattering machine. It is filled with paint, held against the waist, and a handle turned to spatter the paint. Mask areas not intended for spattering.

CHAPTER IV

Bravura
Finishes

More advanced and involved than those in the previous chapter, bravura techniques are not really paint finishes in their own right, but illusory, aiming to deceive the eye of the beholder into mistaking them for the real thing. Their execution requires a degree of artistry from the painter, and they should be used sensitively. Sound advice is to use bravura finishes as one would use the real thing; they will then look in keeping with their surroundings. Their effects can range from pure fantasy to a perfectly conceived, beautiful deception.

The floor was painted all over in floating marble in French Ultramarine, Burnt Umber, white, and small amounts of Indian Red and Oxide of Chromium over ivory eggshell to produce varying patches of colour. When dry, it was marked up in squares. The darker squares were overpainted in a thin glaze of French Ultramarine and Burnt Umber.

Gesso

Gesso is a substance made of whiting and rabbit-skin glue. It is essential as a basis for putting on gold leaf (see pp122–7). It is also used for furniture because it makes a perfectly smooth surface which gives a high quality finish. It is used as a base for marbling because, unlike wood, it is quite cold to the touch (see pp82–9). This is a technique for the perfectionist who wants to create a truly perfect painted finish.

The early Egyptians first perfected the art of using gesso, coating their wooden coffers, chairs, and sarcophagi with a thin layer of adhesive plaster to give a satin-smooth finish. They painted this surface with pigments, or gilded it with leaves of gold. Only a few modifications to this method have been made since then. Gesso is still used by gilders to form a resilient ground for burnished gold leaf. It is also used for painted marble, as it is cold to the touch, like true marble.

Good gesso has an eggshell gloss as hard as ivory. Properly and perfectly applied, it is smoother than silk, and without blemish, pinholes from airpockets, or interruptions from dust. It was painted on 18th-century furniture to provide a smooth texture particularly receptive to watercolour. It was used to conceal crude wood construction. Linen was stretched over the joints and the whole area covered with up to 40 coats of gesso.

There are two types of gesso; traditional and synthetic gesso which is the modern alternative. Synthetic gesso is much easier to prepare but professionals, particularly gilders, find it unsatisfactory.

The 'ingredients'
Gesso is a combination of whiting and glue size mixed together when warm to form a liquid that looks like white paint. Many coats are then laid on the surface. It is very time consuming and requires patience to achieve a really smooth finish suitable for gilding.

Whiting is crushed calcium carbonate, ground to a fine powder. There are two grades: builder's and gilder's. The latter is finer and preferable for gesso.

The glue which binds it is made of animal cartilage and skin. It is soaked overnight in water, warmed until the glue granules have melted, strained, and set aside to gel. It is most commonly available as rabbit-skin glue size granules. Any size not required immediately should be refrigerated in a screw top jar to prevent it going mouldy.

Preparing the surface
Painted and varnished surfaces should be sanded down first to give a 'key' that will take the gesso. If you are laying gesso on an old frame, the joints should be concealed first. Soak fine silk or linen in a thin gesso solution. Press the wet fabric down over the joints, with the fibre running in the same direction as the grain of the wood. Smooth it out with your fingers and leave to dry for at least 48 hours.

Objects that are deeply carved may be gilded, but they may need to be 're-carved' as the gesso builds up in the deeper recesses.

How to make traditional gesso
Neither the glue size nor the mixed gesso should be allowed to boil. (Air bubbles make the gesso unworkable.) Therefore, a double boiler or *bain marie* is essential. You can improvise by fitting a smaller pan or heatproof bowl over a larger one. The base of the top container should not touch the water in the lower pan. Make sure you are going to prepare enough gesso to cover the object with sufficient coats.

Use 1 part rabbit-skin granules to 8 parts water. Add whiting according to the consistency of gesso required.

1. Soak the rabbit-skin glue granules overnight in water until they are soft.

2. Fill the bottom half of a double boiler with sufficient water. Put the rabbit-skin glue mixture into the top container, and heat gently until the granules have dissolved. Do not allow to boil.

3. Remove from the heat and strain through a fine mesh or nylon stockings.

4. Allow to cool and coagulate. It should set like jelly. If you can push your fingers through the size without it breaking apart, it is too strong. In this case, add more water, heat gently, set aside to cool, and try again. If the size is too strong, the gesso will flake off; if it is too weak, the gesso will powder off.

5. Return the double boiler to the heat so that the mixture dissolves again. Sieve in the gilder's whiting until about ¾-full of gesso. Mix together with a wooden spoon, stirring very slowly and pressing out the lumps, until it has the consistency of ready-mixed paint. After you have mixed it in you cannot add any more whiting. Do not let the mixture boil.

6. Work the mixture through a hair sieve about five times to mix properly. Add two drops of linseed or olive oil to stop the gesso cracking. It is now ready for use.

Applying the gesso
Use a flat hog's hair brush. Apply the first coat, sometimes called the thin white. Keep the container over a pan of hot water to prevent it setting. Allow the first one or two coats to dry completely before you apply the next. The second coat must be applied at 90° to the first, the third at 90° to the second, and so on. Continue until six to eight coats have been applied.

Each coat must be dry before the next is laid. The more coats applied, the faster the gesso dries. Do not try to speed up the process by drying the gesso in front of a fire or other form of artificial heat. Once thoroughly dry, it can be rubbed down with fine steel wool.

The surface is now ready for gilding, but, if you wish it to take an oil-based paint, for marbling for example, seal it first with a light shellac or varnish.

Softening brush

This is also called a blending brush. Apart from softening and blending, it is used to smooth over obvious brush strokes. It removes the sharp edge of paint and the hand-drawn quality of a vein in marbling, and blends together different tones and colours of many of the bravura finishes.

It is an indispensible item for which there is no substitute—only a softening brush has the right amount of floppiness. A variety of sizes exists, but a 7·5 cm (3in) brush is the most useful, even for small areas. A smaller brush encourages you to tickle your work rather than stroke it, and is less satisfying to use. There are two sorts of softening brush, badger hair and hog hair. It is advisable to start learning on a badger brush because it is softer and easier to use. (It was originally used for watercolour work.) When you are certain of the technique, you can try a hog hair brush, but it is harder to use because it is very coarse. Hog hair brushes are especially difficult for beginners, who tend to be too heavy handed which causes a patchwork of criss-cross lines.

It takes time to get used to brushing lightly with the right amount of pressure. Good handling of a softening brush is a question of practice. It must be used from the arm, not from the wrist. It is sensible to practise on painted hardboard panels to get the right feel before embarking on the real thing.

These are precious brushes that need delicate handling and care. After use, they must be cleaned in white spirit, washed out in washing-up liquid, and rinsed. Excess water should then be removed by rolling the handle briskly backwards and forwards between the palms of your hands. Store them lying down in a box or wrapped loosely in paper. They must be kept free from dust to prevent this from sticking to your work next time they are used. They are quite expensive, but are essential for all the bravura finishes, except oak graining.

SOFTENING BRUSH PROBLEMS

Problem	Reason	Solution
Scratches on your work	Paint too wet	Mutton cloth again
	Paint too thick	Mutton cloth again
	Brush at the wrong angle	Hold the brush correctly
Mutton cloth marks remain	Oil glaze is too dry	Start again or stipple out with a softening brush
	Brush is used too softly	Brush harder
Softening brush has no effect	Oil glaze is too dry	Start again
	Brush is used too softly	Brush harder or stipple out
Hair or mutton cloth threads* on your work		Lift off gently with a brush
Too many dust particles on the surface	Using a dusty brush	Difficult to rid a brush of dust except by cleaning and rinsing
	Wearing a fluffy jumper	Change your clothes

* see diagram on pp56–7 for how to tear up mutton cloths

Floating marble

This is also called fossil marble. The finish is used on a flat surface, such as a floor or table. The surface has to be horizontal because the white spirit used in the technique would run down a vertical surface.

It is quite an easy and light-hearted introduction to bravura finishes. It gives some practice in softening, but it is not essential to get it absolutely perfect. It can be used to simulate real marble or just to create a marble effect. It is quite a decorative finish and therefore, does not necessarily have to be painted in realistic colours. As it is relatively easy and quick to do, it is good practice for people having difficulty in using different tones and colours together.

The ground coat is very like a 'real marble', and as a lot of it is shown (a lot of white spirit is used), the choice of the ground colour is very important. It has to be strong if you want a dark marble.

Floating marble looks very good used as squares on a floor or as a border. If you are painting alternate squares in different colours, draw them with a pencil, paint the first colour, wipe the squares off, and clean around the edges. When the first colour has dried completely, you can paint the second colour.

Round badger brushes are essential, as they go into round spikes when they are wetted with the white spirit; there is no real substitute.

An alternative method uses water to disperse the oil colour in a similar manner to that used for marbling paper. Water is sprinkled generously over the base colour, and then a mixture of oil colour and white spirit is randomly splattered over the surface. The water evaporates, leaving the oil colour to adhere to the basecoat. Allow to dry thoroughly before varnishing. This method is especially suitable for small objects that can be tilted gently and teased with a small brush.

SUITABILITY

Any horizontal surface, such as floors and table tops.

MATERIALS

50% oil glaze

50% white spirit

Oil colour (for very pale colours, add white eggshell)

White spirit

EQUIPMENT

Fitch to apply glaze

Mutton cloth

Softening brush

Round badger brush of appropriate size (or badger softener if none available)

Small nylon brush or bristle brush to mix paint

1 Using a fitch to give an expressive feel, paint your glaze colour in patches all over the surface. The colours should be close in tone to the basecoat.

2 Mutton cloth the entire area to eradicate brushmarks. Split up a large floor into comfortable working areas.

3 Soften lightly to remove excess paint and mutton cloth marks. This need not be too thorough.

4 Dip a round badger brush in white spirit and remove the excess on a clean rag. Dab the brush unevenly all over the surface.

5 Dip a small, round badger brush into oil colour mixed without glaze. Remove the excess, and dab on to the surface in patches. Use the same colours for this spotting as for the ground coat.

6 To give variety, depth, and a sense of unity, spatter, using a bristle brush, in some areas.

The pattern varies according to how much white spirit was initially dabbed on. The oil colour used for spotting dries at a different rate from the white spirit and patches of glaze. This results in spots, lines, and rivulets.

Cobalt and Yellow Ochre on white

Terre Verte and Indian Red on white

Cobalt, Ivory Black, white, and Venetian Red on white

Marbling

There are many different types of marble and they vary enormously in both colour and design. Marble is often used in building, so simulating it works well and can be extremely convincing. It is found throughout the world, from Georgia, Vermont, and Maryland, to Scotland and the Tyrol, and, of course, Italy.

Both colour and pattern vary enormously from very white to variously patched or streaked with grey, green, brown, and red. The best-known marbles are from Carrara in Italy, and these were used by Michelangelo for his sculpture. The commonest and easiest to paint is a white marble, but there are others in dark greens, purples, and blacks. Try to find a reference of the sort of marble you would like to achieve to establish its general characteristics and subtlety. It should be stressed that you are not going to copy the marble itself, which would be very confusing and difficult. What you are trying to achieve is a general idea, a summing up, a formalized way of presenting marble. If possible, look at a piece of marble, remember it, be stimulated, make a note of colours and tones, and then go back to your own.

There are many different ways of achieving a marble look. In fact, there are probably as many different methods for marbling as there are marbles. It is a good idea to experiment on a piece of coated hardboard before you start putting them into practice. It is common initially to make the colours far too intense and too varied. Some marbles can be fantasy marbles, that is exaggerated in colour and style, but these still have to be well controlled—they can look a mess if not carefully thought through. Marbles can vary an incredible amount, both in colour and in form, so you can make up your own, but be sure you follow the rules to make it realistic.

The basic technique

There are three stages involved in marbling:
1. laying the ground of oil glaze over an eggshell base;
2. distressing the ground while the oil glaze is still wet; and
3. veining the marble after the oil glaze has dried.

The most difficult task is the veining, and beginners tend to make the colour too heavy and strong so that the marble ends up with too many heavy lines crossing over each other in the wrong places. After the ground has been distressed, leave it to dry before adding the veining. This means that unsuccessful veining can be wiped off without disturbing the work already done.

A marble can be left as it is at the end of each of the three stages, just as a ground, or with the ground distressed, or with the veining added. The colours and tone of the ground must be right.

Surfaces and styles

Marbling can be painted on floors and walls. Floors look good made up into different patterns (see pp150–1), while large walls should be divided into slabs. Use a pencil for demarcation lines and leave them on. Do not treat it like wallpaper and paint it all in one long strip. It is also suitable for skirting boards, architraves, and the dado. Table tops and small objects look wonderful, especially with a little wax over them to soften them. Marble on realistic surfaces. Ornately carved fireplaces and cornices do not work; they do not look right, and you cannot use a softening brush on them. Once you have discovered that you can do it, do not go in for overkill. A combination of skirting board and fireplace, or skirting board, dado, and architrave works well.

Marbles generally follow one direction, but there are marbles that have veins running at cross diagonals or that have an area of overall crushing. Initially, it is advisable to tackle marbles with a diagonal streak in one direction. The success and realism of marbling depends as much on its design and colour as on a perfected technique. Look at the negative shapes as well as the positive. Think about drama, weight, and a sense of movement. The shapes within a marble need to be composed to give the whole thing tension. The veins and spaces must not be equidistant nor should they be the same size. Colour and tone are all-important. If there is a sharp contrast, this gives the finish too great a dimension and it ceases to be a flat surface. It is better to make a gentle marble than one that is too strident.

It must be varnished to give it the 'look'. It feels right on a gessoed ground. This achieves the characteristic coldness of marble which is lacking if it is painted on wood. However, this is a fine point. The most important thing for beginners to remember is that tonality is the all-important consideration.

SUITABILITY

Floors, walls, dados, architraves, skirting boards, bathroom furniture such as baths and bath sides, some furniture items such as table tops, pillars, small objects such as boxes, candlesticks etc.

MATERIALS

55% oil glaze

45% turpentine or white spirit

Oil colour (do not use eggshell)

EQUIPMENT

Household brush or fitch for applying paint

Mutton cloth

Softening brush

Other materials could include
- rags
- newspaper
- cling film
- natural sponge
- small bristle brush
- rigger or swordliner
- feather
- white spirit

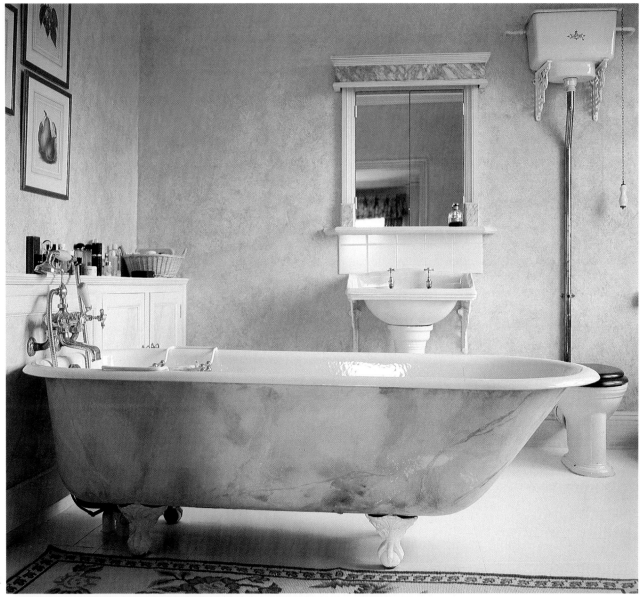

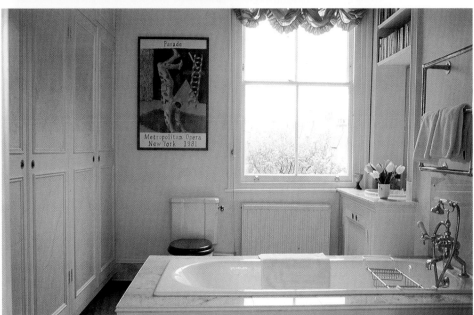

1 Baths and bathrooms are favourite objects for marbling because real marble is a popular architectural feature in the bathrooms of some grand houses. This bath has been marbled in one piece in several tones of Raw Umber with white. This as been picked up in the cupboard door panels and the area above the mirror. The stiles and rails were dragged.

2 A sophisticated bathroom in which the panels of the wall-to-wall cupboards have been marbled in cream, grey, and peach. The surrounds are dragged in cream. The sides of the free-standing bath have been treated in the same way as the cupboards.

Painting the ground

This is a basic ground for an off-white marble. It can be adapted for various other colours. The commonest mistake is to create too great a variance in the tones used. A white marble with grey veining is generally very much the same tone all over, with only a slight leaning towards the darker tones.

The basecoat

Before you apply the ground coat, the surface must be given a flat coat of eggshell paint. Establish the tonality of the marble, whether it is light or medium, and accordingly paint the eggshell basecoat either white or grey. Later on, you can use a coloured or black base, but initially the lighter marbles provide the most satisfactory results.

Ivory is not too sharp and a good, off-white colour for a base. Whites can be tinted with a small quantity of oil colour. There are also various tones of white eggshell already mixed that provide a good basis to start with. Dead white is a little too sharp and, if you are contemplating a very white marble, it is better to add blue to tone it. The old master marblers used to mix their own paint and sometimes did not mind if they mixed it imperfectly so that the basecoat was uneven with some patches of more intense colour. Test the base colour with the lighting before you start painting; some coloured whites can look grey with low lighting.

After the basecoat has been applied and is thoroughly dry, the surface may need rubbing down. Marble typically has a cold, flat, smooth surface, so make sure there are no irregularities.

The ground coat

This is a recipe for marbling dark on a light base, although the word 'dark' is slightly misleading; it really means darker than the basecoat which should be a very light tint. When the basecoat has thoroughly dried, the oil glaze is applied. For small objects it is best to work from a palette (i.e. the paint tray) mixing the oil glaze as you go, but if you are painting a large surface, you will need to mix more paint. For this, mix the colour in jam jars; otherwise the paint mixture will be too inconsistent. If this is your first attempt, mix three tones of one colour.

Using a fitch brush, take up a middle tone with some glaze, and paint it in a more or less diagonal direction. You should not be aiming for evenness or parallel strokes, but a feeling of a diagonal shift. Apply a darker tone with another fitch, using no glaze, again randomly and diagonally. Try to think of the marble you are painting as coming from a larger piece of marble with areas that go off to other places—this helps to give it a context. Paint the dark areas from the edges inwards, not just in middle.

Establish the lighter areas by wiping or removing some patches with the brush to reveal the base, or by adding white. Aim for a soft, gently changing surface with some lighter and some darker areas. These areas should all be very closely related in tone. You need relatively little paint to colour the white.

Mutton clothing

After the ground coat has been satisfactorily applied, it must be mutton clothed to remove the brushmarks, while the oil glaze is still wet. The time available between applying the oil glaze and the time it starts to dry depends on atmospheric conditions, but it is usually about five minutes. Therefore, make sure that you do not paint too large an area or the oil glaze will already have started to dry by the time you want to mutton cloth.

Mutton clothing for all bravura techniques takes a little practice. Fold the mutton cloth into a pad (see pp56–7) and dab the surface firmly. Too much pressure removes too much paint, while insufficient pressure does not remove enough. Do not go over the same area too often as it can take all the paint off. If the oil glaze has started to dry, you may need to be a bit more vigorous. This is a useful time to tone down the dark areas if they are too accentuated.

Softening

Soften with a badger hair softening brush (see p79). Left at this stage, this could be a finished marble, or you can add a mixture of the following techniques.

1 Mix a light tone of the ground coat colour with a little glaze, and apply diagonally with a fitch, leaving some spaces.

2 Fill in the spaces with a middle tone of the same colour, again in a generally diagonal direction.

3 Add a few touches of a darker tone, mixed without glaze, in the same diagonal direction. Be careful not to overdo the darker areas.

4 At this stage, you should already have established the underlying colour and pattern of the ground coat. The stresses should be diagonal but not parallel. Be careful not to make the ground coat too complicated.

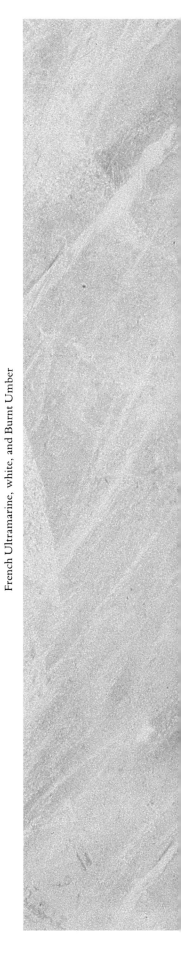

French Ultramarine, white, and Burnt Umber

5 Mutton cloth to eradicate the brushmarks. The mutton cloth can also be used to lighten any areas that appear too dark.

6 Soften. The marble can be left at this stage. If you are going to distress the ground coat, the glaze must remain wet.

Distressing the ground

After the ground coat has been applied, there are various ways to proceed to break up the oil glaze to give variation to the surface of the marble. These are alternatives—do not try to use them all at once. Practice on a piece of coated hardboard first to see what sorts of results the following techniques give and whether they fit in with your ideas about the kind of marble you are going to produce. All these techniques are to be used sympathetically and creatively. They are no good all crammed together on one piece of marble; use them here and there for effect and not for grandiosity.

The wetter the glaze, the stronger the effect will be. Judging the correct moment to distress the ground coat is a matter of experience. It is quite quickly learned by trial and error. Practise on the coated hardboard.

You may decide that your marble is complete after the ground coat has been distressed. However, it can be taken a stage further by veining it. Let the oil glaze dry well before you vein it unless you are using white spirit.

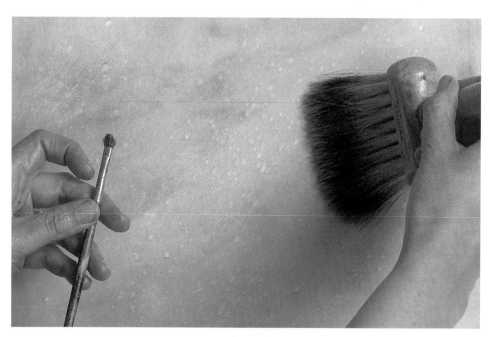

Using white spirit
Dip a short-haired bristle brush in a small amount of white spirit. Remove the excess by gently testing the brush on a surface. When you are satisfied that you have removed enough, flick the brush with your finger so that the glaze is lightly spattered with white spirit. Wait; there will be a delay of a few seconds before the white spirit takes effect. You will see some light spots gradually appearing. The more white spirit you have on your brush and the closer you are to the surface, the larger the spots will be. Do not add glaze to the white spirit while you are doing this, as the glaze acts like glue and it will go thick and lumpy. Soften.

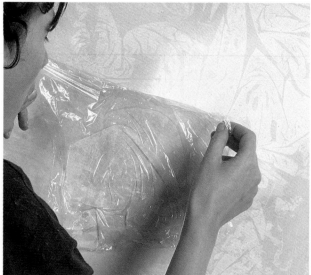

Sheet cling film
For this technique, the glaze still needs to be a little wet. Drop a sheet of cling film on the appropriate area, blow on it, and gently lift it off. This can give a rather alarmingly strident effect, particularly if the surface is still quite wet. Test the edge of the glaze with your finger to see how tacky it is. If it is very wet, the cling film will remove quite a lot of glaze. If it is too dry, the cling film will have no effect. Use a softening brush to blend. Where the effect is too strong, you can use the softening brush as a stippling brush and then soften again.

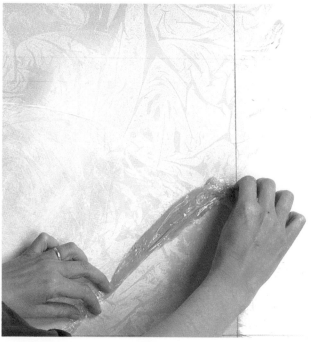

Twisted cling film
Twist a piece of cling film and place it diagonally so that it lies in the general direction of the marble, lift it off, and then soften. (It is advisable to read the section on veining, pp88–9, to avoid a criss-cross pattern or a sheet of parallel lines.)

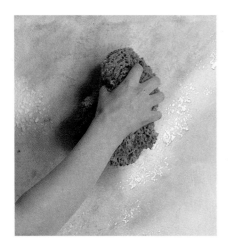

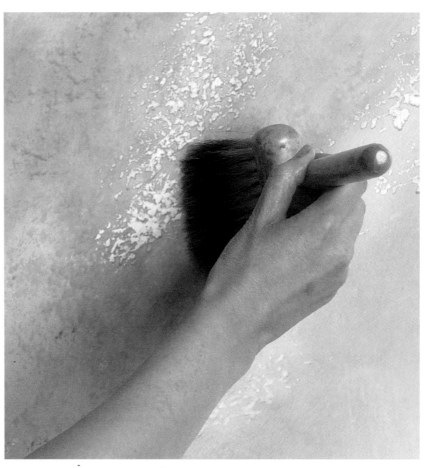

Sponging on

Wet a natural sponge with water and
squeeze it out well. Dip it in a mixture of
oil colour, white spirit, and glaze. Sponge
it on. Unlike other techniques, this works
better as an all-over method. It looks
better as a positive effect with the ground
beneath it varying. The tones and the
colour can be varied. It is quite a dense
effect and is most suitable for small objects
and borders. Soften lightly to take away
the hard edges of the sponge pattern.
Before softening, test the glaze to see if it is
dry enough. If it is still too wet, leave it
and wait for the white spirit to evaporate;
otherwise you will take the paint off
instead of simply softening it. Do not wait
too long or the glaze will be too dry.

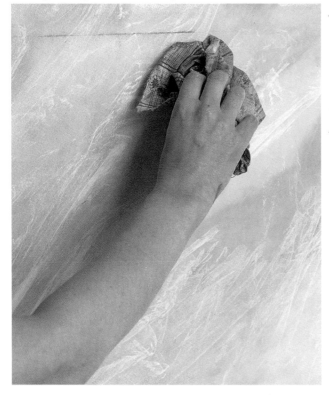

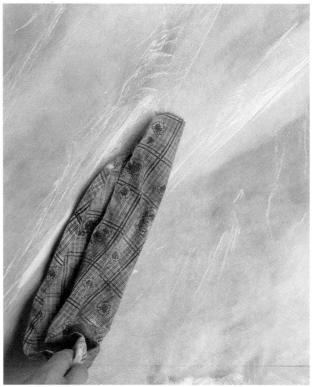

Using a rag

Use a rag to distress some areas or to break up the surface a little.
Alternatively, you can use newspaper. Soften. Test the wetness of
the glaze first. The wetter the glaze, the more distressed the
surface will look.

Hitting the ground

Take a long piece of dry rag. Hit your work diagonally in the
general direction of the marble. This is good as an effect on its
own or on other work you have already done to distress the
ground. Soften lightly.

Veining

Vein in colours which vary only slightly in tone from the ground coat unless you are producing a specific marble (see pp92–3). Some darker marbles have very complex and striking veining.

Different brushes and feathers produce veins with different characteristics. They can be drawn using any long feather (goose feathers are traditional), a specialist brush called a swordliner, or an artist's sable brush. They can be painted over a dry glaze coat or taken out of a wet ground coat with white spirit (the wetter the glaze, the more marked the effect of the white spirit). Veining on a dry ground allows you to wipe off mistakes.

Some marbles have cross veins, but unless you are extremely competent at veining, do not attempt it. It is an individual characteristic of certain specific marbles and needs a good analysis of the tones involved. What you should be aiming for initially is a generalized marble effect with a summary of the characteristics—not a portrait of individual quirkiness.

With a feather, draw the veins in a slightly darker tone than the ground coat. You should have some idea in mind of what you are going to do, but remember that veining with a feather is a somewhat unpredictable technique.

While the ground coat is still wet, dip a feather in white spirit and shake off the excess. Draw in the veins. You can use the feather like a pencil and also flop it over to create a different effect.

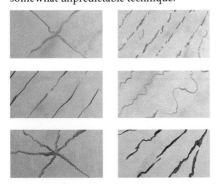

Bad veining

Although grossly oversimplified, these are very common faults: parallel lines, wobbly veins, cobweb effects, broken lines etc.

Good veining

Although the vein may split at intervals to form quite complicated knots, two veins of the same tone never cross.

Veining can be drawn with a long-haired sable brush. This produces a much more controlled line than using a feather. Try to produce a line that varies in weight and character. The vein can also vary slightly in colour.

Dip a swordliner in white spirit. Draw the broad side over the wet ground coat in a diagonal line, flopping it over from side to side.

A long-haired sable brush may also be used for veining the wet ground coat with white spirit. You can produce a line with more character by twisting the brush and by varying the speed and pressure.

The thin side of a swordliner may be used to paint fine veins. Varying the pressure changes the thickness.

Raw Sienna on white; veined in Raw Sienna

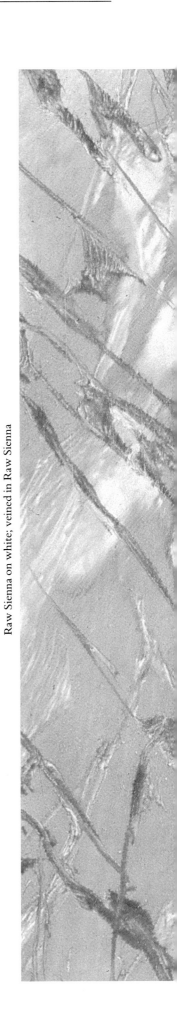

A swordliner may be used with oil colour mixed with a little white spirit to draw veins over the ground coat. Using the broad side of the brush produces generous and erratic marks which may be used in combination with finer lines.

Small areas in the centre of complex veining may be taken out using a sable brush and white spirit.

Marble panels

Real marble is invariably used in panels or slabs. These slabs are often rectangular when on the wall and square when on the floor. Their size varies according to the dimensions of the room. When working out what size to paint marble panels, bear in mind what you would do with the real thing.

Marble panels are not put up in steps like bricks; each slab is positioned directly above the one below. They are butted together without grouting, that is, no whitish mortar is put between them. Therefore, a soft pencil (3B)

is ideal for delineating the painted slabs. The line can be strengthened, if necessary, when the paint is dry.

If you are marbling the dado, for example, paint alternate panels, working around the room. Do not start to paint a panel next to one that is still wet and sticky. After finishing each panel, wipe off any glaze that has spread on to the next slab.

You may want to do the veining later, when all the panels have been painted and are dry, to help bring the work together. The veining is generally all done in the same direction.

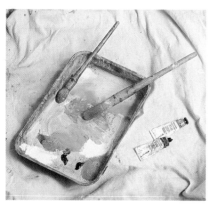

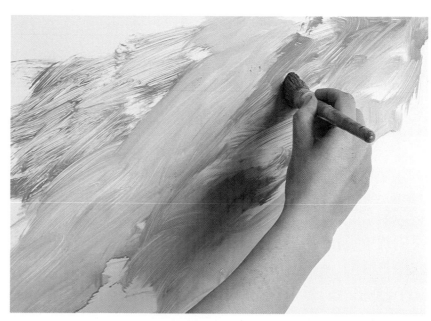

1 Mix one or two main colours in a paint tray (in glass jars for large areas). Mix very small amounts of other colours. Use different brushes for each colour.

2 Paint patches of various sizes in the main colours with a fitch, working diagonally. Vary the density and texture.

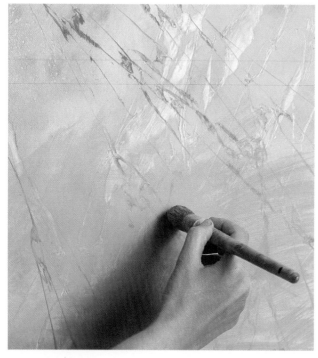

3 Finish the panel in your chosen marble. A coloured glaze may be applied over the dry panel to give it extra depth, darken the colour, tone it down if it is too light or bright, or even change the colour.

4 The second glaze coat may be lighter and darker in patches. This technique may be done with a light colour over several panels to help bring them together. Mutton cloth all over and then soften with a badger hair brush.

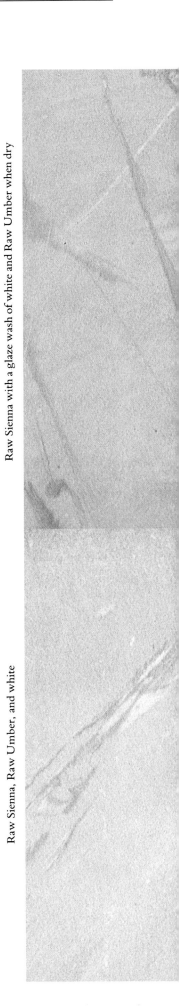

5 Do not paint an adjoining panel until the first one is completely dry. Paint alternate panels. This allows you to wipe the edges of each panel clean with a mutton cloth or rag without disturbing the finish of the panel next to it.

6 Panelling is usually drawn up with a soft pencil. The marks remain visible after painting and simulate the edges of real marble slabs. They may be emphasized when the glaze is dry by drawing over them. Masking tape may also be used, but it is less satisfactory.

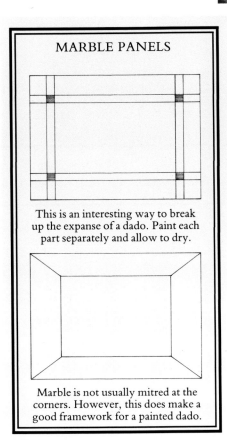

MARBLE PANELS

This is an interesting way to break up the expanse of a dado. Paint each part separately and allow to dry.

Marble is not usually mitred at the corners. However, this does make a good framework for a painted dado.

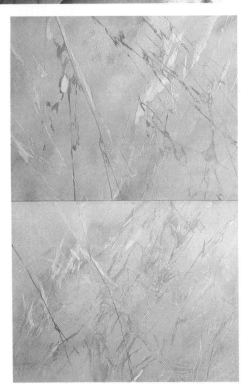

7 Two marble slabs abut directly. Although the veining should be painted in the same general direction, it is important that it does not flow from one slab to the other.

Raw Sienna with a glaze wash of white and Raw Umber when dry

Raw Sienna, Raw Umber, and white

Specific marbles

Marbles are either named after the place from which they come or their colour. Cipollino is a stripy, layered variety from Tuscany. Brecciated marble has small, angular fragments that look like pebbles, caused by the original geological bed being scattered and then reset.

Crinoidal marble is speckled and made almost entirely from shell fragments. Variegated marble is the commonest type, with textured and clouded effects broken by veining.

These are suggestions and glaze and basecoat recipes for specific coloured marbles.

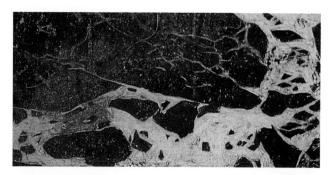

Black and gold marble
Black ground. Large veins in Yellow Ochre and Indian Red, and smaller, finer veins in white and Yellow Ochre. Gold transfer leaf adds a rather sumptuous look.

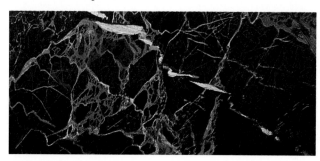

Egyptian green
This uses the same colours as vert antique, but is layered.

Grey marble
White ground using various greys. (For how to mix greys see p16.)

Italian pink marble
White basecoat. Mix a pink oil glaze with Yellow Ochre and Venetian Red, and a grey by adding a green (Oxide of Chromium) to these colours. Use the pink and the greys as your oil ground, and vein with a mixture of the same colours in a deeper tone. Soften and dry. Vein over with a dirtied white.

Hopton Wood
This is an English, fossiliferous marble, mostly used as a building stone. It is a light, creamy grey colour, and a sponge is used to create the marbled effect. The eggshell basecoat is a cool pale cream. A light grey stone ground coat is mixed with Raw Umber and white, and laid over the base. A sponge is then dipped in turpentine, squeezed dry, and dabbed over the ground coat. It is then softened lightly with a badger softening brush.

Red Derbyshire
Bright red basecoat of Venetian Red, a good quality Vermilion, and a little Cadmium Yellow in varying degrees of depth (i.e. not one mixed colour). Alternatively, use a red eggshell base. Soften and dry. Mix an oil glaze of Alizarin Crimson—break it up as described on pp86–7 with white spirit etc. Add a little black (try and make your own black) to your veining colour. Try dabbing on a rag soaked in a little glaze and black and red. Leave to dry. Dirtied white and grey dots and veins are added.

Sienna marble
Dead white basecoat. Pale yellow glaze ground (mixed with Raw Sienna and white) in three tones. Veined with Raw Umber and Raw Sienna. When dry, vein with white.

St Remi
Grey basecoat. A glaze mixture with no colour is put over the whole surface. An oil colour mixture of Burnt Sienna and India Red is sponged on in patches. A wide, flat brush is dipped in white spirit, then pure Raw Sienna, and the edges dipped individually in black and white. This is used to make ribbon shapes. Vein with light grey.

White marble
This is the simplest marble to paint, but the most difficult to imitate faithfully. It has to look realistic as there is not much scope for fantasy. Dead white basecoat (perhaps with a very subtle drop of blue). White oil glaze ground with varying tones of grey, greeny grey, and yellowish grey. It should be light in tone all over and veined in deeper grey.

Vert antique
Worked on a black, or deep green, or vert, or vert antique base. Make an oil glaze from Viridian, Prussian Blue, and Burnt Umber or Oxide of Chromium. Spots and veins in dirtied white.

Breccia marble

Brecciated marble is a mineral that has been blown up by volcanic action and broken into fragments by the force of the explosion. These fragments, subjected to the extreme stresses and temperatures of geological pressure, are then formed into another solid rock. Breccia Africano and Vert Antique (see p93) are two specific, better-known marbles of this class, but it is also possible to imitate the form of this marble more generally and using other colours.

It is characterized by broken chunks of marble, brought together to form particular patterns. These are imitated by wiping shapes out of the ground coat with a rag. The general flow and design of the marble should be considered beforehand and during its execution.

The size and the feel of the marble can be altered according to the surface being painted. Large wall areas and panels, for example, can accommodate bigger patterns than smaller objects. The contrasts in the marble should be achieved more by massing and sparseness than by using strongly contrasting colours.

Breccia marble is very quick-drying because the glaze is applied very thinly. Like all painted marbles, it should be varnished when dry.

SUITABILITY

For small objects using the detailed approach, and for larger objects (columns, panels, etc.) using the bolder, simpler method.

MATERIALS

80% oil paint

10% oil glaze

10% white spirit

EQUIPMENT

Rags

Fitch

Hog hair softener/badger hair softener

Rigger

Flat or one stroke brush

Breccia marble was chosen for these pilasters in an elegant hallway. Real Breccia marble is often used on large architectural features, as it is not fussy and is patterned with large, pleasing shapes. It is also fairly quick to paint.

1 Apply one colour very thinly and drily, spreading the glaze as far as possible over the surface.

2 Wipe away angular pebble shapes with a soft rag, leaving thin areas between. Vary the sizes to get a strong, dynamic design throughout the work, with squashed, thin shapes as well as large, freer shapes.

3 Soften the whole work, using either a hog-hair or a badger softener. A hog-hair brush works better. You may find that you have to press very hard with a badger softener because the glaze is so thinly spread. Continue softening until it is thoroughly blended.

4 When the work is dry, vein with a long-haired sable brush. Pay particular attention to the pebble shapes, encircling them with angular veins and sometimes veining across them.

5 Soften the whole work so that the veins do not stand out too much. Emphasize some parts more strongly than others, leaving some areas quite plain.

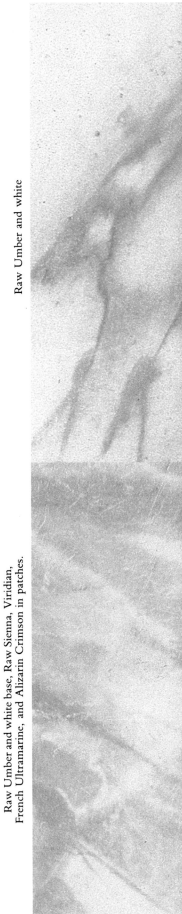

Raw Umber and white

Raw Umber and white base, Raw Sienna, Viridian, French Ultramarine, and Alizarin Crimson in patches.

Malachite

Malachite is a semi-precious and relatively rare mineral. Strongly patterned in incomplete circles and a beautiful bright green in colour, it is hardly ever used in large expanses for decorative purposes. In fact, it rarely occurs in large expanses. The effect of malachite is very intense and so it looks best as a border, 5–8 cm (2–3 in) strip around a floor or door for example, or as an inlay on a small table top.

The patterning within each piece of malachite can vary immensely. It is formed by the cooling of molten copper compounds to form lots of tiny, random crystals. The stress of neighbouring rock sometimes causes fractures in the bands of colour that surround the nucleii. Studying a piece of malachite (try shops and museums) will help to establish the basic formation in your mind. Of all the bravura finishes it is, perhaps, the one which requires the most thought about its composition.

It can look stunning used in combination with other strong, deep colours and equally rich and complex finishes. A combination of malachite and gold offers interesting and sumptuous possibilities. You might also like to experiment with the malachite technique using alternative colour combinations to create a completely new, fantasy finish.

You will need to make the malachite markings with a piece of fairly stiff, but still flexible, cardboard. Thin cardboard used for reinforcing packaging, such as that found in some cereal bars, is ideal; cereal packets and other larger boxes tend to be too soft. Experiment on coated hardboard to find the most suitable cardboard. The size of the cardboard determines the size of the malachite markings, but make sure it is comfortable to hold and move about.

SUITABILITY

Small objects, table tops, panels, and borders.

MATERIALS

Emerald green base in eggshell

80% Monestrial Green or Phthalocyanine Green

10% oil glaze

10% white spirit or turpentine

EQUIPMENT

Fitch to apply paint

Mutton cloth

Softening brush

small pieces of stiff cardboard—various sizes

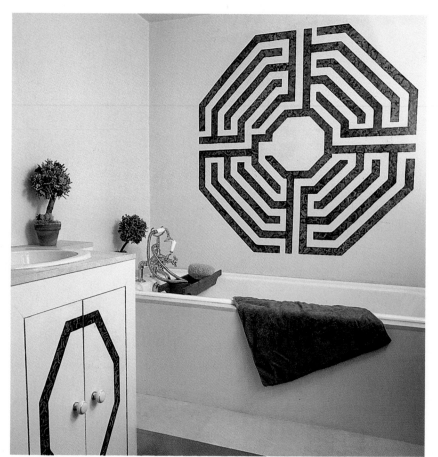

A painted malachite maze on a bathroom wall is an unusual way to use a bravura finish which is more often seen on small objects and as inlay on furniture. It was designed and then drawn on the plain white wall in pencil. The areas not to be painted were masked off with tape, and the maze was painted to look like inlaid malachite (see detail above).

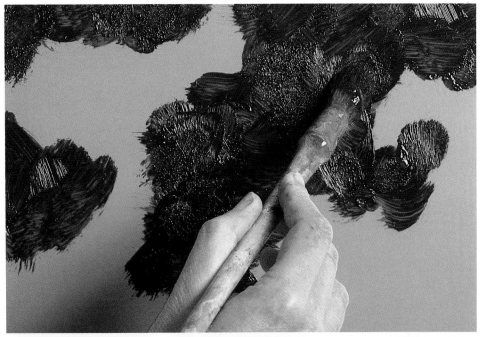

1 Paint pure Monestrial Green, using almost no white spirit and a small amount of oil glaze over an Emerald Green eggshell basecoat. Leave a few areas between for the next stage.

2 Mix a tiny amount of Raw Umber into the green and glaze, partially filling in the remaining areas. The Raw Umber is used to darken the green, not to make it look brown. Then mix a small amount of French Ultramarine with the green and glaze and fill in the remaining spaces. At this stage, the colour variation is very subtle; it becomes more apparent in the later stages.

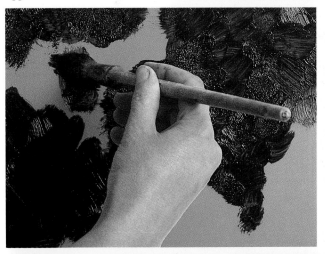

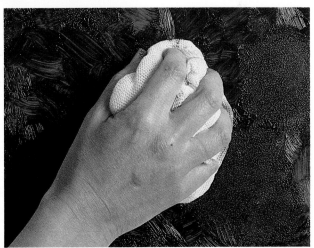

3 Mutton cloth the surface all over quite firmly, eradicating brushmarks and taking off excess paint.

4 Use a badger hair softening brush to remove the mutton cloth marks and to achieve a smooth, glossy finish.

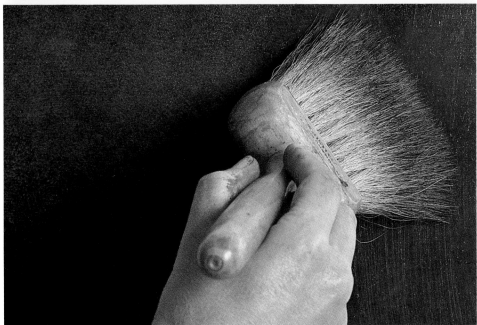

5 Fold a piece of cardboard and tear down the fold. This will be the working edge. Begin to describe a circle, applying even pressure to remove colour. Continue drawing the characteristic malachite shape, keeping one corner of the cardboard roughly in the centre of the circle.

6 Draw another malachite shape that slightly overlaps the first. It is important to be aware of the design. Clean excess paint off the cardboard.

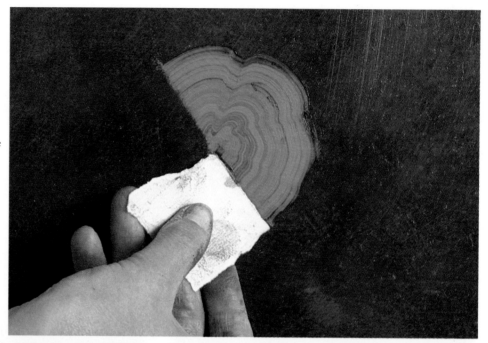

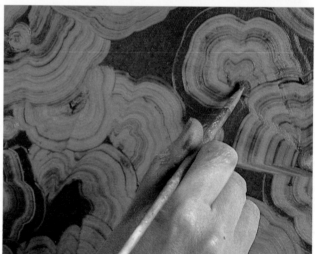

7 Take a fresh piece of cardboard if the first becomes soggy. Malachite circles vary in size, so using different lengths of cardboard adds authenticity.

8 Twist a short-haired bristle brush in circles to create a few, smaller formations of malachite in some of the dark spaces. Do not overdo this.

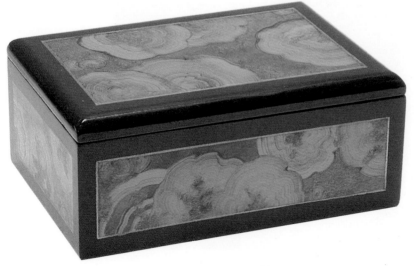

A simple wooden box has been exquisitely decorated. It was painted black with malachite inlays. The gold lining completes a sumptuous colour combination.

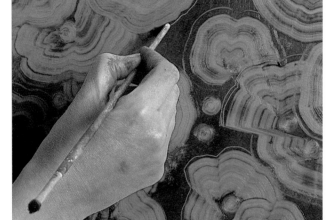

9 Draw a line around any of the negative dark areas remaining, using the end of the paintbrush.

10 Soften gently with a badger hair brush, taking care not to blur the edges of the malachite shapes.

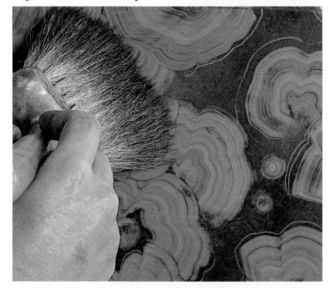

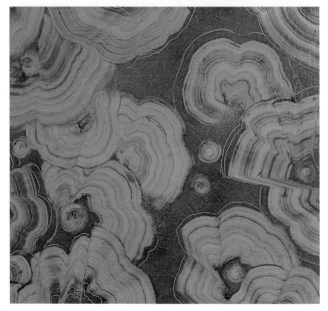

11 The overall design is very important; it is helpful to look at a piece of real malachite. Large complete circles are rare; most are fragmented and split.

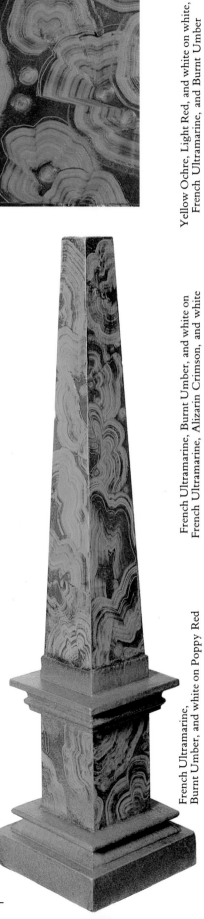

Malachite is a good finish for small objects.

French Ultramarine, Burnt Umber, and white on Poppy Red

French Ultramarine, Burnt Umber, and white on French Ultramarine, Alizarin Crimson, and white

Yellow Ochre, Light Red, and white on white, French Ultramarine, and Burnt Umber

Porphyry

The word porphyry derives from the Greek *por-phyrites*, meaning purple, and is used to describe a granular, red-purple rock. The quality and closeness of the texture can vary. It is often associated with marble; it has the same hard feel and can be highly polished, although it has few or no veins. It occasionally contains flecks of iron pyrites, known as fool's gold. The commonest colour for porphyry is a reddish purple, although there are several other varieties. Egyptian porphyry is reddish-orange, brown porphyry veined with quartz and flecked with pink, red, and green is found in Scandinavia, and both green and violet porphyry come from France.

It is used mainly for small, decorative objects like plinths, ornamental bases, and inlays, although larger items have occasionally been made. Both the Roman Emperor Hadrian and Napoleon Bonaparte were interred in a porphyry sarcophagus.

The imitation of porphyry has a long history. It can be seen on Egyptian murals and on the walls of Pompeii. In the Pitti Palace in Florence is a fine column in a red-brown colour over a golden surface with Raw Umber, Burnt Sienna, Ochre, and yellow-green. The technique was taken to England in the late 17th century.

Porphyry is executed by laying a varicoloured background, mutton clothing, softening, and then spattering with three or more tones of the same basic colours. The spatter goes all over, so very little of the background eventually shows through. Care should be taken to mix the oil paint to the correct density in order to attain a flat, even surface. Do not mix glaze in the spatter as this causes lumps on the surface of the finish. You can make the spatter finer or coarser and more granular by tapping closer or farther away from the surface. It can be translated into any colour, although colours that stay close to the natural feel of the rock probably work best.

Porphyry is not usually used for large objects, but mainly for small bits and pieces. It has also been much admired as a material for desk and table tops. Its density makes it a good finish to use as a contrast with several larger types of marble.

SUITABILITY

Bases and inlays; columns using the sponge method (see Granite, p105).

MATERIALS

4 parts Alizarin Crimson

2 parts Burnt Sienna

1 part Burnt Umber

½ part white spirit

1 part glaze

Gloss varnish

Beeswax to soften

EQUIPMENT

Fitch for laying in

Mutton cloth

Badger softening brush

Small fitch for spattering

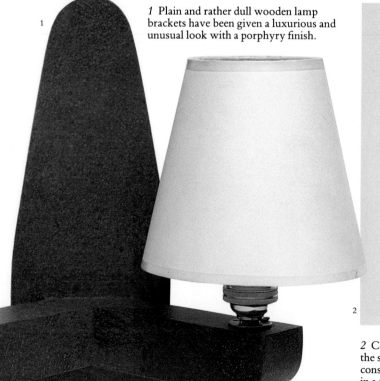

1 Plain and rather dull wooden lamp brackets have been given a luxurious and unusual look with a porphyry finish.

2 Covering a large surface with a porphyry finish using the spatter technique (shown opposite) is too time consuming. This column has been painted using a sponge in a technique similar to that for granite on page 105.

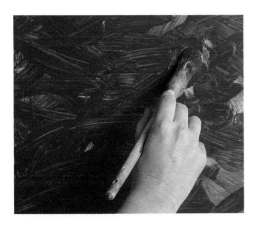

1 Mix the glaze with a lot of oil colour, using very little white spirit. Apply it to the surface, slightly varying the tone.

2 Mutton cloth to eradicate brush strokes and to remove excess paint. Be careful not to take too much off.

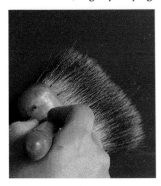

3 Soften all over with a badger hair brush. Try to avoid leaving scratch marks on the surface.

4 Mix three separate colours—a dirty pink, a reddish-brown, and a red—with white spirit and without glaze, ready for spattering. Test the consistency by wiping a loaded brush against the side of the paint tray; if the paint runs, it is right for fine spatter.

5 Spatter fairly evenly all over the surface. Keep the brush at the same distance from the surface throughout. (See Spattering on pages 74–75.)

Alizarin Crimson, Burnt Sienna, Burnt Umber, and white

Lapis lazuli

Lapis lazuli is a very attractive blue mineral, speckled with minute crystals of yellow pyrites, called fool's gold. Some lapis lazuli has light patches, and some has veining which reduces its value. In the 15th century, Italian painters ground this stone to produce a sky-blue pigment used in altarpieces for painting the Virgin's mantle. Now it is too scarce and costly for use in painting; our modern equivalent is Ultramarine.

It is one of the most valuable, semi-opaque, ornamental materials, and is not often seen in large quantities. The ancient Egyptians used it for their seals, and it was later used as inlay on items of furniture.

The best quality lapis lazuli comes from Afghanistan, whence the ancient Egyptians no doubt procured their supplies, although it is also found in parts of Asia in China, Siberia, and in Chile.

Lapis lazuli is painted in much the same way as porphyry (see pp100–1). Porphyry has a more even, all over appearance, whereas lapis has a drifting Milky Way effect, with both very dark and bright areas; it is then flecked and spattered with drifting specks. Its main distinction is the flecks of 'gold'. Real gold leaf or transfer leaf can be used for this, or Dutch metal (cheaper), or bronze powder. It is then varnished and waxed to give it the right feel. The main problem with both lapis lazuli and porphyry is spattering paint of the right consistency so that the spots are not raised above the surface in unattractive blobs. Remember not to mix glaze with oil colour for spattering.

SUITABILITY

Small items of furniture and medallions.

MATERIALS

1 part glaze

3 parts French Ultramarine

1 part Burnt Umber

½ part white spirit (to stop the mixture being too sticky)

Gold powder

Gloss varnish

Beeswax to soften

EQUIPMENT

Fitch for laying in colour

Mutton cloth

Badger softening brush

Small fitch for spattering

Small fitch for gold powder

1 Mix French Ultramarine with glaze, using very little white spirit. Brush on the central areas of the surface.

2 Paint the remaining areas with a mixture of French Ultramarine and Burnt Umber.

3 Mutton cloth the surface to eradicate brushmarks. The blue should look celestial, clear, and translucent. Soften with a badger hair brush.

4 Mix three tones of blue, using French Ultramarine, Titanium White, and Burnt Umber. Finely spatter the surface in drifts, like the Milky Way.

5 Spatter the lightest tone by pulling back the bristles of the brush with your index finger.

6 Very gently, flick a little gold powder in drifts to simulate the flecks of fool's gold.

7 The final effect should have a feeling of clarity and depth. Gold transfer leaf can be used instead of gold powder.

Lapis is traditionally combined with precious metals.

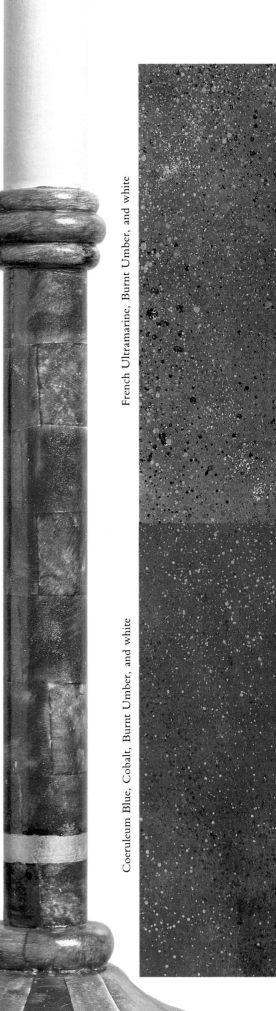

French Ultramarine, Burnt Umber, and white

Coeruleum Blue, Cobalt, Burnt Umber, and white

Agate

Agate comes in lots of different colours arranged in stripes or blended in clouds. The first, stripy type is called ribbon agate; the second type is called moss agate. It can be used as a foil to a busier marble, and is suitable for both large and small areas, and as a border. It can be used on furniture, tables, and smaller objects.

It can be striped and striking, lots of different colours, and is quite a fun finish. It is often painted in beige, and sometimes a red that simulates rust marks. It is painted in a similar way to malachite (see pp96–9). A piece of cardboard is moved down the glaze in a long, slightly undulating strip to create a striped effect. Thin, flexible cardboard used for reinforcing packaging is best. Thick cardboard, such as that used in cereal boxes tends to become very soggy and makes rather indistinct lines. Tear the cardboard to form a wide shape that is comfortable to hold. Use the torn edge as the working edge. The cardboard may become soggy if you are painting a large area; discard and tear off a new piece.

SUITABILITY
Anything flat, such as panels and floors.

MATERIALS
Glaze and white spirit
Titanium white
Raw Sienna
Raw Umber
Light Red or Indian Red

EQUIPMENT
2 fitches
Mutton cloth
Softening brush
Stiff cardboard

1 Cover the surface all over with a mixture of Raw Sienna and Titanium White, with some Raw Umber.

2 Add extremely small spots of Indian Red or Light Red to simulate rust spots.

3 Mutton cloth. The red spots will then become more apparent. Soften.

4 Pull a wide piece of cardboard down the surface in a slightly undulating, vertical line.

5 Agate can be painted in a wide range of colours. This striped variety is known as ribbon agate.

Granite

Granite has the same basic appearance as lapis lazuli and porphyry, but is differently coloured and can sometimes be quite coarse. Granites are solid and substantial. The commonest colour is grey, although granites can also be red, pink, blue-grey, and light greenish-grey. It is not a precious stone, so it is often seen in large expanses and is used in building. It is fairly plain so it looks good used as inlay on a chequered, marbled floor, acting as a foil and accompanying something a bit more extravagant.

Small areas of granite can be painted using the same technique as for lapis lazuli (see pp102–3) and porphyry (see pp100–1), but larger areas can also be sponged and then spattered. A quicker way is to paint on to a grey base. The size of the spattered spots can be varied by moving the spattering stick nearer to and farther away from the painted surface (see pp74–5). Granites range from a fine-spotted appearance to a coarser effect, so use whatever suits your idea.

SUITABILITY
Floors and borders.
MATERIALS
Glaze
White spirit
French Ultramarine
Burnt Umber
Titanium White
EQUIPMENT
Fitch or household brush
Mutton cloth
Sponge

1 Paint a grey coloured glaze, using French Ultramarine, Burnt Umber, and Titanium White, on the surface.

2 Mutton cloth to eradicate the brushmarks, and then soften.

3 Sponge on a lighter and a darker tone of grey than the ground coat. If you are painting a very large area, you may prefer to sponge a third tone.

4 Spatter a darker tone of grey evenly all over the surface. The texture of granite may be variable, so the size of the spatter can be varied.

Venetian Red, Oxide of Chromium, and white

Burnt Umber, French Ultramarine, and white

French Ultramarine, Ivory Black, and white

Tortoiseshell

Tortoiseshell (in fact, the shell of the sea turtle) was first used as an ornamental veneer in the East, and examples of tortoiseshell inlay were probably brought to the West by the Dutch East India Trading Company. With the growing interest in oriental objects, it was soon being imitated by decorative craftsmen. A late 17th-century treatise quotes the imitation of tortoiseshell as being much in request for cabinets, tables, and the like. Furniture as well as small objects, such as picture and mirror frames, and mouldings, were painted and often further decorated with gold. In England and France, ceilings, cornices, and woodwork were painted in this manner well into the 19th century.

Tortoiseshell overlay had been used on different colour backgrounds as early as the 8th century. A base of white, yellow, green, red, or gold gave the shell extra depth and altered the colouring according to the density of the natural markings. Later this effect was copied to render painted versions of green and red tortoiseshell. In the 18th century, André Boulle, cabinetmaker to Louis XIV, used tortoiseshell as a decorative surface on commodes, table desks, secretaires, and clock cases, combining inlays with silver, pewter, and ormolu. He used a coloured ground to show through the transparent tortoiseshell, and two painted fantasies now bear his name—Red Boulle and Green Boulle.

The pattern of tortoiseshell is imitated with a series of strokes of varying widths and lengths, painted in a diagonal direction. It can be painted on various coloured bases; white, cinnamon, or real gold (see pp122–7).

A finish intended to be a direct imitation should not be larger than 15 cm (6 in). Although tortoiseshell is both translucent and pliable, it cannot be carved, so it should only be painted on a relatively flat surface. It was often used as inlay and embedded between decorative channels of ebony, ivory, or ormolu. Tortoiseshell varies widely in colour from very dark to very light, with an assortment of markings from blotchy or stripy, to barely patterned.

Both real and painted tortoiseshell are most commonly used for picture frames. The form and manner of painted tortoiseshell has stimulated other decorative finishes that bear little resemblance to the real thing. It is quite an intense look which can be varied to paint small objects or whole walls.

Real tortoiseshell is used only in small sections, but this is a finish that can look good translated into a fantasy. The design of the tortoiseshell should be scaled up when it is used for a large expanse like a wall, and the spots should be exaggerated. Enlarged like this, it can even look like leopard skin. A wall does not have to be painted in the same detail as small-scale tortoiseshell; the Burnt Sienna can be omitted.

Small objects look best using small marks. As the tortoiseshell only goes in one direction, patterns imitating marquetry can be made out of it by turning it over and contrasting it with black and ivory inlays. Used like this it can be combined to form rectangles, squares, and strips, or baroque designs in the manner of André Boulle. Be cautious with the Burnt Sienna; the red colour can go everywhere and will look awful and much too hot.

SUITABILITY
Small items.
MATERIALS
Basecoat—either white or transfer gold
Glaze
White spirit
Raw Sienna
Burnt Sienna
Burnt Umber
EQUIPMENT
Household brush
Fitch
Sable brush
Softening brush

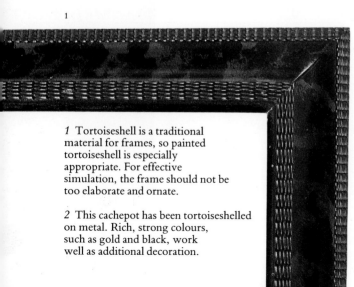

1 Tortoiseshell is a traditional material for frames, so painted tortoiseshell is especially appropriate. For effective simulation, the frame should not be too elaborate and ornate.

2 This cachepot has been tortoiseshelled on metal. Rich, strong colours, such as gold and black, work well as additional decoration.

1 Brush a free-flowing but not runny mixture of glaze and white spirit over a dry base of varnished gold transfer leaf.

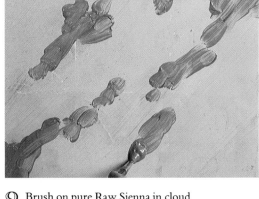

2 Brush on pure Raw Sienna in cloud shapes. It should 'sit' on top of the glaze so, when softened, the colours merge.

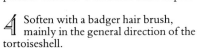

3 Add some small patches of Burnt Sienna (small items only). Add some patches of Burnt Umber for extra depth.

4 Soften with a badger hair brush, mainly in the general direction of the tortoiseshell.

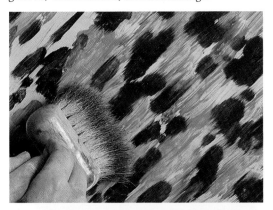

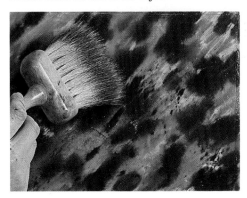

5 Finely spatter occasional small areas with Burnt Umber and white spirit. Bear in mind the size of the object.

6 In addition or as an alternative to spattering, paint small spots of Burnt Umber with a sable brush.

7 Soften lightly. Adding and softening details over a previously softened area, gives a greater feeling of depth.

8 Apply a gloss varnish to give a highly polished look. Tortoiseshell can also be painted on a white background.

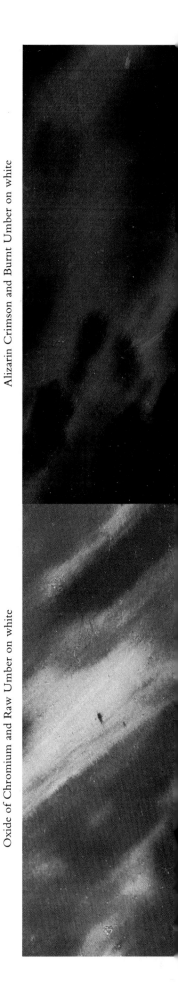

Alizarin Crimson and Burnt Umber on white

Oxide of Chromium and Raw Umber on white

Moiré

This is rather a fun technique to simulate moiré silk, which has a wavy pattern pressed into it. It is derived from a graining tool called a heartgrainer. It is rather time consuming for large areas and may not look so effective, but on smaller panels, where a room has been ragged for example, it can look stunning. It is particularly appropriate on the panels of wardrobe doors; it was once fashionable to line them with silk.

Panels will have to be lined because the tool will not go right into the corners. Alternatively, you could use braid or draw round them. The panels are moired and the edges wiped clean with a cloth and white spirit afterwards or masked off with tape before.

The base colour and ground colour must be very similar in tone; the pattern of moiré is shown by light shining across the watered silk, and too much variance in the tones would look crude. This is a very delicate looking, fine finish.

SUITABILITY

Panels, dado area, and furniture.

MATERIALS

50% oil glaze

50% white spirit

oil colour*

EQUIPMENT

Rag

Heartgrainer

Triangular comb

Flogging brush

*It is essential to paint over an eggshell basecoat that is a slightly different tone of the colour used in the oil glaze.

1 Using a household brush, paint on even and thin coat of glaze, with an up and down movement.

2 Using a soft rag, wipe a lot of the glaze off, so that an extremely thin layer remains.

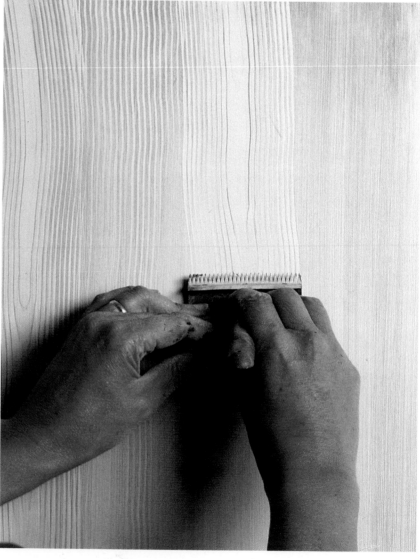

3 Pull down a heartgrainer, gently pivoting it at the same time to make a circular mark. Do this at infrequent intervals.

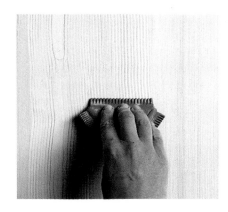

4 On some verticals use a triangular comb to create a plain vertical stripe.

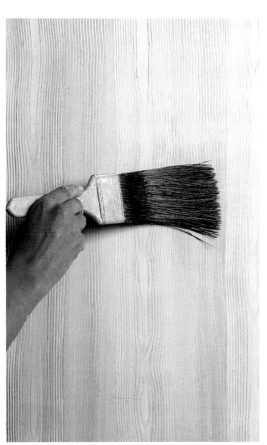

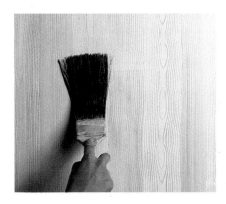

5 When the glaze is tacky and near drying, drag down very lightly with a flogging brush to give a woven appearance.

6 Brush extremely lightly in a horizontal direction with a flogging brush to complete the woven look.

This door was painted with a moiré finish on a dark blue background with a lighter blue glaze to give an intense colour. Moiré fabric is always a single colour, but the tones vary quite subtly.

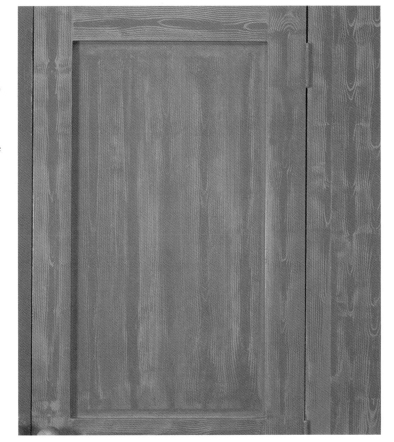

French Ultramarine and white on white

Wood finishes

Woodgraining is generally recognized as the most difficult of the bravura finishes. Even at the height of its popularity in France, a distinction was made between the coarser attempts of the house-painters who were known as woodgrainers and the artists' versions of *faux bois* or false wood.

History

The fantasy of painted wood has a long history and a well-established tradition. Bronze Age pottery with impressions of wood has been found, and there are many early examples from Egypt, a country poor in trees.

Centuries later the art of simulating woodgrain was developed in England, and one of the earliest examples of painted oak panelling, dating from about 1600, can still be seen at London's Victoria and Albert Museum. Later, more sophisticated examples can be seen in the Brighton Pavilion and at Ham House, Surrey. In the mid-19th century, Thomas Kershaw and John Taylor exhibited woodgrained panels to such an impeccably high standard that critics demanded proof that they were painted imitations and not the real thing. Woodgraining became extremely popular with the Victorians, whose decorating manuals show us that clients could choose from juniper, ash, walnut, antique oak, birch, birdseye maple, dark oak, Italian walnut, knotted oak, mahogany, pitch pine, pollard oak, rosewood and satinwood.

Woodgraining is commonly associated with panelling in bars and English pubs, where it can look extremely crude. This is often because the painter used a pot of stainer, which, being a single colour straight out of a can, tends to be flat, rather than using varying degrees of specially mixed colour.

The finest examples of woodgraining are often used in conjunction with marbling, especially in continental Europe where it was used on architectural elements to back up or accompany *trompe l'oeil* paintings. The villa Borghese in Rome has a *faux bois* door which opens on to a *trompe l'oeil* scene. In the palace at Fontainebleau, some of the doors and wainscotting are painted as cypress wood, with a pale grey ground, paler grey peck marks (showing signs of rotting), and Raw Sienna graining.

Woodgraining itself gave birth to many other decorative techniques, such as dragging, combing, and flogging, through the wide range and variety of specialist tools and brushes that evolved.

Styles and techniques

Often early attempts at woodgraining were charmingly simplistic and naive. Nowadays, we find it more difficult to interpret wood as anything but the real thing. We know in detail what wood looks like, recognizing individual graining patterns and colours. It is difficult to translate it into a fantasy without making the results seem crude and banal. The pattern and structure of the wood can be stylized, but the fantasy should be based on a knowledge of the rhythm and growth of the various woods. These can have a myriad of variations and interpretations but each one does have a specific, unmistakable pattern.

If you are intending to woodgrain, look at a piece of wood first and analyse the way it has grown. Establish the general tonality, think about how the piece of wood is going to be positioned and which way the grain is going to flow, especially if you are painting panelling. Most important is to convey a feeling for the wood and its natural structure.

Many woods are equally fine painted in water-based or oil-based paints. Some, like birdseye maple, are finer painted with water-based paints. Others may be better suited to oil-based paints, while a combination of both techniques may also sometimes be used. Often wood is painted as an oil ground with water overgraining. There are curious-sounding recipes for water-based woodgraining, using vinegar and boiled beer, but wood is more difficult to paint in watercolour because of the rapid drying times.

Graining in water-based paints is a very specialized art; with the exception of those shown on pages 120–21, all the woods here use a oil-glaze technique. This involves painting an eggshell base of the correct colour, laying a transparent oil glaze over it, then overgraining. Although easier than watercolour, oil woodgraining is still an exacting technique.

To many people the thought of imitating wood on a piece of wood seems unnecessary and slightly bizarre. The main purpose is an economical one; it is often very difficult and expensive to acquire the exact grain required, and many be impossible to find the requisite colour needed to match another piece of wood. Also, some woods, such as burr walnut and mahogany, are very expensive. Painting a walnut finish on a door made of cheaper wood, for example, can provide the solution to both financial and aesthetic problems.

Although copying wood is exacting in both grain and colour and the manner in which it is applied, there is scope for creativity in the approach to panelling and combinations of different inlays. To do this, paint one section at a time and let each one dry before painting an adjoining panel. Either mask it off, or draw the panel in with pencil, and wipe the edges before it dries. Avoid high gloss varnish.

The most important point to consider is the colour of the basecoat. This should usually be the lightest colour of the real wood. Although the colour can be corrected by the ground coat, the successful combination of basecoat and ground coat is really imperative.

Choosing a base colour

Woods can be found in various colours. The colour depends on the stains and varnishes that have been applied, as well as the age. Sometimes wood is limed or bleached to give it a very pale colour.

To match an existing piece of real wood, make the eggshell base the lightest colour of the wood, and the glaze the darker colour. The glaze and the basecoat should be fairly close in tone.

Pine

Pine was once a very popular wood for painters to imitate. There are some beautiful examples done in the 1930s, using oil-based work with water-based paint over it. Pine is now a much cheaper, easily obtainable wood. There was a tremendous vogue for stripped pine in the 1970s, and the deluge of pine furniture and panels has rather overdone its attraction, and it is now a far less popular wood.

The advantage of pine for the woodgrainer is that it is one of the easier woods to imitate. Perhaps its simplicity allows more room for fantasy and the use of unconventional colours. These days pine is rarely simulated as a natural wood, but it can be fun painted as a fantasy. It is not suited to the meticulous nature of watercolour woodgraining and is invariably painted with oil-based paints. It is a good finish for the first-time woodgrainer to learn the basic techniques and to gain confidence and familiarity with the specialist tools; also it is a well-known wood.

SUITABILITY

Walls and large furniture.

MATERIALS

Glaze

White spirit

Raw Umber

Raw Sienna

EQUIPMENT

Household brush

Short-haired fitch

No 10 heartgrainer

Combs

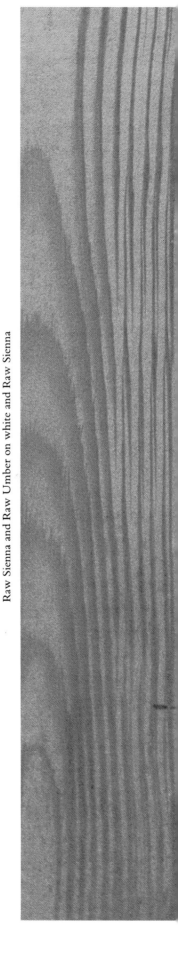

Raw Sienna and Raw Umber on white and Raw Sienna

1 Paint the glaze vertically and then wipe down with a dry household brush to reveal uneven grain.

2 With the edge of the brush, wipe down the surface to reveal a darker and a lighter line.

3 Continue doing this to simulate abutting boards. Oil colour may be added to vary the tone.

4 Press the bristles of a dry brush into the glaze at intervals to create knots.

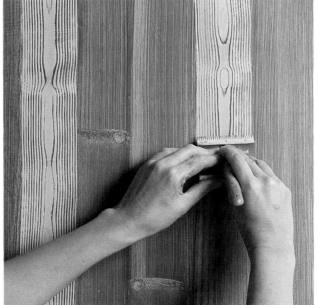

5 Press a short-haired fitch hard on one edge and twist completely.

6 The heartgrainer and combs may be used to vary the grain. These should be dragged over while the glaze is still tacky. This helps to soften the general look.

Oak

Oak is one of the simpler woods to copy, and one of the few that does not require a softening brush. Natural oak is fairly light in colour, and ranges from cream to warm yellow. It can be painted in a variety of colours according to whether you are simulating weathered, stained, limed, or a modern stained oak. After the glaze is laid on it is dragged, flogged, and then marked to put in the lights. The lights can be put in by a variety of methods. You can use your thumb or a cork wrapped in cloth, or a triangular comb wrapped in cloth can be used to make broken arch shapes.

Together with pine, it is one of the few woods that looks effective painted in other than natural colours, such as shades of grey, slate blue, and greens.

Oak was often used to panel whole rooms, and, if you are going to paint a large area, it is most effective to treat it as panels. They are best drawn in 1 m (3 ft) sheets with a pencil, in the same way as marble panels. It also looks effective painted under the dado.

As with most finishes, it is important to get the relationship of the colour and tones right. Most oak finishes are painted in oil.

SUITABILITY
Doors, dados, panelling, walls, and most furniture.

MATERIALS
Basecoat—white and Raw Umber
Glaze
White spirit
Titanium White
Raw Umber
French Ultramarine

EQUIPMENT
Household brush
Graduated comb
Triangular comb
Flogger
Rag

1 As with all woodgraining, the base colour of oak is important. Here, white eggshell was tinted with Raw Umber.

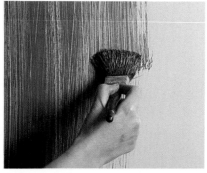

2 Paint on a thin and even coat of glaze with a household brush. The tone and colour may be varied slightly.

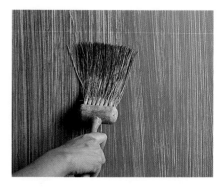

3 Drag up and down with a flogging brush to produce a very thin glaze coat to avoid ridges during combing.

4 At intervals, mark the glaze with a triangular and a graduated comb. Hold the combs with both hands to prevent them slipping.

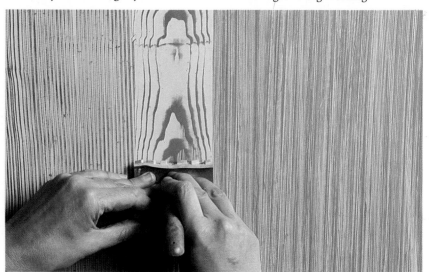

5 Adjust the heartgrainer for painting oak (wide grain). Pull it down, gently pivoting it at the same time. Do this at infrequent intervals.

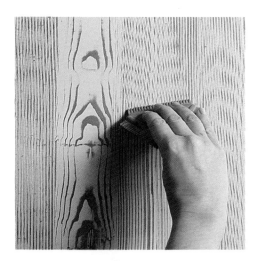

6 Pull down the triangular comb diagonally to make ticking marks in the vertical grain. Also use the comb over the heartgrain to break it up.

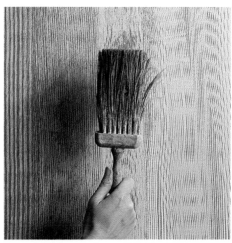

7 When the glaze is tacky and nearly dry, flog it with a flogging brush from the base to the ceiling.

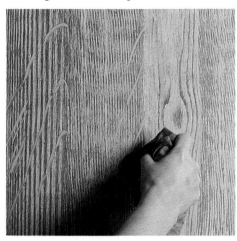

8 Various methods are used to produce the 'lights', such as a thumb or cork wrapped in cloth. Here a triangular comb wrapped in cloth is used.

9 When the lights have been put in, the entire work can be flogged for a second time to give it a more even texture.

This oak panelled dado in a city office was painted without using a heartgrainer. Various combs were used, and lights were put in only on the rails.

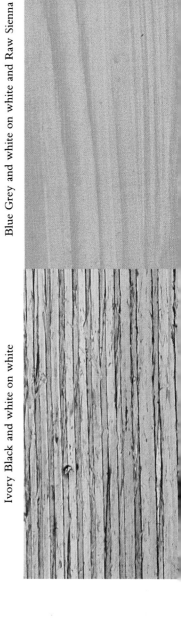

Yellow Ochre and Raw Sienna on white

Blue Grey and white on white and Raw Sienna

Ivory Black and white on white

Birdseye maple

This wood is more difficult to paint than oak, and looks best when water-based paints are used. Nevertheless, using oil-based paint works well and allows you to paint larger areas and to keep the surface workable for a longer time.

Birdseye maple has a peculiar appearance with small dots or 'eyes'. It cannot be used in large sections; probably the largest suitable area would be under the dado. Picture frames are often painted in birdseye maple, ranging in colour from yellows to reds.

There are various methods of painting. Use a white or cream base. The first method is to use either a household brush or a mottler in a runny glaze mixture. 'Wiggle' the brush down in erratic strips, and then dab with your little finger or knuckle to lift off paint to simulate the spots. A second method is to apply the glaze with a household brush, and then, with a second brush or mottler, again 'wiggle' in strips. This simulates the grain of the wood. Use your finger or knuckle to create the 'eyes' or speckled look. A larger area can be very lightly sponged.

It can be overgrained using a conte crayon or a pencil brush. Care must be taken not to make the lines look too hard. At one time, specially manufactured graining crayons, made from pipeclay, gum arabic, and colour were available.

SUITABILITY

Small areas, such as panels, and small items, such as boxes and frames.

MATERIALS

Glaze

White spirit

Raw Sienna*

*Other colours: can also be painted in Burnt Sienna and Alizarin Crimson, with Burnt Umber to darken, over a dirty pink eggshell base.

EQUIPMENT

Household brush

Natural sponge

Fine sable or nylon brush for overgraining

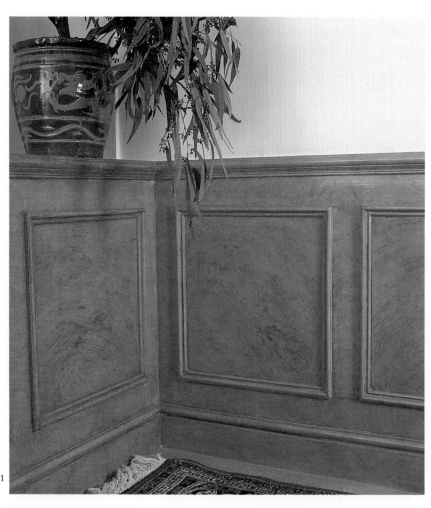

1 This panelled dado has been painted in birdseye maple using watercolour. This is a particularly large area to tackle because of the speed with which watercolour dries. However, it gives a particularly soft and fine effect.

2 A vase holder has been painted in birdseye maple using oil paint. It is very important to use the right colours.

1 Using a thin mixture of glaze and colour, wiggle the brush down the surface, varying the pressure to make lighter and darker patches.

2 Dab lightly all over the surface with a damp sponge to break up, but not destroy, the initial grain of the glaze coat.

3 While the glaze is still wet, dab either your knuckle or the edge of your little finger into the wettest areas to put in the eyes.

4 The finish can be left to dry at this stage and then varnished, or taken on to another stage (see below).

5 When the wettest areas of the glaze are nearly dry (the eyes), soften in a downward direction, using a badger hair brush.

6 The finished maple can be left or overgrained using either a conte cayon or thin sable brush.

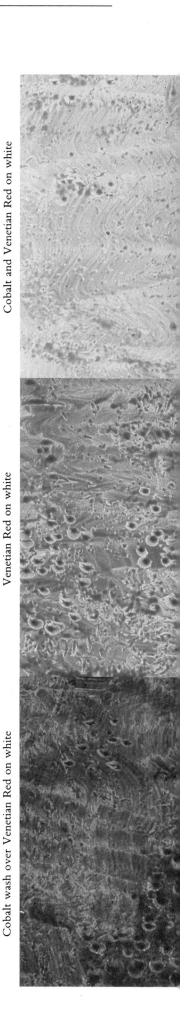

Cobalt and Venetian Red on white

Venetian Red on white

Cobalt wash over Venetian Red on white

Burr walnut

This is a very beautifully coloured, attractive wood that has, therefore, often been painted. Nowadays, it is very expensive and highly prized. In the 1930s there was a fashion for quite dark-stained walnut, but really the best examples are beautiful creamy yellows. The burrs, clusters of knots twisting and twirling in all directions, are produced by cutting down the trees and pollarding. Not all walnut is burred; it can be plain but looks rather like a yellow mahogany. Walnut is not usually found in great expanses. Quartered panelling is quite frequent, but even so, the panels are usually small. It is a popular wood for flat and panelled doors, both on cupboards and into rooms. It is also a good choice for many items of fine furniture such as desks and tables.

Walnut can be imitated with water-based paints as well as with oils. It is time consuming to execute, but, as with most of these woodgraining techniques, the time spent is worth the effort.

For an oil-glaze technique, a fine glaze of paint is applied over a coloured base, and then gently wiped over with a rag. Clusters of knots are added with a brush, and then softened. The burrs are used largely in panelled work and on other medium-sized areas.

The best examples of painted walnut were done in the 17th century. At Belton House, Lincolnshire, one of the rooms has a fine dado painted in walnut.

SUITABILITY
Medium-sized and small areas, such as door panels; furniture, such as tables and boxes.

MATERIALS
Basecoat—white and Raw Sienna
Raw Umber and Raw Sienna
Glaze
White spirit

EQUIPMENT
Household brush
Soft rag
Short-haired fitch
Badger softening brush

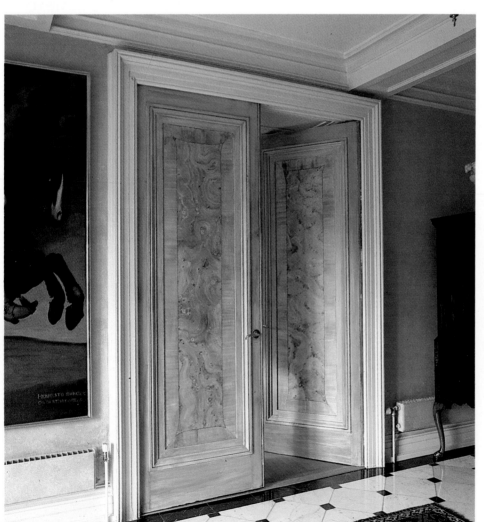

The impressive panels of these large doors have been painted in burr walnut to match real walnut doors in the same hallway.

A detail of the doors. The moulding, stiles, and rails were dragged to give a grained effect. The walnut panels were painted as inlay in a satinwood surround.

1. Mix two batches of glaze; one with Raw Umber and one with Raw Sienna. Paint them in patches on the basecoat.

2. Wipe your brush clean and gently brush over the entire surface to blend in the two colours and remove excess glaze.

3. Fold a soft cloth to make a firm but not stiff edge. Pull it down the surface to make undulating ribbon shapes.

4. Alternatively, a soft cloth may be crumpled and used to make similar, but less regular, ribbon shapes. Leave spaces between the ribbons.

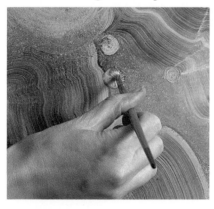

5. Stipple the in-between areas with a bristle brush. Twist the brush to make knots; vary the size of the brush.

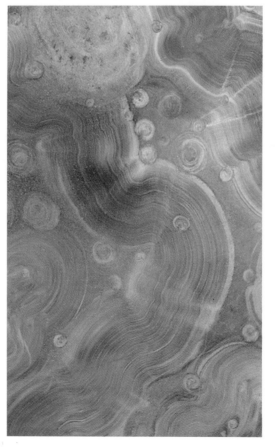

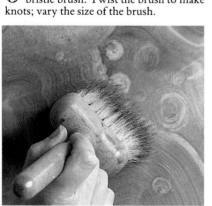

6. Soften the entire surface rigorously in different directions, using a badger hair softening brush.

7. The finished walnut should be varnished when dry with a gloss or eggshell varnish, and then beeswax should be applied.

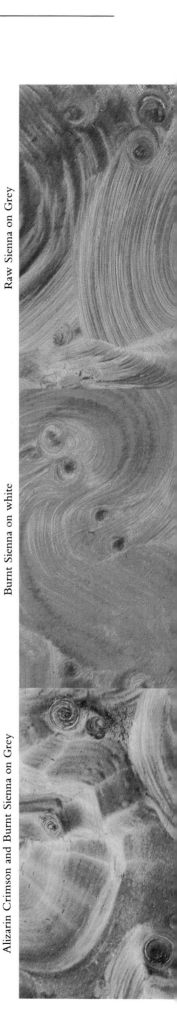

Raw Sienna on Grey

Burnt Sienna on white

Alizarin Crimson and Burnt Sienna on Grey

Mahogany

Mahogany wood is greatly valued for its rich, warm colouring. The pattern of the graining is very distinctive and beautiful. The grain differs according to which part of the tree the wood is taken from. There are three different types of wood pattern which are very pronounced in mahogany because of its girth. The straight grain is taken from the outer edges of a cross-section; the heartgrain from the centre of the cross-section; the feather (also called flame or curl) is cut from the part of the tree where branches grow out of the main trunk or from the topmost part. The highly decorative graining is ideal for door panels, while the plainer grain is more suitable for the stiles and rails of the door. Painted mahogany can be extremely effective, and, in some ways, is a good wood for beginners to imitate.

Mahogany is mainly painted over a dirty pink basecoat. Oil glaze is brushed on in darker and lighter areas to cover the base. A dry brush is used to mark the pattern of the grain. This is then softened across the feather in the opposite direction to the flow of the wood. When this is dry, another coat, using watercolour, may be applied to darken and/or strengthen the colour using an overgraining brush or a mottler.

The patterned wood is difficult to paint on a dado rail as it cannot be softened; it is easier to use water-based paints as they blend in more readily. If you need to match an existing panel, always look at the lightest colour, as this will be your base colour.

Satinwood, which resembles mahogany in grain and which comes from a related tree, was a popular wood for furniture in the 19th century. There are feathered and mottled varieties, as well as plain heartwood, but the grain is smaller. The colour is lighter than mahogany. Painted satinwood can simply be grained and softened slightly, or grained and left. It is also imitated in a similar way to mahogany, but is a golden yellow colour.

SUITABILITY

Panels, doors, and large items of furniture.

MATERIALS

Basecoat—white eggshell, Burnt Umber, and Alizarin Crimson*

Burnt Sienna

Burnt Umber

Alizarin Crimson

Glaze

White spirit

*Other colours: to match existing mahogany, use the lightest colour for the basecoat, and the darkest colour for the glaze.

EQUIPMENT

Household brush

Dry household brush

Badger softening brush

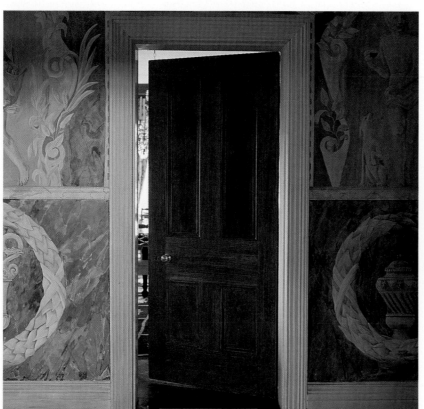

1 These panelled pine doors have been painted in mahogany grain to match real mahogany doors opposite. An oil technique was used.

2 A panelled dado was painted in mahogany grain using watercolour. In both examples, the stiles and rails have been dragged and softened in the opposite direction, while the panels simulate heartwood.

1 Paint a glaze of Burnt Sienna and Alizarin Crimson over a dirty pink eggshell basecoat.

2 Add pure Burnt Umber and Alizarin Crimson to the central area and to the corners of the panel.

3 After wiping your brush clean, brush lightly all over the surface to blend the colours and remove excess glaze.

4 At this stage you will have established the basic colour of the mahogany on which the grain can now be marked.

5 Make an arch shape with a dry household brush, keeping it at the same angle throughout. Leave no gaps between each arch.

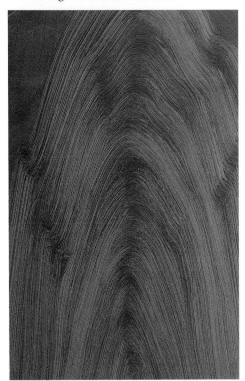

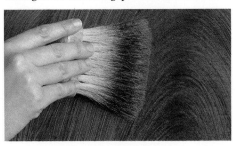

6 This is a flame, a typical pattern of mahogany that occurs in wood cut from the place where branches grow out.

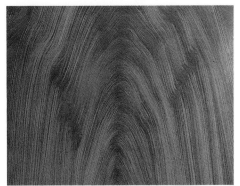

7 Soften across the grain of the wood with a badger hair brush. It may also be necessary to soften with the grain.

8 The finished mahogany can be varnished and waxed, or it can be overgrained with a mottler, using watercolour or oil colour.

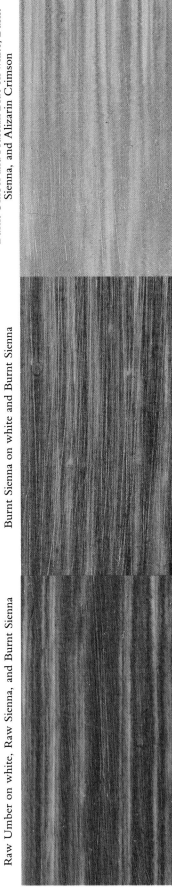

Burnt Umber and Prussian Blue on white, Burnt Sienna, and Alizarin Crimson

Burnt Sienna on white and Burnt Sienna

Raw Umber on white, Raw Sienna, and Burnt Sienna

Watercolour woodgraining

Woodgraining can be painted with oil- or water-based paints. Unlike other basic and bravura finishes, woodgraining in watercolour has a beautiful, vibrant quality. It is a very fine technique in every meaning of the word. Some woods, such as birdseye maple, are particularly beautiful executed in water-based paints. Traditionally, the best quality and finest woodgraining for indoor work was done in watercolour. The grainer has to be extremely practised, as the paint dries quickly and allows no time for mistakes to be rectified. Oil graining was left for areas, like front doors, that would get rougher treatment.

Water-based paint lays a very thin skin which maintains the flatness of the surface. Its transparency is excellent, and the effects are variable, being both hard-edged and subtle as appropriate. Its limitation lies in the speed with which the surface dries and becomes unworkable. A painter has to work with a practised and efficient hand in order to cover a reasonable area. Experienced grainers are very proficient in the patterns and the colours of the woods they imitate, and are able to execute them with a high degree of efficiency and skill.

Like oil work, watercolour woodgraining needs a coat of eggshell as a basecoat. Similarly, just as oil paints use turpentine and linseed oil, water paints use a variety of binders, together with water, to carry the pigment. These are often rather unusual, and vary from stale beer, fuller's earth, and skimmed milk to vinegar.

Overgraining

Another positive aspect of water graining is that, because it dries quickly, overgraining can be done. Some grainers like to lay the first grained coat in and seal it with a quick-drying, transparent shellac-type varnish. Then the overgraining can be done without fear of disrupting the first coat of paint.

In this technique a second grained coat is applied over the whole or part of the first grained coat. For birdseye maple, very small grained lines, looking rather like contour lines on a map, are put in. For mahogany, the grain of the heart is enhanced, and with burr walnut, more burrs or knots are put in. This technique gives greater depth to the work. Although watercolour work is delicate to do, the dry finish is quite tough.

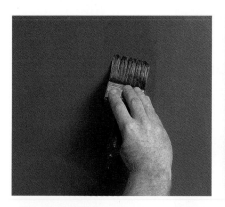

1 Brush a mixture of equal parts of water and vinegar over an eggshell base. Here, terracotta was used.

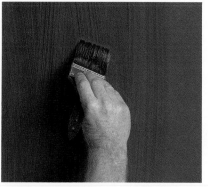

2 Dip the brush in Vandyck brown pigment and brush it into the wet base. Any type of brush is suitable.

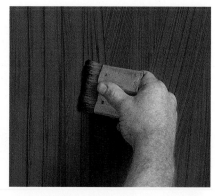

3 Brush some parts thicker or thinner with a wavy mottler using vertical strokes. This forms the underlying pattern.

4 Dip the wavy mottler in and out of the mixture, squeezing with the fingers to create ripples in the straight grain. The thumb or fingers can be used to press the bristles into different patterns to create a variety of ripples.

5 The edge of the brush can also be used. This has to be completed fairly quickly before the water and vinegar dries.

6 Stipple marks into the pigment with a badger hair brush. A hog-hair brush is not suitable for watercolour work.

7 Soften and blend the lines with the badger hair brush. Allow the surface to dry; it will then be ready for overgraining in oil.

8 Mix up a glaze of 1 part linseed oil, 2 parts white spirit, and a commercial mahogany scumble glaze (with a consistency of single cream). Brush over the surface.

9 Overgrain with a wavy mottler, pushing the glaze into vertical streaks.

10 You can use a flogger for extra emphasis with oil glaze.

11 The finished mahogany straight grain. Tackle small areas to begin with as it is difficult to work the water, vinegar, and pigment into a good pattern before it dries.

Gold leaf and gilding

Gilding is a very specialized technique that takes many years and much practice to perfect. The information given below describes the processes used by professional gilders. Certainly, amateurs can have fun working with gold leaf, and will be able to produce some very satisfying effects, but they should not expect to achieve the exceptionally beautiful finishes of professional gilders simply by following the instructions given here. There is no substitute for hard work and experience.

There are two types of gilding: water- and oil-gilding. Water-gilding is a highly skilled craft where water is used to make wafer-thin sheets of gold leaf adhere to a gesso surface. Oil-gilding is less delicate; the gold leaf adheres to the surface by laying it on to a coat of almost dry oil.

Water-gilding

The manner and method of water-gilding and the tools used have remained the same for centuries. Once a surface has been water-gilded, it is extremely durable. The Egyptians used this technique 3,000 years ago, and the beautiful mask of Tutankhamen's mummy remains in perfect condition still. Nowadays, gilding is used on picture frames and architectural details.

Wafer-thin leaves of gold are applied to a surface previously coated with several layers of gesso (see p78). If you gild straight on to a surface like wood, the grain will tear the gold leaf, so layers of gesso must be built up to create an extremely fine, smooth surface. As many as 8–12 coats of gesso should be applied before a surface can be gilded, and many more coats were quite usual.

The gesso for water-gilding has to be extremely fine and well prepared. If you bear in mind that the gold leaf is only 0.0001 mm (1/250,000 in) thick, it will be obvious that any discrepancy in the surface will tear the gold.

The gesso need not necessarily remain white; it is quite often coloured before the gold leaf is laid on. This is done by applying a layer of 'bole' with a brush. Bole is a clay, often red in colour, mixed with rabbit-skin glue. Other colours are yellow, black, and Venetian blue, or you can mix colours yourself.

The name bole is derived from a Greek word meaning clod or lump. It is made from a soft clay containing iron oxide that is found in deposits throughout Europe. Colours range from light pink and deep purple to yellow ochre and grey. It is fat and soapy, as smooth as wax, and capable of receiving a high polish. During the Renaissance, there was a preference for Armenian bole. Red bole is the commonest; it glows through the transparent gold, warming and intensifying its colour.

Bole can be bought ready prepared and mixed. Several coats should be brushed on, and the final coat may be smoothed over with very fine sandpaper so that it presents a highly polished, dark red surface. The surface is then ready for gilding.

At all times the surface must be completely clear of dust and dirt. It is painted with a little methylated spirits, (to speed the drying process), water, and a tiny drop of size. The leaf is then laid over the surface and, as the water dries, the gold adheres. When it is thoroughly dry, the gold is burnished.

Water-gilding can be burnished to produce a highly polished surface. The burnisher is made of agate. It is essential to use gesso as a ground, as it is the only surface fine and smooth enough to take the gold without tearing it. The lustre and shine of burnished gold cannot be obtained in any other way.

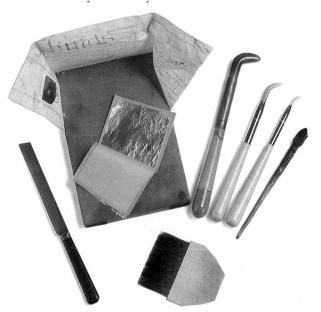

Materials and equipment

Gilder's pad This has a wall of parchment at one end that can be folded flat when the pad is put away. The parchment is used to protect the gold leaf while it lies on the pad. The gold is so thin that the slightest breath could blow it off the pad. The pad has a loop so that it can be held with one thumb, leaving the fingers free to hold the other tools.

Gilder's tip This looks like a very thin brush and is made of hairs sandwiched between two pieces of very thin cardboard. It is used to pick up the thin leaves of gold. Gilders often stroke their cheeks with the tip to pick up the natural grease of the skin, which will then pick up the gold leaf as it lies on the pad.

Burnishers These are made of agate. They are highly polished and extremely smooth to prevent the gold from being scratched and torn.

Gilder's knife This is used for cutting the gold into smaller pieces. Since the gold is so delicate and fine, the knife does not need to be very sharp. It is very well balanced for easy handling.

Book of gold leaf This holds the loose sheets of gold leaf. The gold is put through mechanical rollers and finally hand beaten to a thickness of 0.0001 mm (1/250,000 in). The leaves are extremely delicate and very easily torn and disturbed. They disintegrate if they are picked up by hand.

Gilder's brush This is used for brushing the water on the surface to be gilded.

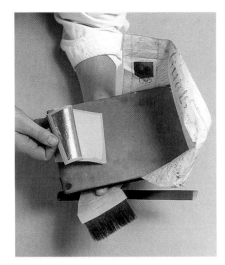

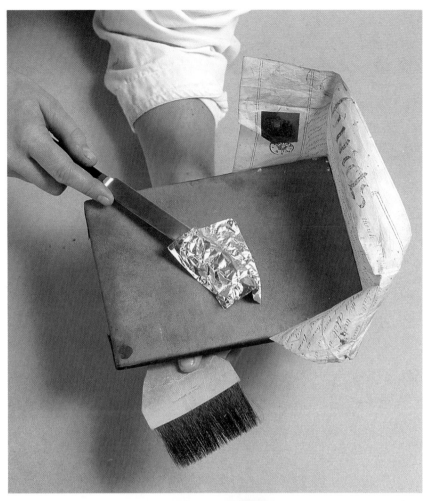

1 Gold leaf is extremely delicate and should not be touched with hands. Transfer it gently to the gilder's pad. The parchment wall protects it from any draughts that may blow it on to the floor.

2 Gently tease the gold leaf with the flat side of the gilder's knife to adjust it to lie flat. Keep all your tools in one hand to minimize the amount of movement.

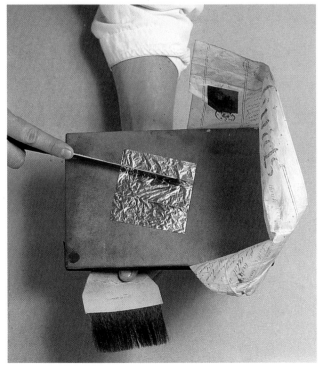

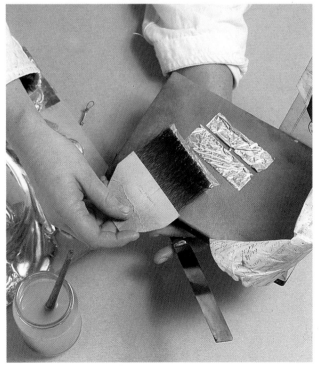

3 Cut the gold leaf to the appropriate size with the gilder's knife. Work close to the object that you are going to gild to minimize disturbance to the gold leaf.

4 Very gently lift the gold leaf with the gilder's tip. If the tip will not pick up the gold, brush it against your cheek to pick up some grease from the skin and try again.

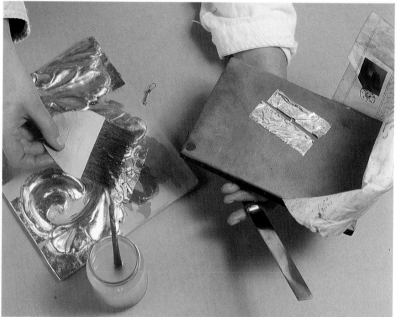

5 Hold the tip with the gold leaf in one hand and paint the small area to be gilded with a mixture of water, size, and a tiny drop of methylated spirits.

6 With the tip, gently place the gold leaf in position while the surface is still wet. It cannot be adjusted once it has been laid down.

The high polish and perfection of gilding sometimes looks ostentatious. This frame has been gilded over red bole and then distressed with a mixture of white spirit, beeswax, and pigment washed over it and then rubbed into it with wirewool.

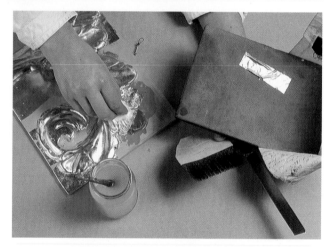

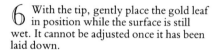

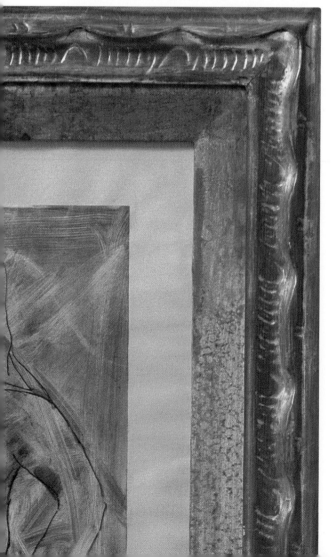

7 Help the gold leaf to adhere by gently pushing, not stroking, it with cotton wool. Leave to dry thoroughly.

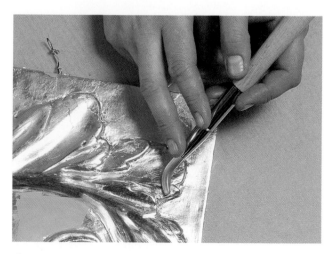

8 When it is dry, burnish the gold leaf to a high shine. You can be quite vigorous about this, and, provided there is no dust or grit under the surface, it will not tear.

Using bronze powder

This may be used as a cheaper and somewhat easier alternative to water-gilding. Either gesso the surface, or prime it and then paint two to three coats of Plaka paint. These may be flat colour, or the first coat can be painted as flat colour in ochre and then stippled in red, black, blue, or grey. Paint on a mixture of bronze powder and gum traganuff in a thin layer. When it is dry, burnish it with an agate burnisher. Half of it will come off, giving an antiqued effect. Spray with fixative and then varnish with a cellulose varnish.

Oil-gilding

Oil-gilding is simpler than water-gilding, and there are fewer stages. It is easier to use in conjunction with other decorative finishes as it does not always require a gesso ground. It can be laid over a painted finish, providing it has a smooth surface. It is sometimes used as a base for tortoiseshelling (see pp106–7) or to imitate the feldspar in lapis lazuli (see pp102–3). Oil-gilding cannot be polished with a burnisher.

The gold used is called transfer gold, rather than the loose gold leaf used for water-gilding. The transfer leaf is attached to tissue paper by a wax film, which makes handling easier. With care, it can be cut into pieces with scissors while still attached to the tissue paper.

The surface is painted with gold size. This is usually named according to the time it takes to become tacky and ready to take the gold leaf. It is available as 3-hour, 18-hour, and 24-hour size, but Japan gold size, which becomes dry in about one hour, can also be used.

Paint all over the surface with the size. It should be well brushed out so that the surface is covered with a minimum layer of size. The object to be gilded should lie flat so that no runs are caused. Care must be taken while the size is drying to prevent any dust blowing on to it. When the size is practically dry, the transfer gold can be laid over and pressed down with cotton wool.

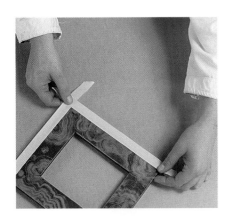

1 Mask off the area that is not going to be gilded. Masking tape can be cut or bent to shape. The surface must be firm so the masking tape does not lift it.

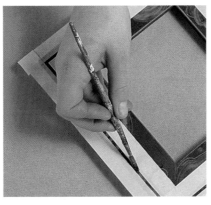

2 Paint the surface with a thin layer of gold size. Allow it to dry for the correct length of time so that it is just tacky to the touch.

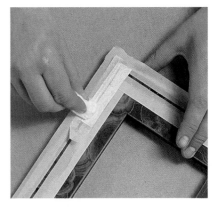

3 Lay a piece of gold transfer leaf in position and smooth it down with cotton wool over the backing paper. Remove the tissue paper.

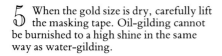

4 If you start to lift the tissue paper and the gold has not adhered properly, you can apply additional pressure by smoothing gently with your fingertips.

5 When the gold size is dry, carefully lift the masking tape. Oil-gilding cannot be burnished to a high shine in the same way as water-gilding.

1 This chair back was given two griffon motifs, using acrylic paint, gold transfer leaf, and gold paint.

Tole ware, which is painted and gilded tin, was developed in the 18th century but originated from Oriental lacquer work.

2 This pot was painted in matt black and then gilded using bronze powder applied over a tacky gold size. The surface was varnished with a matt varnish.

3 The design of convulvulus was stencilled. Gold transfer leaf was applied in places and some areas were overpainted with watercolour to draw in the design. The background was painted matt black.

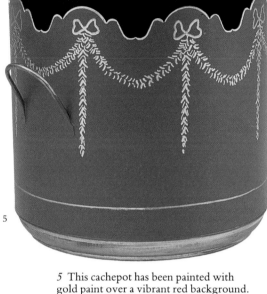

5 This cachepot has been painted with gold paint over a vibrant red background. It was varnished to protect it and maintain the shine. This is easy to apply but lacks the authenticity of gold leaf.

4 A 19th-century tea caddy has been restored using gold leaf and acrylic paint.

6 Gold leaf can be used in an unconventional way as a decorative technique. Gold size was applied to parts of this ornately carved frame and transfer leaf was rubbed on. The frame has a rough surface and the gold leaf does not adhere to it perfectly.

Ageing and antiquing

A freshly painted object or surface—whatever decorative technique has been used—is bound to look new and perfect. This newness may not suit the style of the surroundings, and you can add an air of mystery and antiquity to a piece by ageing it, albeit at an accelerated pace. Getting away from a beautifully flat, new, and pristine paint surface and acquiring an old, worn look makes an object more comfortable to live with and more relaxing to look at.

There are several ways of going about this process, some more drastic than others. 'Antiquing', a delicate and refined technique, can simulate the beauty and patina that usually results from years of care. An imposed ageing process must be handled with sensitivity to simulate the way the passing of time has quietly touched the surface of a genuine antique. Edges that have been brushed by the comings and goings of a hundred people, and surfaces that have been worn by endless polishing should be treated gently rather than enthusiastically. Imitating years of polishing a flat surface, exposing paint along edges that have been rubbed and worn down, darkening areas that would get dirty and superimposing 'flyspots' are all part of the antiquing process.

When an item or a surface has been completely painted, the brightness of it should then be taken down a tone or two by another coat of thinned and coloured oil glaze. This means colours should not be too fresh. Colours which are too bright can be dulled by washing them over with either a thin mixture of glaze, white spirit and dirtied artists' oil colour, or a thin, dry 'coat' of pure dirtied oil colour. The best colours are combinations of Raw Sienna, Raw Umber, Light Red, Oxide of Chromium, and Titanium White. These duller colours can simply be wiped, or stippled and wiped over the ground coat. For the drier method, use a large fitch to 'scrub' the colour into the corners and imperfections.

As long as the previous coat is dry, the top wet coat can still be manipulated without disturbing the underlying one. Surfaces can be rubbed down with fine steel wool to reveal the colour underneath. Dirtied colour can remain in the corners or between the mouldings, where dirt and dust would normally build up. A cotton rag is the best material for wiping the glaze off raised and flat surfaces.

It is a technique that works best when underplayed; it is rather an addictive process, and the line between the finished article and an object that has been overplayed is very fine. Tones and colours should be very close to achieve the right degree of subtlety. Remember that age dims the shine and takes the edge off colour. The surface can be spattered here and there, but not too over-enthusiastically.

Use can be made of the imperfect surface of an old item of furniture. Dents and scratches should be left. A new piece may need drastic measures to obtain the dents and knocks of time. These can be produced by hitting the surface with chains and bunches of keys. This is done after the coloured glaze has dried but before the final ageing with the dirtied colour.

Using crackle varnishes (see p133) also assists in the ageing process. If the work needs to have a protective varnish, use one with a matt or eggshell finish. A beeswax finish over the surface will give it a softer, less garish look.

1 This bureau and cupboard has been painted in traditional Swedish colours – blue and cream. Several colours were washed on and, when nearly dry, wiped back to reveal the layers beneath.

2 This is a new cupboard. The panels were painted in an overall buff colour and then stencilled. When they were dry, they were washed and stippled with Raw Umber. The colour is darker at the edges, and small specks of paint were flicked on.

3 This Swedish bureau bookcase (*circa* 1850) was covered in 16 layers of paint, but was scraped down to the original and traditional blue-green colour.

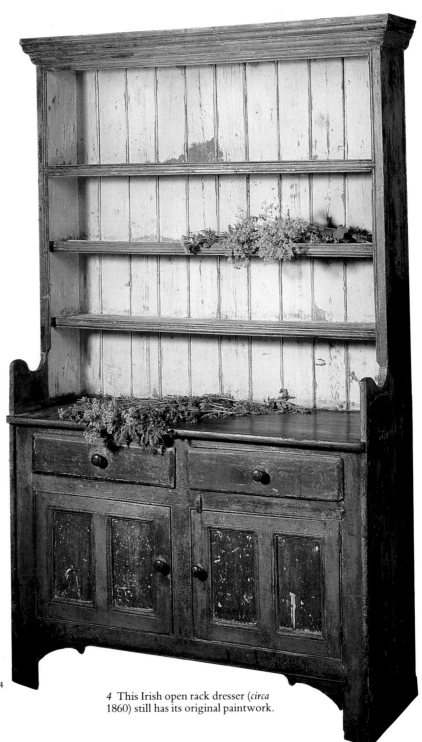

4 This Irish open rack dresser (*circa* 1860) still has its original paintwork.

5 This French armoire (*circa* 1800), probably from the Lyonnais area, still has its original paint finish.

Varnishes

Varnishes are also sometimes called glazes, which can cause confusion. Painted surfaces are varnished for two reasons. The most important and obvious is to protect against wear, water, and other damage. The glaze can wear away easily with constant use and cleaning, so doors, skirting boards, and furniture must be varnished.

The finish of an oil-glazed surface tends to be semi-matt because of the eggshell either used in the glaze or showing through from the basecoat. Varnishing gives you the option to change from eggshell to matt or glossy.

Unfortunately the perfect varnish, that is one that is extremely durable and colour free, does not exist, except within the commercial and furniture trade, and these varnishes are toxic and difficult to obtain. Durable, hard varnishes are yellow in colour, while colourless varnishes offer less protection. All varnishes, except emulsion, are yellow to some degree. There are many different sorts of varnish and the choice can be confusing.

Finishes

Three different sorts of finishes are available, matt, gloss, and semi-matt (also known as eggshell).

Matt varnishes, available in most ranges, are good for surfaces with an uneven finish as they do not catch the light and show all the irregularities. They present a pleasing, 'dry' finish. They are particularly useful for a chalky look.

Gloss varnish is used for an imitation lacquer finish, and all tortoiseshelling and marbling will need a gloss finish. This may make it too shiny, so apply some beeswax. This should be applied and rubbed in with an extremely fine grade of wirewool, and then polished with a soft cloth. This gives a very soft, glossy finish.

Eggshell or semi-matt Because eggshell paint has a semi-matt effect, a glazed wall looks semi-matt. It will, however, be patchy, as the glaze dries differently. To make the appearance even, use eggshell varnish.

All varnishes alter the appearance of your work. How much you varnish an item or a wall and what sort of varnish you use will depend on its function and location—whether it is in a kitchen, a bathroom, a child's room etc. There are some very good varnishes which are really only available to the trade, but they are worth getting hold of if you can.

Protection

The protective qualities of some varnishes can be increased if the surface is first given a coat of gloss varnish. When this is thoroughly dry (this may take several days) it may be rubbed down lightly with the finest grade of wet and dry paper to give it a key. A second coat of matt or eggshell varnish can then be applied. It is the first coat of varnish that gives a surface its protective film. Various strong, protective varnishes are available.

Polyurethane varnish is the best known, most readily available, and toughest. For woodwork, such as doors, furniture, such as table tops, and floors, polyurethane varnish is unbeatable. However, it has the strongest yellow coloration. Like glaze, it will alter the appearance of some light colours, but dark colours will not be noticeably affected. Polyurethane varnish is easy to apply, impervious to alcohol, and heatproof.

Polyurethane varnish is also obtainable in a spray can. This is particularly good for small or awkwardly shaped items. It would be too expensive to varnish larger pieces in this manner. Be careful not to put too much on at a time, otherwise it will run. Spray a little at a time, turning the object round, so that a series of thin layers is built up, rather than one thick one. Spray varnishes are available from good decorator's merchants and hardware shops.

Marine varnish For extreme durability, on floors for example, there are various marine or yacht varnishes. Floors need a minimum of five or six coats of hard-wearing varnish. The floor must be thoroughly clean and dust free before the varnish is applied.

Cellulose varnishes are completely transparent, but very smelly and toxic. They are difficult for the general public to obtain as they are mainly available only to the trade and must be handled with care.

Oil varnish is also a specialist varnish and difficult for the general public to buy. Craig and Rose varnish is an oil-based varnish that is more readily available. It is an old-fashioned varnish, needs constant stirring, and may need thinning before application. Do not apply wet varnish over dry or drying oil varnish, as this will leave a mark. It is available in dead matt, eggshell, and gloss.

Emulsion varnish is water based. It is not very strong, so several coats could be applied. It is a clear varnish with no yellowing properties. It is best used on walls and small items, but it is not suitable for use on furniture. It is fairly easy to apply but not quite as easy as polyurethane varnish, as it is a bit thin. It looks like milk in the can but dries to a clear, transparent finish. It is available in matt, eggshell, and gloss.

Shellac is a resinous varnish with a base of methylated spirits. It tends to be yellowish in colour. It is extremely quick drying and, therefore, is difficult to use. It is useful where a second glaze is to be applied, as in woodgraining.

Beeswax Small objects can be given a protective coat by sanding them very lightly and then rubbing beeswax into the finish. It should be applied with wirewool of the finest grade, and rubbed into the surface like a polish.

Application

The success of varnishing depends on the surface being scrupulously clean, dry, and free from dust. Putting on a varnish is difficult, even for those used to painting; the process is a much more meticulous one. Varnishing must be carried out in the right atmosphere, and there are a few simple precautions to help ensure perfect results. One of the most important is to check that you are not wearing a woollen jumper or anything else that might shed fibres. The room should be cleaned if it is dusty, and the dust should be allowed to settle. Make sure there are no draughts from open windows or doors. Cold draughts can cause some varnishes to dry to a milky, opaque finish.

The temperature of the room is important—it should be warm and dry. Clean the surface or object with white spirit if it has any greasy fingermarks on it, or the varnish will adhere poorly.

Follow the manufacturer's instructions. Some varnishes need stirring thoroughly before use, while others do not. Avoid stirring the varnish if instructed not to, as this will cause air bubbles. Before you start, work the brush into a small amount of varnish until the bristles are saturated; throw the remains of the varnish away. Do not overload the brush, as this will cause drips and runs. Press the brush against the side of the can to get rid of the excess before application.

It is important to work up to a wet edge, so the surface must be covered quickly to avoid ridges. Varnish is best applied like oil glaze in a strip about 1 m (3 ft) wide, working down the wall. This also eliminates the possibility of missing any patches. If you do miss out an area, do not go back to it immediately; wait until the varnish is dry.

Brushes must be kept dust free and used only for varnishing. If there is any colour in your brush, varnish picks it up, and it will colour your work. Buy one brush specifically to be used for varnishing, and make sure it is stored well, wrapped in paper away from dust. Strain previously opened varnish through a fine mesh (old tights or stockings are satisfactory) into a clean, dry pot. Lift any stray bristles from the wet surface with the edge of the varnishing brush.

1 The wall was colourwashed with a mixture of Alizarin Crimson and Indian Red. Crosses and wavy lines were wiped out. After it had dried, a second glaze coat was applied and stippled. Gloss varnish then gave the finish depth, vibrancy, and clarity.

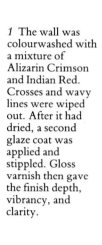

2 Circles and spirals were drawn with a dry brush in a glaze of Burnt Umber and Venetian Red. Gloss varnish intensifies both the pattern and the colour.

3 A pale blue glaze was striated with cardboard. When dry, it was overpainted with a thin wash of white. Here, matt varnish was used to emphasize the chalkiness.

Lacquer and crackleglaze

Nowadays, a lacquer finish describes a flat, smooth, highly glossed surface with a beautiful depth and sheen to it. It is an imitation of real lacquer imported from the East, and differs greatly in appearance and method of manufacture from the real thing.

Real and simulated lacquer

The ancient oriental art of lacquering was extremely time consuming. Based on the sap of the sumac plant, the lacquer was coloured with the addition of cinnabar which produced a red liquid, and charred bone meal which produced black. A thin layer was applied to a highly polished wood surface. This was allowed to dry for 12 hours, and the surface was buffed to a high polish. Twelve to 16 basecoats were needed before decoration could begin, and then another three to six layers would be applied to finish the piece.

It originated in China where very early remains of lacquer have been found. It reached a peak in the production lines and popularity when a royal factory was established in Peking in 1680. In Japan, the technique was perfected to such a high degree that the Chinese were soon importing Japanese lacquer. Increased trade and contact between East and West created a seemingly insatiable desire for lacquered objects among the European aristocracy. It was a demand that could not be met, and this led to craftsmen all over Europe developing alternative, look-alike techniques.

Growing demand led to cheaper ways of production. In France, *vernis martin* was named after the Martin brothers who were the best-known users. In Italy, *lacca contrafatta* was developed as a cheaper and quicker alternative. The Italians made use of coloured cut-outs, engraved or printed designs which were glued on to painted furniture. It was then varnished many times so that the prints appeared to be painted. It was used most often to adorn large pieces. Italian lacquer was painted on a multitude of colours, not just the usual black or red. The most popular colour was cream but images were also painted on pale yellow, ivory, coral pink, scarlet, olive, pale green, and pale mauve.

The method of sticking cut-out pictures on to a highly polished surface was known as *découpage* in England, where it became a popular pastime for ladies. The English lacquering technique known as japanning was invented in the 17th century. There were various guides and handbooks on the subject. An 18th-century account describes how the wood was sanded smooth and then coated with a layer of gesso. Craftsmen would glue sheets of fine linen to the surfaces to be lacquered to accommodate any warping of the grain caused by changes in humidity. The background colour was laid in, and the image then painted in tempera, often outlined in black or another dark colour. The whole piece was then protected with varnish.

Modern techniques

There are various ways to simulate lacquer. One of the problems is to create a feeling of depth. Surfaces have to be very well prepared, rubbed down, and beautifully

2 This is a traditional lacquer on a modern piece, and shows the deep brilliance of the finish. Real lacquer has a tactile quality and a depth of colour that cannot be simulated. A photograph cannot do justice to it.

1 This frame has been painted in acrylic over a buff coloured base, building up colours: Umbers, Ochres, Siennas, and ending with black. Many layers of industrial lacquer were then sprayed on.

3 The lacquer work of this antique Oriental brush box has been restored. Traditional lacquer work is a highly skilled craft.

smooth. Generally speaking, the more coats of paint and varnish, the greater the depth, and the more rubbing down with fine grade sandpaper, the smoother the finish.

Small objects are best 'lacquered' with a standard mixture of glaze and white spirit, and artist's oil colour. Use more oil colour than usual, as the colour should be quite intense. Paint this mixture over an eggshell base of an appropriate colour, one that blends well or complements the oil glaze. The oil-glaze mixture should be mutton clothed, softened, and allowed to dry. It may then be varnished with a high-gloss varnish, such as polyurethane (see pp130–1).

This method is quite time consuming, so if you are going to lacquer a large area like a wall, a simpler method is better. Paint the surface with a gloss paint and varnish several times. The coats of varnish can be rubbed down in between to attain a beautifully smooth surface.

A third method is to tint some varnish with thinned oil colour. This is then painted over an eggshell or gloss base. Choose a base colour that complements the varnish. It is extremely difficult to get a perfectly even mix of oil colour and varnish without causing air bubbles. One way to distribute the colour evenly on the surface is to stipple the tinted varnish after it has been applied. This treats stippling brushes harshly, so it is really only worth trying with old brushes.

Crackleglaze

This is a finish that gives an aged patina to an underlying plain paint or painting. Two types of varnish are used, painted one on top of the other. The two varnishes have different drying times and, as a result, they work against each other and produce a cracked surface. This is not really noticeable until some paint has been rubbed into the cracks to make them more conspicuous. It can be bought as a proprietary varnish, but any two varnishes may be used.

The first coat of varnish is applied and left to begin to dry. When the surface is still a little damp but not too sticky, the second coat of varnish is applied. Within 20 to 30 minutes, the cracks should start to appear. The cracks will be larger and more pronounced if the second coat of varnish is applied quite soon (after about one to one and a half hours). If a longer time is left between applications (about two to three hours), then the cracks will be smaller and more refined. The time allowed to elapse between coats depends very much on atmospheric and drying conditions as well as judgement and personal preferences. A warm atmosphere helps to speed up the process.

If the cracks are too small, the first coat of varnish was allowed to become too dry before the second coat was applied. If this happens, you may wash off the second coat of varnish with a damp sponge and then repeat the entire process. When the surface is dry, apply another coat of the first varnish, leave it to dry for a shorter period than before, and apply another second coat.

To intensify the cracks, rub in some oil paint with a dry rag. The colour is up to you; you may wish to use the crackleglaze as an ageing varnish or as a decorative finish, in which case it could be any colour you wish.

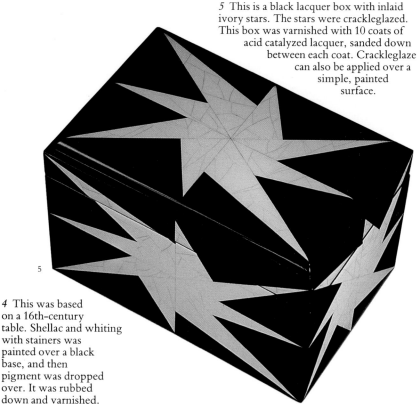

5 This is a black lacquer box with inlaid ivory stars. The stars were crackleglazed. This box was varnished with 10 coats of acid catalyzed lacquer, sanded down between each coat. Crackleglaze can also be applied over a simple, painted surface.

4 This was based on a 16th-century table. Shellac and whiting with stainers was painted over a black base, and then pigment was dropped over. It was rubbed down and varnished.

CHAPTER V

The Rest
OF THE
Room

Usually the walls of a room are the element that should be considered first. They lend atmosphere, and colour first impressions. The doors, windows, fireplace, and the rest of the room should reinforce or complement this feeling. Depending on the shape, size, and character of the room, several different treatments may be considered. A classical approach would be to paint the walls in the main colour and to pick out the woodwork in a neutral shade. A small-scale room might benefit from being painted in the same colour throughout. Ugly features, such as radiators, can be disguised and blended in.

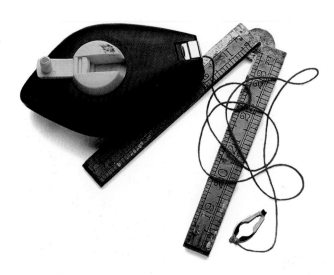

The dado rail and skirting board were dragged, and then wiped when they were beginning to dry to reveal the highlights on the moulding. Alizarin Crimson, French Ultramarine, and Oxide of Chromium were mixed in slightly different proportions from those used for the dado. The basecoat was ivory eggshell.

Panels and kitchen units

Panels can mean many different things: they can be on walls, doors, and cupboards, and they may be plain or ornate. You can buy panelling and make your own according to your taste and the age of your house. Sometimes false panels are painted on walls, either by *trompe l'oeil*, or, more simply, as outlines, or by marking out in pencil and filling in with a different finish. They can be treated like a picture frame, with a freehand painting or stencilled motif painted within them. Panels on cupboards or built into a room can be positive or negative, ornate or plain with simple moulding on a flat wall.

The classical approach is dragging with a typical 18th-century colour such as biscuit. The centre of a panel can provide a place for lots of effects, while the rails and stiles are kept plain, or are dragged, wiped, or flogged. Raised, ornate moulding is often best wiped; take care not to put too much paint into the corners, which can be stippled before wiping to get rid of the excess.

Kitchen units also offer plenty of possibilities, but they need to be varnished very well because of the heavy wear they inevitably suffer (see pp130–1). Anything from marbling to stencilling is suitable, depending on the style of the kitchen. They must be carefully prepared and require at least three coats of varnish. Bear in mind that varnish will yellow your work slightly. Some modern kitchen surfaces will take paint better than others. If you want to make sure your work will stay intact for longer than a few years, contact the paint manufacturer.

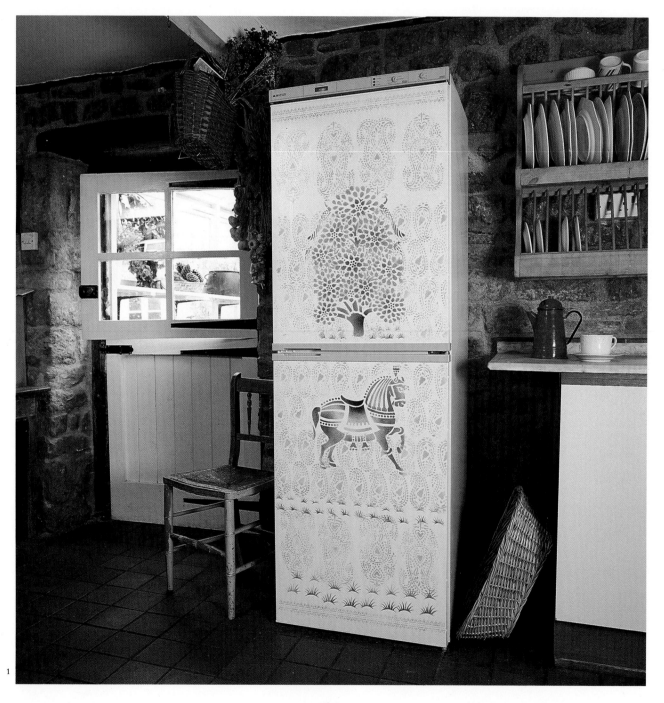

1

1 Car spray paint adheres well to shiny, impervious surfaces, but keep the pattern away from the edges of the door which are handled frequently.

2 A freehand painting in acrylics can enliven a conventional, laminated kitchen unit.

3 A kitchen stippled in Yellow Ochre; the panels were rag rolled and the mouldings were wiped.

4 Wooden cupboards were painted freehand and distressed using oil colour and watercolour to repel each other.

Doors and architraves

Painting a door always takes a long time, considering the relative surface area. Give yourself plenty of time in which to complete the job and do not try to hurry. Always remove the door furniture (handles, knobs etc.) if you can. Painting round it is fiddly and interrupts the flow of paint, particularly if you are dragging.

A typical treatment is to paint the panels one way and the stiles and rails another, possibly to match the walls. Alternatively, you can cover all the door in one finish, most usually by dragging it. The interior decorator John Fowler developed a system of using different tones of white. He painted the recess panel areas with darker whites than the stiles and rails, and used a tone in between for the moulding. This can look very elegant, and may be adapted for any colour. Woodgraining, either to imitate a different wood or to match other doors is also a very suitable technique.

Marbled architraves look well, but marbling on doors can look odd. This is probably because logic tells us that what is usually made of wood cannot really be made of a heavy slab of cold marble. It has been done, but can probably only work in the context of a total fantasy. A combination of dragged doors and marbled architraves works well, with the architrave acting as a frame to the door. When marbling an architrave, use a stippling brush rather than a softener to blend the marble.

If the door has been treated in a strong manner and the walls are also fairly positive, you might consider leaving the architrave plain. It serves as a break between the wall and the door and should be colour-coded accordingly. If the wall, door, and architrave have been treated in different finishes, colours, and tones, they will be at odds with each other and fighting for visual attention. Architraves may also simply be wiped; because most architraves are moulded and curved, they may have to be stippled first to spread out the paint.

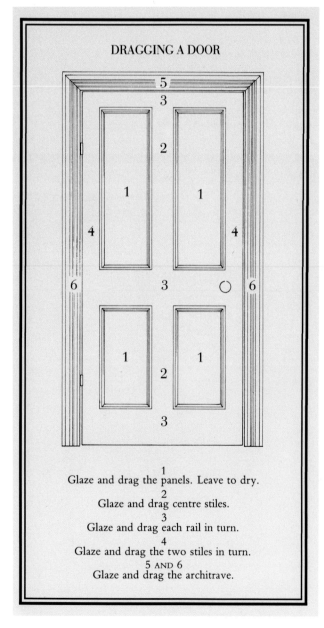

DRAGGING A DOOR

1
Glaze and drag the panels. Leave to dry.
2
Glaze and drag centre stiles.
3
Glaze and drag each rail in turn.
4
Glaze and drag the two stiles in turn.
5 AND 6
Glaze and drag the architrave.

1 An inexpensive flush door can be made to look grand by attaching moulding to it. To complete the effect, the dado and door have been woodgrained in birdseye maple. In this case, a watercolour technique was used, but doors can also be woodgrained in oils.

2 This door has been classically treated by dragging Burnt Umber and white over ivory eggshell. This requires concentration and the work needs to be executed precisely to achieve the appropriate and traditional clean look.

3 The panels of this hall door were ragged in Yellow Ochre and Raw Sienna, and the mouldings were highlighted using a ragged on technique (applying paint with a rag) in Terre Verte. The main frame of the door was dragged in the same mixture of yellows to match the walls.

4 Mahogany is an extremely expensive wood, but you can achieve the same richness and opulence with a painted finish on a cheaper door. Mahogany can be grained in watercolour or oil colour

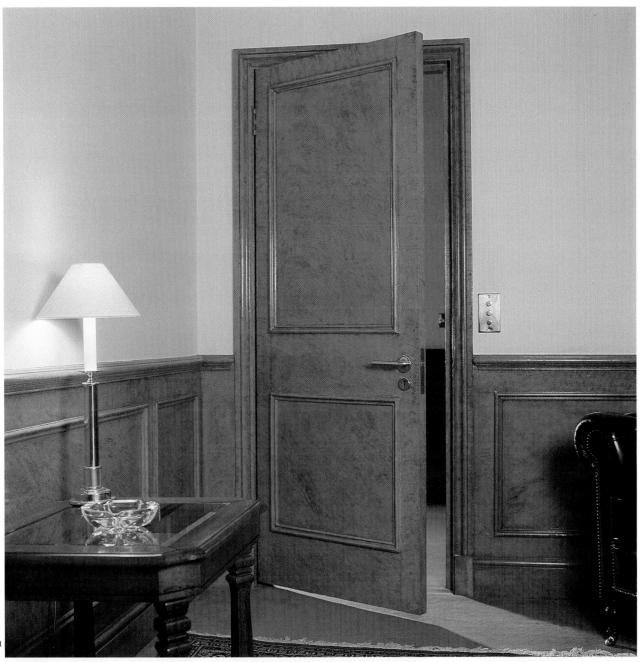

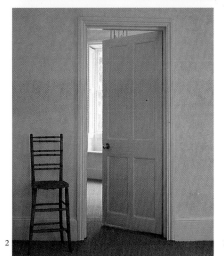

Dados, radiators, and skirtings

The dado is the area underneath the chair rail. The dado rail was an 18th-century device to protect the wall from chairs. Traditionally, it was sometimes panelled and sometimes left plain. It eventually evolved into a wall divider, positioned at different heights, and has lost its original function. Dados in Edwardian houses can be very high. They became unfashionable in the 1950s and 1960s, but are now popular again.

A dado provides all sorts of scope for decoration, and replacements can still be bought if yours has been removed at some point in the house's history. You can also paint a false dado, either as a *trompe l'oeil*, or as a line or darker tone.

The dado area is usually darker than the rest of the wall, acting as an anchor to the room. Traditionally, the wall might be dragged above and marbled below, or given a heavier stippled look below *trompe l'oeil* panels. The rail itself can be colour wiped or dragged. A variety of bravura finishes, such as porphyry and woodgraining, are also suitable for the dado.

Anaglypta, a type of raised wallpaper made to look like old, Spanish, raised leather, was sometimes pasted on the dado, especially in Edwardian houses. (Anaglypta was originally the name of the company that manufactured it.) To achieve this effect, paint in dirty yellow, stipple in umber colours, and gently wipe over the surface to look like raised leather. Different variations of colour can be used to simulate different types of leather.

1

Radiators

Radiators are always a problem. If you are redecorating the whole room, remove the radiators and put them back on later. Needless to say, radiators should be switched off before they are painted!

The scope for finishes on radiators depends on their shape; try sponging, ragging, and marbling. Help them to disappear by blending them in with the background and colour of the woodwork.

The heat from a radiator will make the conventional glaze mixture go yellow. Light colours should be made from artists' oil colour mixed with eggshell, which will make the mixture stronger. It is possible to buy a radiator enamel that does not yellow at all. Dark colours without white eggshell in them do not show yellowing so much. Avoid varnish; unless you have used a dark colour, varnish will only bring out the yellow.

Skirting boards

Skirting boards are often in bad condition because they tend to get knocked by furniture and kicked by people. If they are in good condition or have been replaced, a simple solution is dragging. Marbling and all fancy marble finishes work well. The skirting board and dado rail can be marbled to match. Alternatively, they can be ragged in strong colours with another heavy colour over, or ragged twice in similar colours to imitate marble and then varnished in gloss or eggshell varnish.

1 The skirting board, dado, and dado rail were marbled in a mixture of deep crimson on a bright pink background. Before starting, the dado was divided into slabs with a soft pencil. The wall above the dado was stippled in the same colour.

2 and *3* Radiators are often unfortunately positioned. You can try to blend them into the background or you can leave them plain. These are two examples of radiators merged into a marble background.

4 A deep and heavy Victorian skirting board and architrave were painted to match a real marble fireplace. The marbling was done in several stages and then varnished to protect it from scuff marks and scratches.

5 The dado rail was dragged in a mixture of colours and, when it was partially dry and the glaze was sticky, it was wiped. The paint spatters add to the antique effect.

Ceilings and cornices

The inaccessibility of ceilings make painting them in special finishes difficult. Colour washing and sponging on are the easiest finishes, and can be either light or quite dark to give a glossy, interesting look. Skies and clouds are also a possibility (see p210).

Ceilings are usually treated lightly. This is especially necessary in modern houses where they tend to be quite low. The balance of a room works far better with darker colours on the floor and lighter colours overhead. Occasionally, flats converted from older-style houses have disproportionately high ceilings. In such cases, you might consider a darker tone than would otherwise be feasible. Try not to leave the ceiling stark white; an off-white or a very slightly tinted white looks mellower and softer. The ceiling of a small corridor with a painted finish on the walls looks better if it is either painted in one colour or treated with a finish to match the tone. This prevents attention going to the ceiling.

Cornices act as a transition between the colour of the walls and the ceiling, so choose a colour in between the two. If you do not have a cornice, you might like to stencil a border. Small cornices are best wiped; stipple them first so that the colour does not run into the corners and accent the dips. If you have an ornate cornice, do not be tempted to pick out the shapes in different colours. It provides too much focus in the wrong area and is too fussy.

The space between the picture rail and the ceiling is called the frieze. It is a good area for freehand painting or stencilling. The picture rail can be dragged or painted in with the rest of the room.

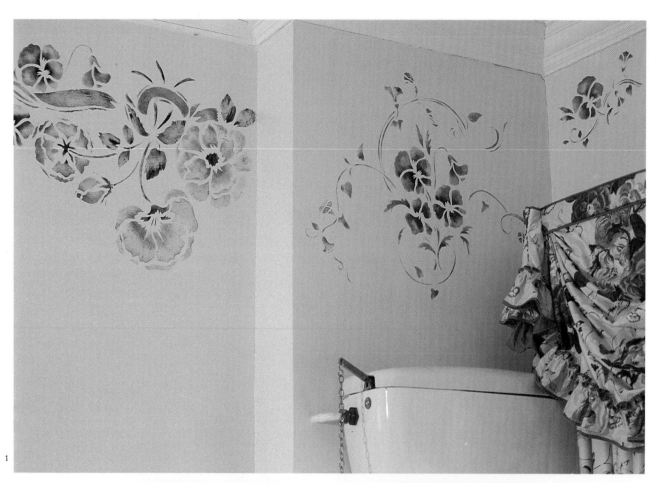

1

1 The best way to paint a moulded cornice to give depth and highlights is first to paint it in glaze and stipple it to distribute the paint evenly.

2 Leave the glaze until it is tacky, then wipe the moulding with a cotton rag to reveal the raised pattern. This is usually the last stage in decorating a room.

2

1 A border, based on the motifs of the curtain fabric was stencilled, using a brush technique. Although the design repeats itself in some places, it gives a generally free, uninhibited feeling.

2 Because this stencil has to fit into a restricted space, it is important that it retains a feeling of rhythm, rather than having a static quality. Although the design is derived quite faithfully from the curtain fabric, the stencil has been cut in a much looser and freer manner.

3

3 To provide a transition from the grey mutton clothed walls to the lighter ceiling, the plastered beams and cornice were painted in a light marble, using various tones of grey.

Fireplaces

The fireplace is THE focal point of a room, and it is probably a good idea to treat it differently from the rest of the room. There is scope for a lot of interest, especially if you have a plain fireplace. Marbling is always a popular technique, but any of the bravura finishes would be suitable. If there is carving on the fireplace, softening brushes do not work, as they only wipe the glaze off the raised areas rather than blending it, leaving glaze in the recesses. To marble such a fireplace, you will need a stippling brush to soften out the veins and patches of colour. Using frisk film or masking tape, an elaborate fireplace can be painted with a variety of decorative techniques. If a fireplace has extensive carving, it can be stippled and then colour wiped.

Wooden fireplaces can be bleached and limed to give a worn, weathered appearance. For added interest, try inlays with bravura finishes, or marble with inlay on plain fireplaces. Plain fireplaces also provide an opportunity for you to go mad and bold with freehand painting, picking up motifs from the rest of the room.

Whether made of stone, cast iron, wood, or even real marble, all fireplaces must be prepared with the appropriate primers and undercoats, before being given one or two coats of eggshell as a base.

1

1 A fireplace stippled in Payne's Grey, white, and Raw Umber to match the marbled dado. The mouldings have been wiped. The walls were stippled in Chrome Yellow. (Note the painted tortoiseshell mirror frame.)

2 Before it was marbled, this cast iron fireplace was extremely rusty and required considerable preparation. The generous veining gives the impression that the fireplace has been carved from a single block of marble.

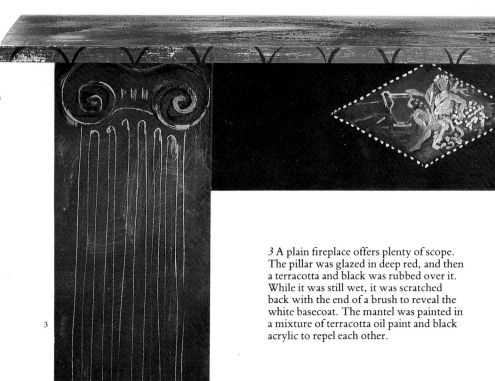

3 A plain fireplace offers plenty of scope. The pillar was glazed in deep red, and then a terracotta and black was rubbed over it. While it was still wet, it was scratched back with the end of a brush to reveal the white basecoat. The mantel was painted in a mixture of terracotta oil paint and black acrylic to repel each other.

Windows and shutters

Most window decoration is provided by curtains, which, nowadays, are becoming progressively more dressed and ornate. However, there is scope, albeit a little limited, for using decorative paint finishes.

Shutters are good for freehand painting, stencilling, or dragging, but most window frames are best simply wiped with a hint of colour; otherwise the colour provides too much contrast and is too stark. The outer moulding can be dragged. The wall area around the window can be stencilled with a border or painted with a freehand decoration. This is a good solution if the windows have blinds and need livening up. In South America, window panes are stencilled in simple patterns using white paint to block the harsh sun.

If the shutters are kept permanently folded back, the oil glaze behind them will become increasingly yellow because it is deprived of light. On exposure to light, the glaze will resume its original colour, given enough time.

1

2

1 The shutters and wainscot have been dragged in a classical manner in Burnt Umber and white to complement pink ragged walls. The window frames have been simply coloured wiped.

2 Curtains are not needed on this window, so a border has been painted around it for interest. Very dry Indian Red oil colour was used around a leaf shape cut from cardboard. A similar technique was used on the walls.

3

3 A small, square, cloakroom window has been sprayed with car paint in several colours on overlapping stencils, thus providing privacy. Ferns were chosen to merge with the garden outside.

4 The mouldings of the shutters were used as picture frames to create these charming, stylized paintings in a children's room. Either acrylic paint or oil paint may be used.

4

Halls, bannisters, and stairs

Halls should be welcoming, interesting, and friendly. They provide first impressions to guests and link different parts of the house. The hall should bring together the different elements and atmospheres of the individual rooms. This can make it very dull, but it does not need to be. Larger halls can be treated as a separate element, slightly zany perhaps in their colour schemes and approach, as they are areas which are only seen in passing. Halls very often lack good or interesting furniture, and the family's least favourite pictures are frequently relegated to the hall walls, so at least the paint can provide some interest.

The width of a hall and the height of its ceiling determine the scope for decorative painting. Narrow halls can end up looking like tunnels. If the hall is dark, use a yellow to reflect the light and bring a bit of life into it. The same colour on the ceiling should open it up a bit more too. Visual excitement can crowd a narrow hall so you may have to choose a soft colour with a delicate finish.

Bannisters

Only a limited number of finishes can be used for bannisters because they are fiddly. It is hard working around bannisters so do not take on anything which is going to be too time consuming. Quick and plain techniques that work well are ragging-on, mutton clothing and wiping, and simple colour wiping.

Stairs

Skirting boards are important on staircases because they are much more conspicuous; they should provide a link between the carpet and the wall. Generally, colour wiping is probably the best technique, but very intricate finishes, including marbling, can also be done.

The stairs themselves can be stencilled, perhaps like a simplified carpet pattern. Some older houses still have a stair rail; if yours has not, you can either fit a new rail, or paint a false dado where the stair rail used to be. This might be a *trompe l'oeil*, or, more simply, a masked out line or freehand brushline.

The beauty of staircases is that they are viewed from all sorts of angles, with continuous changes of viewpoint as you ascend and descend. This means that any part of the wall, floor or ceiling can be decorated.

The problem with decorating ceilings is reaching them. You must either hire scaffolding, or use a system of planking and step ladders, but it must be level and stable.

The borders along the skirting board can be stencilled up the staircase. They are easy to reach and can provide an interesting element of decoration.

Staircases offer different viewpoints all the time, so bear this in mind if you are contemplating a *trompe l'oeil* painting. *Trompe l'oeil* panels can be executed quite simply, once the principle has been established, and they look effective under the dado rail.

1 This hall has been given a traditional look by painting the dado in marble panels. The middle panel is a darker tone.

2 Bannisters are fiddly, and so need to be painted in a way that is not too time consuming. These have been ragged in Yellow Ochre and Raw Sienna first, and then in Terre Verte.

3 A *trompe l'oeil* rope and garland makes an attractive feature of this spiral staircase. The stair treads are stencilled with chevrons.

4 Another classical approach to staircases is to combine dragged newel posts and mutton clothed and wiped mouldings. The walls were mutton clothed in a nicotine colour.

5 A more elaborate and time-consuming approach is to paint a marble effect on the balusters. White spirit has been used to great advantage.

Floors

Now that paint and a feeling for the decorative have been rediscovered, a mass of new, old, and seductive ideas has opened up. Floors can, of course, be laid with carpets, tiles, and other conventional floor coverings, but a painted floor presents a more individual, conscious sense of style. That a floor is painted need not restrict it to a particular look. The beauty of paint lies in its flexibility and potential visual impact: in the formal or informal use of pattern, in faded, washed-out finishes, in crisply delineated designs, in classic symmetry and sophisticated colour—the possibilities are limitless.

You can experiment with a variety of finishes to achieve different effects. Floors can be stencilled, boards can be painted individually, some areas can be left unpainted and bleached or stained, a whole floor can be left plain with a *trompe l'oeil* rug painted in one corner, and elaborate or simple patterns, using inlaid marbles, porphyry, granites, and floating marbles, can be painted.

Painted floors can be much more practical than most people imagine. Their most obvious advantage is cost; paint is a cheap form of floor covering and can, therefore, be changed with comparative ease when the room is redecorated. This means you can go for something a bit more exciting than neutral carpet colours which have to blend in with the colour of the walls and furnishings, whatever they may be. When it is well protected with enough coats of suitable varnish (see pp130–1), it wears extremely well and is easily cleaned.

These floor designs are taken from John Carwitham's *Various kinds of floor decoration* (1739). Originally they were designed as patterns for stone, marble, or painted floor cloths.

They would be suitable for translating on to a floor using a variety of finishes and different colours. Paint the floor

with primer, undercoat, and two coats of eggshell in the appropriate colour. Leave it to dry thoroughly for 24 hours. Then, taking one colour at a time, the different areas can be masked off with tape, or drawn freehand depending on the look you wish to achieve and the steadiness of your hand.

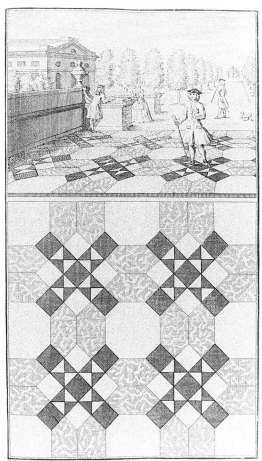

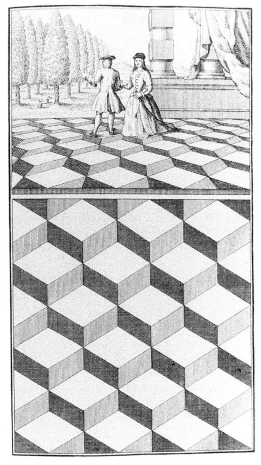

Whether you are designing a stencilled border or a completely inlaid marble floor, it is important to consider how your design is going to fit into the floor space and how you are going to deal with the corners. It is also a good idea to bear large and protruding pieces of furniture in mind. Remember that tiles, geometric shapes, and repeat or interlocking patterns will not look so satisfactory if they do not fit exactly on to the floor area. To this end,

you might consider altering the scale or the proportion of the design. In a room that is an awkward shape, or has a bay window, for example, a border can solve many problems. Otherwise, you will have to establish the centre by eye and intuition, particularly if the room is L-shaped. Most floor designs work better if they follow an even, overall pattern, or if they are based on a central motif, rather than on an asymmetrical design.

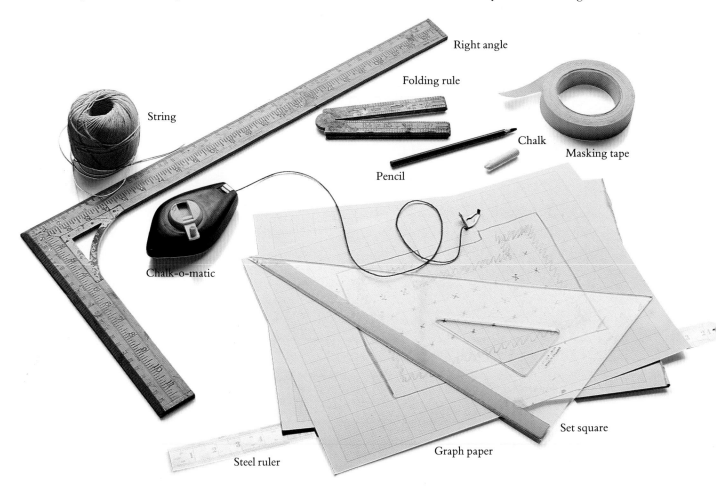

Right angle

Folding rule

String

Chalk

Masking tape

Pencil

Chalk-o-matic

Set square

Graph paper

Steel ruler

The technique

1. Measure the floor accurately, taking all its idiosyncracies into account. Draw it to scale on a sheet of graph paper. Now you can plan your design. This can be regular or irregular, conforming to traditional tile patterns, or something a bit more ambitious, such as translating a hand-woven rug into a painted floor design.

2. Before you begin work on the next stage, make sure that the floor is properly prepared and that the final basecoat is as you want it. Find the middle of the room. To do this, make a mark in the centre of each wall, and with the piece of chalky string join the mid-points of the opposite walls together. Alternatively, run the string diagonally across the room from corner to corner. Either fix it to the floor with drawing pins or ask someone to hold it. Make sure that the string is taut, lift it up, and let it spring back to place, making a cross with a central chalk mark on the floor.

3. Working from the middle outwards, draw up reference squares on the floor in scale with the graph paper. Indicate the width of the squares on either side of the chalk cross with a pencil. Check the right angles with a set square and use a metal straight edge to draw the lines. It is important to be accurate, as any discrepancies and mistakes will become exaggerated as the grid builds up. Alternatively, use the chalk cross as the centre of the first square, and then build the grid up. This method will work better for floors based on a central design.

4. Continue to work in this fashion, until you have all the reference points that you will need. Draw the design on the floor, matching reference points on the floor to those on the graph paper. Diagonal patterns can be drawn by joining up points on the grid. Arcs and circles can be drawn by tying a soft pencil to one end of a length of string and fixing the other end firmly to the floor, so that it acts like a pair of compasses.

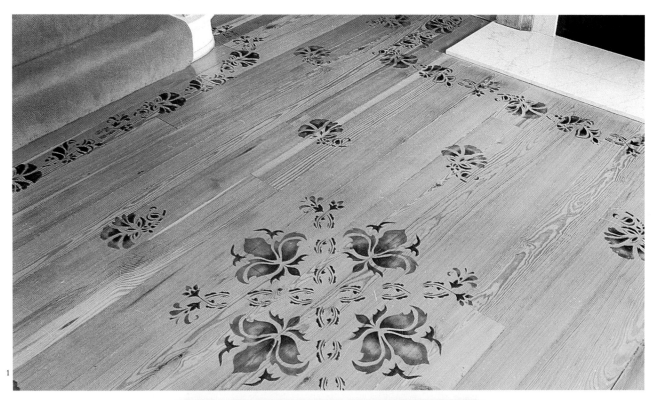

1 You can create an interesting and wholly appropriate effect by stencilling on wooden floorboards.

2 It is a shame to conceal good quality floorboards with carpets or other coverings. Stencilling provides a traditional and attractive form of decoration. Here, motifs from a regular border have been taken out and stencilled on the floor at random.

Preparing the surface

Naturally, the final look will depend very much on the state of the floor and how much time and money you are willing or able to spend on it. Old floorboards that have been hiding under carpets will almost certainly need attention before you can start to apply any paint (see pp42–3).

A floor in a poor condition can be covered with hardboard panels. This provides a firm, flat surface which can be stained, stencilled, or painted. You can lay the hardboard in large panels or smaller squares, and either nail or stick them down. The hardboard will need priming, undercoating, and eggshelling before the oil glaze can be painted on.

Bleaching wooden floors

Some floors may require sanding first. It is best to hire a commercial sander. Make sure all loose boards are nailed flat and that protruding nails have been hammered down.

Floorboards can be bleached by scrubbing with thick, domestic bleach. Make sure the room is well ventilated, as bleach fumes can be exceedingly irritating to eyes, nose, and throat. Rinse well when you have finished.

If household bleach is not effective, stronger bleaches are available. Use with extreme caution and follow the manufacturer's instructions.

Staining wooden floors

Coloured wood stains can give quite a different look to floorboards. The preparation is much the same as for bleaching. The boards should be sanded, if necessary, and, if not bleached, they should at least be well scrubbed and clean. Follow the manufacturer's instructions for applying the stain.

Stained floors can be stencilled or used as part of a floor design. If you use floor stainers as part of a pattern, gouge out the line of the design. This will stop the stainer from running on to adjoining areas.

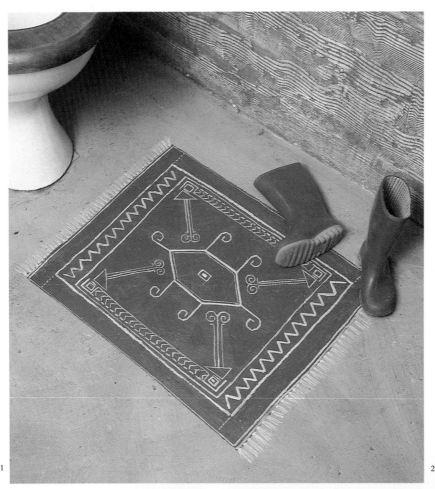

1 A *trompe l'oeil* rug has been painted on this cloakroom floor. This is a relatively quick and inexpensive way to add a stylish touch of humour to an otherwise plain floor. The concrete floor was first given several coats of floor paint. The rug was painted in acrylic and then varnished. An area like this that will have heavy wear requires a minimum of seven coats of very durable varnish.

2 A wooden floor in bad condition can be covered quite cheaply and to good effect with hardboard squares. Those shown here were painted in a loose and fairly haphazard manner before being stencilled.

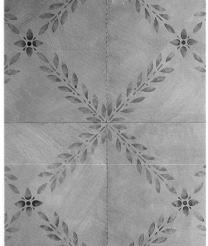

3 A border of leaves in a flowing design was stencilled on the wood block floor of this hall. It follows the curve of the wall and flows around the shape of newel post, making an unusual and eye-catching feature.

4 A large area can be covered fairly quickly with floating marble. The entire floor was painted and floating marbled. It was divided into squares using a Chalk-o-matic, and alternate squares were then painted with a thin mixture of blue glaze, allowing the underlying pattern of the marble to show through.

5

6

5 This floor was colourwashed over a geometric pattern of masking tape; successive layers of tape were peeled off at various stages.

6 Floating marble was painted over a bright blue basecoat in an indigo colour made up of French Ultramarine, Alizarin Crimson, and Burnt Umber. A dirty Indian Red was painted over. The floor was well varnished to withstand the rigours of constant splashing.

7 Plain and practical coir matting has been given a traditional border design. Painted freehand with oil paint, it is quick to execute but takes a long time to dry. Acrylic may also be used. 7

CHAPTER VI

Furniture

Painted furniture is found in palaces, rustic farmhouses, country mansions—almost any situation. Examples stretch from the ancient Egyptians to the present day and incorporate a wide variety of styles. The folk art of provincial America with its wide mix of European influences, the sophisticated French and Italian styles, and Scandinavian painted pine are among the best known. In the 18th century, furniture was often painted to reflect the elements and atmosphere of a specific interior design. Modern interests are more widespread and influenced by a diverse mixture of cultures and styles.

It is nice to paint the furniture to bring out the colours used on the walls. This chair was given a coat of dark green eggshell. It was then lined and hand-painted in Indian Red and dirtied white.

Small objects

Many small objects and similar pieces of furniture can be decorated with finishes not used elsewhere because of their intensity and their scale. Surfaces simulating semi-precious stones, tortoiseshell, and lapis lazuli, for example, are only convincing on a small scale. Some objects, like obelisks and plinths, probably look more effective painted with bravura finishes, but, in general, they are quite as good when decorated with simpler finishes like ragging, stippling, and spattering. Lining (see pp170–1) adds a nice detail to both types of finish, and bravura finishes can make use of inlays and imitation marquetry.

The smaller the object, the more refined the detail. Brushmarks have to be smaller because the scale works better, and the brushes used should, in any case, be the appropriate size for the object. Although the work can be fiddly, the paint covers the surface quickly so that small objects can be painted more precisely and with greater care. You can experiment and combine basic finishes with freehand painting or stencilling.

Remember that simply because an object is small, it does not necessarily mean it is easier or quicker to paint. Of course, it may certainly appear less daunting than a large one. Small things are open to closer scrutiny, as they can be picked up and examined. They must, therefore, be painted extremely well.

Frames

A carved frame offers less scope for decorative painting than a flat one. Stippling and colour wiping are suitable techniques for a frame with ornate moulding, but plainer ones can be sponged, stippled, ragged, and combed. The paint technique should also complement the picture within. Frames for mirrors can have an elaborate finish, but prints and paintings require a more subdued surround. It is quite usual to bring out a colour in the picture so that the frame and picture complement each other.

Frames were traditionally made from birdseye maple or tortoiseshell, and may be painted to simulate these (see pp106–7, 114–5). Beautifully carved frames may be gessoed and gilded (see pp122–7). Layers of gesso fill in the carvings and often have to be carefully carved back to imitate the original carving.

After painting the frame, it is often a good idea to decorate the mount. Watercolour washes can be applied with a wide brush, and lines with a ruling pen.

Baskets

Baskets can be sprayed quickly and easily with spray paints. These give a hard, shiny surface that may need some protection with varnish if the basket is to be put to practical use, as the paint can chip easily.

Boxes

Boxes and other flat surfaces can make use of decorative inlays. Busy marbles and other elaborate finishes can be offset by simpler finishes, but do not mix simple and bravura finishes. Marbling marks and veins do not have to go right through a box. The inside can also be painted, but it is difficult to get a stippling brush into the corners. Here the finish has to remain fairly rough, or be left in the ground coat, or painted another suitable colour.

It is impossible to paint the whole box at once; generally, the inside is painted first. Devise a method of

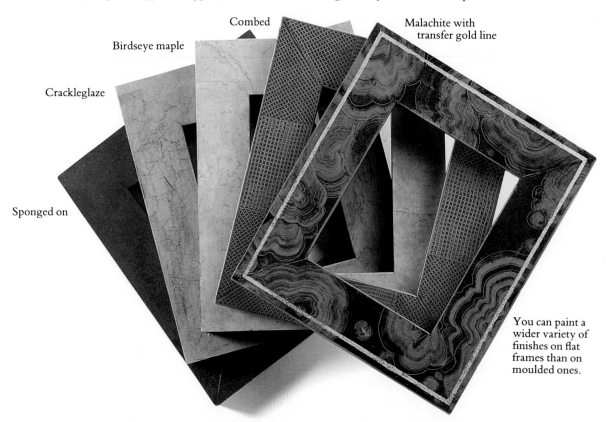

Combed

Birdseye maple

Crackleglaze

Sponged on

Malachite with transfer gold line

You can paint a wider variety of finishes on flat frames than on moulded ones.

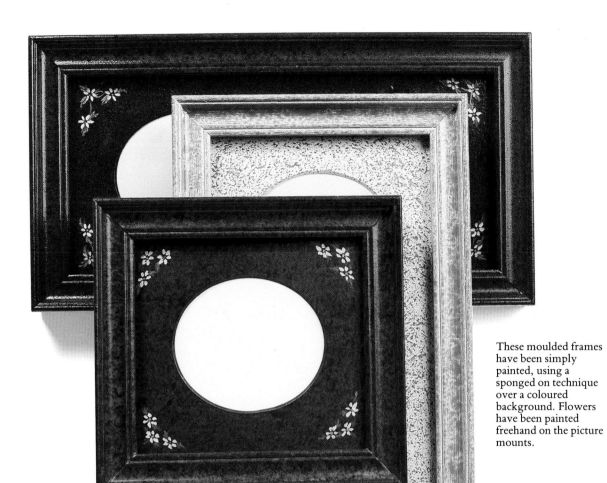

These moulded frames have been simply painted, using a sponged on technique over a coloured background. Flowers have been painted freehand on the picture mounts.

1 A simple rag rolled finish, defined by a green line.
2 A *faux bois* finish.
3 A tortoiseshell finish. Note the directions of the painted marks.

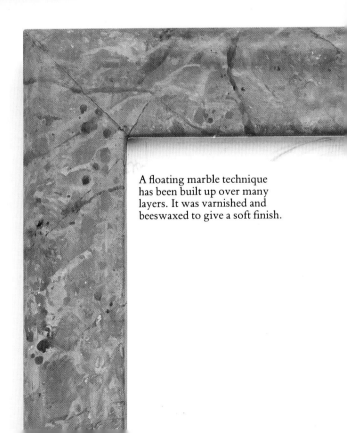

A floating marble technique has been built up over many layers. It was varnished and beeswaxed to give a soft finish.

supporting the box to leave your hands free. A good way is to use a cake decorating stand, or to stick it down on a large, round cake tin with a proprietary brand of mouldable adhesive. You can then turn the object round to give access to all sides and so paint it in one go, with the exception of the base. If you prefer to hold your object, you will probably have to paint it in several stages. For instance, the top and two sides of a box can be painted and allowed to dry. Then the remaining two sides can be painted. Remember that when an object is wet, you cannot move it around, so think about the order in which it is to be painted before you start.

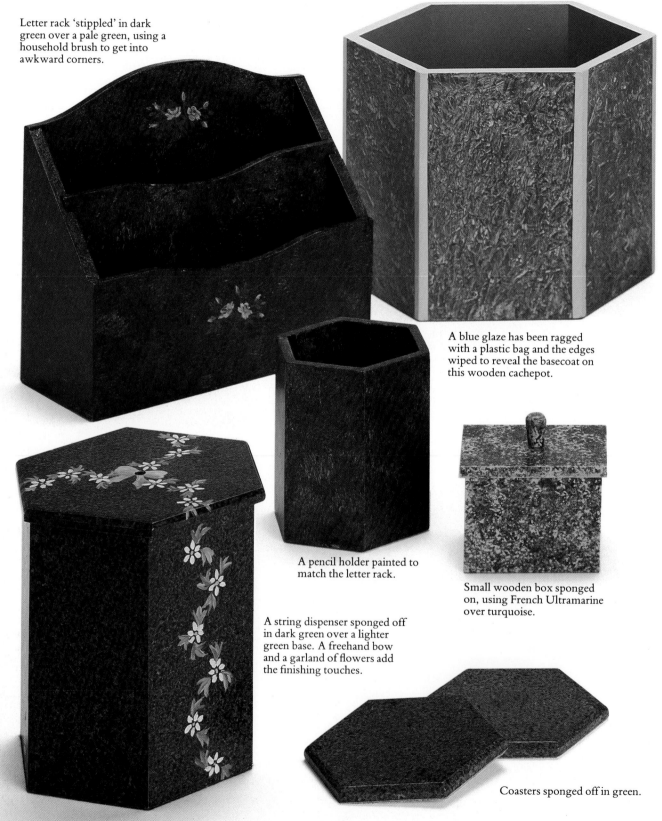

Letter rack 'stippled' in dark green over a pale green, using a household brush to get into awkward corners.

A blue glaze has been ragged with a plastic bag and the edges wiped to reveal the basecoat on this wooden cachepot.

A pencil holder painted to match the letter rack.

Small wooden box sponged on, using French Ultramarine over turquoise.

A string dispenser sponged off in dark green over a lighter green base. A freehand bow and a garland of flowers add the finishing touches.

Coasters sponged off in green.

Protecting the finish

Generally, the finish of objects liable to be picked up and handled should be protected in some way. Beeswax looks good and feels nice. The surface should be very lightly sanded with the finest grade of sandpaper, called flour paper. The beeswax can then be rubbed into it with wirewool. Anything that might be subjected to heavier use can be varnished (see pp130–1). To get a really smooth finish, you can rub down between coats of varnish. Be careful if you are using wet and dry sandpaper, as it works very quickly and easily. Flour paper is probably better and less risky.

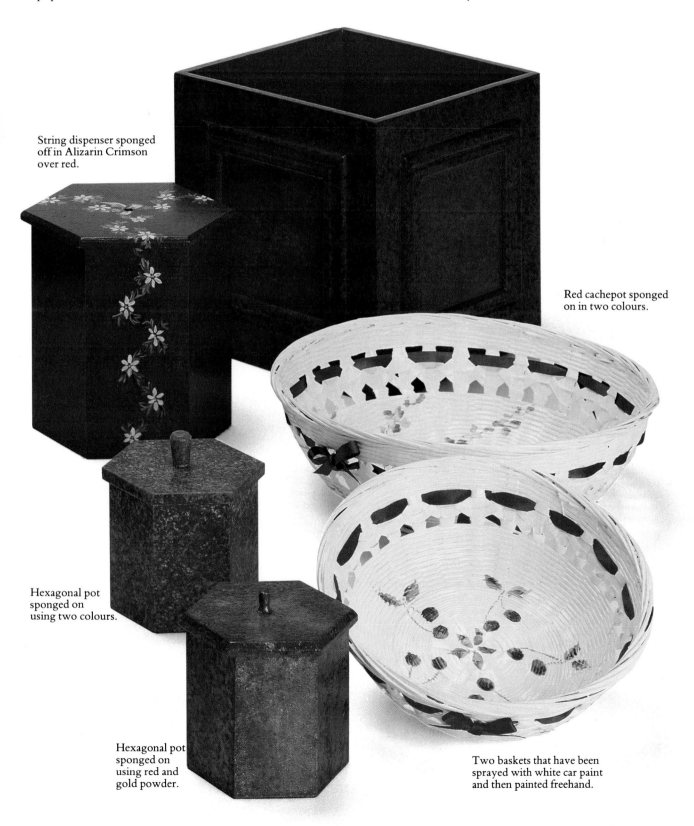

String dispenser sponged off in Alizarin Crimson over red.

Red cachepot sponged on in two colours.

Hexagonal pot sponged on using two colours.

Hexagonal pot sponged on using red and gold powder.

Two baskets that have been sprayed with white car paint and then painted freehand.

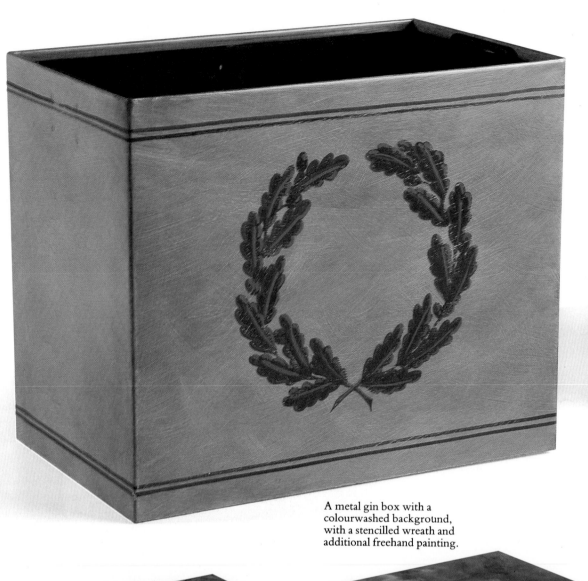

A metal gin box with a colourwashed background, with a stencilled wreath and additional freehand painting.

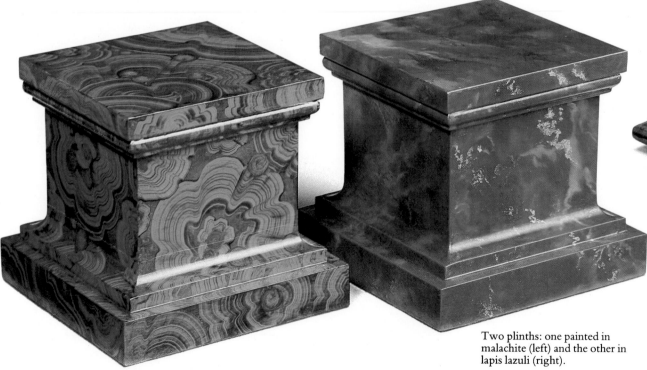

Two plinths: one painted in malachite (left) and the other in lapis lazuli (right).

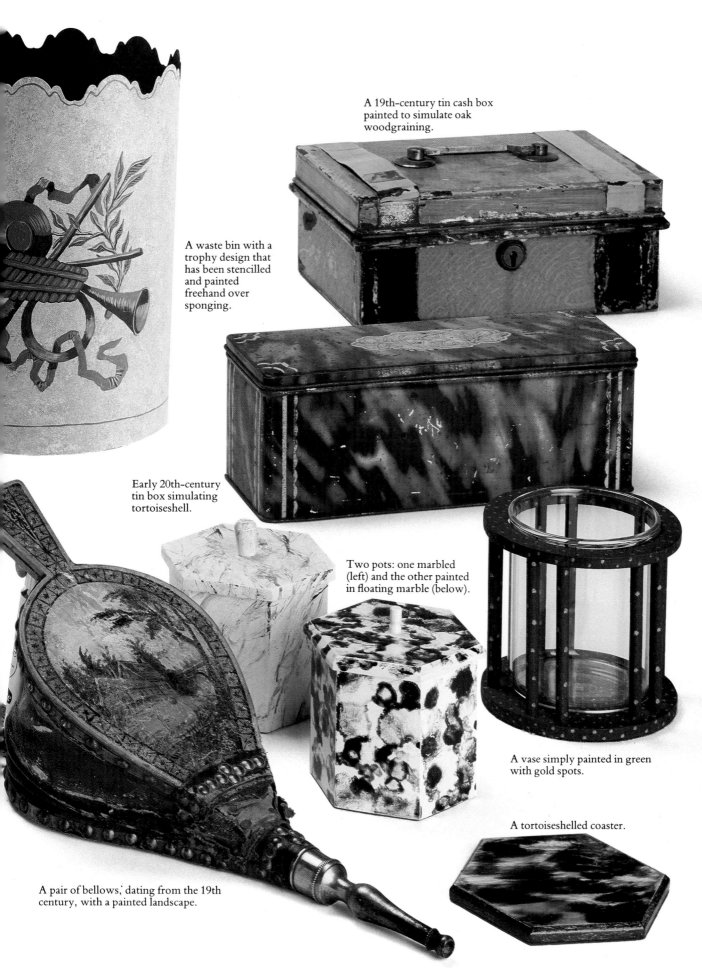

A 19th-century tin cash box painted to simulate oak woodgraining.

A waste bin with a trophy design that has been stencilled and painted freehand over sponging.

Early 20th-century tin box simulating tortoiseshell.

Two pots: one marbled (left) and the other painted in floating marble (below).

A vase simply painted in green with gold spots.

A tortoiseshelled coaster.

A pair of bellows, dating from the 19th century, with a painted landscape.

Large objects

Large pieces of furniture offer the opportunity to use surfaces to paint motifs and stencils as well as straightforward decorative finishes. In the 18th century, James and Robert Adam commissioned ornaments and furniture with designs of wreaths, honeysuckles, vines, and fans. The motifs they made popular were widely imitated, and medallions on chairbacks, for example, were even painted in grisaille.

Many larger pieces of furniture used to be lacquered. By the early 17th century, the Portuguese and the British were trading actively in the Orient, and the British East India Company's imports created a demand for lacquered pieces. Cabinetmakers began to experiment with domestic manufacture, using the varnishes and pigments available in Europe. Thomas Sheraton, George Hepplewhite, and Thomas Chippendale all painted and japanned furniture. Chippendale was an enthusiast of the 'Chinese' style in furniture. His admiration of *chinoiserie* resulted in a bamboo-like style; the best known examples can be seen in the Royal Pavilion, Brighton.

Large furniture offers a wide range of decorative options. The 'semi-precious' effects, such as tortoiseshell, malachite, and lapis lazuli, are best used as inlays, unless you are going for a total fantasy look. Marquetry designs are a fruitful source of inspiration.

Many larger pieces of furniture, such as blanket chests, have been charmingly and naively painted with folksy decoration. Even some of the beautiful Scandinavian *armoires* and cupboards have been painted with fairly loose interpretations of marbling. These look wonderful in the context of their own surroundings, and it is an important point to remember that a large piece of painted furniture may dominate a room and must appear in keeping with the general colour scheme and style. Bear in mind the surface of the wall behind it and the style of other furnishings in the room.

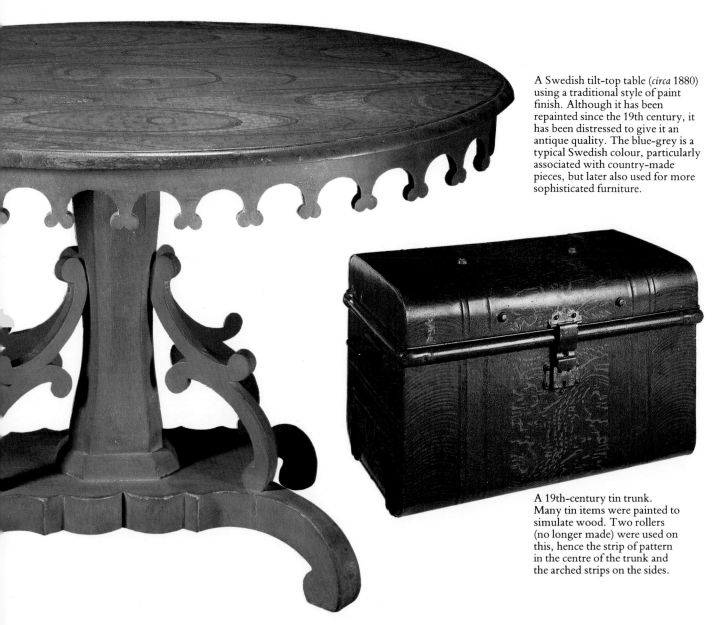

A Swedish tilt-top table (*circa* 1880) using a traditional style of paint finish. Although it has been repainted since the 19th century, it has been distressed to give it an antique quality. The blue-grey is a typical Swedish colour, particularly associated with country-made pieces, but later also used for more sophisticated furniture.

A 19th-century tin trunk. Many tin items were painted to simulate wood. Two rollers (no longer made) were used on this, hence the strip of pattern in the centre of the trunk and the arched strips on the sides.

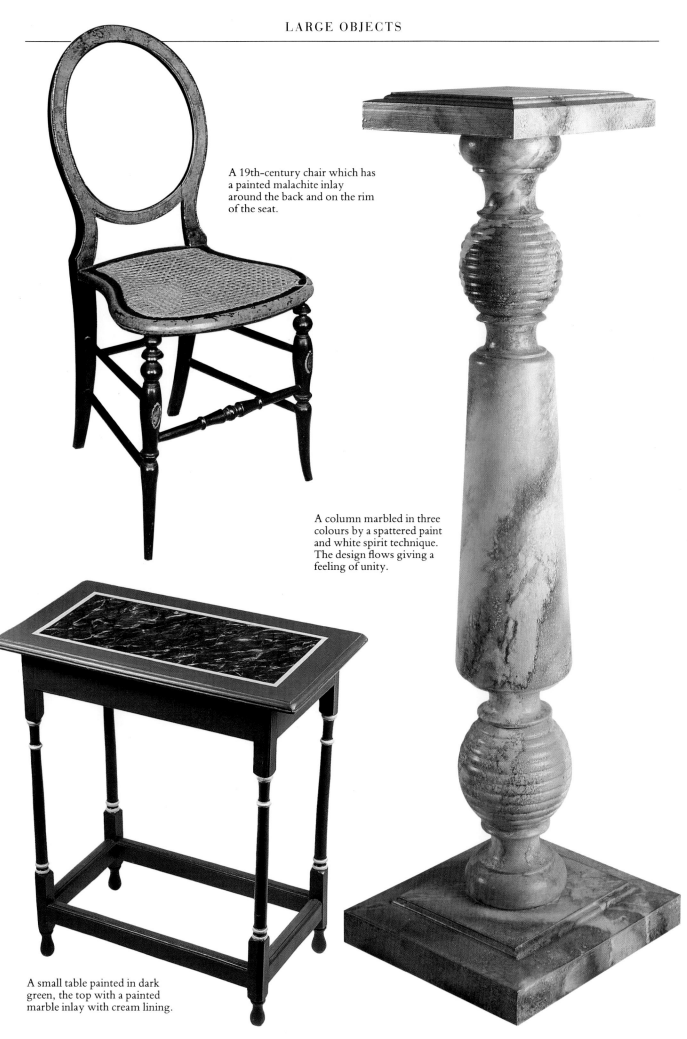

A 19th-century chair which has a painted malachite inlay around the back and on the rim of the seat.

A column marbled in three colours by a spattered paint and white spirit technique. The design flows giving a feeling of unity.

A small table painted in dark green, the top with a painted marble inlay with cream lining.

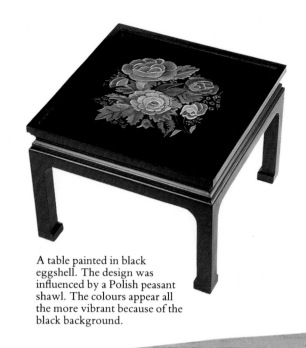

A table painted in black eggshell. The design was influenced by a Polish peasant shawl. The colours appear all the more vibrant because of the black background.

A fuso machine has been used to decorate this chest of drawers to give it a contemporary look appropriate to the style of the piece.

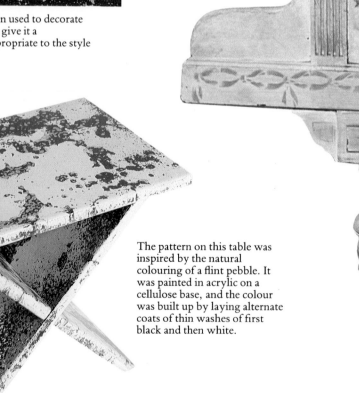

The pattern on this table was inspired by the natural colouring of a flint pebble. It was painted in acrylic on a cellulose base, and the colour was built up by laying alternate coats of thin washes of first black and then white.

A thin piece of wood has been shaped, given a stand, and painted to make an attractive firescreen. Such screens derive from 18th-century companions, thin, wooden, painted figures of people. All sorts of shapes can be made.

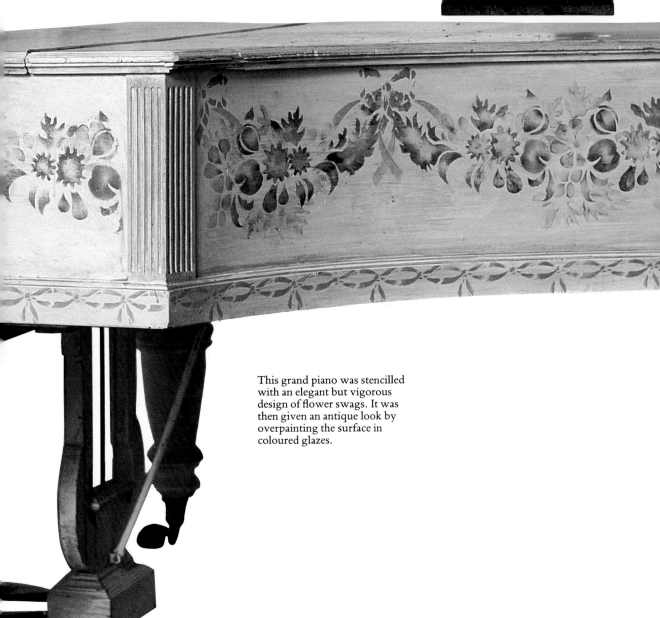

This grand piano was stencilled with an elegant but vigorous design of flower swags. It was then given an antique look by overpainting the surface in coloured glazes.

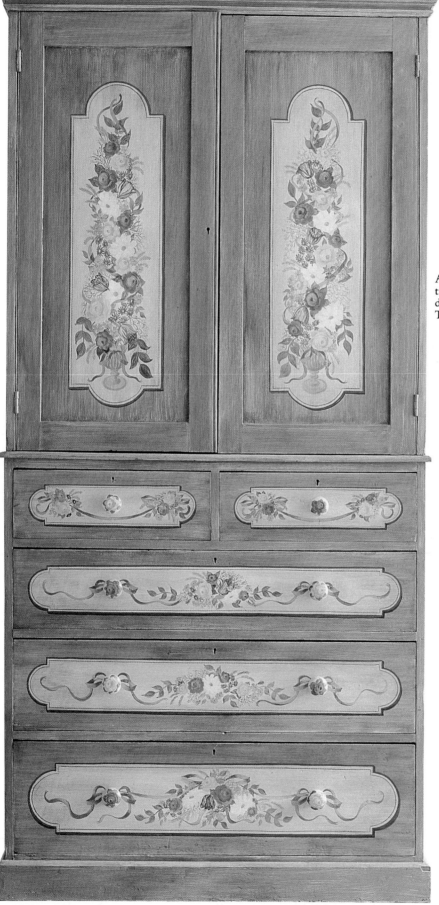

A contemporary linen press given a
traditional look using Swedish blue
dragging and hand-painted panels.
This was done using acrylic paint.

A 19th-century German chest of
drawers in traditional colours
and patterns.

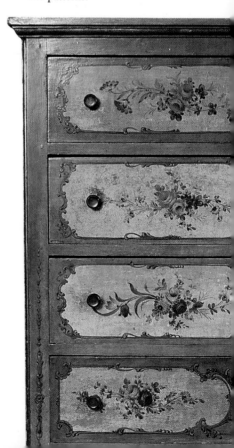

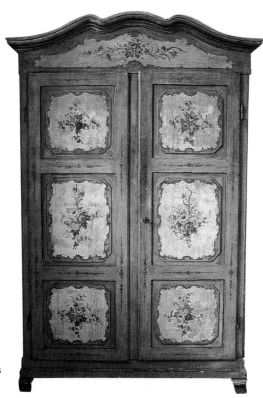

Irish corner cupboard (*circa* 1840). This unique piece of furniture originated from Kilkenny in Eire. The panels and drawers have a fantasy woodgrained finish.

A 19th-century German wardrobe with traditional painting.

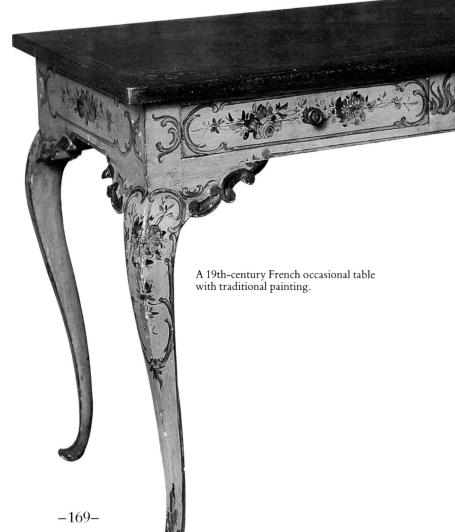

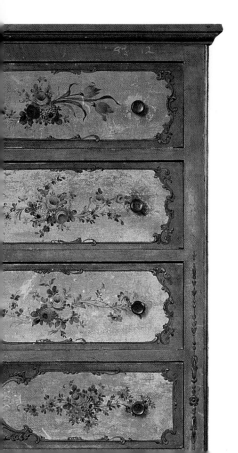

A 19th-century French occasional table with traditional painting.

Lining

Lining is used as additional decoration on a wide variety of painted furniture and other objects. Lines of colour are painted around an area of furniture, such as a table top, to sharpen or stress its basic shape. It works well on most types of furniture.

It gives an object structure and strength, and this is particularly true where colours are pale or the overall design lacks strength. Lining is especially useful on furniture that has been decorated with one of the basic finishes, such as sponging, ragging, and stippling, and that needs added decoration to provide a focus of interest. It also enhances the sophistication of pieces which have been painted with any of the bravura finishes. In the 17th and 18th centuries furniture was often lined over painted marbling, even though this did seem to contradict the reality of the marble.

Colour

The colour should relate to or contrast with the background. If it is used as a containing line, it may need to be a shade or two darker than the background colour. A light colour over a dark background will need to be opaque enough to cover it, so make sure the white you use is a good one, like Titanium White.

Techniques

There are various, classic design patterns, and they all have variations and permutations. The simplest approach is a single line that follows the shape of the surface at the same distance from the edge all the way round.

Obviously, thick lines are easier to paint than thin ones, and, if your surface is square and has been protected by a coat of varnish, you could make a line by using masking tape. It can be further embellished by adding a thinner line within the piece and by varying the thickness of the lines and the space in between.

Lining is usually done in between the last coat of dry oil glaze and the varnishing. Good, well-finished, professional lining needs a very smooth surface to allow an uninterrupted flow of paint. If the finish is not as smooth as it could be, you might apply a coat of varnish, and then rub it down with the finest grade of sandpaper to achieve a beautifully smooth surface. Equally, it may be worth finely sanding down the surface with flour paper to eradicate any irregularities in the paint finish.

Professional lining brushes have very long bristles or hairs. These hold a lot of paint and allow for a long, uninterrupted flow before they need to be recharged. However, they are difficult to control. It takes a steady hand and a lot of skill and practice to produce a perfect line with a professional brush. Swordliners are also excellent for lining. A brush like a rigger, which has longer hairs than an ordinary artist's sable brush, is a good alternative for the unpractised.

The colour needs to flow freely from the brush and should, therefore, be fairly thin. Use oil colour dissolved in a little white spirit to increase the flow of paint.

The more pressure you use, the thicker the line. You can use your little finger to keep your hand steady and at an equal distance and height from the surface. The brush has to follow the eye, not the other way round. Do not watch the brush; look slightly in front of it and trace the line the brush is *going* to draw with your eye. If you watch your brush, you will certainly wobble.

It is important to make yourself and your hand comfortable. Start lining in a place where your hand gets

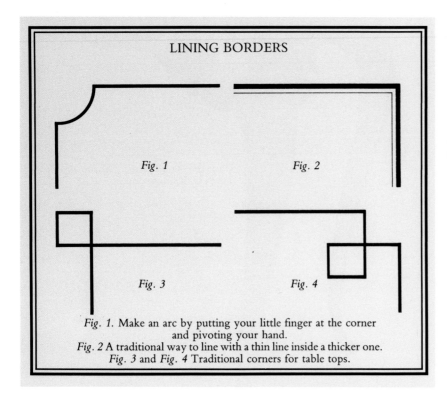

LINING BORDERS

Fig. 1

Fig. 2

Fig. 3

Fig. 4

Fig. 1. Make an arc by putting your little finger at the corner and pivoting your hand.
Fig. 2 A traditional way to line with a thin line inside a thicker one.
Fig. 3 and *Fig. 4* Traditional corners for table tops.

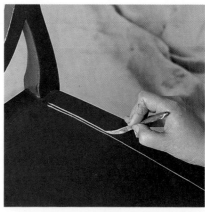

1 Load the swordliner with sufficient paint to finish one line at a time. Guide it down the edge of the piece of furniture, keeping your little finger stiff. Increasing the pressure will thicken the line. Continue the line down as far as possible. Paint the next line, and then wipe off any lines not required to make the corner neat.

the longest run with the most control; do not start lining and then find your arm runs out of sweep. Be careful not to smudge lines already drawn. If you are lining a straight-edged table, you can overlap the lines and then carefully wipe the overlap off with a rag. This is easier than trying to paint accurately up to a corner, as your hand will slow down as you approach the corner, and the quality of the line will change.

Short cuts
There are other, slightly cheating ways of lining that can work just as well. You could use a felt-tip pen; gold or silver might be particularly effective. Some felt-tip inks are water soluble; water-resistant pens work better. The lining should be protected with a coat of varnish afterwards (see pp130–1).

You will have to draw the lines out first with a sharp, soft pencil. Masking tape can also be used, but make sure the line is straight; masking tape can stretch and produce a curved line rather than a straight one. The adhesive is quite strong and has been known to lift off paint, so make sure the surface is thoroughly dry and has adhered well.

Manufacturers of rub-down lettering also produce lines of varying widths. These are quite thin and can bend round corners. If the surface is carefully varnished, it can look as good as the real thing.

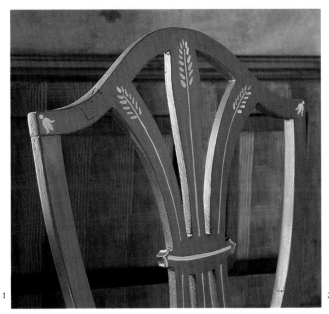

1 The edges of the chair were lined in Indian Red, using a small, sable brush, to highlight the general shape of the chair back.

2 These classic green dragged, hanging shelves were lined to emphasize their elegant shape.

3 Swedish grey-blue colour has been used in several tones on this small chest of drawers. A dark outer line with a lighter inner line defines the pale panel shape and echoes the bow above and below. This may have been done using a raised straight edge on which to rest the finger.

Printing

AND

Stencilling

One of the joys of the decorative techniques in this chapter is their immediacy and simplicity. In fact, 'techniques' is a misnomer in some instances, since anyone who made potato prints as a child can decorate a room using some vegetables, a small kitchen knife, and a pot of paint. Similarly, stencilling can be as complex or as simple as you care to make it. Stencils can be bought ready cut and in kits, or you can make complicated cut-outs with a myriad of registration marks. The results are immediate, and both stencilling and printing are within virtually everyone's capabilities.

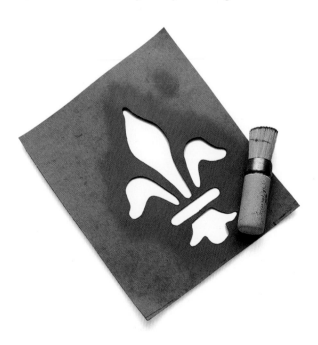

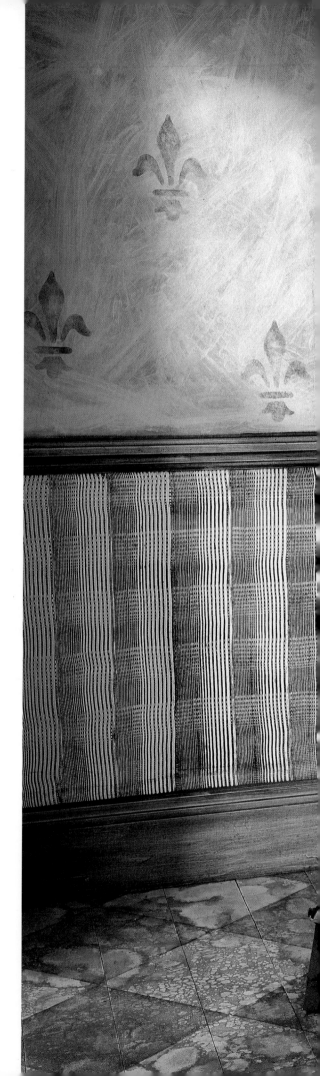

To balance the richer effect of the dado and floor, the upper part of the wall was lightly stencilled in a considered but irregular pattern, using Alizarin Crimson, French Ultramarine, and white.

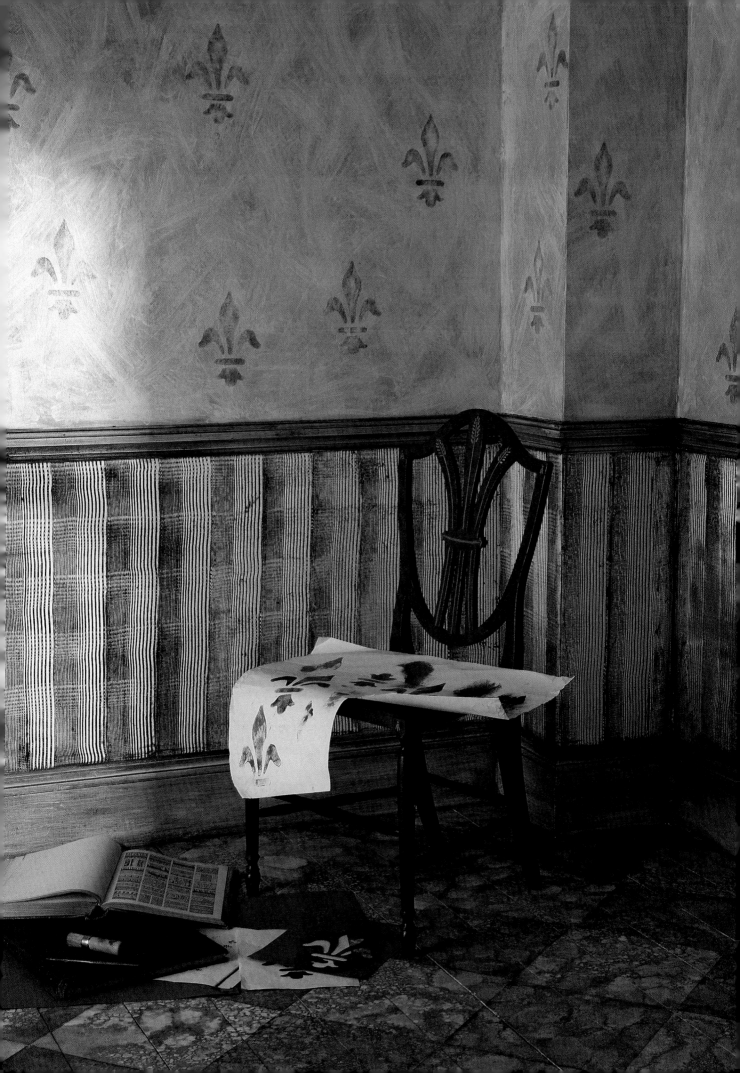

Fruit and vegetable prints

Anyone who can remember being at school should be familiar with potato cuts and prints. The ingenuity lies not just in the cutting and the quality of the print, but how it can be used to make a variety of patterns. These patterns can be used to decorate a border around a door or window, along the skirting board running up the staircase, as a frieze above a picture rail, to embellish a panel, or to decorate the wall above the fireplace.

Some of the nicest vegetables to use are the most unusual ones; mangel-wurzels, pumpkins, globe artichokes, large swedes, and turnips. You can experiment with almost anything.

The choice of paint depends on what you have available, but, generally speaking, water-based paints are best (perhaps oil-based paints do not mix with the water in the vegetables). The paint can simply be brushed on to the cut surface or rolled on to a sheet of plate glass for the vegetable to be stamped in.

It takes a while for the vegetable to absorb the paint properly and its printing quality will improve with use. Very wet vegetables or fruit are more difficult to use, but eventually the paint will act as a seal and start to permeate the flesh. Try it out on sheets of newspaper first until you get a satisfactory print.

Vegetables can be cut horizontally or vertically, used whole, or have patterns cut out of them. Really large, baking potatoes can be used to cut any shape you like—squares for a chequer board pattern or tile design, a fleur de lys, larger and smaller versions of flowers to print swags, etc. Make sure you can hold them securely so that they do not slip on the wall. Alternatively, you can make a handle by sticking a fork into them.

1 These are the basic tools for using vegetables and fruit to make prints. The design opposite (3) used a potato for the chevron and a carrot for the circle, over a frottage technique.

2 The panel on this door has a simple circle of leaves printed with a potato. Small, blue berries were hand-painted.

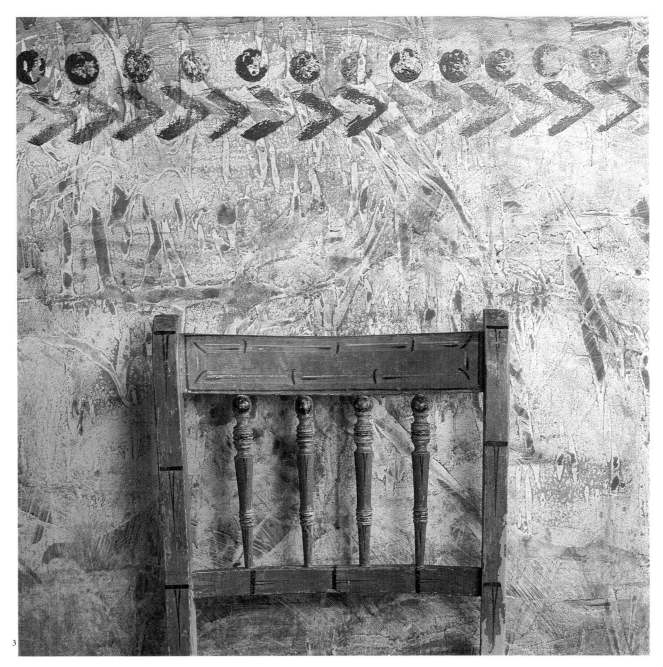

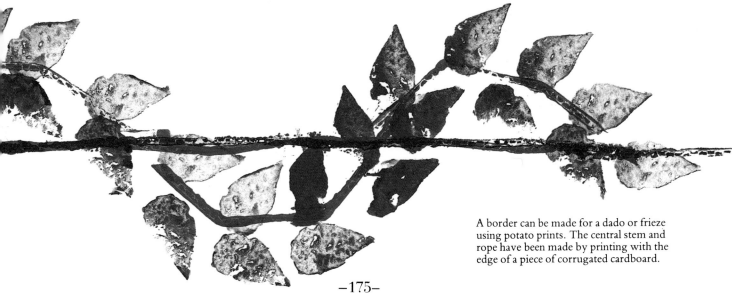

A border can be made for a dado or frieze using potato prints. The central stem and rope have been made by printing with the edge of a piece of corrugated cardboard.

Mechanical prints

Wallpapers used to be handprinted and, with some ingenuity and creativity, you can make your own at home. We are not suggesting that you turn your house into a William Morris workshop—homemade printing should be fun, immediate, and is not to be taken too seriously. The idea is to take a manufactured object, dip it in paint, and print it on the wall.

You can raid the children's store cupboard for paint (and objects). Children's ready-mixed PVA paint is good to use as it is water soluble when wet. Brushes can be washed in water and mistakes can be wiped away, but it dries to a practical, waterproof finish. Acrylic paints can also be used like this, but other water-based paints, such as gouache (especially vulnerable) should not be washed too frequently. These will require a coat of varnish as they remain soluble in water, even when dry.

The quality of the print depends on the surface, what you are printing with, and the density of the paint. Absorbent surfaces, such as lining paper, will take a print differently from, say, a non-absorbent, eggshelled wall. You may have to experiment first. Do not worry if only part of the object prints; you may decide to leave it like that, or overprint it, or touch it up later. Some absorbent objects may need to soak up some of the paint first before they print satisfactorily.

Suggested objects include children's wooden blocks, various bottle tops and caps for circles, nail heads for smaller dots, nuts, bolts, shapes cut out of corrugated cardboard, string, and rope. In fact, you can use anything that suits your needs.

You could paint a base colour over lining paper (perhaps using quite a subtle finish like mutton clothing) and then, when it is dry, use a combination of masking fluid, masking tape (do not forget you can buy different widths), and printed objects over the top. How random or formal you make it depends on the atmosphere of the room and your patience. A more structured design will need some careful planning using a plumbline and T-square to ensure that no lines run crookedly.

The essence of this technique is for you to enjoy yourself and to end up with something unusual, creative, and pleasing. Think about colour schemes and co-ordination carefully before you begin. Simply because this is a light-hearted approach does not mean your attitude to the preparation should be casual. It is easier to carry it out with panache if you know what you are doing and have thought about it all beforehand. Equally, this does not mean you cannot be adaptable or that you must put yourself in a strait jacket. Very often objects print differently from the way you expect them to, so you will need to step back and make assessments of the general effect from time to time.

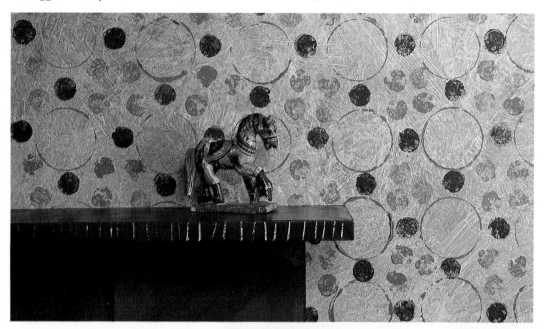

To complete the design and add depth and contrast, blue circles were printed with the wine cork. You can develop this idea by adding to it with gold felt-tip pens, hand-painted motifs, and drawing with oil crayons etc.

1 The background was colourwashed with a rag, and left to dry. The rim of a plastic cup was dipped in dark green PVA paint and used to print circles on the wall. Do not worry if the printing is irregular in places; this is part of its charm.

2 A cork from a wine bottle was used to print solid green circles. Some objects will print better than others.

Tree print project

This mural was produced almost entirely from printing techniques of one sort or another. It was executed on a white emulsion wall, with only the circle shape of the foliage roughly drawn in by hand. Virtually pure dark green was applied using a large fitch.

When the dark green paint was dry, the leaves were added. These were printed with swedes cut in a variety of shapes. Several colours were mixed in jam jars and then painted directly on to the swedes. The prints were made in a fairly loose haphazard manner, keeping the overall design in mind. The pears were printed using real pears. Different colours were painted on them in blobs, and then transferred to the wall. The stalks were added later with the wrong end of a paint brush.

Both the trunk and the pot were painted using a frottage technique with newspaper (see p193). Finally, artists' oil colour and white spirit were rubbed all over the wall to bring down the contrast and create a bit of background interest. The oil paint was absorbed into the emulsion, making a slightly soft, mottled look.

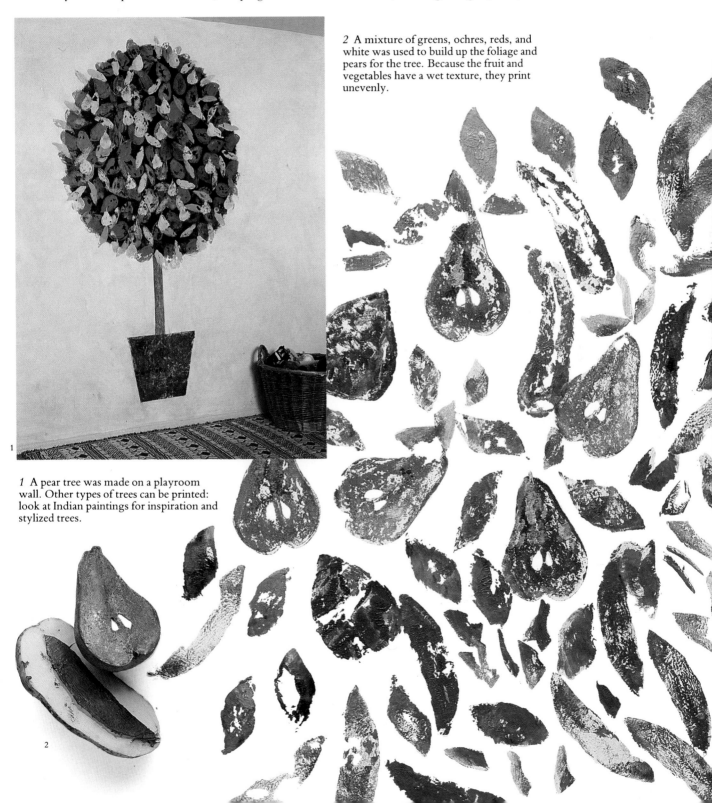

2 A mixture of greens, ochres, reds, and white was used to build up the foliage and pears for the tree. Because the fruit and vegetables have a wet texture, they print unevenly.

1 A pear tree was made on a playroom wall. Other types of trees can be printed: look at Indian paintings for inspiration and stylized trees.

Blocking

The earliest form of wallpaper was stencilled. As early as 1690, wallpaper was available in sheets and printed in patterns and effects called Floc-work, Wains-cot, Marble, Damask, Turkey-work, and Irish Stitch (a term for Florentine stitch, a popular and well-known zig-zag embroidery pattern). An increased tax on printed and painted paper then made wallpaper expensive, and people started stencilling directly on to walls.

It is equally easy to make wallpapers by printing directly on to the wall. The term blocking comes from the way in which wallpapers were first printed, that is to say from carved wooden blocks. Some William Morris wallpapers are still produced using the same techniques.

You can make your own blocks in a variety of ways. The easiest and quickest is to cut a shape out of a synthetic sponge. The design has to be something fairly simple because of the nature of the sponge, but you can overprint in another colour. Because a sponge is a chunky object to hold, you can use the body of the sponge itself as a handle.

Other block printing techniques are a little more complicated. A simple block can be made out of a flat piece of wood with a wooden cupboard handle screwed into the back. Anything that will present a flat surface capable of printing can be stuck on to the block.

You can experiment with different sorts of paint. Children's PVA paint is recommended; it is thick and ready mixed, although the choice of colours is limited. You may also like to try lino-printing ink on non-absorbent surfaces; it is available from most art shops.

1 Draw a rough outline of your design on a synthetic sponge with a felt-tip pen. Close-grained sponges are best. Cut away the areas of the design that you do not want to print with a sharp knife.

2 Either brush the paint on the sponge or dip it in a small amount in a paint tray. Water-based paints are best, with the exception of acrylic which dries too quickly.

3 Simply print the sponge on to a wall which has previously been decorated with a suitable finish. Here, the wall was wiped over with slightly diluted oil paint. If you are going to print an overall pattern, it is advisable to mark occasional guidelines with white chalk to help keep the pattern regular. If the pattern starts to print out of line, it is impossible to rectify later and the effect will be unsatisfactory. Simple designs and motifs will work best with sponges.

1 A piece of thick cardboard was cut to fit a wooden block. An interlocking design was drawn on it with a pencil. This kind of design requires more thought than a single motif. It was cut out with a sharp knife and stuck on the block with PVA glue.

2 Printing with a hard block works better on a flat wall, whereas a flexible sponge will accommodate greater unevenness. Areas which do not print clearly can be touched in with a brush later. The block can be painted with a roller or a household brush.

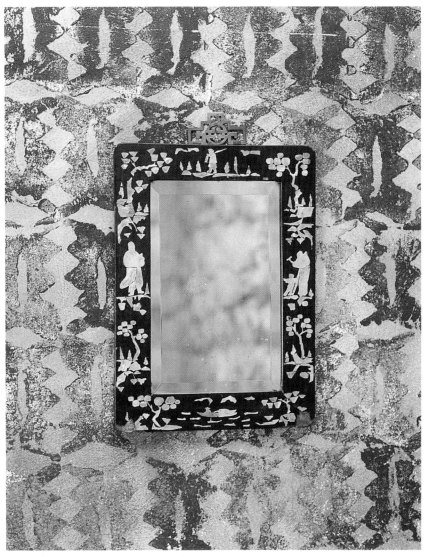

This design was based on an African motif. It was cut out of a polystyrene block. Any small discrepancies in printing are lost in the general effect.

Stencilling

Stencilling is basically making a hole of a certain shape in a piece of cardboard through which paint can be pushed. Cardboard is usually used nowadays, but the Victorians used zinc. This was a way of preserving stencils.

The art of stencilling is very ancient; one of the earliest known English examples is a stencilled wallpaper dating from 1509. The technique was known in the Middle Ages, and the word seems to have originated from the French *estenceler*, meaning to sparkle or cover with stars. It seems a nice idea for a modern stencil. Stencilling has been used as a decorative technique by many cultures. The Japanese, for example, use very fine, intricate stencils, where the paper and cardboard become as important as the image itself.

Stencilling directly on to walls became popular because of taxes on printed paper. It remains one of the simplest and easiest ways to decorate a room. The results come quickly and the whole process is fairly inexpensive. The great advantage of stencilling is its adaptability; it can fit into the shape and character of a room, whatever its size and dimensions. In addition, a stencil can be used and reused an infinite number of times and in many different ways before it exhausts its impact.

There are many different ways of stencilling; some people use a very precise method to suit a meticulous personality, while others have a more flexible and immediate approach. The same stencil can be reversed, turned upside down, twisted, and flipped over. It can be repeated, used singly, staggered, and dropped.

Surfaces

The best surface to stencil on is eggshell because mistakes can be wiped off with ease. Vinyl emulsion may be used as a basecoat, but paint has to be wiped off immediately. It cannot be wiped too many times because it is not waterproof.

A paint finish, such as ragging, is also a very good surface for stencilling, giving a broken effect to match the 'broken' effect of the stencil. Other suitable finishes include colourwashing and mutton clothing. The varied look of an unpainted plastered wall also looks effective.

Equipment

There are various attitudes about the amount of equipment and the method of execution (see pp38–9). Basically, stencilling is simply pushing paint through a cut-out design to decorate a wall. It is a very straightforward technique that can be enjoyed by creative and non-creative people alike.

Stencils can be bought already cut out, or they may be printed but still needing to be cut out. Alternatively, you can buy special paper and design, draw, and cut your own stencils. Some people seem to need the back-up of a variety of equipment, while others manage equally well on the minimum.

It depends, too, on the amount of work to be undertaken. It is hardly worth buying a cutting mat if you are only considering decorating one small room; a sheet of hardboard from a builders' merchant is perfectly adequate. Indeed, hardboard is the cutting surface used by many professional stencillers.

All equipment for cutting and painting your own stencils is available from diy shops, craft, and specialist stencil shops, and some department stores.

Drawing paper and pencils for designing the stencil and working out where the bridges are going to be.

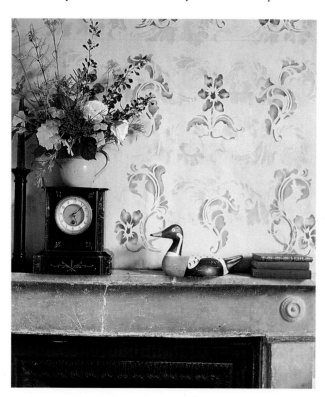

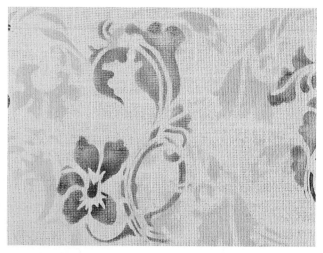

This beautiful design has been stencilled on a hessian background that was previously given a coat of white emulsion. It was first stencilled in subdued tones and then in stronger colours (see detail above). This is a wonderful way of transforming a boring wall into a rich and exciting feature, reminiscent of tapestry wallhangings.

Tracing paper for transferring the drawing on to the stencil paper. Confident stencillers can draw straight on to the stencil paper.

Practice paper Lining paper or the back of wallpaper is useful for trying out effects and colours, and for seeing how various elements of a stencil can be used together to create a different feel.

Masking tape for mending breaks and a large number of other general uses.

Cutting board The best is really a sheet of hardboard. It is cheap, portable, and readily available. Some people prefer special cutting mats which can be bought from art shops. A sheet of plate glass can also be used, provided the eges are taped. Glass is heavy to transport, and the cutting knife can slip on such a shiny surface. It also tends to blunt the blade.

Small craft knives The cheap, disposable types are best. Those with an indent on the handle for your index finger to rest on work very well. They are available from diy shops. Many varieties of cutting knives are available; make sure the blades are sharp and fairly flexible. Large solid knives are difficult to manoeuvre.

Stencil paper or acetate from art shops. The stencil must be cut from specially prepared, oiled paper, called manila paper, or from a transparent acetate, such as Mylar. Not all acetates are suitable, as some tear easily, particularly when you are cutting awkward corners. Manila paper is stiffer and easier to hold; acetate curls and can therefore be difficult.

Some people prefer acetate because you can see what you are doing and this helps if you are registering colour. However, colours can be stencilled individually with different brushes, and so registering is not difficult. For many professionals, the pros of using manila paper far outweigh the cons.

Stencil brushes are available from specialist shops. There are traditional brushes with short, stubby handles and brushes with long, thin handles. Shorter bristled brushes are best, as the long bristles tend to splay out with constant use.

Paint must be quick drying, so artists' acrylic is generally used. Keep's Intenso colour is a quick-drying oil paint, and artists' oils may be used if they are applied exceedingly sparingly and with a very dry brush. Acrylic must be washed out with water before it dries, while oil paint, which takes much longer to dry, should be washed out with white spirit.

Stencil crayon is also available from stencil shops. This is not applied directly through the stencil, but transferred to a small area of manila paper where it is picked up with the brush and used like paint.

Spray paints like car sprays, can also be used. Safety rules (see p187) should be observed.

Palette Plastic lids and tubs and old plates, etc. can be used for mixing paint.

Kitchen paper roll is useful for taking excess paint off brushes and general cleaning-up operations.

White spirit is necessary if you are using oil-based paints.

Chalked string is necessary for marking walls with a straight line when stencilling borders etc.

Other useful equipment includes a spirit level and plumbline, a tape measure, a ladder, if necessary, and rags for cleaning up.

Some people use a touch of spray glue to hold the stencil in place but it is not strictly necessary.

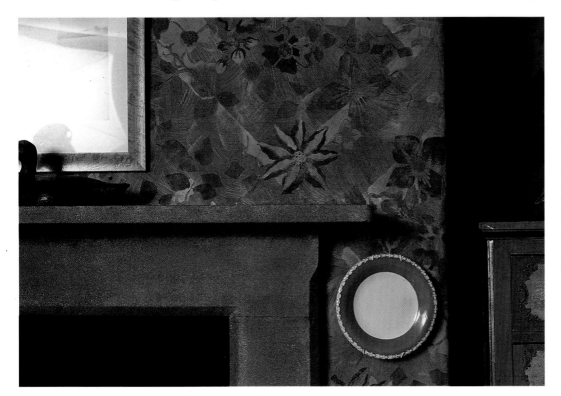

This dramatic and exotic stencilling was painted on a wall colourwashed in crushed raspberry. Various elements in the design have been stencilled over one another in a lively way not usually associated with stencilling.

Making a stencil

1. Draw your design and convert it into a stencil pattern by putting in the bridges. The bridges prevent the stencil from 'falling out'.

2. Trace the design and transfer it on to the stencil paper, or trace directly through the acetate.

3. Cut out the stencil with the knife pulling towards you and rotating the design when cutting circles and curves, rather than rotating the knife. The general flow and direction of the cutting line is almost more important than the quality of the cut edge, since stencilling produces a fuzzy rather than a hard-edged line.

4. Practise painting out on a sheet of lining paper.

Painting out

Using paint and an even, short-haired brush is the traditional way to stencil. This can give a grainy effect, and this can also be achieved with a stencil crayon. The colour can be filled in until solid; it is important to keep the tones similar, otherwise the stencil can look stark. It is important to put very little paint on the brush; most mistakes come from an overloaded brush. Wipe off surplus paint with kitchen roll. Dampen the brush very slightly in water (acrylic paint) or white spirit (oil paint) if it is too dry, but ensure that all excess is removed.

Paint through the cut-out using gentle, circular strokes, building up colour to achieve a shaded look and adding more as you want it. Use one brush for each colour. Merge the colours into each other; where they overlap they will produce a third colour, adding to the hand-painted look. Do not worry about small mistakes. They will probably not be noticeable when you have finished a run of stencilling. If they are conspicuous, clean off acrylic paint with a small amount of bath cleaner, or retouch the wall with a little base paint. Oil paint may be cleaned off with white spirit before it has dried.

The most important aspect to bear in mind is to use hardly any paint, and to go over the stencil again to build up colour. It is surprising how little paint is needed to make an impression. You can lift the corner of a stencil (or remove the stencil from the wall and then reposition it) in order to see what sort of an effect you are making.

Useful tips

Take a palette with extra paint up the ladder with you. Otherwise you will have to keep going up and down, which is extremely tiring. Every now and then, stop and relax your arm to prevent the muscles stiffening. Do not worry about discrepancies in colour and shading; these add to the charm.

1 Make a rough drawing, indicating where the bridges of the stencil will be. Fill in the areas that you are going to cut out to check that the bridges are in the right places, and that the stencil works.

2 Make a tracing of your drawing. Secure it with masking tape at the corners to prevent it moving. Experienced stencillers sometimes prefer to draw directly on the manila paper or acetate.

3 Turn the tracing over and place it on a piece of manila paper. Scribble over the lines of the design with a soft pencil (2B). This transfers the drawing.

4 Fill in the areas to be cut out. This will help you to concentrate on what you are cutting out and to avoid mistakes.

5 Cut the stencil out with a sharp knife. Always pull the knife towards you. When you are cutting round corners, turn the paper, not the knife.

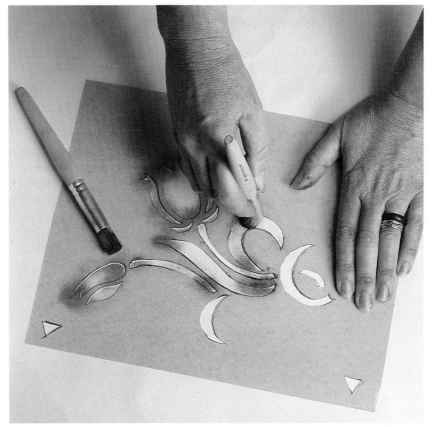

6 If the knife has not cut properly and some edges are not sharp, do not worry. This will not be apparent in the finished stencil. Cut any necessary registration marks.

7 Test the stencil by painting out on a piece of lining paper. Use a separate brush for each colour and very little paint.

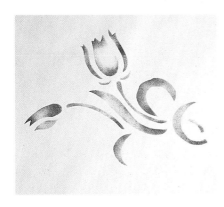

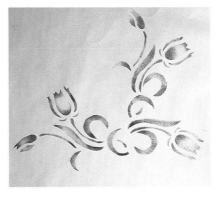

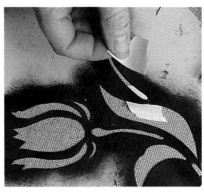

1 When you are stencilling a single stencil in more than one colour, leave it in position until it is finished. Where two colours overlap, they merge.

2 Try out the various ways of using your stencil. You can repeat both the whole stencil and different parts of it.

3 You can mend a broken stencil with masking tape. Stick a piece of tape over the tear, and stick another piece on the back. Press them into place and re-cut the stencil.

Positioning

Borders and friezes Besides a single, central motif, stencilling very often involves a border or frieze. It is important to work in straight lines; crooked lines will ruin the effect. Even if the floor and the ceiling slope, the frieze or border must run straight. Plumblines, chalky string, and spirit levels are immeasurably helpful. If the floor is straight, measure up from the skirting board in several places on each wall and mark with a pencil or chalk. Then, with a helper, stretch chalked string through the chalk marks and 'twang' firmly to make a chalk mark. This will give a straight line on which to place the edge of the stencil paper.

For borders with leaves and fruit, keep the weight at the bottom of the design by shading more heavily. Make stalks and other small parts of the design darker than the rest. Tall houses with deep drops on stairways can make use of stencilling at skirting board level. This brings the eye down and adds interest to an otherwise boring space. Try putting one border inside another, or edge a stencilled design with double lines and allow the motifs to break through the lines.

Borders around floors To mark up positions for a border around a room, first find the centre of the floor by stretching lengths of string diagonally across the room. Repeat the process, stretching the string from the mid-points of the walls, ensuring that the two strings cross each other at right angles and through the centre of the room. From these two straight lines measure out the desired width of the border, and mark. Join up the marks and stencil.

Corners To change direction at corners either fake them by eye, adapting your stencil, or make a stencil corner or mitre with masking tape. Your eye will constantly adjust a crooked line but not notice a faked corner. (Carved picture frames are nearly always faked at the corners.)

All-over stencilling Work out a grid system. Decide the intervals between each stencil, then mark that distance on a piece of wood or cardboard, and use in place of a ruler.

Circles To make a central motif, such as a wreath, for tables and ceilings, take a suitable length of string and tie a piece of chalk to one end. Fix the other end with a drawing pin and use like a pair of compasses.

Choosing a suitable design

It is not necessary to be good at drawing for successful stencilling. Pre-cut stencils can be bought, or you can trace or copy a design. Even very simple designs work well, for example egg and dart, and dot and dash.

Inspiration and design sources for stencilling may be drawn from a number of starting points. Natural forms provide a host of ideas: plants, flowers, climbing and trailing plants (ivy, clematis, honeysuckle, convulvulus, roses etc. are particularly good for running borders), ferns and leaves, fruit, birds, butterflies, dragonflies, snails, and shells. Animals work, too, if their shape is fairly simple and identifiable.

Wallpaper designs are particularly helpful, especially those that imitate damask, like flock wallpapers of the 18th and 19th centuries. A background stippled with an intense colour with a darker stencil over in quite solid colour can look very rich.

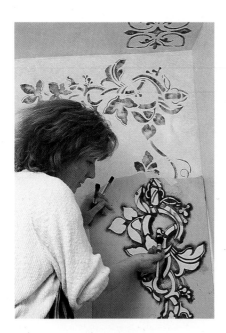

When stencilling in awkward corners and inaccessible places (here, above a bath), you will need to secure a manila stencil with masking tape. Elsewhere, it can be held in place by hand. The cornice (see right) can be made more interesting if the stencils are not symmetrical.

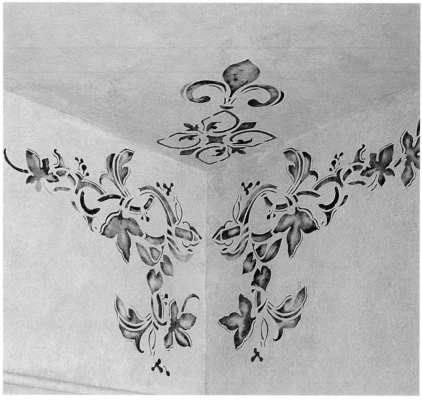

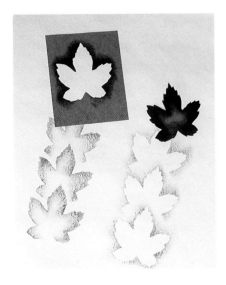

The outline was drawn round a leaf on manila paper. It was cut out and used as a traditional stencil. The solid leaf shape was then used; paint was brushed away from the edges. This second method was used for the frieze (right).

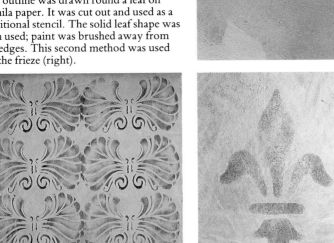

This design has been stencilled on raw plaster. The tonal shading is ideally suited to the texture of the plaster. The design was based on a Victorian brocade.

A fleur de lys provides a perfect motif for a stencil design. The bridges fall automatically into the right places.

This stencil is based on an early American design and is made up of several motifs. In the 19th century, itinerant stencillers used to travel the country with pattern books.

The lavatory seat and cupboard under the basin have been decorated with a pansy motif derived from the curtain fabric. Furnishing fabric is often a good source of inspiration, but the design should be quite freely adapted for the stencil, as it is here.

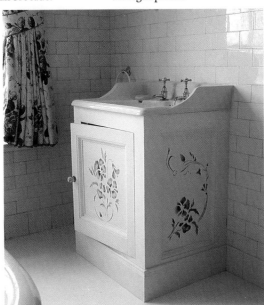

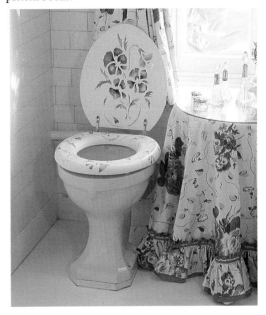

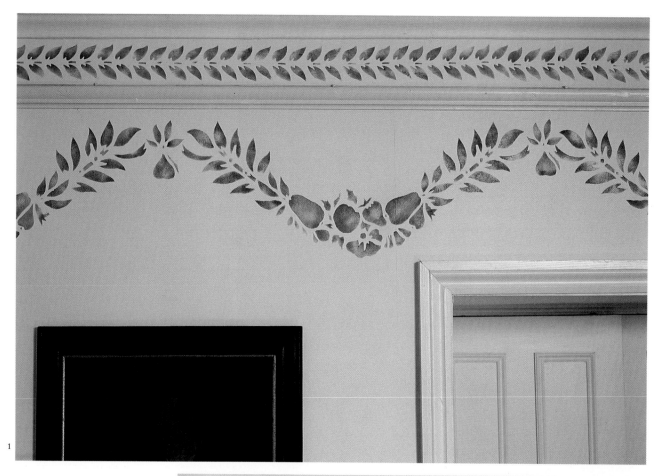

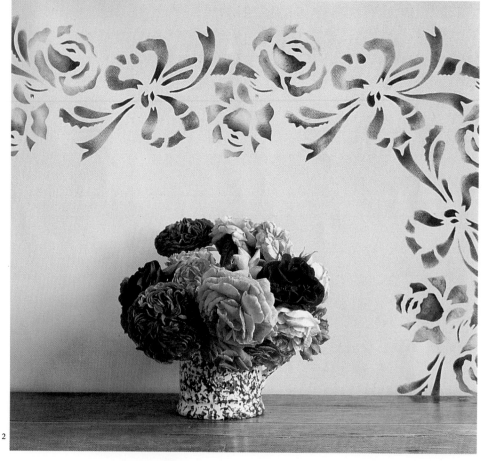

1 A classical swag of fruit and leaves has been interpreted in a modern-style stencil. It was painted using a brush technique and quick-drying oil paint in a mixture of colours. Both the stencils shown on this page were designed and executed by Felicity Binyon.

2 Bows are traditional and popular motifs for stencils because they are flowing and adaptable shapes. Besides being pleasing shapes, they also help to make a connecting link between other motifs, giving the stencil continuity and rhythm. Note how the different intensity of paint gives form to the flowers.

Spray paints

Different effects can be obtained with spray paints; usually car spray paints are used. They are readily available in a wide range of colours. The effect is very fine and delicate, with clear, clean lines. Colours cannot be confined to one small area, but give dispersed colour. The chief advantage of spray paints is that they can be used to paint on all sorts of unlikely surfaces and will adhere quite well. Shiny kitchen surfaces and metal can be painted and, even if the paint starts to wear, it can easily be retouched by matching up the stencils and carefully blending in another layer of paint.

As with other paints used in stencilling, it is important not to be too heavy handed. Use a light spray initially, and build up colour, rather than make too sharp an edge and too definite a colour. Colours can be mixed on the surface by spraying first one and then another.

If you want particular colours to be in particular places and the spray has been misdirected ending up in the wrong place, do not worry too much. The hand-made look is part of the charm and, as long as you are not too heavy-handed with the paint, it will not matter.

Precautions with spray paints

Vapour given off by spray paints can be toxic so:
1. Always work in a well-ventilated room.
2. At least every three hours leave the room altogether for a while.
3. Wear at least a non-toxic particle mask for short jobs. For a longer job, wear a protective mask available from car paint shops. It should be stored in a plastic bag.
4. Shake the cans well before use. When the job is finished, turn the can upside down and spray a few short blasts on to newspaper to clear the nozzle.
5. If the nozzle sticks when you are in the middle of a job and you cannot clear it, take the nozzle from another can to replace the faulty one. Clean the blocked nozzle with acetone.
6. Only the lids of spray cans are marked with their colours, so be sure to mark the bottoms as well to avoid confusion when you are using several all at once. It also helps if you want to use a particular mix of colour again.

Spray paint equipment

Additional equipment besides that previously mentioned is required.
Acetone or nail varnish remover for removing mistakes and cleaning hands.
Spray glue Spray paint has a habit of creeping under everything so the stencil needs to be held more firmly in place than for stencilling with a brush. The reverse side of the stencil can be sprayed very lightly with spray glue to hold it in position. Only the slightest amount is needed to make the surface tacky.
Newspaper is needed for masking. Areas which are not to be sprayed should be masked off using masking tape and newspaper. You will also need rough paper for trying out colours and for use when clearing nozzles etc.
Silicone release paper If you are working on a very long border, the stencils may become too tacky. Silicone release paper laid over the top and gently pressed over the stencil helps.
Cotton wool buds are useful for removing small errors.
Cotton wool pads can be used for wiping the nozzles.

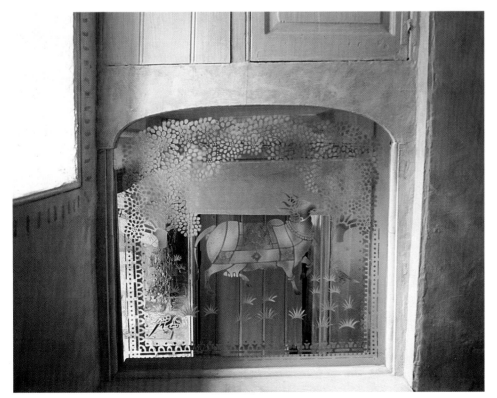

A window at the bottom of a staircase was stencilled with car sprays. Three motifs were taken from a Dover Book of Indian stencil designs. Their scale was altered by means of a photocopier; various sizes were tried against the window until the design was satisfactory. The stencil was then traced and cut out. Four spray colours were used and allowed to drift on to each motif to give a soft, cloudy look. Although this is fairly tough, it cannot withstand a lot of cleaning.

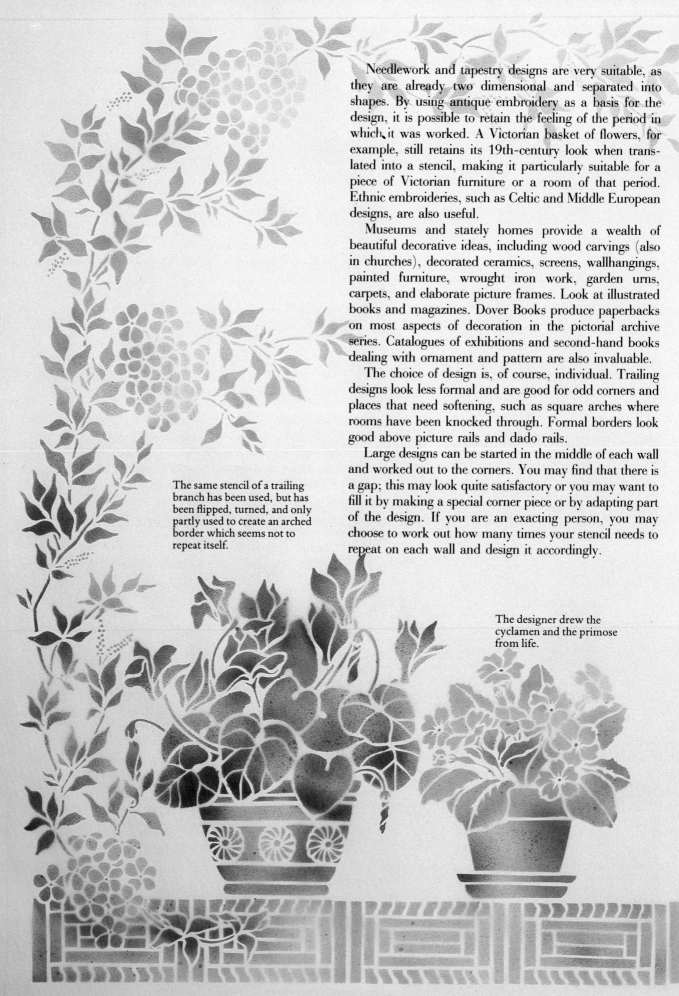

Needlework and tapestry designs are very suitable, as they are already two dimensional and separated into shapes. By using antique embroidery as a basis for the design, it is possible to retain the feeling of the period in which it was worked. A Victorian basket of flowers, for example, still retains its 19th-century look when translated into a stencil, making it particularly suitable for a piece of Victorian furniture or a room of that period. Ethnic embroideries, such as Celtic and Middle European designs, are also useful.

Museums and stately homes provide a wealth of beautiful decorative ideas, including wood carvings (also in churches), decorated ceramics, screens, wallhangings, painted furniture, wrought iron work, garden urns, carpets, and elaborate picture frames. Look at illustrated books and magazines. Dover Books produce paperbacks on most aspects of decoration in the pictorial archive series. Catalogues of exhibitions and second-hand books dealing with ornament and pattern are also invaluable.

The choice of design is, of course, individual. Trailing designs look less formal and are good for odd corners and places that need softening, such as square arches where rooms have been knocked through. Formal borders look good above picture rails and dado rails.

Large designs can be started in the middle of each wall and worked out to the corners. You may find that there is a gap; this may look quite satisfactory or you may want to fill it by making a special corner piece or by adapting part of the design. If you are an exacting person, you may choose to work out how many times your stencil needs to repeat on each wall and design it accordingly.

The same stencil of a trailing branch has been used, but has been flipped, turned, and only partly used to create an arched border which seems not to repeat itself.

The designer drew the cyclamen and the primose from life.

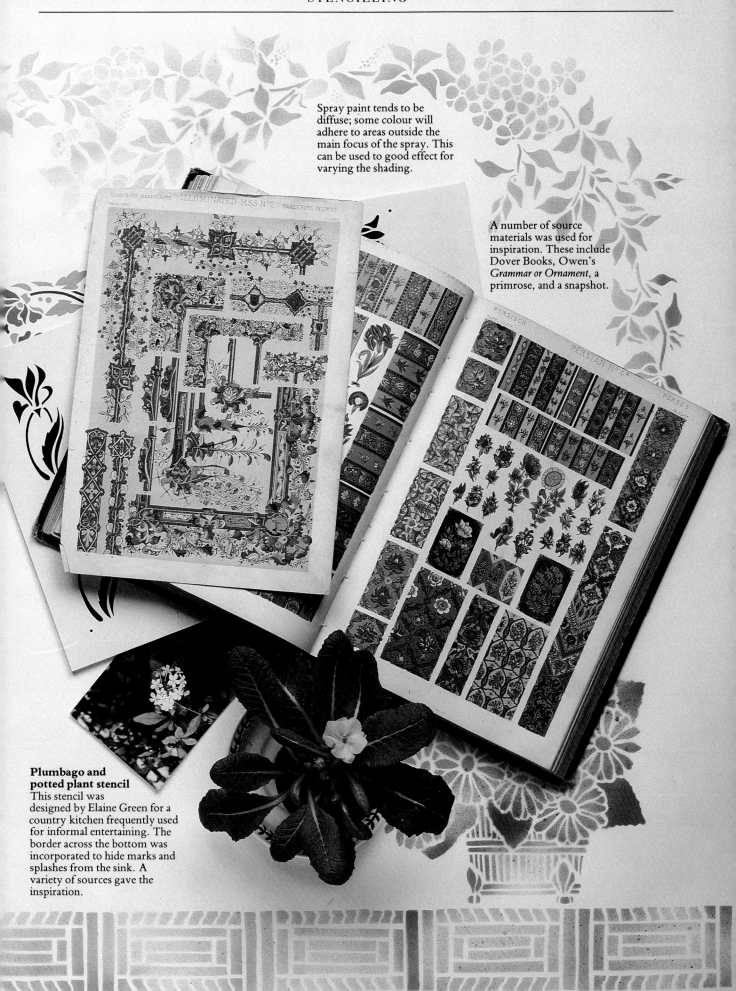

Spray paint tends to be diffuse; some colour will adhere to areas outside the main focus of the spray. This can be used to good effect for varying the shading.

A number of source materials was used for inspiration. These include Dover Books, Owen's *Grammar or Ornament*, a primrose, and a snapshot.

Plumbago and potted plant stencil
This stencil was designed by Elaine Green for a country kitchen frequently used for informal entertaining. The border across the bottom was incorporated to hide marks and splashes from the sink. A variety of sources gave the inspiration.

Using found objects

Here, 'found objects' means things that form natural stencils, like lace, fabric or paper doylies, perforated zinc, and leaves. Any flat, firm object can be used as a positive stencil.

The idea of using lace as a stencil came from a Mr S. T. Bullinger of New York, and is mentioned in a Victorian book for painters and decorators. He suggested using specially prepared lengths of lace curtains. He advised tacking a piece of curtain to a wooden frame and then coating it with shellac. When dry, the curtain could be taken off the frame and used as a stencil. Nowadays, it should be sufficient to dip the lace into a bowl of dilute varnish, let it soak thoroughly, and hang it up to dry.

Some ingenuity will have to be used if the lace does not exactly fit the surface to be stencilled. It can be cut down or repeated. It might also be nice to use some of the pictorial lace curtains that are now becoming more readily available and popular.

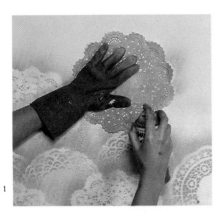

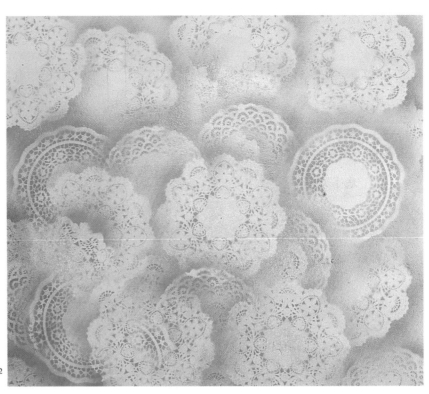

1 A variety of paper doylies were used as stencils. As they are fairly delicate, it was easier to use spray paint than apply paint with a brush. This also gives a delicate, cloudy effect. Handle car sprays with care, as the vapour is toxic.

2 The pattern was built up irregularly, with the doylies overlapping. Only very little spray paint is needed to complement the delicacy of the outlines. Before you start, experiment by testing the stencil on some lining paper.

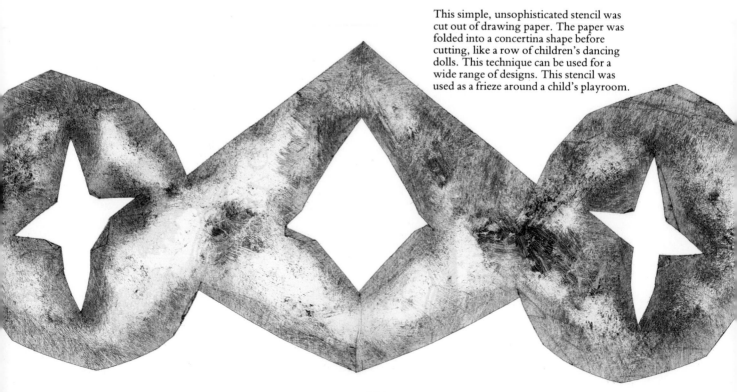

This simple, unsophisticated stencil was cut out of drawing paper. The paper was folded into a concertina shape before cutting, like a row of children's dancing dolls. This technique can be used for a wide range of designs. This stencil was used as a frieze around a child's playroom.

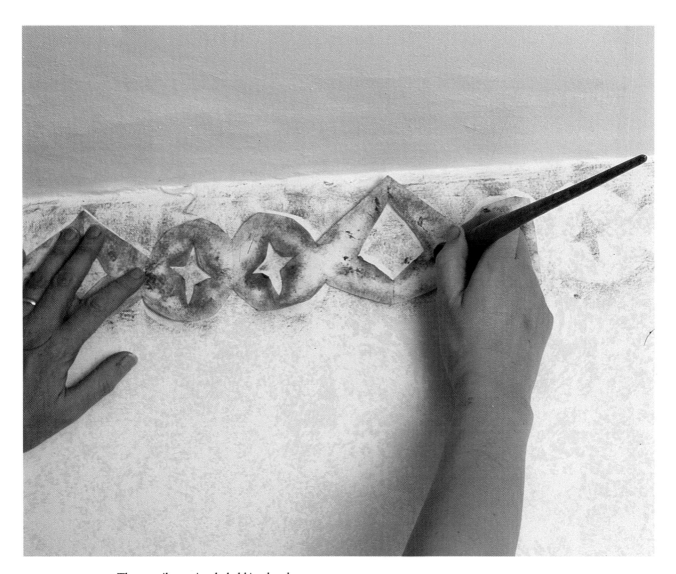

The stencil was simply held in place by
hand, and very dry oil paint was used. As
the room was small and the stencil was not
intended to be reused, it was not necessary
to use oiled manila; drawing paper was
quite adequate.

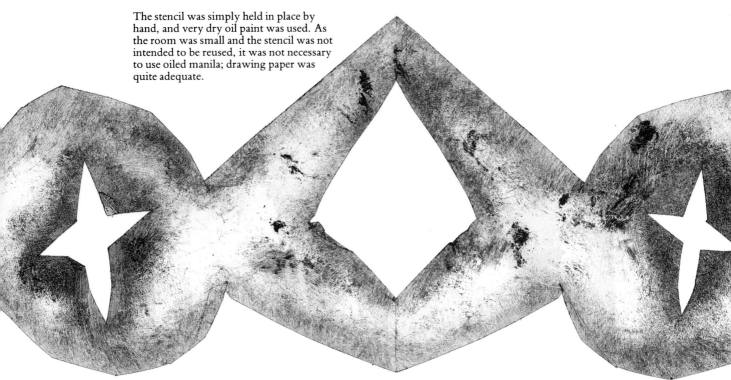

Stripes

Stripes have long been an answer to wall decoration, and according to their colour, proportion, and manner, present either a cool, classic sedateness or a contemporary, jazzy feel with a host of differences between. They may be wide and evenly spaced, close in tone and/or colour, with straight edges; they may be hand painted with superimposition or overlapping.

Stripes can be made by dragging (see pp66–8) in different colours using an oil glaze over an eggshell base. Alternatively, you could paint a striped eggshell base and drag over the top. You can also create stripes with a comb (see pp72–3).

Lines with more character can be painted in by hand. A fitch filled with paint and pulled down a wall following a plumbline or previously drawn chalk line can produce an interesting, wobbly effect.

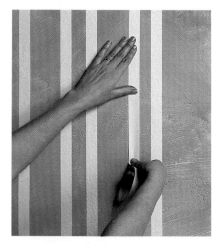

1 Stripes were masked off with cheaper quality masking tape, using a plumb-line at intervals as a guide. Make sure that the basecoat is thoroughly dry first.

2 Some stripes were painted by feathering dark blue paint over the edges. The paint must be quite dry so that it does not run down the wall.

3 Other, solid stripes were filled in. Using masking tape in different widths and at varying intervals offers scope for an immense variety of stripes.

1 These dining room walls were decorated in lively, wobbly stripes. They were painted in three shades of yellow, using emulsion paint.

2 The feathering gives an informal effect, but a more classical look can be achieved by painting solid stripes in more traditional colours.

Frottage

Frottage, that is literally rubbing the surface of the paint, works particular well with water-based paints. It is an extremely useful technique for mural work where a loose, irregular texture is required, on grass, distant trees, sea, skies etc. It can be used either as a base for further painting or as an end in itself.

You can lose the painted brush line quality of hand-painted stripes by using frottage. While the paint is still wet, place a sheet of newspaper on the wall, and gently rub over the paint. If you have used your paint too thickly, it will splodge about underneath the paper with some unexpected results. If it is too dry, the frottage will have no effect. It is a matter of trial and error until you have found the right paint consistency. With this slightly unpredictable technique the happy accident can be an added bonus.

1 The background was painted with PVA paint and when it was dry, a second coat of a different colour was liberally applied.

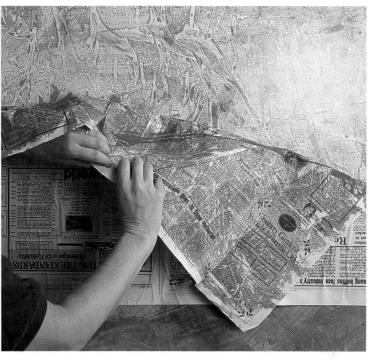

3 Peel the newspaper off the wall. Unsuccessful patches can be touched in. Oil colour may be used, but a lot is needed because the newspaper is very absorbent.

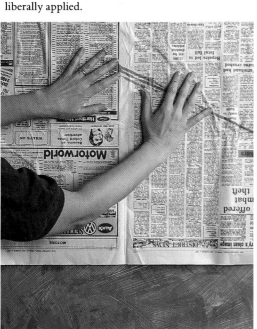

2 A sheet of newspaper was placed on the surface and rubbed smoothly. Varying pressure will have different effects, but it is always an unpredictable technique. Papers vary in absorbency.

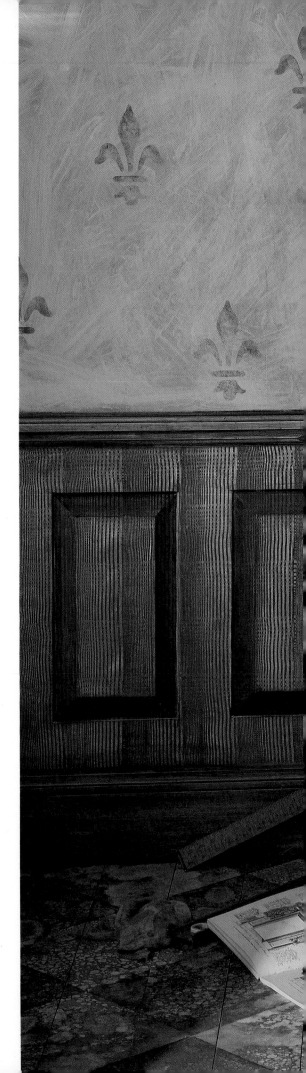

CHAPTER VIII

Painting Freehand

Freehand painting can be simple and straightforward, or complex and creative. You may choose, for example, to paint a simple, freehand dado rail—a painted line can have much more life in it than one created with masking tape and a ruler—or a full-scale *trompe l'oeil* painting. There is a world of difference between the two and no short, easy route from one to the other. Like any skill, practice makes perfect. This chapter should help to make the journey a little easier and more understandable.

Trompe l'oeil panels were painted on the dado, using Alizarin Crimson, French Ultramarine, and Burnt Umber for the shadows, and Alizarin Crimson, French Ultramarine, and white in the lighter areas. Using differing proportions of a limited palette, a surprising range of colour and tone was achieved in the room.

Brushwork

Free brushwork can range in scale from the very simple blobbing of a paintbrush, a few dots and dashes, to the grandness of a full-scale mural. Many people need first to overcome an initial inhibition to painting on a pure white wall—perhaps those without this drawback belonged to the tribe of children who were inveterate wall-scribblers.

The advantage of using oil paint is that it can be wiped off; the advantage of using acrylic is that it dries rapidly, and can therefore be overpainted and corrected quickly. Both paints have different properties of handling, feel, drying times etc., and these are best discovered through experience. Freehand painting is probably best done in oils if you need a line with some verve and life to it. Acrylics work well as underpainting for more complex works, especially if you are going to plan a mural virtually 'on the wall'. Poster colour and gouache cannot be used, as they are not waterproof.

A sense of design

One of the most important requirements of freehand painting is a sense of design. Many people interested in paint and interior decoration have an innate sense of design without being particularly aware of it. It manifests itself in the combinations of colour, texture, and scale they use in a wide variety of ways and situations.

Designing a full-scale mural can be a daunting task. Where does the tree go? Should there be a balustrade behind or in front of the columns? What did ships look like in the 17th century? A source of reference is crucial, whatever you are painting. If you are working out a composition, look at the works of Old Masters and Renaissance murals; their compositions are unerring. They can also provide quite a few ideas. If you are painting cupids, for example, take a look at Rubens. Adapt them, if you can; otherwise a photocopier with a facility for enlargement is a wonderful help.

Style

Painting freehand can be as formal or as loose as you like, but it must be appropriate. Grand, classical landscapes are difficult to integrate into most modestly sized houses, and you should be aware of the consequences if you embark on one.

You do not have to be an artist to paint freehand, providing you have a grasp of design and colour. No great ability is required for painting such things as dashes, dots, stripes, and geometric shapes. Let your brush do the work for you. The brushes you use offer many design opportunities. For example, simply by changing from thick to thin brushes, bristle to sable brushes, and flat-ended to pointed brushes, you can vary the marks you make.

Treat your wall like a canvas, and remember that oil paint can be wiped off. Do not worry if 'mistakes' are made. These can add character to your work, rather than having a bland but perfect rendition.

To make something symmetrical a flexicurve may be used. This is a plastic-coated metal rod that can be bent and curved in various directions. Shape it to match the painting on one side, and then turn it to make a match the other side.

White chalk is a good way to mark up the initial stage of the painting. Beware of getting the paint too thick, as this will look unattractive.

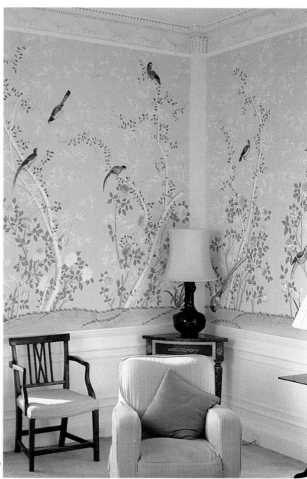

1 White eggshell has been painted in a loose and free criss-cross to reveal the sand-coloured basecoat. The end of a brush was used to scribble crosses, squiggles, and irregular patterns.

2 A door in an informal country house was painted with fairly loose, free brushwork. Some details were scraped back into the paint.

3 The artist, Jane Gifford, painted this exquisite wallpaper in her studio. It was inspired by motifs from ancient Chinese silk hangings.

4 Traditional floral motifs were painted in acrylic on the panels of the shutters. This is a good example of how the shape and size of the brush can dictate the type of mark. The pink (6) was added to complement the colour scheme in the rest of the room.

5 The claustrophobic nature of a long, dark corridor is alleviated by the painted window at the end. This purely decorative feature is not intended to deceive the eye.

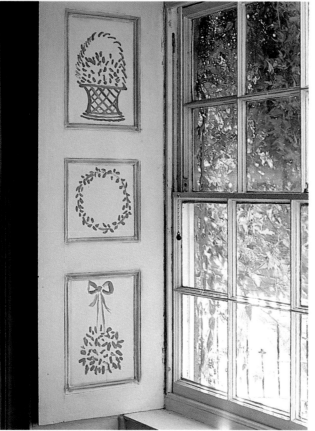

Unplanned mural

An unplanned mural is a painting on a wall that takes advantage of chance techniques and where brushmarks are used as expressive lines. In a planned mural, and particularly in a *trompe l'oeil*, the viewer should not be aware of brushmarks. An unplanned mural is also executed more quickly.

Any mural has to be planned to some extent. Some people like to organize everything beforehand, leaving nothing to chance, while others prefer to do the main 'creating' on the wall. In any case, a certain amount of thought needs to go into the project beforehand. Collect pictures from magazines, postcards, and books. These will serve as an inspiration to get the work going and will help with details. Then make a rough sketch of the overall shape of the design. Make colour and tone notes by dabbing paint on a page to get an overall feel.

Assemble brushes in a variety of sizes and shapes, and items for making other marks. Thin paper for frottage, and a sponge, rag, and mutton cloth for removing and adding paint are also useful. To paint a tree, for instance, a sponged on mark can be used to make the foliage. A piece of cardboard with paint along the edge can be used for printing on lines etc.

Once everything has been collected, colour notes have been made, and the overall design has been decided, then you can begin work on the wall. Use chalk to start the work. This will give you a chance to get the scale correct.

If you are using oil paint, start with a thin wash of paint, tentatively marking in shapes and colour. If the painting is to look spontaneous and fresh, little overpainting is possible. Final brushmarks may be made with thicker paint, but remember that this may look unsightly when it is dry and ridges are seen on the wall. There are a variety of glazes to make the paint transparent and to make it dry quickly; these may make the work easier.

In some ways, acrylic paint is easier to use, but the finish may be less attractive. It is also easier to get the paint thick and in ridges. You can make use of this. However, it may be unattractive if the mural has been overpainted and ridges remain underneath.

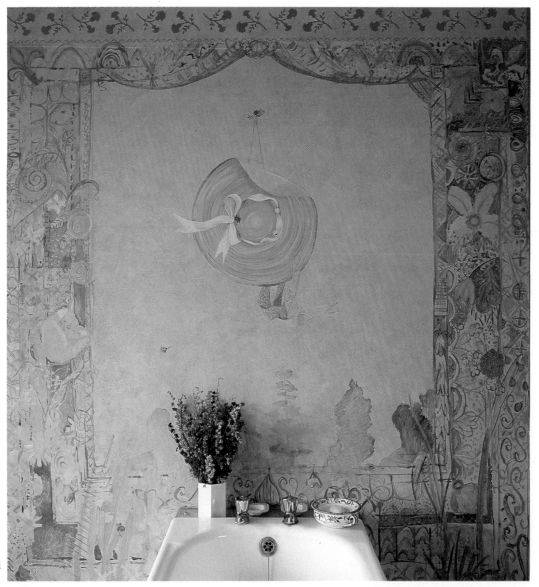

1 This mural was painted on a pink ragged wall. The loose border uses traditional motifs and designs, such as flowers and crosses. The realistic depiction of the hat contrasts with the stylized border.

2 This is part of a room-sized mural. The artist drew with chalk on an acrylic gesso background. Using a small range of acrylic colours, he painted out and re-drew as the design evolved.

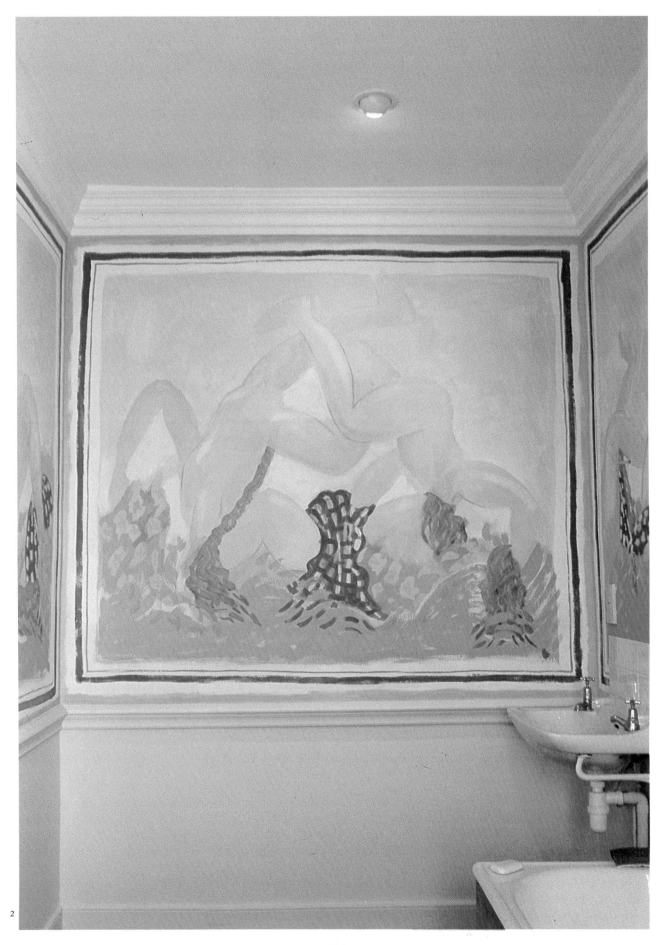

Planned mural

There are two main approaches to creating a mural or painted wall decoration. One extreme is to work out the design more or less on the wall (see pp198–9). This method gives a vigorous, expressionist and impressionist painting, and should, perhaps, only be attempted by a very experienced painter. The other extreme is to plan the mural thoroughly and meticulously so that nothing is left to chance on the wall. This will give a more contained and precise result; it is essential for any *trompe l'oeil* work (see pp202–7). How far the design and colour is worked out in advance is largely up to the experience, personality, and ability of the muralist.

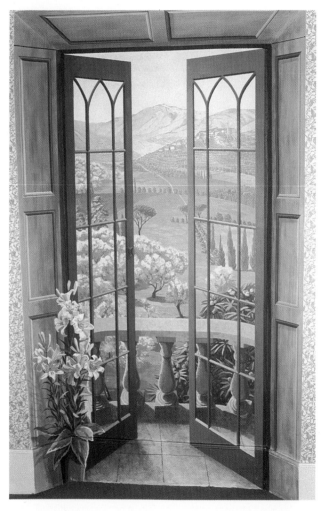

This acrylic mural of a Tuscan view was painted in an alcove in a wood-panelled corridor. Photographs and other pictures were used as sources of inspiration and reference. The shape of the french windows corresponds to real doors in the house.

The design

The first stage is, of course, to choose the subject. Then you must research it and collect sufficient reference material to make a start on the rough, overall design. Work on this until you have a clear idea of the mural.

Next, an accurate scale plan of the wall should be made. If you are going to use paint for your colour and tone notes, you must stretch the paper to prevent it buckling when wet. You will need a piece of board slightly larger than the paper. Wet the paper with a sponge, pushing out the edges so that there are few bubbles. Be careful not to stretch it too much, or it will tear when it dries. Secure the edges of the paper to the board with gummed brown paper tape, and leave it to dry naturally.

The larger the plan, the better, as more detail can be drawn on a large plan or cartoon. Divide it into squares. Draw out the design on the paper, refining the work until all areas of the design have been resolved.

At the same time, you can make tonal notes, and you could also consider colour. You can use coloured pencils or paint such as gouache. You may start with grisaille (see pp206–7) to ascertain the tones, or you can use colour immediately. The work is either painted in complete detail or small sections of each area are painted in to ascertain the exact colour and tone of the work. When all this has been decided, you are ready to start to transfer the design on to the wall.

Preparing the wall

If you are going to use water-based paint, then the wall can be painted in a good quality, silk vinyl emulsion to provide a good, reasonably non-porous surface. If you are going to use oil colour, then you should paint an eggshell basecoat. The surface should be without dents or lumps that might distract the eye. It is usually preferable to work on a neutral background of a middle tone.

Transferring the design

Draw a grid on the wall to correspond to the grid on your plan. You can use a variety of materials for drawing the grid and the design; each has its own limitations. White chalk on a neutral ground is a good idea, as the chalk does not discolour the paint. Thin sticks of charcoal can be used, but it is essential to fix it on the wall with a proprietary spray fixative, otherwise the charcoal will dirty the paint. Alternatively, you could draw with a very soft pencil. This is sometimes difficult to remove, as a pencil can dent the wall and shows through pale colours. Some people prefer to use a stiff bristle brush and quick-drying paints, such as acrylic or gouache. Acrylic paint may make ridges and, as it is a plastic, water-based paint, may not make a permanent surface over the eggshell base. It may not fully adhere to the eggshell if an oil paint is to be painted over it. Using paint and a brush does not have the accuracy of the other two methods, but it does allow you to get the design on to the wall with expression. Colour and tone can also be introduced at an early stage.

Draw up the design from the grid, line by line and square by square. Then fill in the colour square by square. Work from the background up, ending with the details and the brightest, lightest tone and colour. If there is to be a sky, put this in first. It is essential that it is the correct tone. If it is too dark, then the darkest areas of the mural will end up totally black; if it is too light, then the darkest tones will not be dark enough and the whole painting could end up looking bleached.

Acrylic paint, tempera or oil paint may be used.

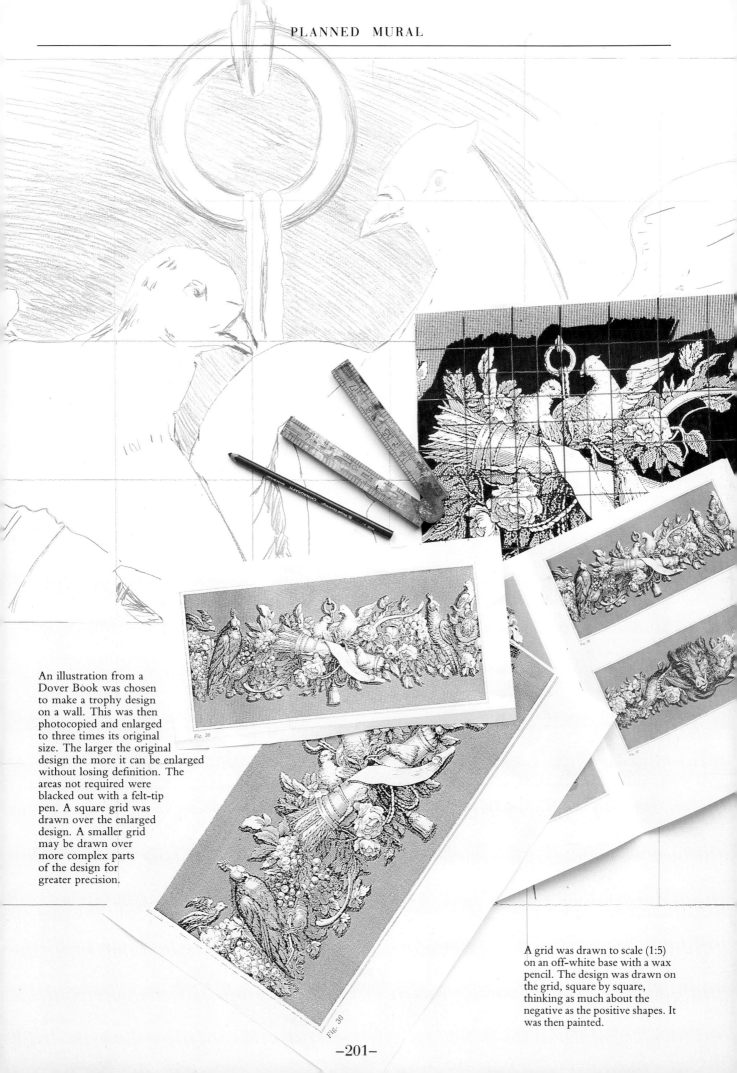

An illustration from a
Dover Book was chosen
to make a trophy design
on a wall. This was then
photocopied and enlarged
to three times its original
size. The larger the original
design the more it can be enlarged
without losing definition. The
areas not required were
blacked out with a felt-tip
pen. A square grid was
drawn over the enlarged
design. A smaller grid
may be drawn over
more complex parts
of the design for
greater precision.

A grid was drawn to scale (1:5)
on an off-white base with a wax
pencil. The design was drawn on
the grid, square by square,
thinking as much about the
negative as the positive shapes. It
was then painted.

Trompe l'oeil

Trompe l'oeil means to deceive, to outwit the eye, and this is entirely the purpose of *trompe l'oeil* painting. At first sight, it must mystify, surprise, and beguile the spectator into believing that he is seeing three-dimensional objects rather than a painted, two-dimensional surface. The deception is momentary, since a pause and a second glance is long enough to tell us that we are looking at a painted surface. To be successful the painting has to be more than real, better than a photograph. Artists have developed a set of rules to achieve this seemingly impossible task, and, while a complex composition is a skilful and demanding task, a simple *trompe l'oeil* can be made less arduous by understanding a few rules, the help of good references, and a few tips.

The essence of *trompe l'oeil* is the initial impression of surprise—which is more or less momentary before the viewer realizes the hoax. We are all prepared to accept the visual world presented to us, so the *trompe l'oeil* artist must take advantage of this. This gives rise to two crucial rules about the design of *trompe l'oeil*. All objects must be painted life-size. Our unconscious visual knowledge is very highly developed, especially where well-known, familiar objects are concerned. The illusion will not be convincing if an object is slightly reduced or enlarged. The second important point is that no object must be cut off or incomplete in the way it can be in a conventional painting, where elements may be obscured by the frame.

The history

Trompe l'oeil started with an intense desire to paint reality—real objects and people—in the most life-like way. The discoveries by Renaissance artists of the structure of human anatomy and linear perspective gave them the opportunity to paint with an increasingly virtuoso sense of reality. Along this route to reality artists began to slip jokes into their works, such as life-size paintings of flies on the canvas and pieces of folded paper with signatures on them. Their life-size interpretation often put the picture back into the realm of illusion, while it stood out so fantastically that the folded paper made a regular appearance in the *trompe l'oeil* painting. This in turn led to paintings being a regular subject in *trompe l'oeil* works.

Later the success with which painters were able to imitate wood led to the use of woodgraining in *trompe l'oeil* painting, either as doors behind open doors, for example, or as table tops with objects laid down on the horizontal surface. In the 18th century, firescreens were being decorated with *trompe l'oeil* painting. They often had an unusual, downward viewpoint.

1 This is a good subject for *trompe l'oeil* because it does not involve perspective. The artist, Dorothy Boyer, started this straightforward painting by rubbing down the table with a wet and dry block to remove old varnish and dirt.

2 She positioned two overlapping playing cards and drew round each one with a coloured pencil. Old cards with character, creases etc. are best.

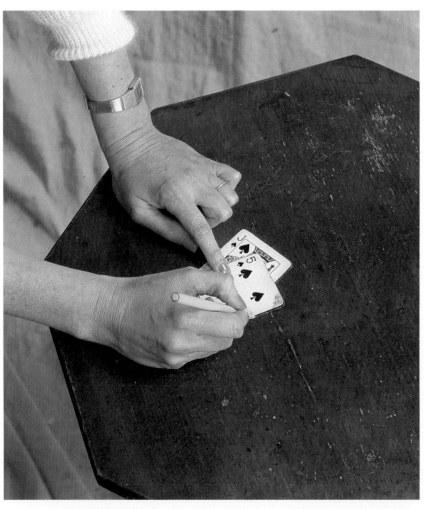

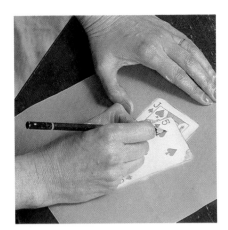

3 She outlined the main shapes and numbers with an HB pencil on tracing paper, turned it over and drew over the lines.

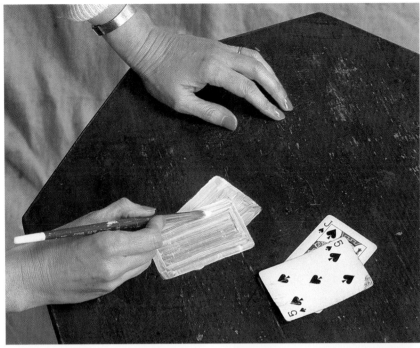

4 She painted out the whole area of the cards in white acrylic paint, until it was well covered.

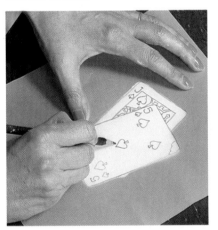

5 When the white paint was dry, she drew over the lines of the tracing with an HB pencil to delineate the separate cards and mark the suits.

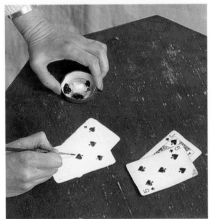

6 She mentally divided the cards into three tones. She started by painting the darkest tones—the black of the spades, the denominations, and dark shadows.

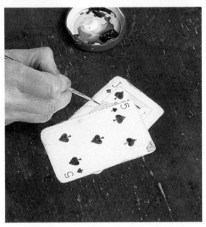

7 She then added the middle tones, using only greys to bring out the tonal difference between the red, blue, and yellow, and the shadows and creases.

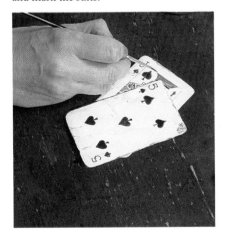

8 A thin wash of colour was painted on both cards, allowing the underlying tones to come through. Extra colour was added on creases, shadows, and the Jack.

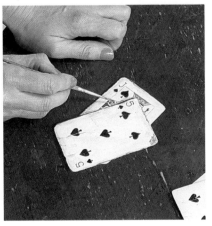

9 Extra attention was paid to making edges very straight and neat. It may be necessary to have a light tone along them next to the darkest tone to give sharpness.

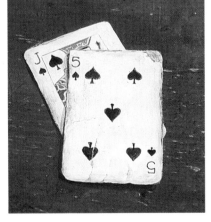

10 The entire table top was varnished again with a mid-sheen varnish.

Artists have set out to overcome the flat surface of the wall, either by increasing the depth beyond it or by extending out from it into the room, or by laying objects down on a horizontal surface.

Subjects for *trompe l'oeil*

Some subjects are constant themes for *trompe l'oeil* paintings. Some of these have been arrived at for technical and practical reasons, others for historical ones. Many *trompe l'oeil* paintings contain objects redolent with symbolism, especially those like skulls, crosses, glasses of wine, and bread, painted on altar pieces.

The commonest interpretation is, perhaps, a chaotic arrangement of objects on a shelf or in a niche. The niche allowed a *trompe l'oeil* artist to give the impression of depth, thereby 'punching a hole' in the wall.

It was also possible to come out of the picture plane or the wall by apparently hanging objects or shelves on its surface. Half-open cupboards added to the air of mystery, and, from a painter's point of view, it was easier to invade the space of the spectator by coming out of the wall and throwing the niche behind into shadow.

Paintings of paintings were common, since it was only the frame which needed to deceive the eye, with perhaps a torn canvas, broken glass, and a wooden stretcher showing. Towards the middle of the 17th century, representations of crumpled and folded papers fixed to a flat surface were common. Drawings and engravings in a jumble of texts and a bewildering confusion of overlapping papers and envelopes were depicted realistically.

A painted violin at Chatsworth house, Derbyshire gives passers-by a real trick of the eye. The open door dictates the viewpoint and there is an element of humour.

Hunting trophies presented artists with the additional problems of depicting fur and feather, whereas reflections of everyday life often had elements of humour which bore a particular relationship to the house and its inhabitants. In certain respects the painting became the portrait of an unseen person.

Rules for *trompe l'oeil*

The dividing line between a realistic mural painting and true *trompe l'oeil* is sometimes very fine. True *trompe l'oeil* should follow these rules.
1. All objects must be life-size. This makes the business a little easier, as flat objects, like envelopes, can be traced and measured accurately.
2. A *trompe l'oeil* painting shows as little depth as possible. It is difficult to create an exaggerated feeling of depth. Therefore, a true *trompe l'oeil* painting avoids views from windows or down long corridors, and focuses more on small niches or flat objects on a pinboard. However, there have been some very effective paintings and murals with long vistas. It really is a matter of what your objectives are.
3. The painting must fit perfectly into its setting in order to be believable. Taken to a logical conclusion, this means that the elements that make up the *trompe l'oeil* must fit into the age and style of the room. Some contemporary *trompe l'oeil* paintings verge towards decorative murals because they portray antique objects in a modern setting.
4. Anything that moves, such as animals and people, is to be avoided. Insects, like flies and butterflies, work because they do stay still, albeit momentarily, but people will look like strangely frozen objects.
5. A *trompe l'oeil* painting cannot be treated like an artist's canvas, where objects are 'cut off' by the frame.

Perspective

Many true *trompe l'oeil* paintings have very little depth and therefore little evidence of linear perspective. Nevertheless, it is still important to have a working knowledge of perspective, if only to understand how artists first managed to punch a hole in the picture plane.

Linear perspective is simply a device invented by man to allow him to represent three-dimensional objects on a two-dimensional flat plane. It is a visual trick and illusion which is really the essence of *trompe l'oeil*. Nevertheless, *trompe l'oeil* does more than aim at reality. In many ways it has to be more pronounced and more real than reality.

The most important element of linear perspective is the fact that it only works from one viewpoint. That is, it works for a single, immobile spectator keeping his eyes still. As soon as he, or his eyes, move, his viewpoint and perspective change. When that happens the trick of *trompe l'oeil* is fully revealed. When the laws of perspective were first being discovered, artists constructed elaborate drawing machines with peepholes and devices that kept their eyes in the same position.

The *trompe l'oeil* artist must present his painting from the most obvious viewing position. Deception sometimes works best if you view the painting as you first enter the room, so that it has an element of surprise. This will often require a niche or set of shelves to be painted in two-point perspective (see below). This is more difficult to accomplish and can look odd and unsatisfactory from inside the room. On the other hand, you might consider painting it from the viewpoint where it is likely to be seen most and will deceive most readily. A row of *trompe l'oeil* books among a collection of real books, for example, can be

viewed directly ahead of the prospective reader.

The next important points to consider are the eye level and the horizon line. If you look straight ahead, your eye level is an imaginary flat plane stretching from your eyes to meet the horizon line. This can drastically alter a picture; a bird's eye view has a large sky and a small landscape, whereas a worm's eye view has large grasses in the foreground and a small sky. It follows that, as you lie down, sit down, or stand up, your viewpoint and perception of the world changes.

It is important to establish where your horizon line is on the picture plane. (For muralists and *trompe l'oeil* artists, the picture plane is the wall.) *Trompe l'oeil* pictures are usually painted with a horizon line for viewers who are standing up. By the time a spectator has sat down, the element of surprise is already lost.

All parallel lines which go from the spectator towards the horizon appear to meet at a point (the vanishing point) on the horizon line. There can be many different vanishing points all along the horizon line. For example, several books standing at different angles on a shelf, will all have a different set of parallel lines and vanishing points. Several objects on a shelf with different vanishing points is a more successful *trompe l'oeil* subject than several objects with a single vanishing point.

A cube is the easiest three-dimensional object to imagine. Think of it set directly in front of you so that you see only one side; it will have only one vanishing point on its horizon line. If it is placed at an angle so that you see two sides, it will have two sets of parallel lines and two vanishing points at different places along the horizon line. This is called two-point perspective. (There is always only one horizon line in every picture.)

There are some historical examples of three-point perspective being used in *trompe l'oeil*. This happens if the spectator is looking either up or down at a cube and can see both sides and the bottom or the top. In this case, three sets of vanishing points are set up.

Light and shadow

Light picking out objects in contrast to a dark background often gives a more realistic feeling of depth than any perspective construction. A shadow from an object thrown on to the back wall of a niche will convince the spectator of the space surrounding it.

Always take into account the natural light sources in a room (there will almost certainly be more than one). Study the highlights and shadows of the natural light in

A dull door leading to the owner's wine collection was woodgrained. The panels were painted as shelves of small items. The book titles were invented for the family.

the room, and consider what time of day the room is most often used. The light and shadow cast in a *trompe l'oeil* painting should be as close as possible to the light in the room itself.

Shadows are the most important feature in a *trompe l'oeil* painting; they are a real help to the artist in abetting his trick on the eye. It is wise to study the light in a room, to see where it falls and how many windows and light sources there are. The greater the number of light sources, the more diffused the shadow will be. Also, the farther the light source is from the object, the weaker the shadow will be. A single light source which throws a single shadow in one direction is easier to paint, but the *trompe l'oeil* painting will need to be viewed in a room with a single consistent light source.

How to go about it

Unless you take a photograph of a special set up for a *trompe l'oeil* painting, you will have to use your ingenuity and knowledge of perspective. Certainly black and white photographs are a great help, as they establish the all-important tones. Nevertheless, they can be confusing because the light and shadow will have to be invented if they do not conform to the rest of the piece. They will almost certainly not be taken from the right viewpoint either. And since *trompe l'oeil* is bigger and better than reality, the shadows and tones will need to be exaggerated. Photographs can be a great help, but only if you know how to 'read' them.

These complications presuppose that the *trompe l'oeil* on which you are about to embark is a complicated one with niches, shelves, books, and other objects. If you have never painted a *trompe l'oeil* before, you are surely being over-ambitious. It is better to start with a small, simple, and less demanding theme. Very often the best *trompes l'oeil* are the most unassuming.

How to use paint

There are no hard-and-fast rules about what sort of paint to use. If you are going to use oil and acrylics, an oil-based paint like eggshell is best. The surface must be as smooth as possible because any imperfections will catch the light and destroy the illusion. Acrylics dry quickly and are good for underpainting, but you cannot use them on top of oil paint. Either use them for roughly blocking in the general design, or as proper underpainting thoroughly to indicate the tones and to give greater depth.

It is best to cover the whole wall with a mid-grey tone and work into the darks and lights. It is very rare to get a tone as light as the white from an oil tube.

Grisaille

Grisaille is a style of painting in monochrome (usually grey but also in tones of Indian Red or grey-blue), representing solid bodies in relief. These typically may be trophies, cartouches, carved stone ornaments, architectural features, and statues. Grisaille has been used since classical times to produce very deceptive imitations of marble statuary. Usually grisaille work is *trompe l'oeil*.

Two rooms with complete 18th-century mural scehemes executed in grisaille, yet in a less classical mode and probably executed using distemper, have been discovered in a farmhouse in Avon. They were probably intended to imitate the more expensive wallpapers, which would have been printed in a limited range of perhaps five or six tones. The murals are painted in a blueish monochrome with pastoral and decorative subjects on a dirty pink background. Used like this, the grisaille is not a *trompe l'oeil*. Beneath the murals, a *trompe l'oeil* dado imitates blue marble.

Grisaille may be used as underpainting for mural work, as a structure to underpin the tonal plan. The van Eycks, the Flemish painters credited with having invented oil painting, used this method, taking it to a very high standard indeed. Tone—that is to say, tonal relationships or the relative lightness and darkness of a given scene—is often the most difficult aspect of making a thoroughly credible picture. That is why this technique was established. Objects, whether figures, architectural features, trophies, or *trompe l'oeil* features, take their place on the picture plane, standing forward of each other or being placed one behind the other.

The technique

The method usually adopted is as follows. A single light source is decided upon and all the relative tones are dependent upon it. The artist mixes three basic tones to correspond to those decided upon. He observes the scene—taken from life or drawings—as a monochrome. This is easier than might at first be thought; by narrowing the eyes, tonal distinctions are much better seen.

There are two methods of grisaille underpainting. The tones may be slowly built up (with your eyes narrowed) until the painting begins to take on a sense of dimension. Alternatively, you could lay a middle tone across the whole surface, and use the darker and lighter mixes to touch in the foreground and distant planes, allowing the middle tone to establish the centre plane.

Grisaille can be used as a finish in itself, or it can be used as an underpainting (see pp200–1).

This painting, depicting the history of Bell Foundry, was done with emulsion and acrylic paint. It was painted in tones of terracotta on a sponged terracotta background.

1 Although very little colour has been used, the shadow on the left of the door makes the ribbon seem very real.

2 and 3 The rough outlines of the fruit bowl and the wreath were drawn out and then the background was marbled. The main elements were painted in a mid-tone with a small fitch. The darkest tone was added, followed by the lightest. Then finer details were painted in all three tones. The grey was mixed from Titanium White, Alizarin Crimson, Oxide of Chromium, Raw Umber, and a tiny amount of Ivory Black. Although the painting is broadly monochrome, some Indian Red and Raw Sienna were added to the palette for warmth. The references used were drawn from historical architectural design books.

Doors and panels

Panels are small, plain areas raised or below a surface, or merely marked off by a border or frame. They may be square, oblong, oval or circular in varying proportions to each other. The word panel is derived from a Latin word meaning a folded cloth, and this can be seen in the curious edges given to many old, carved panels.

They are often decorated with carving, inlay, painting, or motifs; sometimes they are left blank. In ancient Greece, Rome, and Byzantium, panels were frequently painted with miniatures, and they received special attention during the Renaissance and neoclassical periods, when they featured paintings by Watteau, Boucher, and others. In England, Robert Adam employed Flaxman, Angelica Kaufman, and many more. Later panels were usually filled with floral pieces or trophies.

You can create an illusion of panelling on a flat surface, such as a door, quite simply, following precise rules. Decide on the style of panelling—extravagant, simple, complex, or restrained—and make a preparatory drawing of the whole thing, either full-size or to scale. The reason for this is to anticipate mistakes in measurement, or character and proportion, leaving only the technical work to be done *in situ*. After you have made the template, you must decide the direction of the light source, the colour, and the strength of tone. Usually, the light source is from above (the sun or a central room light) and from one side. Unless there is good reason to deviate from this, it is recommended that such 'rule of thumb' be observed. Make sure that you fully understand the tonal relationships—the dark recesses and light extrusions. The freshness resulting from this preparation is a desirable quality in such illusionary work.

The panels are painted in a darker tone than the stiles and rails. A simple panel can be painted using only four tones. There are various brushes that may be used for the lining—a swordliner, a long-haired pencil brush, or a signwriter's lining brush. Masking tape may be used, but it tends to make a raised, 'hard' edge.

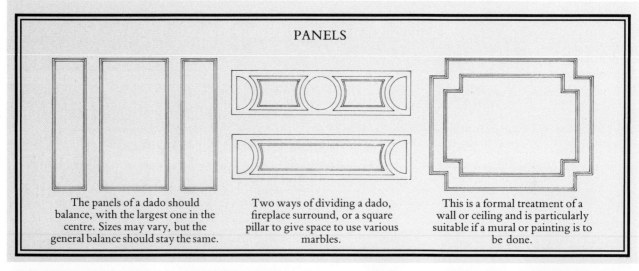

PANELS

The panels of a dado should balance, with the largest one in the centre. Sizes may vary, but the general balance should stay the same.

Two ways of dividing a dado, fireplace surround, or a square pillar to give space to use various marbles.

This is a formal treatment of a wall or ceiling and is particularly suitable if a mural or painting is to be done.

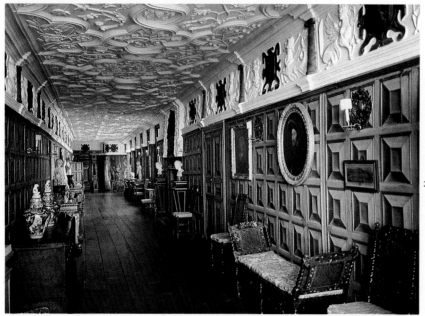

1 A corridor in Powis Castle was painted in the 16th century to simulate wood panelling. Simply done in just a few tones, it works very well.

2 Panelling does not necessarily have to be painted in a classical manner, but it is important to draw the correct aesthetic proportions to be convincing.

1 To paint panels on a flat door, start by measuring and drawing them with a soft pencil. Mix up two glazes and apply the darker tone to one panel.

2 Drag with a flogging brush. Paint and drag the remaining panels with the darker tone of glaze, one at a time.

3 Wipe the edges of the panels with a soft rag, leaving the stiles and rails clean. You do not have to be too meticulous about this.

4 When the panels are dry, apply the lighter glaze to the rest of the door. Drag with a flogging brush in the appropriate order: centre stiles, rails, outer stiles.

5 As the glaze dries, you may need to apply additional pressure to the bristles with your other hand. This also helps to keep the brush steady.

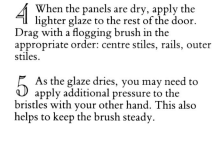

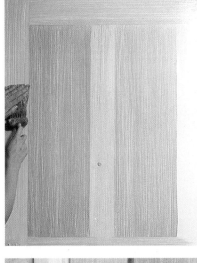

6 Leave to dry overnight. This allows you to work freely the next day without smudging the dragging, and any mistakes can be wiped off.

7 Rest a straight edge on the architrave with the ferrule of the brush on it so that the paint cannot seep underneath. Pull the ferrule along. Mitre the corners.

8 Only two tones are needed. Paint the light tone at the bottom and one side of the panel, depending on the direction of the light.

Skies

Quite an obvious, but still very effective, way to decorate a ceiling is to paint it as a sky. This gives a room an ethereal, heavenly feeling. The approach can vary enormously, from a simple sprayed on blue to a grandiose *trompe l'oeil* effect. It really depends on what sort of sky you are after and what is most suitable. Usually, the sky stops at the cornice, but you can bring it over the edge to come down into the rest of the room.

It is hard work painting a sky, particularly on high ceilings. You may hire proper scaffolding if it is really high, but planks of wood balanced on two ladders may suffice, as long as they are secure.

You can mix a wide range of blues, depending on the weather and the time of day you want to imitate. Most people go for a sunny, summer's day for obvious reasons, but you can introduce a few changes in tone and colour for added interest. It may be more interesting to use a colour other than white for the basecoat, so that you may highlight with true white later on.

First method
1. Paint eggshell blue and leave to dry.
2. Paint the white glaze in patches, in thick and thin areas.
3. Stipple out.

Second method
1. Paint eggshell blue and leave to dry.
2. Manipulate oil or acrylic paint with fitches. Use various sizes of brushes to get the correct feeling.

This method can be complicated or simple, depending on your capabilities. It is a good idea to look at some references, including the skies of famous painters and other painted ceilings.

You may reverse the process by painting the surface with a light colour, such as pure white or ivory, and then paint blue over it. A softening brush may be useful for blending colours and tones together.

Third method
1. Paint white eggshell and leave to dry.
2. Spray using blue car spray (or other spray) to simulate the sky, leaving space for clouds. The room needs to be well ventilated. (See Stencilling for safety notes when using car sprays.) Cover all other surfaces with dustsheets first.

Fourth method
1. Paint white eggshell and leave to dry.
2. Paint a suitable colour glaze and mutton cloth (see p56–7). Take off more paint in some areas to create a drifting cloud effect.

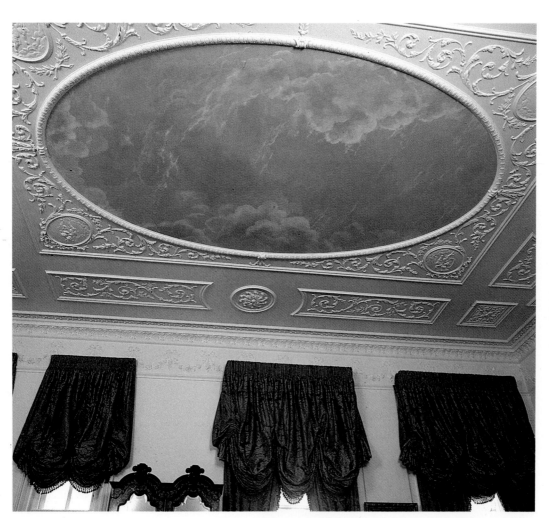

The unusual shape of the ceiling inspired this interesting and delightful painting of sky. The ornate moulding provides a framework. It was painted in oil colour, the artist lying on scaffolding in traditional manner.

Stonework

There was a fashion in medieval interiors for marking out white walls with red lines to imitate masonry. Stonework is still popular today, although it is in keeping with fewer houses. Painted stonework is generally best suited to entrance halls, stairwells, lobbies, and cloakrooms. It can be done quite simply and very convincingly, once care has been taken to mark out the stones. It is mainly a matter of proportion and colour.

Stonework can be grand but restrained. It can also look ridiculously out of place, unless it is painted in the right context or treated as a total fantasy. It may be used as a finish on its own or as a base to be incorporated in *trompe l'oeil* painting.

Regular stonework

1. Mark the wall in squares and rectangles with a pencil or chalk, using a straight edge, plumbline, and spirit level as necessary.
2. Put the colour on in patchy areas, all over in different tones.
3. Stipple out using a large fitch or stippling brush (this gives a very fine look).
4. Go over the lines of pencil in a lighter and varying colour.

For the look of a Cotswold or other uneven stone wall, the stones can be painted freehand. Think about scale, and look at a wall or a photograph for reference.

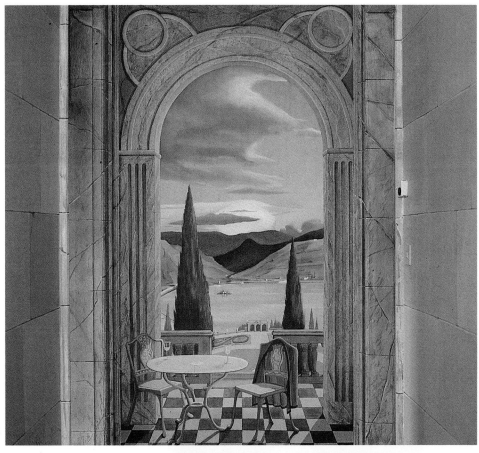

1 This Mediterranean scene was painted in acrylic. The stonework in the passage way was drawn and then stippled and sponged for a cool, fairly even look.

2 Also painted in acrylic, the base was done in different colours by sponging over a light wash. Colour was then flicked and sprayed on to give varying effects.

3 The plinth is drawn in straight perspective. The pale stonework is painted in ochres, with green in the shadows, playing off the dark patina of the bronze figure. The paint was dabbed and ragged to achieve a textural surface.

Using fabric paints

Fabric can be painted to make your own curtains and soft furnishings. A wide variety of fabric paints and pens are available from art shops, craft shops, and other suppliers. Some, like those specially prepared for fabric stencilling, can be bought at shops which sell stencilling equipment. Acrylic paints can also be used. There are paints specifically intended for silk and cotton fabrics, and some that can only be used for printing. There are also fabric pens which allow more freedom to draw.

Special paint is required for use on fabric because it soaks through the fabric rather than remaining on the surface and later cracking off. The colours are also more resistant to washing. However, ordinary acrylic and oil paints can be used. Anybody who has accidentally got paint on his clothes and then tried to remove it knows how difficult it is to wash out or clean off. However, it does tend to stiffen the fabric.

Before they are painted, new fabrics should be washed to minimize shrinkage and remove any starch present. It is always advisable to test an offcut first. When painting, protect your table with newspaper or plastic. It is easier to paint if the fabric is taped down at the sides: This is especially important if you are painting a fine fabric that might wrinkle and pull in the wrong direction.

Work directly on to the fabric. You can use a freehand approach, or softly draw a more carefully worked-out design with a pencil or a crayon before painting. These will wash out. A 'resist' can be made by drawing with a wax candle. The wax forms a barrier to the paint. Melted wax, using a batik method, is even better.

Alternatively, objects can be dipped into the paint and printed on to the material in the same way as on a wall (see pp174–6). You could use sponges, wine corks, plastic cups, vegetables, or even your hands.

For a softer effect, either dampen the fabric before painting or dilute the paint. This allows the paints to bleed into each other. To paint on to a darker colour, it is best to use white first. Fabric pens are terrific for creating patterns as they are less inhibiting than paint, but colours cannot be so easily mixed.

A candle was used to draw a grid pattern, forming a barrier to paint. Successive grids were painted in red, green, and blue. The fabric was then ironed to fix the colour and to melt the candle wax.

This pattern was printed with a wooden block from India in a traditional paisley design. The two colours were painted on the block with a brush and printed simultaneously.

The orange stripes were painted with the aid of masking tape. When the stripes were dry, the blue flowers were painted freehand, and the orange centres were added with the tip of a brush.

The blue background was ragged on and allowed to dry. The circles were printed using a cork, and the grid was painted freehand with the aid of a straight edge to keep it even and regular.

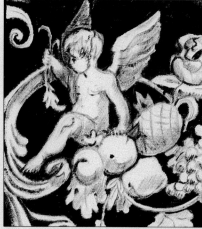

This charming cupid was painted freehand using only black paint to create an unusual silhouette effect. Some people might prefer to draw the design with fabric pens before applying paint.

A small piece of crumpled corrugated cardboard was dipped in fabric paint and printed at random. No attempt was made to make the pattern regular in weight, tone, or angle of design.

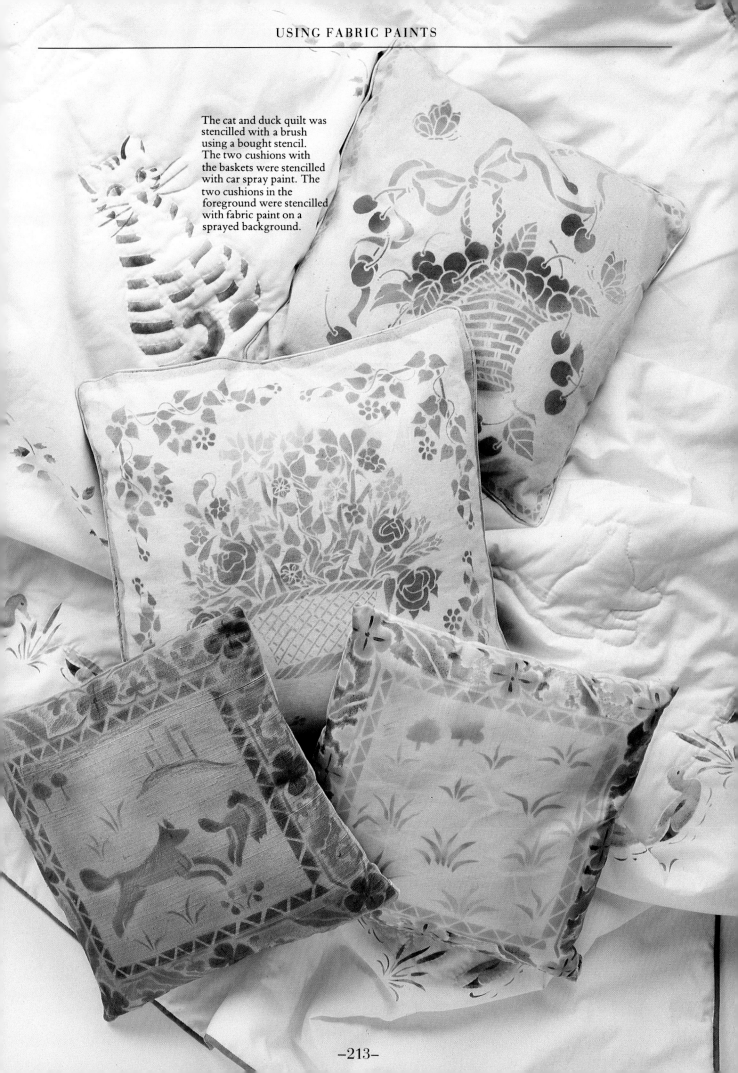

The cat and duck quilt was stencilled with a brush using a bought stencil. The two cushions with the baskets were stencilled with car spray paint. The two cushions in the foreground were stencilled with fabric paint on a sprayed background.

Glossary

A

Acetate Transparent or semi-transparent film used for making stencils.

Acrylic Fast-drying, water-based paint that dries to a waterproof finish.

Ageing A technique for simulating the effect of time and wear on a freshly painted finish. Also called *antiquing*.

Antiquing A technique for simulating the effect of time and wear on a freshly painted surface. Also called *ageing*.

Architrave The wooden frame surrounding a door or window. It can be simple or moulded and ornate.

Artists' oils Oil paints manufactured for artists, used by decorators for tinting *glaze*. The *pigments* are highly refined and bound with *linseed oil*. Available in a wide range of colours.

B

Badger brush Softening brush made of badger hair. They may be various shapes (e.g. round, flat, and full), and various sizes. Used primarily for blending, particularly in marbling, *woodgraining*, tortoiseshelling, and other bravura finishes. An essential tool.

Basecoat The first coat of paint for most decorative paint finishes, applied before the *glaze* or *ground coat*. *Eggshell* is used for all oil techniques.

Beeswax Wax produced by bees. Used by decorators to protect and shine a paint finish.

Blending brush See *softening brush*.

Bole A coloured clay mixed with *rabbit-skin glue* sometimes applied over *gesso* before *gilding*.

Border A design around the edge of panel, wall, floor, etc. It may be stencilled, printed, or painted freehand.

Bridge Small tabs left in place in a cut-out stencil to prevent it 'falling out'.

Burnisher Extremely smooth agate polisher used for burnishing in *water-gilding*.

C

Colour wiping Coloured *glaze* is wiped off raised areas.

Comb Wood or plastic toothed implements, originally developed for *woodgraining* and now also used for combing. They can be cut from stiff cardboard.

Chalk-o-matic A commercial version of chalky string used for marking panels and patterns on floors and walls.

Cornice Moulding around a room between the walls and ceiling, traditionally found *in situ*, but nowadays prefabricated.

Crackleglaze A finish produced by using two varnishes that work against each other to produce a crazed effect.

D

Dado The part of a wall beneath the *dado rail*, traditionally painted, panelled, or otherwise decorated differently from the rest of the wall.

Dado rail A rail, developed in the 18th century, fixed to walls to prevent damage from chair backs.

Découpage A surface decoration with paper cut-outs.

Distressing A technique for simulating the effects of wear and tear on a newly painted surface. Also used to describe the technique for breaking up the *ground coat* in marbling.

Dragging brush See *flogging brush*.

Driers Chemicals mixed with paint and *glaze* to accelerate the drying process.

E

Eggshell A mid-sheen, oil-based paint used as a *basecoat* for basic and bravura finishes. White eggshell is also used for mixing some pale colours for the *glaze* coat. Also used to describe a mid-sheen finish of paints and *varnishes*.

Emulsion Water-based paint; not suitable for most decorative paint finishes, except sponging on with emulsion paint or *acrylic*.

Emulsion glaze A water-based *varnish* available in matt, mid-sheen and gloss finish. Used as a varnish, but it can also be used to make water-based paint transparent. It is very quick drying.

F

Faux bois French term for *woodgraining*.

Faux marbre French term for marbling.

Fitch Hog-hair brush suitable for oil work (one type is available for watercolour work). The five types are round, filbert, long, short, and herkomer. Used in many techniques and as an alternative to a *household brush*.

Flogging brush Coarse horsehair brush used for dragging and flogging; available in a range of sizes.

Floor paint A range of specially tough paint suitable for use on wood, linoleum, and concrete.

Frieze The area of a wall between the cornice and picture rail. Also a band of decoration, usually just below the cornice, that may be wallpaper, stencilled, or painted freehand.

Fresco A method of watercolour painting, usually on a wall or ceiling, executed before the plaster is dry; rarely used today.

Fuso A machine used for spraying paint, rather like coarse spattering.

G

Gesso A white powder prepared with *rabbit-skin glue* and applied to surfaces in many layers to give a completely smooth finish before *gilding* or painting such as marbling.

Gilder's brush Brush used to apply water to a surface before *water-gilding*.

Gilder's knife A well-balanced knife used for cutting *gold leaf*.

Gilder's pad A pad with a folding wall of parchment used to hold and protect the delicate *gold leaf* in *water-gilding*.

Gilder's tip Device, made of hairs sandwiched between two pieces of very thin cardboard, used to pick up the delicate *gold leaf* used in *water-gilding*.

Gilding A specialist technique for applying gold to surfaces, used mainly on picture frames. See also *oil-gilding* and *water-gilding*.

Glasspaper Abrasive paper.

Glaze A transparent mixture of *linseed oil*, *driers*, *whiting*, and other oils in which colour is mixed. See also *emulsion glaze*.

Gold leaf Sheets of gold beaten to a wafer thinness used in *gilding*.

Gold size Oil used as adhesive for *transfer leaf* in *oil-gilding*. Various types are available with a range of drying times.

Gouache Opaque, water-based paint used for freehand painting. It is not waterproof, so it should be protected.

Grisaille Decorative monochrome painting simulating architectural detail and sculpture. Sometimes used as underpainting for *trompe l'oeil*, generally in greys and blues and reds and terracottas, but it can be any colour.

Ground coat In marbling the *glaze* coat is applied over the *basecoat* and then subsequently *distressed* and veined.

H

Heartwood The dense, inner part of a tree trunk yielding the hardest timber.

Household brush Decorator's paint brush, available in a wide range of sizes. Used for applying the *basecoat* and, sometimes as a substitute for a *flogging brush* in dragging.

L

Lacquering A technique for simulating the high-gloss finish of Chinese and Japanese lacquer.

Lining A technique for outlining the shape of a surface with one or more decorative lines.

Lining brush Long-haired brush used for *lining* furniture. *Swordliners* are also used.

Lining paper Plain, flat wallpaper used to line the walls of a room, often to disguise the poor quality of the plaster. It can be painted if it is first sealed with diluted *undercoat*.

Linseed oil A yellow vegetable oil; one of the main ingredients of *glaze*.

M

Mahl stick A stick with a padded end used by sign-writers and muralists to rest and steady their hands, while avoiding smudging their work.

Manila paper Strong brown paper; oiled manila paper is used for making stencils.

Masking tape A self-adhesive tape with many uses.

Megilp An old-fashioned name for *glaze*.

Methylated spirits Industrial alcohol used as a solvent.

Mottlers Brushes used for *undergraining* and *overgraining* wood. The three main types are long-haired, short-haired, and wavy.

Moulding Ornamental plasterwork or woodwork outlines.

Mural A painting on a wall.

Mutton cloth Also known as stockinet (stockinette), this cotton cloth with a variable weave is used for mutton clothing and for lifting off surplus paint.

O

Oil-gilding A technique in which *transfer gold* is applied to a surface.

Oil glaze See *glaze*.

Overgraining Painting a second layer of graining lines on some woods in *woodgraining*.

Overgrainer Brush used for *overgraining*.

P

Paint kettle A small bucket-like container, made of metal or plastic, in which small quantities of paint can be carried easily.

Palette Tray used for mixing paint. Also the term used to describe the range of colours used by the artist or decorator.

Pigment Colouring matter used in paints.

Plumbline A weighted string used for marking verticals.

Primary colours The colours from which all others can be mixed. The primary colours in paint are red, yellow, and blue. They combine to form *secondary colours*.

Primer A sealant for new plaster or woodwork before painting.

R

Rabbit-skin glue Glue made of animal cartilage used in the making of *gesso*.

Rail The horizontal section in the main frame of a panelled door.

Registration marks Guides used to indicate the position for second stencils when you are *stencilling* with more than one colour.

Retarder Chemical mixed with paint to inhibit evaporation and so slow the drying process.

Rigger Artists' brush with long hairs.

S

Sable brush Artists' high-quality brush.

Sandpaper Abrasive paper available in varying degrees of coarseness.

Scalpel Surgeon's knife with very sharp, replaceable blades, used by decorators for cutting out stencils.

Scumble Also known as *glaze*.

Secondary colours Colours made by mixing two *primary colours*. Together they form *tertiary colours*.

Shellac A resinous varnish.

Softening brush A long-haired brush used for softening and blending paint in marbling, *woodgraining*, and many other bravura finishes. Badger hair softeners are easier to use but more expensive than hog-hair softeners. Available in a range of sizes.

Spirit level A glass tube partly filled with spirit; the position of the air bubble indicates horizontality.

Sponge, natural Marine sponge used in sponging on and sponging off. It is also sometimes used in marbling and freehand painting.

Sponge, synthetic Man-made sponge with even, close holes. Useful for cutting into a shape for printing. Not really suitable for traditional sponging on and off, but may be used experimentally for a contemporary look, giving a denser and more defined area.

Squaring up A system of measuring and drawing up a grid to enlarge or reduce an image or to transfer it on to walls or floors etc.

Squirrel brush Artists' brush.

Stainers Sometimes known as universal stainers. Used as an alternative to *artists' oil* colours for colouring *glaze*. The range of colours is less extensive and less subtle than *artists' oils*.

Standard mixture Term used to describe the usual mixture of equal parts of *glaze* and *white spirit* used for many basic and bravura finishes.

Steel wool An abrasive made from fine shavings of steel; available in varying degrees of coarseness.

Stencil kit A pack containing pre-cut stencils and sometimes including *stencilling brushes* and paint.

Stencilling A decorative technique in which paint is applied through a cut-out design.

Stencilling brush Short-haired brushes designed to hold small amounts of paint for *stencilling*. Available in a wide range of sizes and with long or short handles.

Stile The vertical section in the main frame of a panelled door.

Stippling brush A rectangular brush used for a stippled finish and for removing excess paint in *cornices* and *architraves* etc. Available in a variety of sizes.

Stockinet (stockinette) See *mutton cloth*.

Straight edge A metal edge used for drawing and cutting straight lines.

Swag Ornamental festoon, usually of flowers.

Swordliner Paintbrush that tapers to a point, used for *lining* and as a substitute for feathers in marbling. Available in sizes 0 to 3.

T

Tertiary colours Colours made by mixing two *secondary colours*.

Tone The term used to describe how dark or light a colour is. Different colours may be the same tone.

Transfer gold Sheets of gold attached to tissue paper used in *oil-gilding*.

Trompe l'oeil A two-dimensional painting designed to deceive the viewer into believing that he is seeing a three-dimensional scene or object.

Turpentine A resinous solvent mixed in some paints and *varnishes*.

Turps. sub. (Turpentine substitute) A cheaper form of *white spirit*, used for cleaning brushes.

U

Undercoat Matt oil paint applied to a surface before the *basecoat*.

V

Varnish A transparent protective coat applied to completed paint finishes. Varnishes may be matt, *eggshell*, or gloss, and they may be water, oil, or spirit based.

Veining A specialist technique for painting in the veins on simulated marble.

W

Water-gilding A technique for applying *gold-leaf* to a surface.

Wet-and-dry sandpaper Abrasive used with water to achieve a really smooth finish.

White spirit Mineral solvent mixed with *glaze* and *artists' oils* for the glaze coat in many basic and bravura finishes. See also *standard mixture*. Also used for cleaning brushes, wiping away paint splashes etc.

Whiting Finely ground calcium carbonate used in making *gesso*.

Woodgraining Bravura finish to simulate the appearance of wood.

Index

Suppliers, decorators, and artists

Suppliers

Felicity Binyon and
Elizabeth Macfarlane
6 Polstead Road, Oxford.
Stencil kits

J.W. Bollom
314 Old Brompton Road,
London SW5.
General painting supplies

C. Brewers
327 Putney Bridge Road,
London SW15.
General painting supplies
Various branches in
S.E. England

Brodie and Middleton Ltd.
68 Dury Lane,
London WC2.
Pigments, paint

Cornellisons
105 Great Russell Street,
London WC1B.
Pigments and brushes

Craig & Rose plc
172 Leith Walk,
Edinburgh EH6 5ER.
Glaze

Dover Books
Earlham Street,
London WC2.
Reference and stencil books

W. Habberley Meadows Ltd.
5 Saxon Way,
Chelmsley Wood,
Brmingham B37 5AY.
Gilding materials, artists'
paints and brushes

J.T. Keep & Co,
13 Theobalds Road,
London WC1X 8SN.
General decorating supplies

Keeps Ltd
PO Box 78,
Croydon Road,
Beckenham,
Kent BR3 4BL.
Glaze

McDougall Rose
89 Richford Street,
London W6 7HW.
General painting supplies

Milners
Cowley Road,
Oxford.
General painting supplies
Other branches in S.E. England

The Paint Service Co Ltd.
19 Eccleston Street,
London SW1.
Glaze, brushes, household paint

E. Plotons
273 Archway Road,
London N6.
Glaze, paint, pigments, stencilling
and gilding materials

J.R. Ratcliffe & Co (Paints) Ltd.
135a Linaker Street,
Southport PR8 5DF.
Glaze

George Rowney and Co Ltd
12 Percy Street,
London W1A.
Artists' materials

Stuart R. Stevenson
66 Roding Road,
London E5.
Gilding materials

Carolyn Warrender Stencils
1 Ellis Street,
London SW1.
Stencil kits and equipment

Decorators and artists

Beaudesert
8, Symons Street,
Sloane Square,
London SW3.
Decorative objects

Beaudesert
Woodstock, Oxon.
Decorative objects

Felicity Binyon and
Elizabeth Macfarlane,
6 Polstead Road,
Oxford.
Stencilling

James Booth
Water Lane Cottage,
Water Lane,
Steeple Aston,
Oxon.
Decorative painting

Roderick Booth-Jones
14 Davisville Road,
London W12.
Trompe l'oeil and murals

Dorothy Boyer Interiors
14 Dove Street,
Norwich,
Norfolk.
Trompe l'oeil decorative
painting

Chalon Ltd.
Hambridge,
Somerset TA10 0BP.
18th- and 19th-century
European furniture

Serena Chaplin
32 Elsynge Road,
Wandsworth,
London SW18.
Gilding and lacquer
restoration

Lady Daphne
Manor House Decorations,
Dry Sandford,
Abingdon,
Oxon.
Decorative objects

Peter Davey
Hope Cottage,
Phoenix Lane,
Ashurst Wood,
West Sussex RH19 3QZ
Decorative painting

Victoria Ellerton
Unlimited Effects,
209 Chevening Road,
London NW6 6DT.
Decorative painting

Colin Failes
6 Elfindale Road,
London SE24.
*Trompe l'oeil, murals
and frescoes*

David Genty
7 South Grove,
Tunbridge Wells,
Kent.
*Decorative painting, aged and
distressed furniture*

Caroline Gibbs
25 Henning Street
London SW11.
Stencilling

Jane Gifford,
6 St Mark's Rise,
London E8 2NJ.
Murals

Golfas and Hughes
27a Thames House,
140 Battersea Park Road,
London SW11 4NB.
Tole ware

Elaine Green
Ladbrooke Cottage,
Penn Lane,
Hockley Heath,
Solihull,
West Midlands B94 8HJ.
Spray stencilling

Belinda Hextall
Baverstock Manor,
Dunston,
Salisbury,
Wiltshire SP3 5EN.
Gilding

Karl's Painted Swedish
Furniture
6 Cheval Place,
London SW7.
Painted furniture

Sally Kenny
16a Talbot Square,
London SW2.
Decorative painting

Kensington Leisure Courses
Blythe Road,
London W12.
Decorative painting

Harry Levinson
35A Dartmouth Park Avenue,
London NW5 1JL.
*Woodgraining and painted
furniture*

Thomas Messel,
Bradley Court,
Wotton-under-Edge,
Gloucestershire TL12 7PP.
Gilding

Michael Midgley
13 Hewer Street,
London W10 6DU.
Decorative paint finishes

Victoria Moreland
Marston Hill Farm,
Greatworthy,
Banbury,
Oxon OX17 2HF.
*Decorative painted objects
and furniture*

Katie Morgan
Sudely Castle Craft Workshops,
Winchcombe,
Gloucestershire.
*Painted firescreens and
companion figures*

Shelley Nicholson,
Sudely Castle Craft Workshops,
Winchcombe,
Gloucestershire.
Stencilled fabrics

Felicity Wakefield
Lincoln House,
28 Montpellier Road,
Twickenham,
Middlesex.
Decorative painting

Acknowledgements

Mobius International would like to thank the following
people for their assistance in the production of this book.

Editor
Linda A. Doeser

Design
Stephen Bull Associates
Art Director: Stephen Bull
Designers: Paul Burcher, Sue Corner

Photographers
Jon Bouchier
Michael Dunning
Andreas Einsiedel
Shona Wood

Illustrations
Jim Robins

Picture Research
Shona Wood

Mobius International would like to thank the following people for kindly allowing their houses etc. to
be photographed.

Beaudesert 10–11, 61T, 62, 63, 68T, 83T, 94BL, 106L, 116, 118L, 139BL, 140, 141T, 142T,
143T, 143B, 146TL, 148L, 149BL, 162TL, 163TL, 163CR, 185BL, 185BR, 207BL, 207BR;
Fiona Bell 205; Carola Bird 192BL; Chatsworth House 204; Colour Counsellors 186T; Clare
Copeman 83B; Carrie Hinton 145T; Mrs Hume-Kendall 56, 57BL, 61BL; Peter Makertich 75BL,
166TL; Helena Mercer 139BC, 148R, 165TL, 168–169B, 169BR; National Trust 7, 208L; Mrs
Sasse 144; Hamish Scott-Dalgleish 96; Dolores Sloan 213; Louise Wigley 9, 64, 198.

Mobius International would like to thank the following artists and decorators for kindly allowing their
work to be photographed.

Felicity Binyon and Elizabeth Macfarlane Stencil Designs 142T, 143T, 153T, 153B, 154TR, 154BL,
167B, 180, 184, 185CL, 185BL, 185BR, 186T, 186B; James Booth 148L; Roderick Booth-Jones
211L, 221B; Suzie Cartwright 213 (quilt, stencil design by Carolyn Warrender); Chalon 129TL,
129BL, 129R, 164L, 169TL; Serena Chaplin 132TR, 132BR; Peter Davey 132L, 133L, 133R,
166BL; Victoria Ellerton 83B, 96, 192BL; Colin Failes 199, 211R; David Genty 56, 57BL, 61BL,
144; Caroline Gibbs 181B; Jane Gifford 197TR, 200, 206, 207T; Golfar and Hughes 106R,
126TL, 127TL, 127TR; Elaine Green 136, 146B, 187, 188–189, 213 (large cushions); Pamela
Griffiths 145T, 149R, 165R; Belinda Hextall 124BL; Karl's Swedish Painted Furniture 128L,
171B; Sally Kenny 103R; Kensington Leisure Centre Courses 168L; Harry Levinson 113B, 114L,
118R, 139T, 139BR; Manor House Decorative Woodwork 159T, 160, 161, 163C, 163CR, 163BR,
165BL; Thomas Messel 126TR; Michael Midgley 126B, 128R; Katie Morgan 167T; Victoria
Moreland 1, 3, 93B, 114R (for Colefax & Fowler), 159BL; Shelley Nicholson 213 (small cushions);
Caroline Richardson 139BL; Felicity Wakefield 100R, 141BL, 162B, 210; Carolyn Warrender
185CR.

Mobius International would like to thank the following people for their help with step-by-step
photography.

Felicity Binyon (Stencilling), Dorothy Boyer (Trompe l'oeil), Belinda Hextall (Gold leaf and gilding),
and Harry Levinson (Watercolour woodgraining).

Picture credits

Jon Bouchier 9, 52, 53T,C & colourways, 54, 55, 57T & colourways, 58, 59T, C & colourways, 60,
61T & colourways, 63T, C & colourways, 64, 65T,C & colourways, 66–67, 68BL & BR, 69, 70,
71B & colourways, 72–73, 74, 75T,C & colourways, 80–81, 83T, 84–85, 86–87, 88–89, 90–91,
94–95, 96–97, 98, 99T,C & BL 100R, 101, 102, 103TL,CL,BL & colourways, 105–106, 107,
108–109, 111, 112–113, 114–115, 116–117, 118–119, 120–121, 122–123, 124–125, 131,
136, 137TL, 138TR & BR, 139T & BR. 140, 141T & BL, 142–143, 148L, 149TL, 154TL, 155T
& BL, 159BL, 170R, 174TL, 175, 176, 178–179, 182–183, 184, 185B, 187, 190–191, 192T &
BR, 193, 196, 197BR, 198, 202–203, 207BR & BL, 209, 210, 92; Michael Dunning 10L, 12, 14–
15, 16–17, 18–19, 20–21. 22–23, 24–25. 28L, 42, 45, 48, 50L, 61BC, 76L, 79, 99R &
colourways, 100L, 103R, 106. 126TL, 127. 132–133, 134L, 137B, 145B, 149R, 152, 154TR,
155BR, 156L, 158, 159T & BR, 160–161, 162–163, 164R, 165BL & R, 166TR & B, 167T,
171TR, 172L, 177B, 179B, 180BR, 188–189, 194L, 201R, 212–213, 93TL, BR, TR; Andreas
Einsiedel 2, 11, 29, 30–31, 32–33, 34–35, 36–37, 38–39, 40–41, 51, 76, 135, 141BR, 157,
171TL, 173, 185C, 195, 208BR; Colman Getty 185CR; Anthony Spinks 129, 164L, 169TL;
Shona Wood 53B, 56L, 57B, 59B, 61BL, 62, 65B, 68T, 71T, 83B, 137TR, 138CR, 139BL & BC,
144, 145T, 146–147, 148R, 149B, 150–151, 165TL, 168C, 169T & B, 174TR, 177T, 181, 185T
& CL, 186T, 192BL, 197TL, BC & CR, 205; Harry Cory-Wright 167C, 180L, 186B.

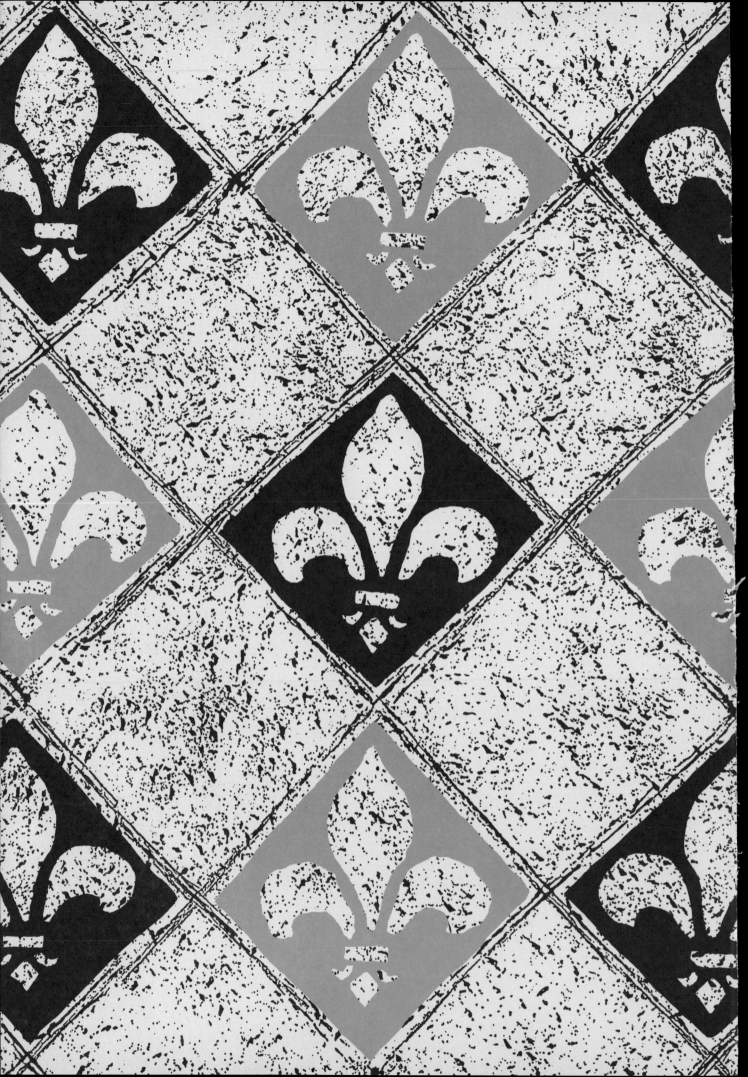